CW00747255

1/1000th

THE SPORTS PHOTOGRAPHY OF BOB MARTIN

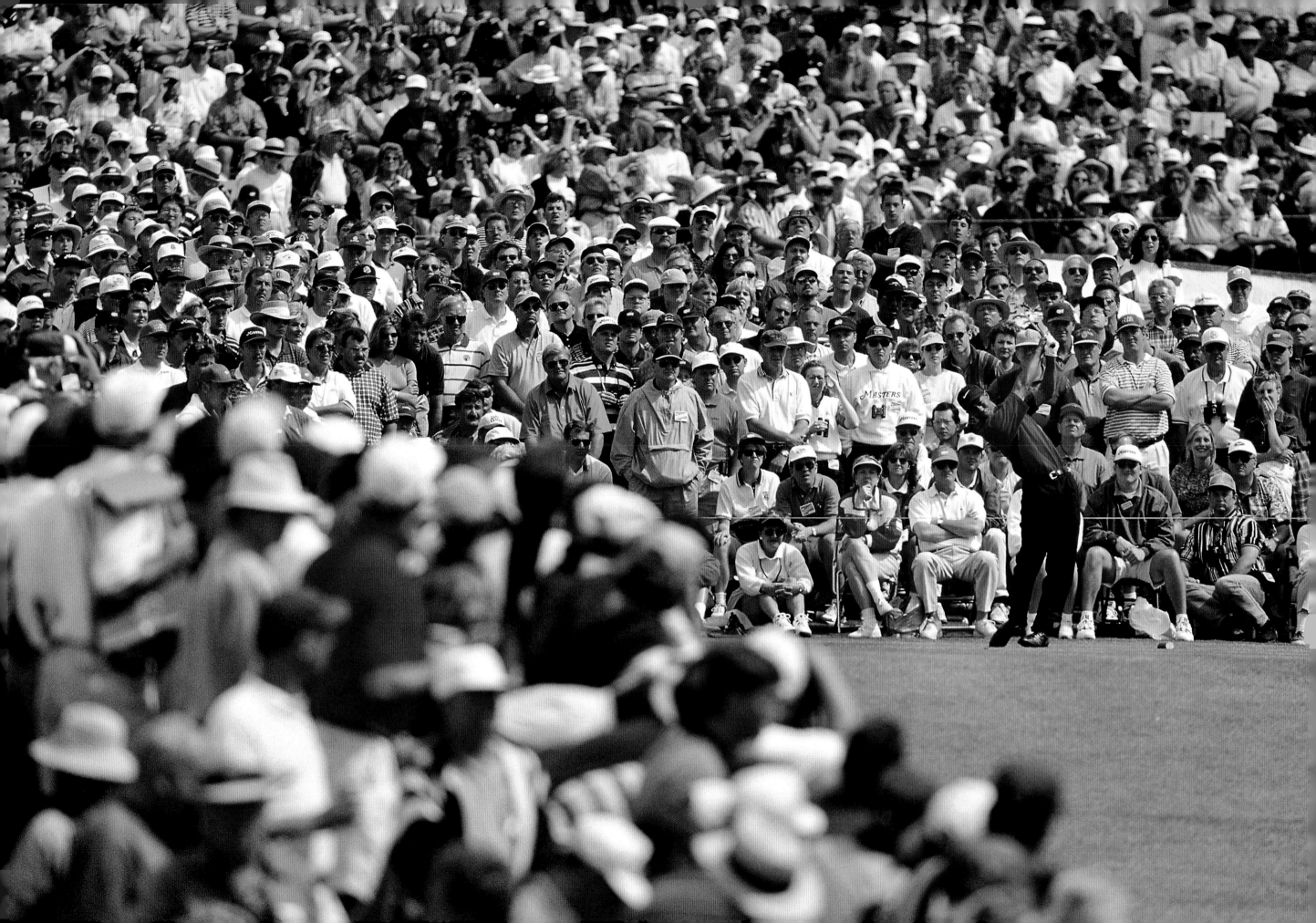

1/1000th

THE SPORTS PHOTOGRAPHY OF BOB MARTIN

NIKON AMBASSADOR
UNITED KINGDOM & ROI

VSP

Published in 2015 by Vision Sports Publishing Ltd

Vision Sports Publishing Ltd
19-23 High Street
Kingston upon Thames
Surrey
KT1 1LL

www.visionsp.co.uk

ISBN: 978-1909534-53-7

www.bobmartin.com

Editor: Jim Drewett
Production editor: Paul Baillie-Lane
Designer: Doug Cheeseman
Imaging: Jörn Kröger

Printed in China by Toppan Printing Co.

FSC
www.fsc.org

MIX
Paper from
responsible sources
FSC® C104723

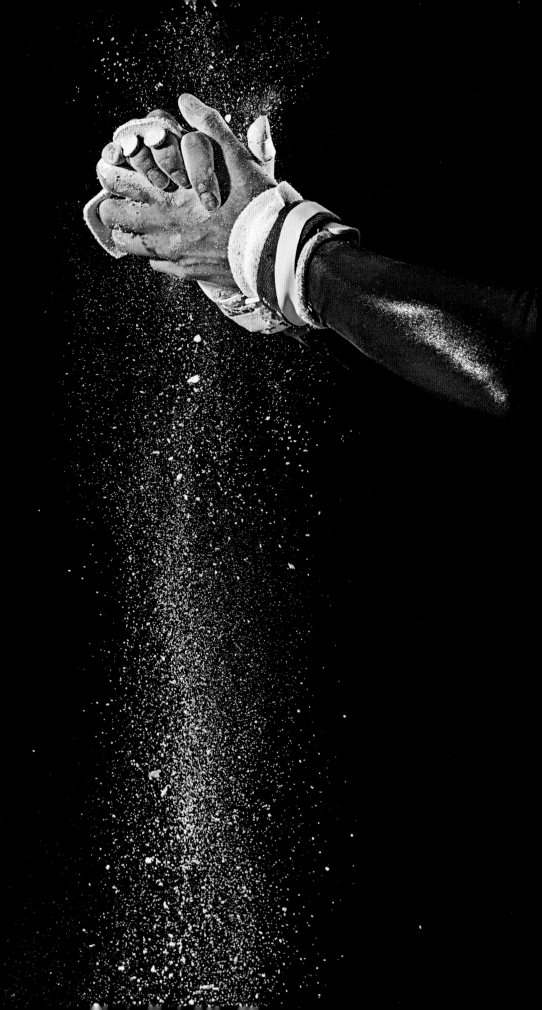

CONTENTS

FOREWORD

BY ANTHONY EDGAR HEAD OF MEDIA OPERATIONS, IOC

I had a number of iconic images in my head when I started working with the Sydney 2000 Olympic Games organising committee in 1997.

Top of the list was an athlete frozen at the peak of their dive over a glorious Barcelona skyline, punctuated by Antoni Gaudi's inspiring Sagrada Familia cathedral. It was an image that captivated the world during the 1992 Olympic Games in Barcelona. This image was first captured by Bob Martin for *Time* magazine while perched atop a ladder at a pre-Games event, and the majesty and popularity of the shot resulted in the organising committee having to build a platform at the diving pool so that all accredited photographers would have a chance to capture a similar picture.

The resulting photos of Fu Mingxia and Sun Shuwei, both of China, and Mary Ellen Clark of the United States, were the iconic images of Barcelona – the view becoming the seminal portrait of the Games which every Olympic city since, using one sport or another, has attempted to replicate.

When London won the 2012 Olympic Games, Bob was appointed Photo Chief, responsible for identifying photo positions at all venues. Of course, he went far beyond this. London was regarded by the international media as having the 'best ever' in-venue imagery and 'look' elements, sympathetic to the media's requirements, in precisely the right locations, the right size, the right hues. This gave photographers and broadcasters the ability to capture exquisite imagery of Olympic athletes at the peak of their performance, but with an unequivocal sense of place.

Bob is now consulting for the Rio de Janeiro 2016 Olympics to reprise what London was able to achieve with photographic coverage. Come Games-time, though, he will be back in the moat, photographing, leaving the photo chief role to someone else.

Photography is a labour of love for Bob. His 'eye', his innate sense of place, style and composition, his understanding of light and colour, combined with his knowledge of sports, has put him second to none in sports photography. I hope you enjoy his magnificent book as much as I do.

BARCELONA,
1992

This is the iconic view that everyone remembers from the Barcelona Olympics. Before every Olympics I always visit the host city in advance, so I knew all about this stunning location for the diving, and when *Time* magazine asked me to shoot a feature to preview the Games I knew just where to start. The problem was that none of the Spanish team would dive for me because they said the water was too cold in March. So I managed to find an English diver called Tracey Miles and persuaded her to model for the shoot. I had to light the picture with big studio flashes as in spring the view was too backlit – the sky would have been a milky grey – and I made poor old Tracey dive 15 times to be sure we had the shot... she was freezing cold and shivering by the time we finished.

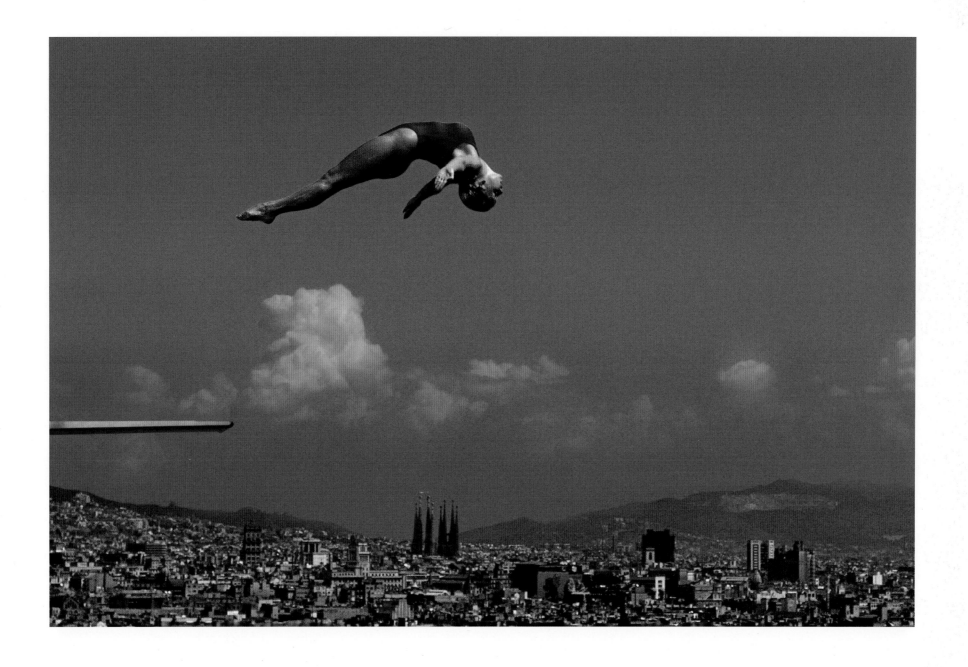

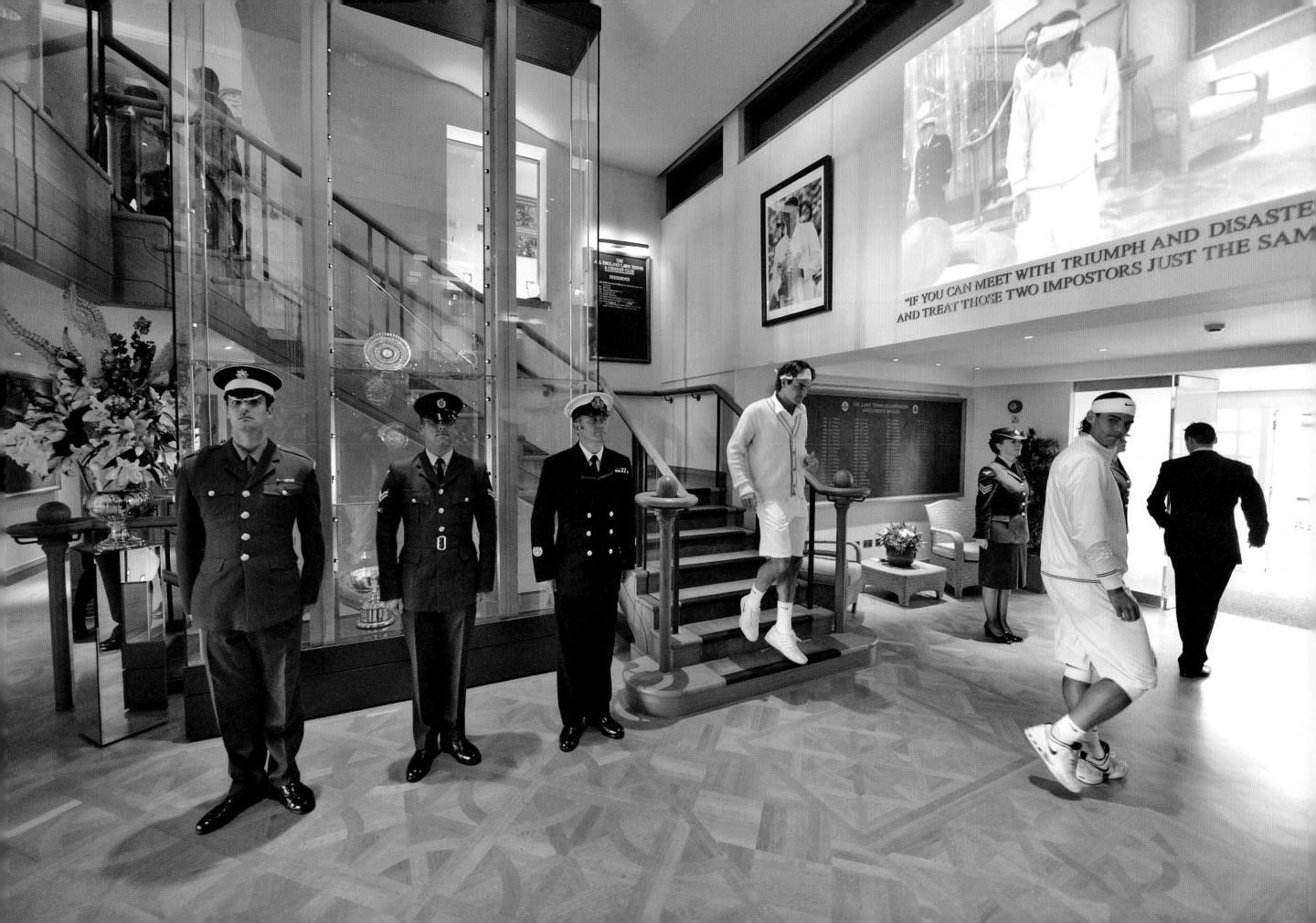

INTRODUCTION

BY BOB MARTIN

Welcome to *1/1000th – The Sports Photography of Bob Martin*, a retrospective collection of the best photographs from my career so far, presented as they were meant to be seen on high quality art paper and as big as the publishers would allow me to go. This is all about what I love to do.

So what is that exactly? Well, I have often thought about that, and I think the neatest way to sum it up is to say that I am a creative sports photographer who is always looking for something new, to get a picture that is different from the one everyone else has. I always try to find a twist. Be it a great background or a different angle or a great sense of place like an Olympic city, a stormy grey sky or a captivated crowd.

Of course it wasn't always like this. When I first started taking pictures I wasn't even particularly interested in sport. But I was fascinated by photography, and especially the technical side of things – in fact I really started taking pictures just so I would have something to process in the school darkroom. I would take my camera wherever I went, and soon realised how exciting it was to photograph sport. I was drawn to the action and drama I could get in a frame, even if I was only taking pictures for my mates at a school sports

day. Then I started going to motorbike scrambles in the Surrey Hills near where I lived. It was like, 'Wow look at this, they're flying through the air. What a shot.' My first ever published picture was a shot taken at one of these events which was printed in the *Surrey Comet*.

Once I realised that I really wasn't remotely intelligent enough to become a vet (my first-choice career), I eventually managed to get a position as a photo technician at Imperial College, servicing the research students in the civil engineering department. So we were doing things like using potassium permanganate in water to show the flow patterns going past models of the Thames Barrier and coating bits of steel with oil and then photographing them under ultraviolet light to show the stress fractures in the metal. It was very technical photography and I think that this training was the beginning of me always being ready to try a new toy or a new bit of gear.

When I was 20 I got a job in the photo lab for a sports picture agency called Allsport. It was a small company, so if someone was willing to go out and take pictures at the weekend, they would say, "Off you go, here's a pass." So they'd send me off to sports like gymnastics or football. Then in time I became a junior photographer and ended

continues on page 10

up staying wih Allsport – on and off – for about 15 years.

In those days my approach was exactly the same as everyone else's. I was just trying to take sports pictures – keep the action in focus and capture the moment. The sports photographers then were incredible technicians. They had to be. The really good ones – and I don't include myself in that bracket – could follow focus wonderfully. But in those days there weren't many good, old sports photographers because it wouldn't be long before their eyes had gone.

After a few years mine had gone too, and in the mid-1990s I was almost at the point of giving up and thinking, 'Right, I'll do some other kind of photography.' But then along came autofocus and everything changed. When this technology arrived, along with all the other wonderful things that these cameras can do today, sports photography became less about capturing the moment – because that was easy now – and more about being a 'proper' photographer. And that's when I blossomed.

I started to approach everything differently. Because the technical side of things was taken care of, suddenly I had time to think about the picture. The background, the context, the colours… and I began to plan everything in minute detail to get myself in positions to shoot interesting and unique pictures.

Around this time I started working for the legendary *Sports Illustrated* magazine in the States. One of my first big jobs for them was when they sent me all the way from England to cover The Masters golf. So off I went to Augusta and I was running round like a mad dog taking loads of pictures and I think I got 17 pictures published out of about 35 they used in their coverage. And I thought, 'My God, I've arrived. Half the pictures are mine!' But they were all little

ones. I flew home via New York and went into the mag and I was sitting next to Heinz Kluetmeier, the picture editor, and I was saying how great it was. But he said, "Yeah, but you didn't get the cover and you didn't get the opener. Those little pictures don't matter. You'll have arrived when you get those."

That really, really brought it home to me. It was a seminal moment. I realised that if I was going to be a success as the lone Englishman at this American publication then my photographs would have to be something special, something different. I became determined to beat the local photographers. And, in the nicest possible way, throughout my career I have always loved nothing better than getting one over on the Yanks!

So how did I then approach getting these kinds of pictures? It may sound stupid, but I started thinking. I began to spend all my time planning, plotting and conniving to get something that the other guys wouldn't have. Whatever it took. If it was an extra assistant, if it was a special bit of equipment, if it was special access – any little twist I could get on the mob is what I went after.

One of the major reasons why I have been able to get many of the pictures in this book is access – getting into areas in stadiums where other photographers will not be or gaining permission to place a remote camera in a unique vantage point. So that's all about contacts, relationships and bridge-building. In the old days that meant blagging my way up to the back of the stand or hiding behind the TV cameras, but nowadays I find it far more effective to speak to the clubs or the organisers, or get in with the TV production people. For instance, my award-winning picture of the Paralympic swimmer diving into the pool at the Athens Paralympics was the result of years of negotiation. It took me three trips to Athens and about 10 letters to get myself up into the lighting

continues on page 13

XAVI TORRES

This picture from the 2004 Paralympics in Athens has won more awards than any other photo I have taken, including the highly prestigious World Press Photo of the Year. I was shooting the 200 metres freestyle heats from the catwalk above the water, where the floodlights are fixed, but when the competitors came out for this particular heat there was this one guy in a tracksuit who didn't have any noticeable disability. Then I saw him start to take his large prosthetic legs off and put them next to his chair and I realised it would make a great picture. But I was half a pool length away so I had to rush over there as quick as I could along all these narrow, rickety catwalks. I didn't quite make it in time for the start, but luckily for me there was a false start so they had to get out and line up again, which is when I got the shot. The picture had a huge impact all over the world and was widely considered to be the best sports picture of the year.

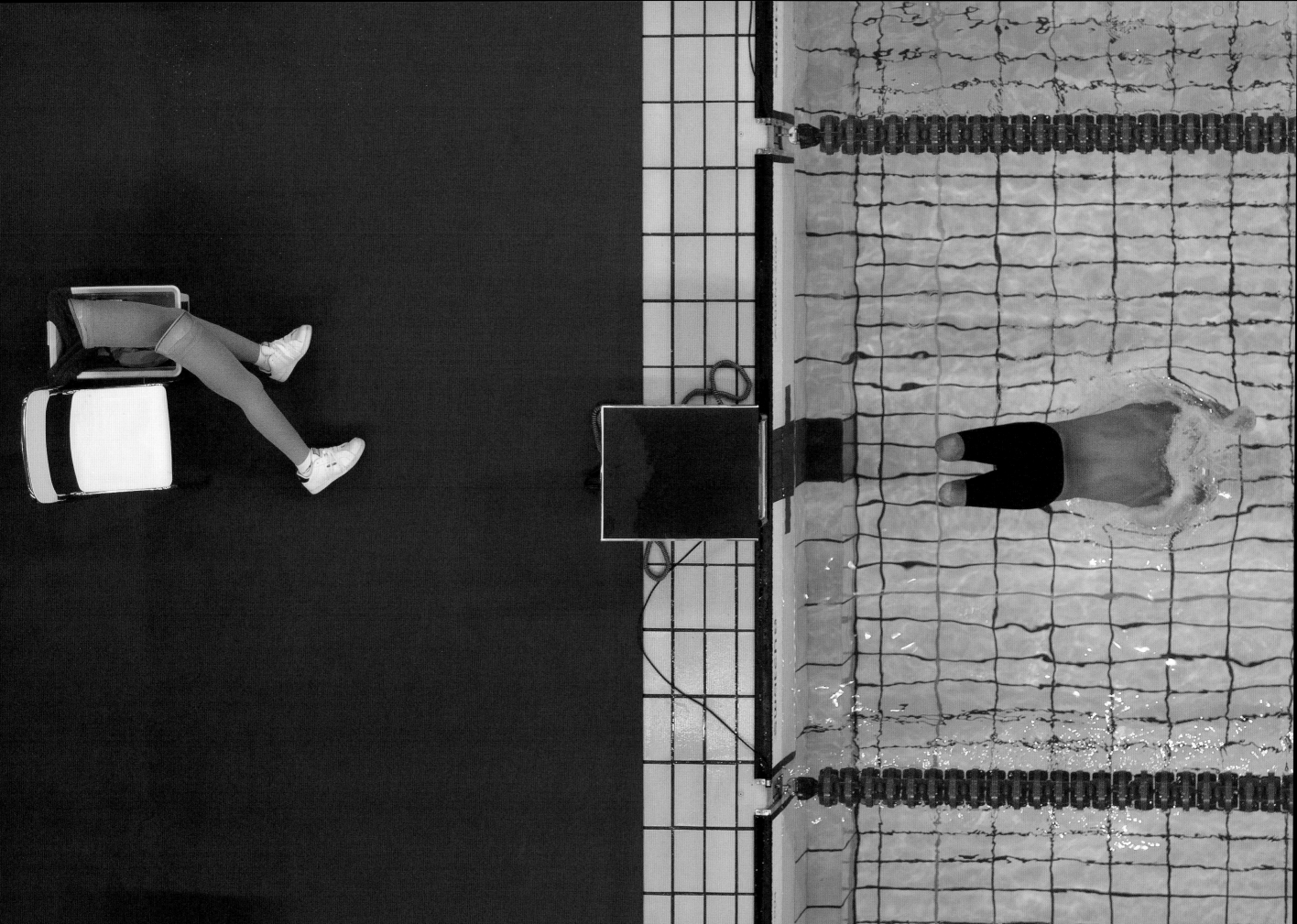

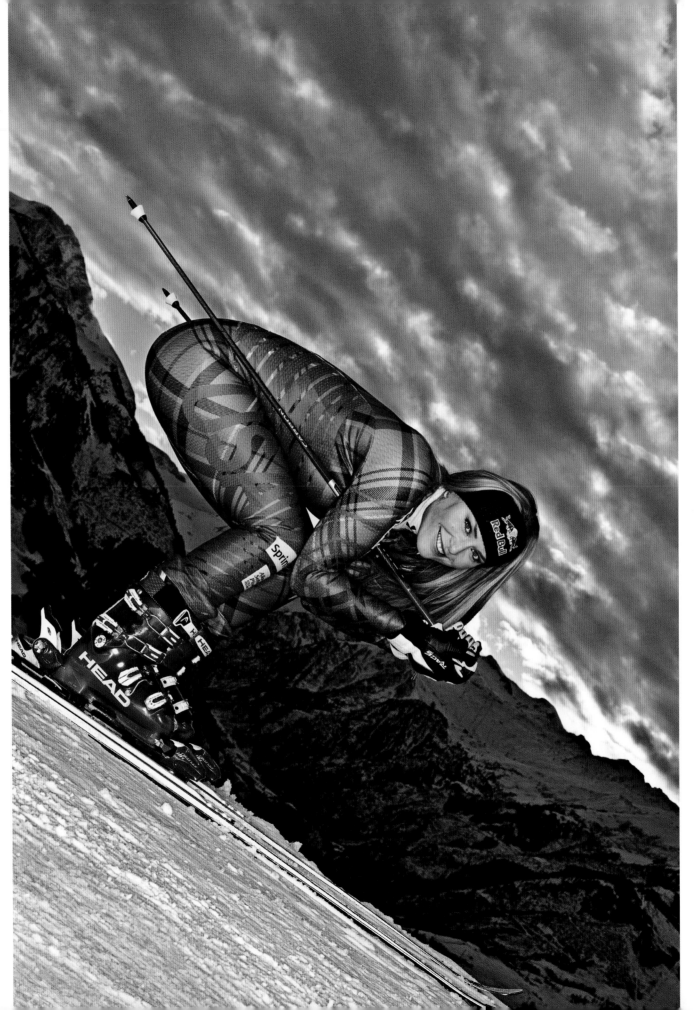

LINDSEY VONN

Little did I know when I took this picture of Lindsey Vonn – it was actually done by the side of the road in Austria and then tilted to make it look as if she is going downhill – that it would cause an international controversy. When it was used on the cover of *Sports Illustrated* prior to the Vancouver Winter Olympics it provoked outcry with people saying it was sexually provocative and demeaning to women. It was in all the newspapers in the US, it was mentioned on the *Jay Leno Show* and when I flew into Vancouver for the Games there were TV crews waiting to interview me. I was told that Vonn herself loved the picture, although for the entire Games I was known as 'The Pervert' by my fellow photographers.

gantry above the pool to get that shot. Just for that one moment, in the lighting rig with a safety harness, with a safety man looking after me. It's all part of the drive to get something that no one else has.

Behind every great picture is an untold story of meticulous planning, one which has gaining the trust of the event organisers at the heart of the plot. And on the back of these carefully nurtured relationships I have started to work for the likes of the IOC and the All England Club at Wimbledon to help them manage their photography and set up the facilities for all the photographers in such a way that it maximises the opportunities for showing off their event or city.

When I was employed as the photo chief for the London 2012 Olympics I wanted, as always, to push the envelope. It was a tough decision to take the job because it meant that I wouldn't be able to take pictures at my home Games. So I decided that if I was going to do it then I wanted to make the photography of this Olympics better than it had ever been before at any other Games. I wanted to create better photographic positions than there had ever been before, a press centre that was perfectly designed, and use robotic cameras – the development of which I have pioneered over recent years – like they had never been used before.

The 'sense of place' philosophy was at the core of everything that we did in London. The photographs from the 2012 Games undoubtedly showed off the host city in all its glory better than any Olympics before it. And it was all laid on a plate for the photographers. For instance, the background from the key photographic position we set up at the beach volleyball at Horseguards Parade had the old barracks and the rooftops of London above it. I remember an early meeting where they showed me the initial plans and I said, "Well, you've got a whacking

great stand right in front of the barracks. You're wasting the whole point of having the event there. You might as well dump a load of sand in a car park in Stratford." In Sydney they had the beach volleyball on Bondi Beach, but apart from the sand on the court you couldn't see the actual beach unless you were shooting overhead from a helicopter. So in the end, for London, they left the side off one of the stands so you could see the barracks behind. And they left the side off one of the stands at the showjumping in Greenwich Park so you could see through to Canary Wharf. And we had a special position reserved for us opposite the Houses of Parliament so 150 photographers could shoot the marathon runners going past. We had the same for the bike race going past Buckingham Palace. It's not rocket science…

But despite all this my first love still is, and always will be, being behind the lens and I think I am more passionate about taking a great picture now than I ever have been. That is my driving force. As the years go on it gets tougher and tougher to get something new, but I am always trying to drive myself forward.

It is getting harder and harder but with the help of Nikon – who have always been tremendously supportive and absolutely brilliant to work with – we are doing great things, especially with robotic cameras. It took me years to get permission to put one of these on the roof of Centre Court and in the first year we had them we captured the moment when Andy Murray won Wimbledon. He turned to the crowd, with his back facing the majority of the photographers in the pit, and my shot was the only one that captured his face at that historic moment.

It's pictures like that that keep me going. And you can be sure that, while you look at this book, I am planning the next one…

Bob Martin, July 2015

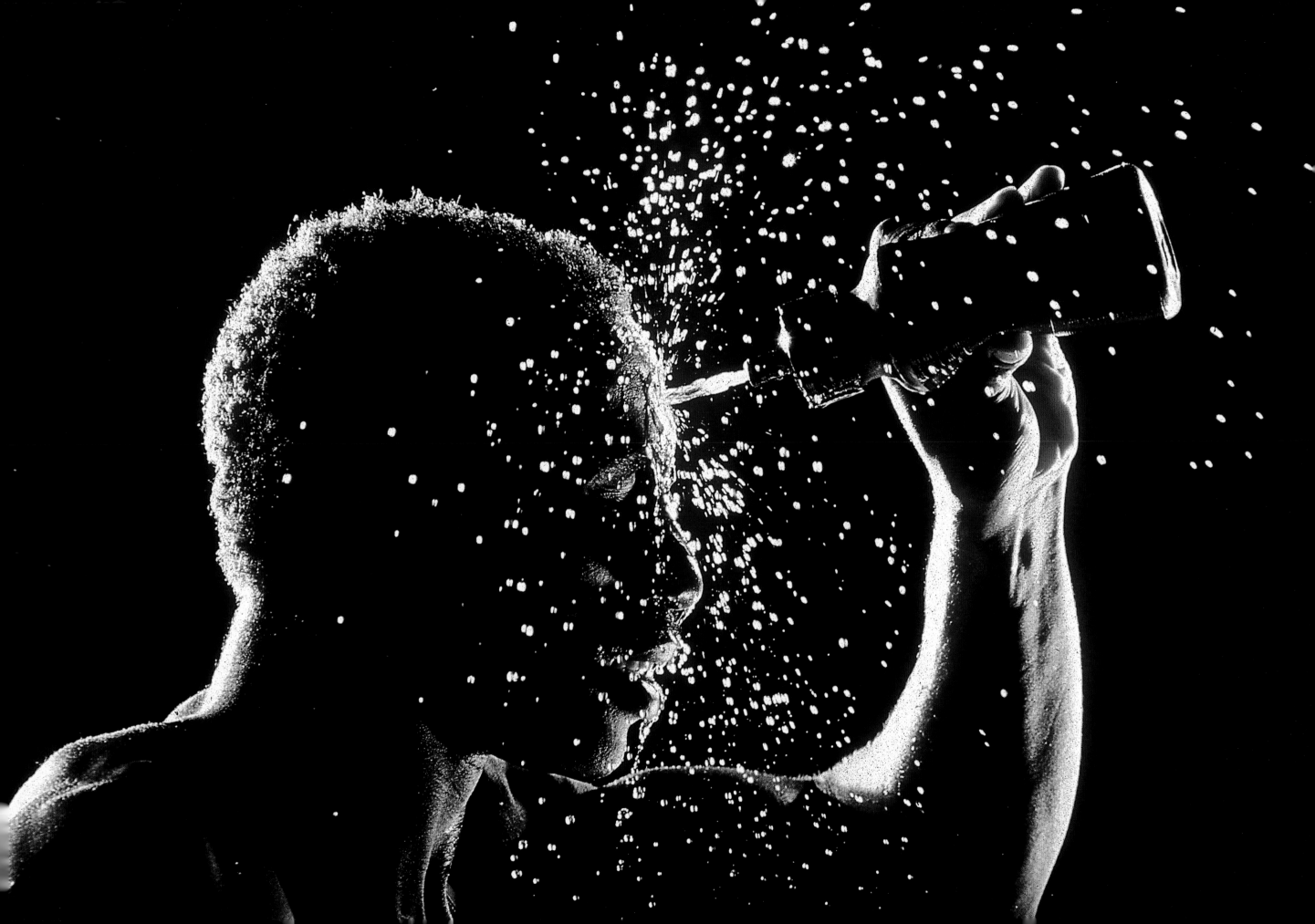

01

SHADOWS & SILHOUETTES

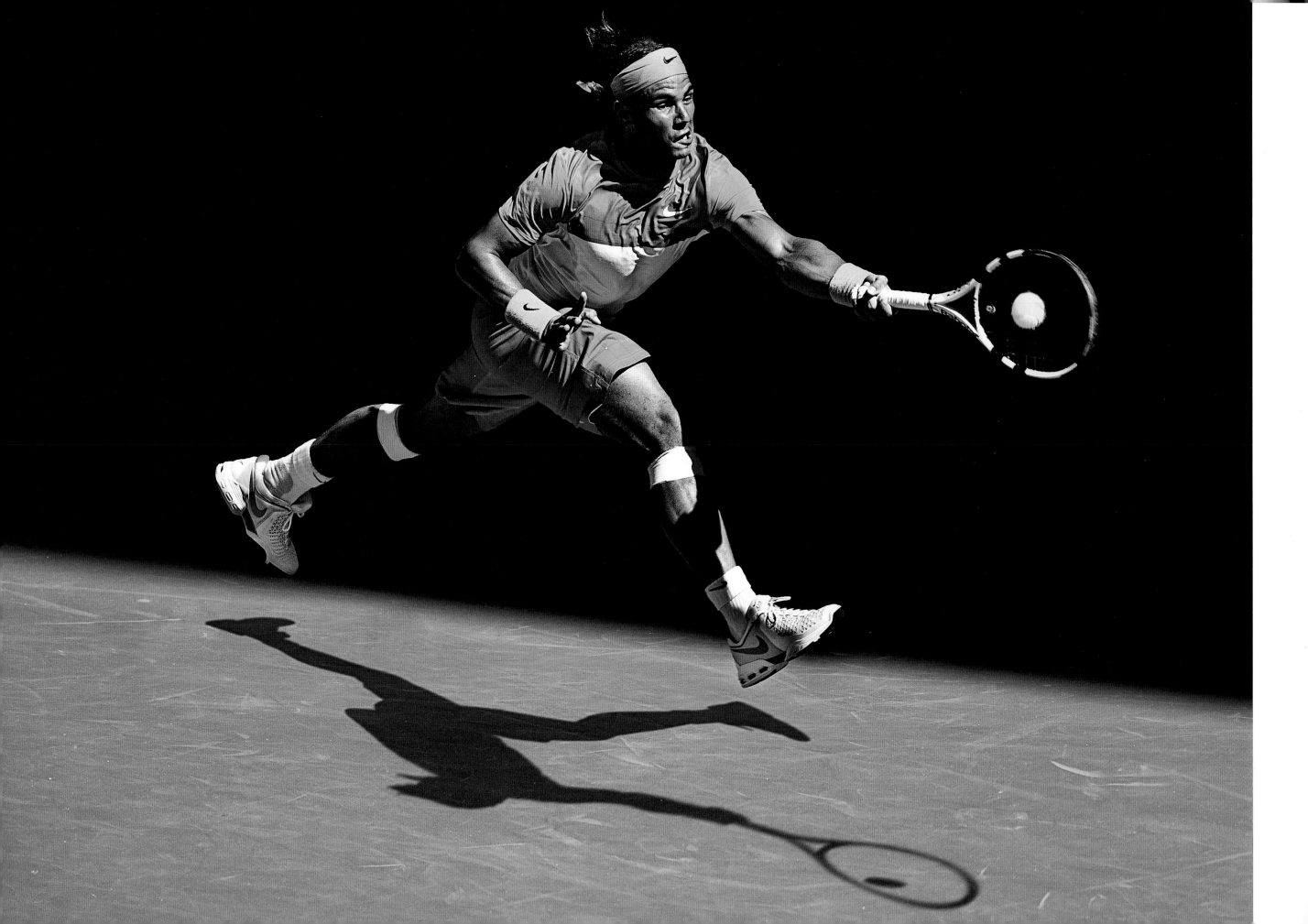

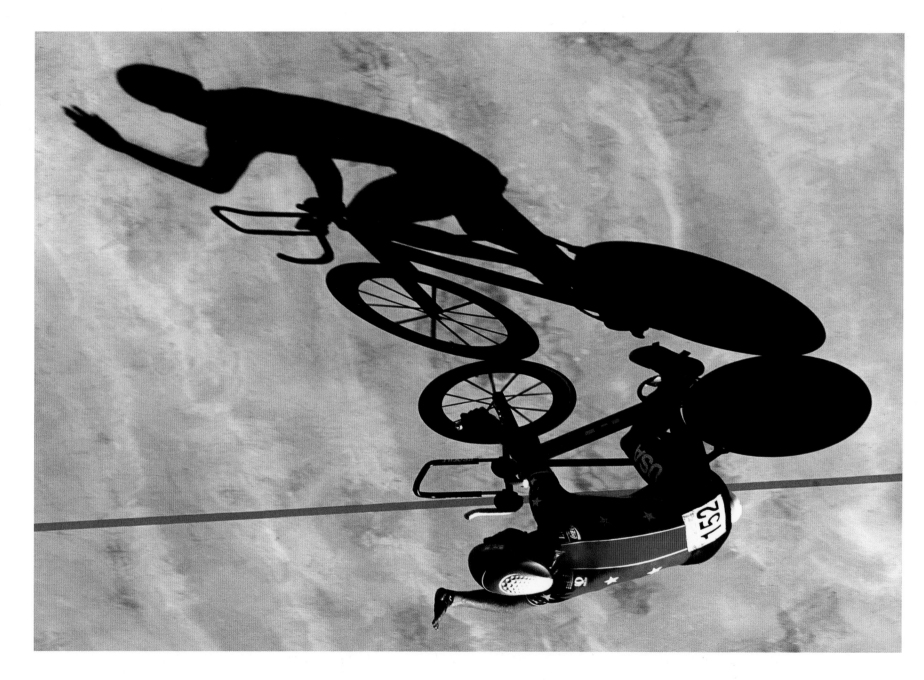

PAN AMERICAN GAMES

Unusually, the velodrome at this event in Mar del Plata, Argentina, was outdoors and the track was concrete. It looked like marble and I wanted to get up high to use it as a background. There was a water tower next to the track and I managed to blag my way past the security guard to get up there and get this shot. Because of the recent history between Britain and Argentina, anyone with a Union Jack on their pass was having trouble even getting a taxi. So, for once I was delighted that, because I was working for *Sports Illustrated*, my pass had the Stars and Stripes on it.

RAFA NADAL

As the shade comes across the court of the Rod Laver Arena at the Australian Open, the light is just right to take this shot from the concourse in the grandstand. The light is perfect for this shot at 4.35pm precisely.

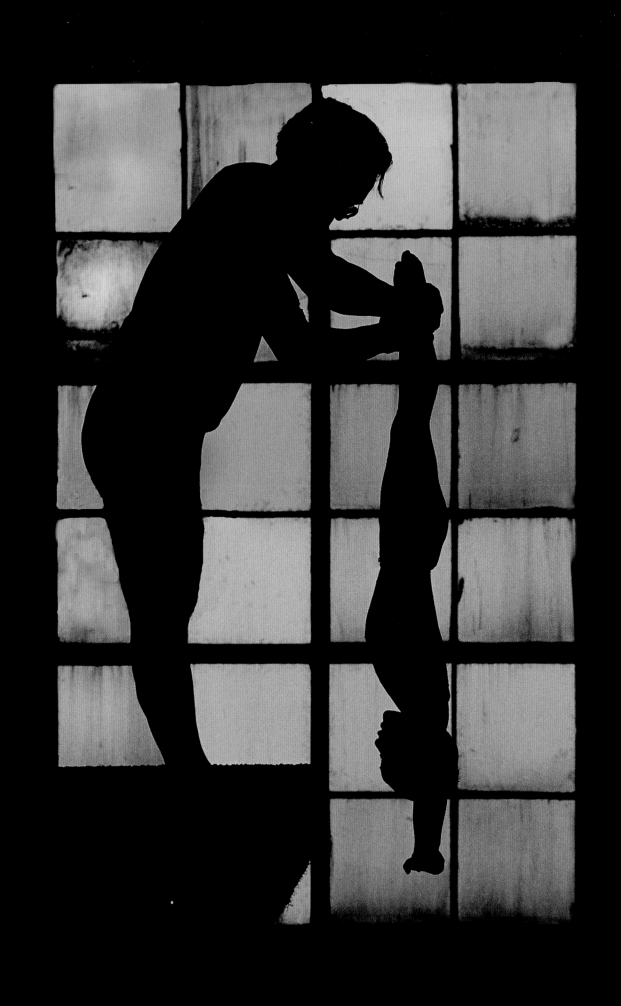

IAAF WORLD
ATHLETICS FINAL,
MONACO

I shot this from one of the
lighting pods in the roof of
the stadium. I'd watched
the shadows the day before
and knew exactly where I
had to be to get the shot.
The hard part was the
negotiation to get up there.

CHINESE DIVING

A Chinese coach at the
Beijing National Aquatics
Centre begins a training
session by dangling young
divers by their feet and
dropping them into the
water from the 10 metre
board. We were horrified
but the kids were loving it!

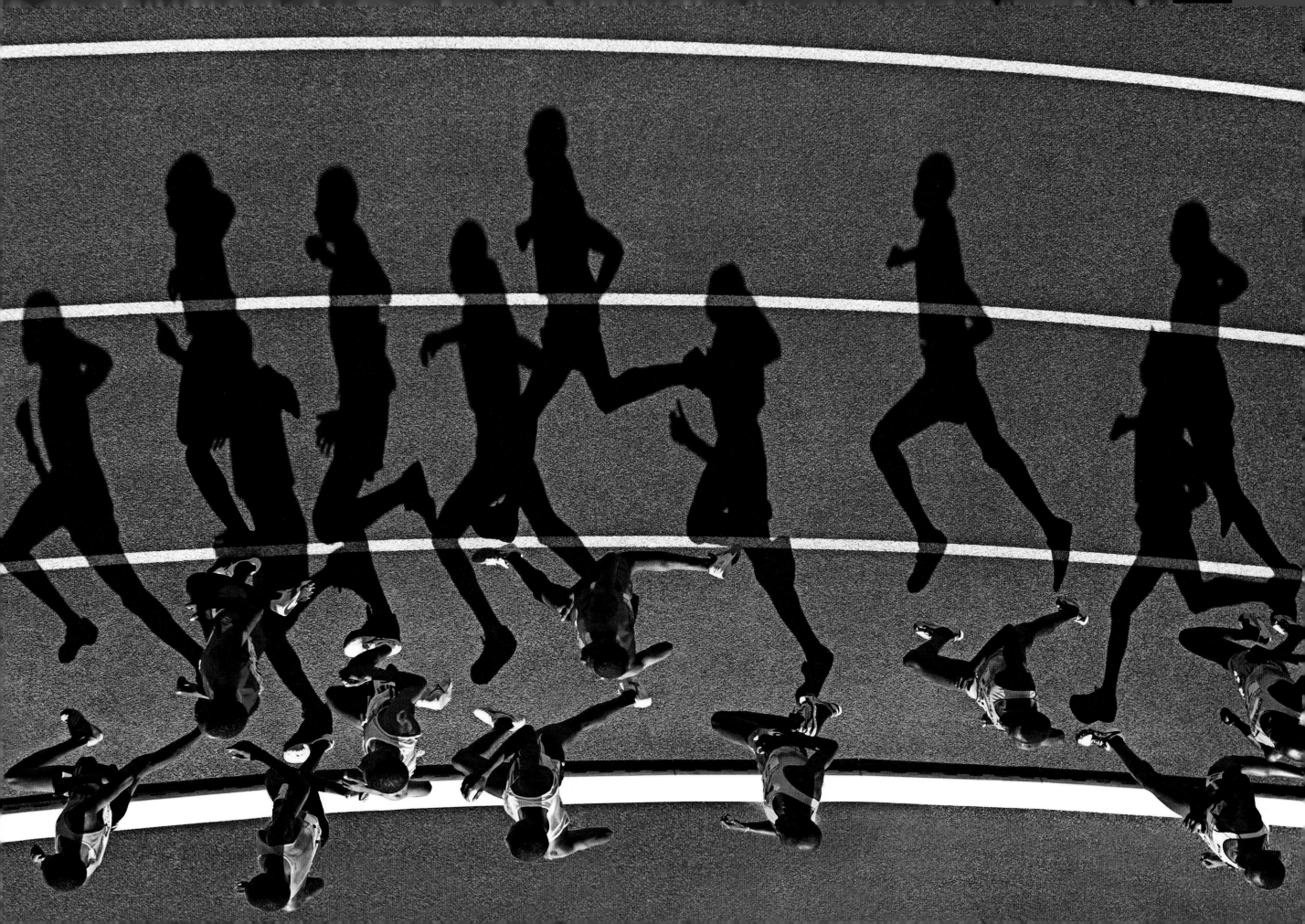

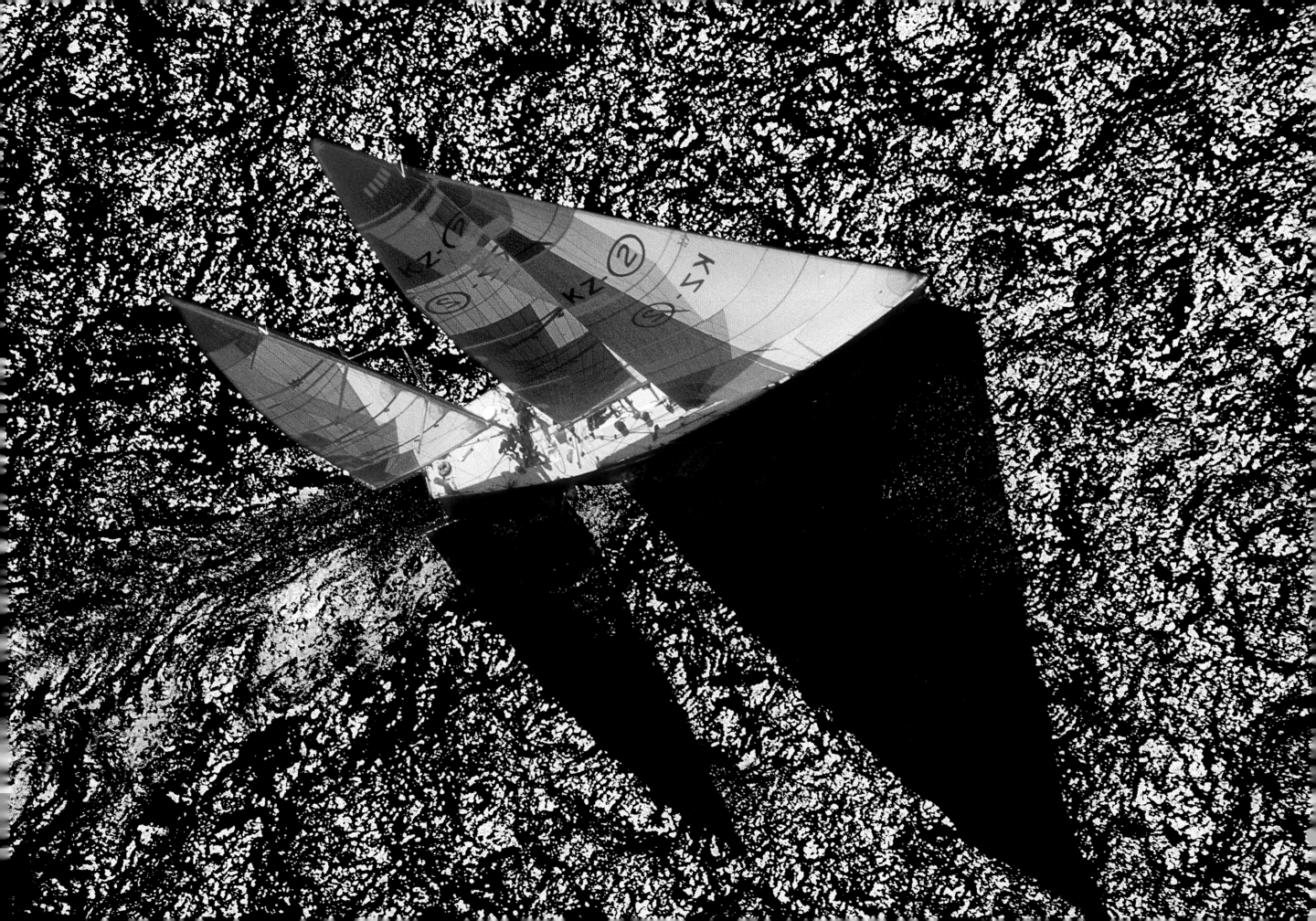

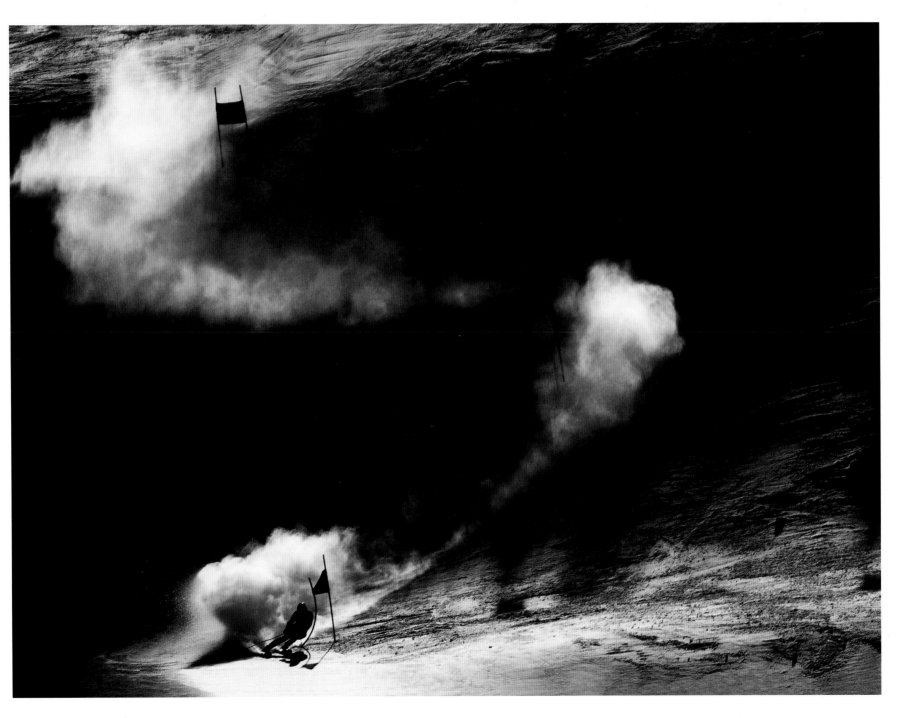

Previous pages:

ROUND
THE WORLD
YACHT RACE

Three of us clubbed together
to hire a helicopter to get
this shot of Steinlager 2 at
the start of the Whitbread
Round the World Yacht
Race in Auckland. We
were actually in New
Zealand to photograph the
Commonwealth Games.

STEFFI GRAF

A portrait of the great
German tennis star around
the time that her father had
been jailed for tax evasion.
It was shot for *Sports
Illustrated* but also ended
up on the front cover of
Time magazine with the
heading 'Home Alone'.

WINTER
OLYMPICS, TURIN

I took this shot from the car
park, just as the sun came
over the hill. I literally got out
of the car and went, "Look
at that!" The light would
have been like this for about
two minutes. Sometimes
you just get lucky.

US MASTERS

Every day of The Masters
I would try to stand on the
hill at the back of the 2nd
green at 8am for at least
15 minutes, when the sun
would cast these beautiful
shadows across the fairway,
hoping a good player would
play through. Finally Retief
Goosen came along...

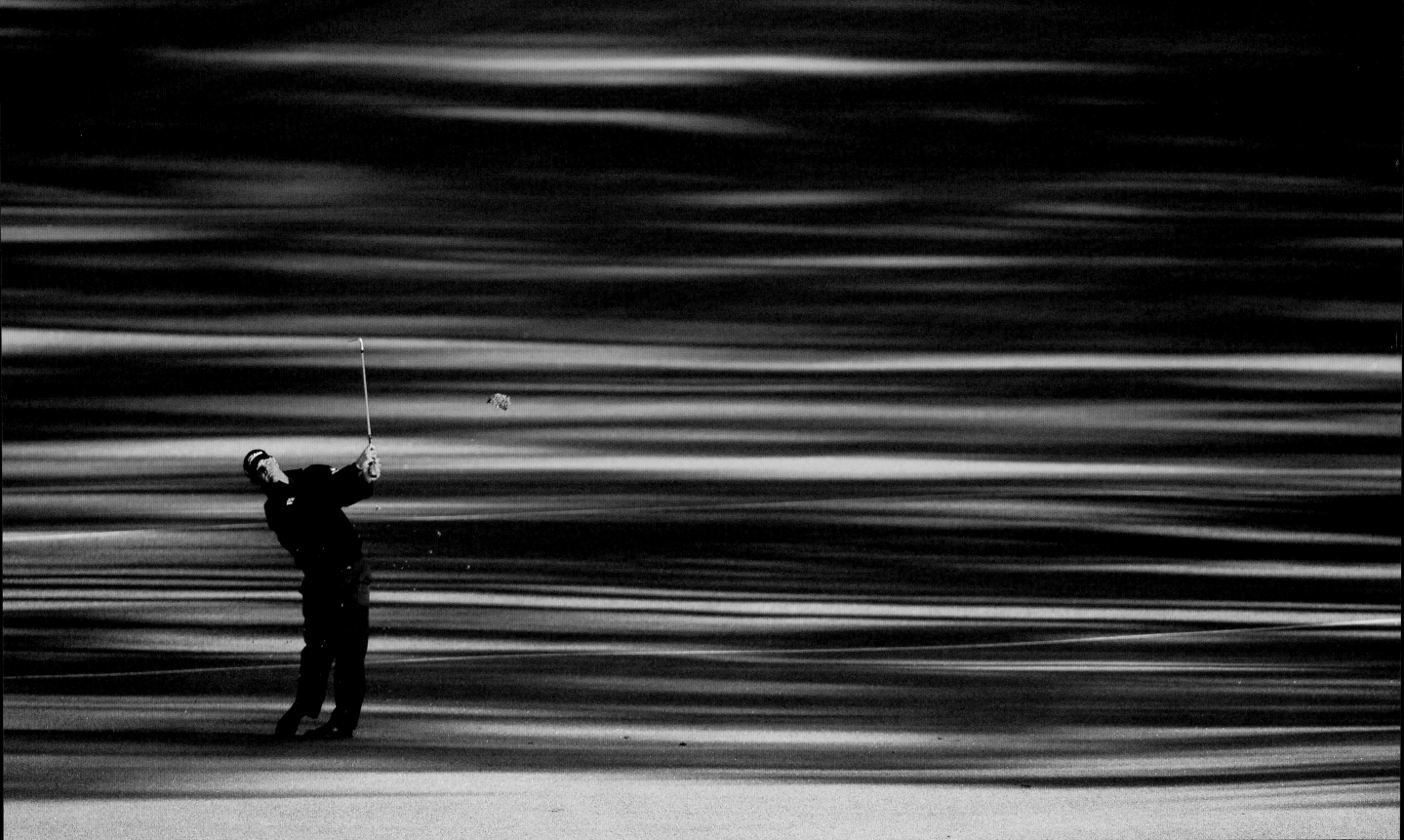

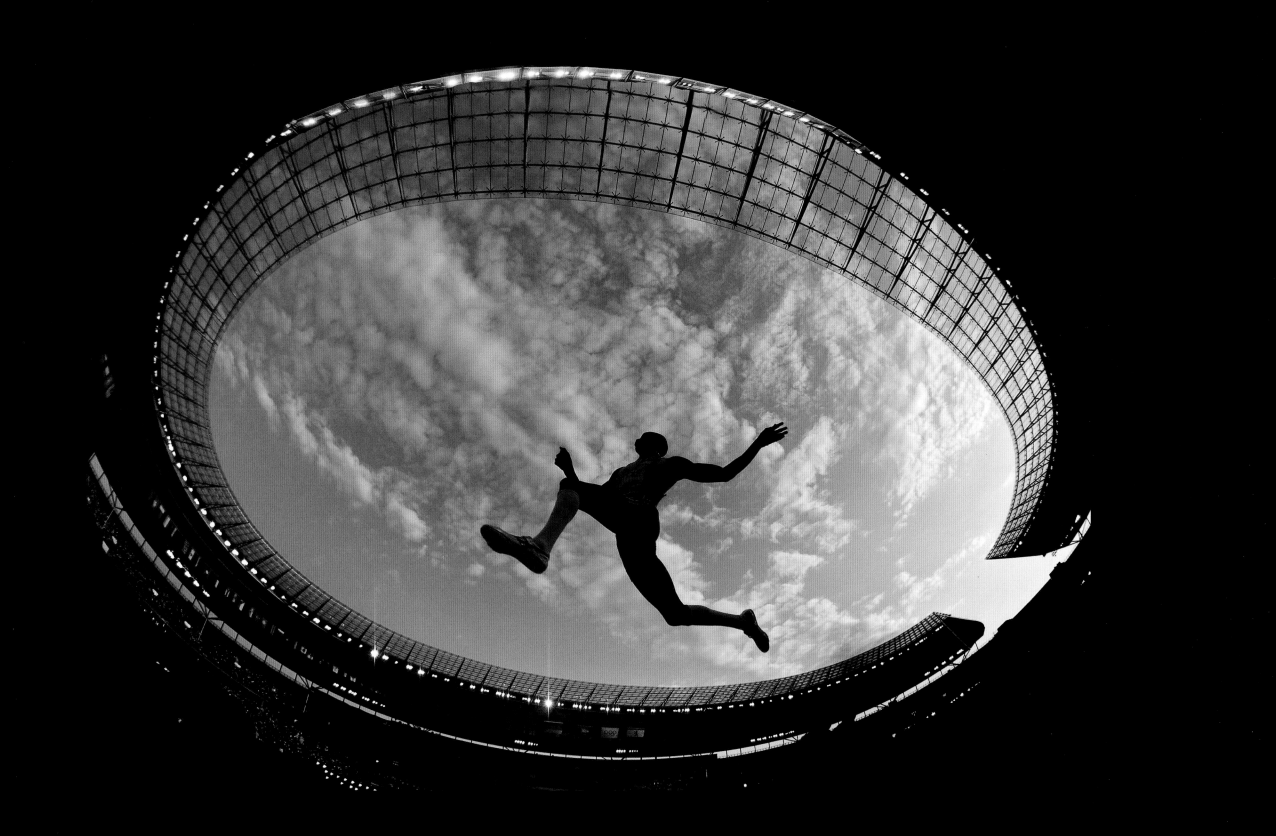

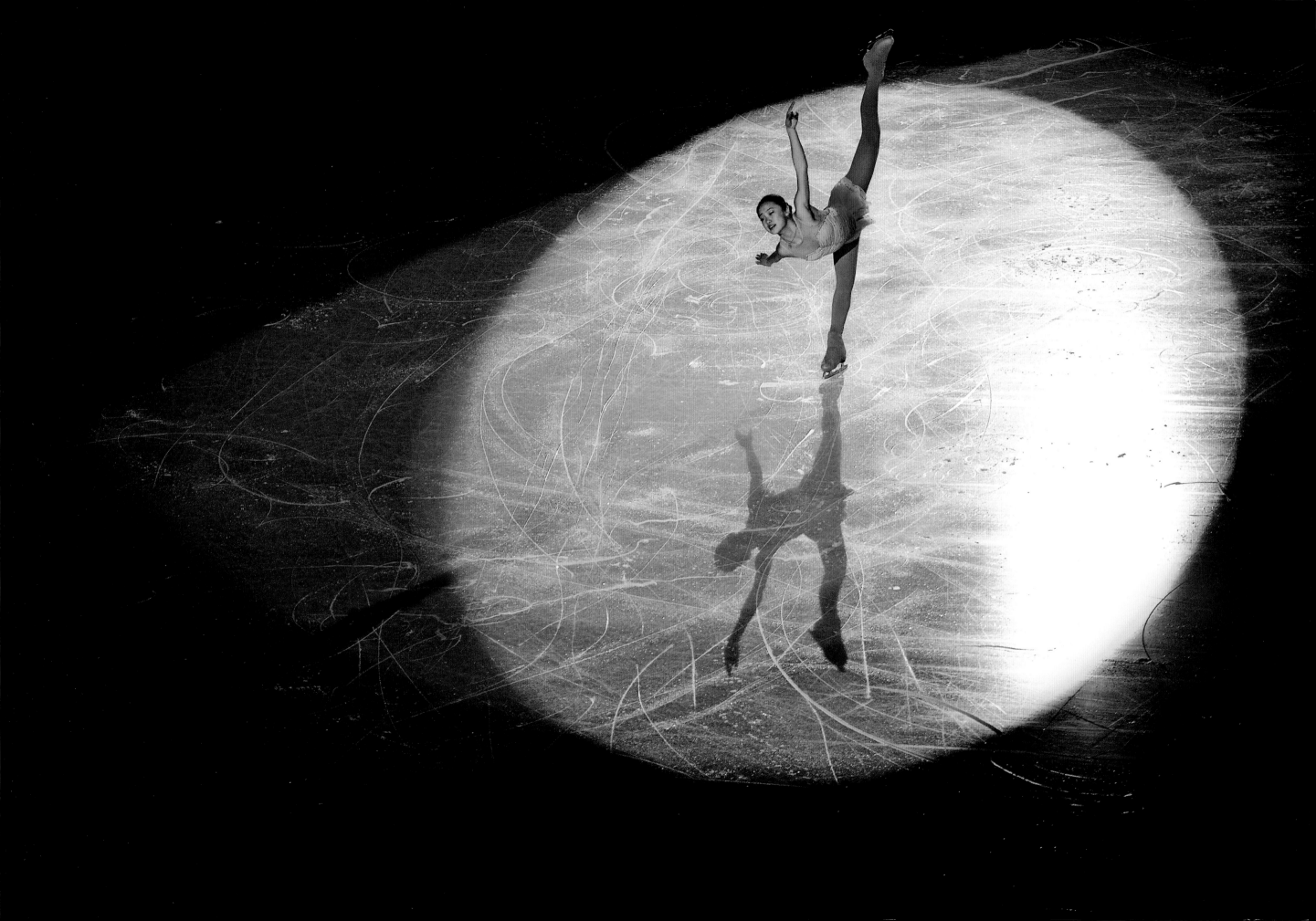

RHYTHMIC GYMNASTICS

It's very difficult to capture the movement of rhythmic gymnastics in a single still image because the whole point of the sport is that it is a sequence of complicated movements. But by using a low shutter speed and a telephoto lens at the Asian Games I used the ribbon to show the movement of the athlete.

Previous pages:

GODFREY KHOTSO MOKOENA

I took this with a remote camera at the IAAF World Athletics Championships in the iconic Olympic Stadium in Berlin in 2009.

MICHELLE KWAN

Ice skating is much more interesting to photograph under spotlights as opposed to the full lighting of major events. This was a test event before the Vancouver Olympics and I really like the way the spotlight accentuates the scratches on the ice.

SYNCHRONISED SWIMMING

During the World Swimming Championships in Barcelona, when the TV people on the edge of the pool were interviewing competitors who had been knocked out of the synchronised swimming competition, they switched on their interview lights which illuminated the water droplets in the air for this picture. Luckily the best teams went last so when the Russian team came on to win, it all came together.

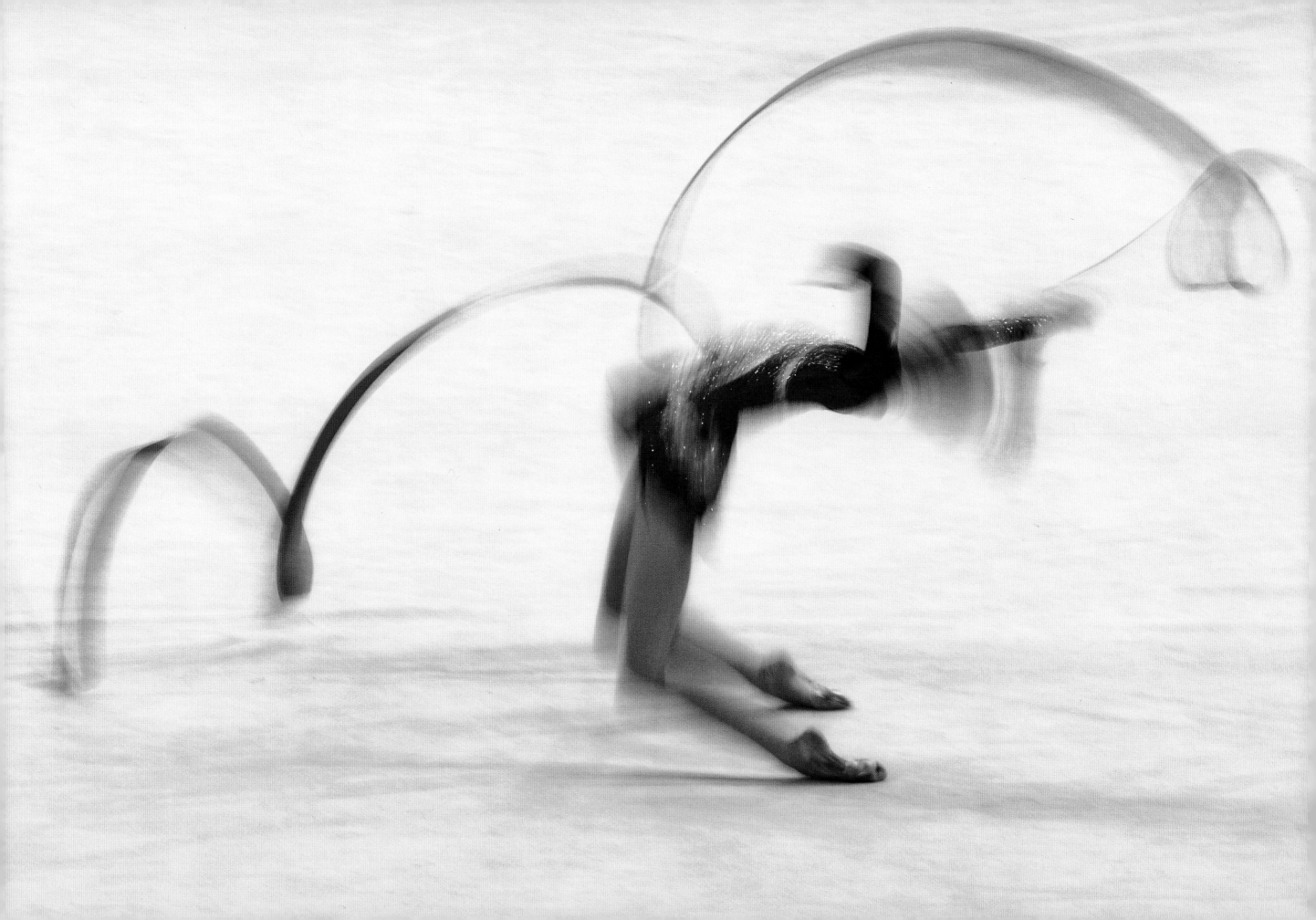

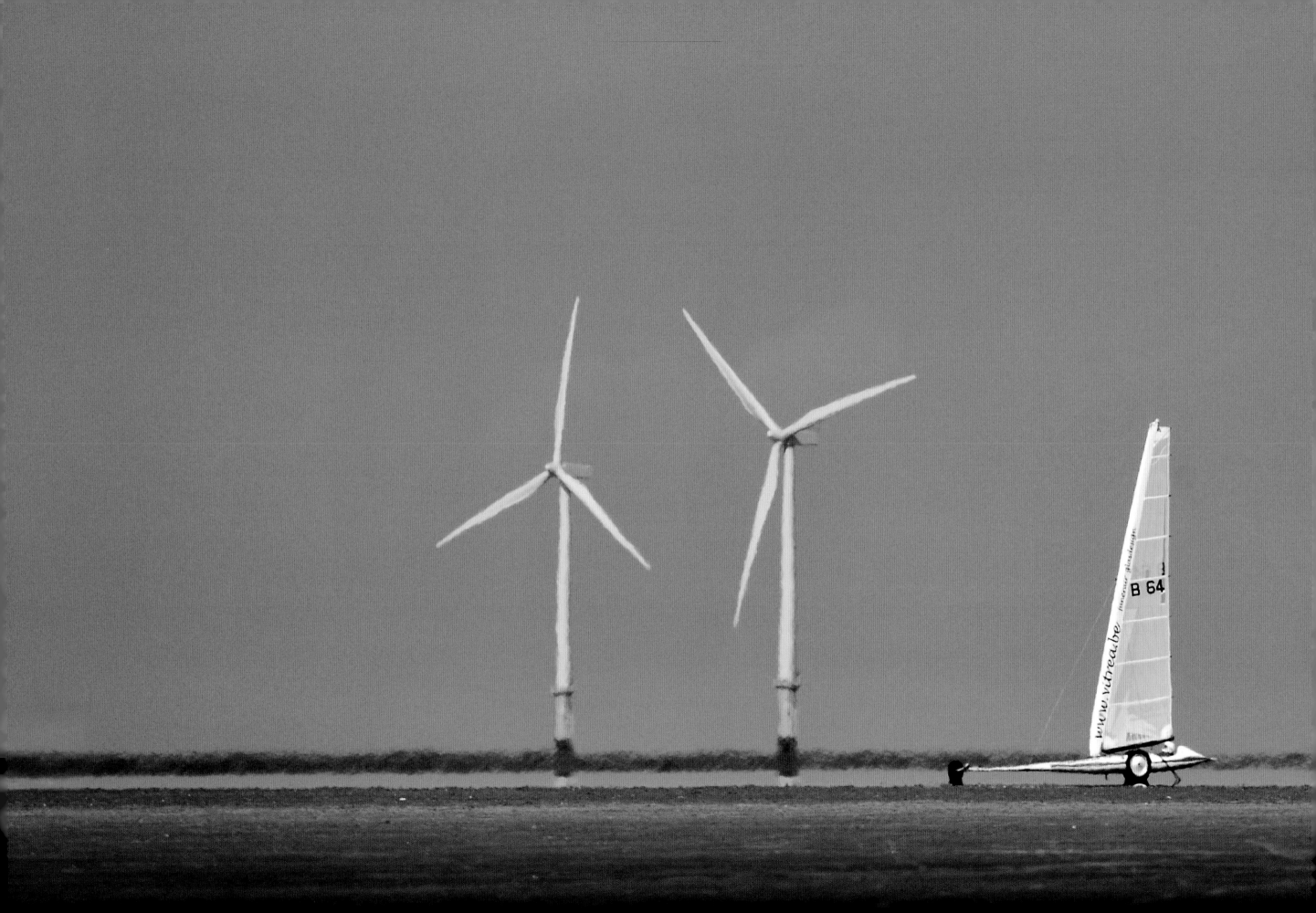

LAND YACHTING

When I arrived at the beach at Hoylake, near Blackpool, to shoot the European Land Yacht Championships I initially felt that the wind turbines ruined the opportunity for a great picture. But I soon realised that I could use them in my composition, with the obvious relationship between these huge windmills and the sails of the land yachts. The heat haze completes the effect.

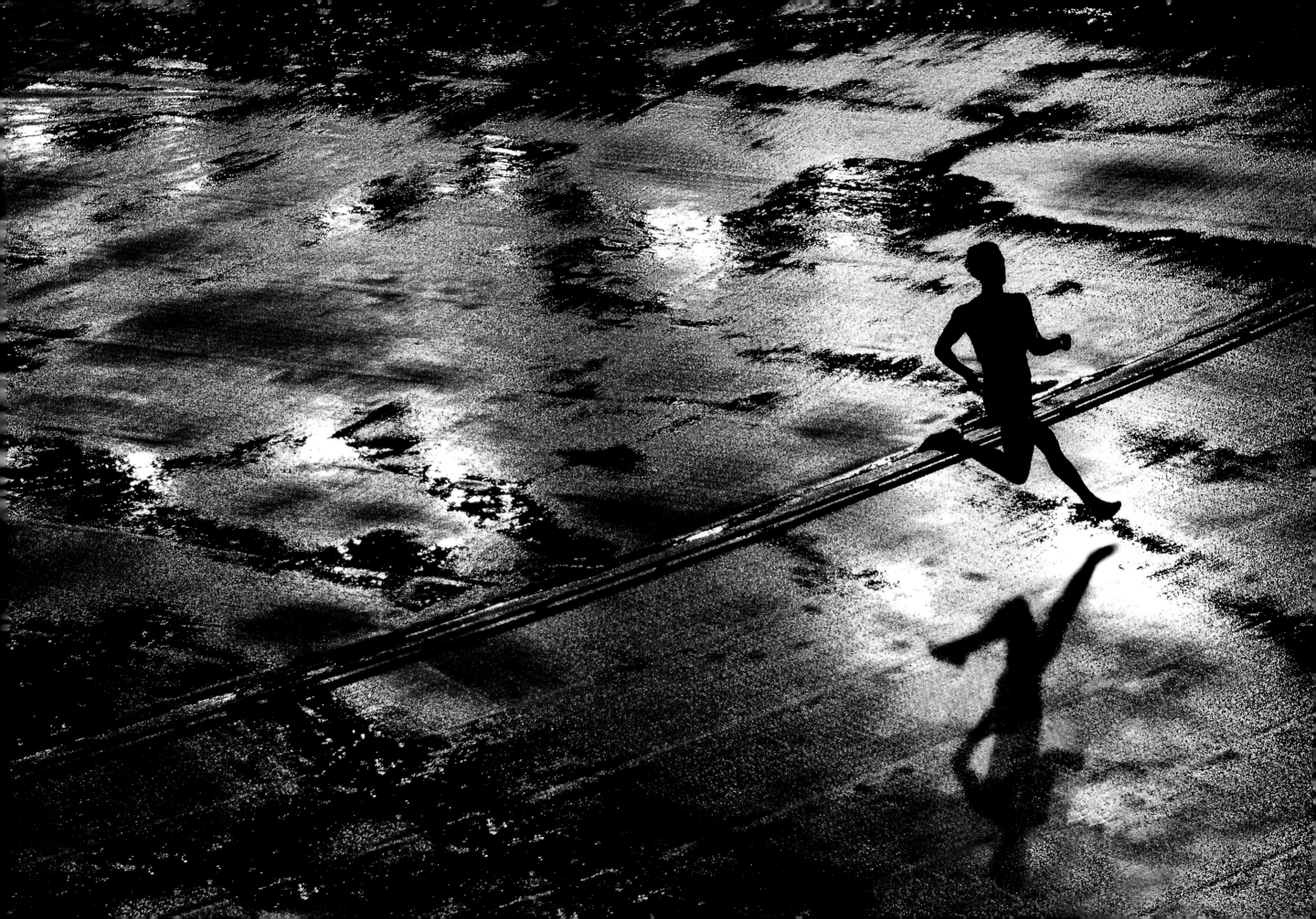

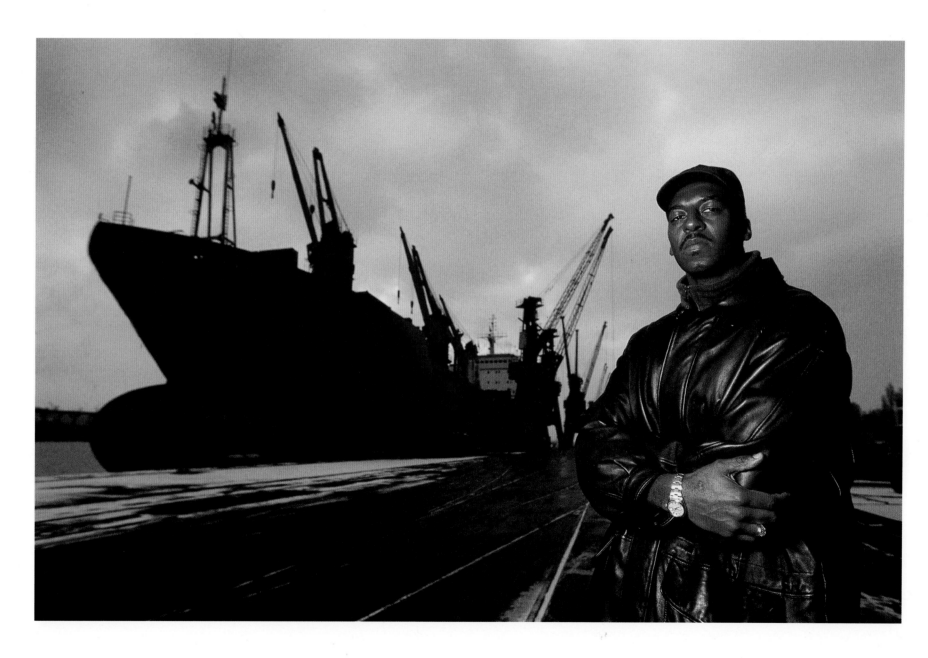

JERROD MUSTAF

I went to Poland to get a shot of this basketball player who had been banned from playing in the NBA because he was under investigation for his alleged involvement in the murder of his pregnant girlfriend. He'd gone to play in Gdansk so we took him down to the shipyards to get this gritty portrait.

ATHLETICS

During the IAAF World Athletics Championships in Helsinki the worst storm I can remember during an athletics event broke. It was not my turn on the rota for the infield, so I was up in the stands. Normally you'd hate that and miss everything, but on this occasion I was able to get this shot of the lights reflecting off the track while all the other photographers got soaked.

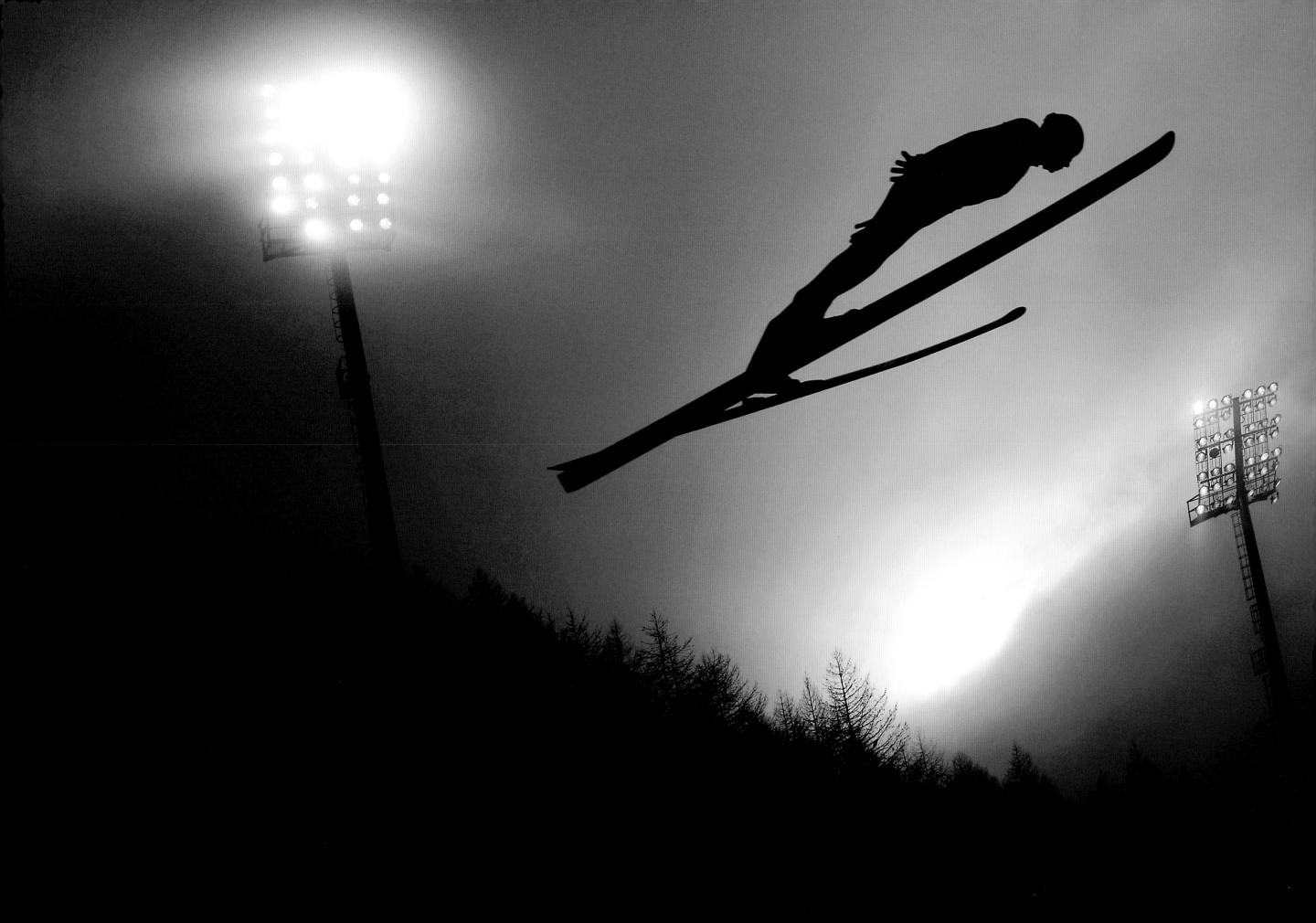

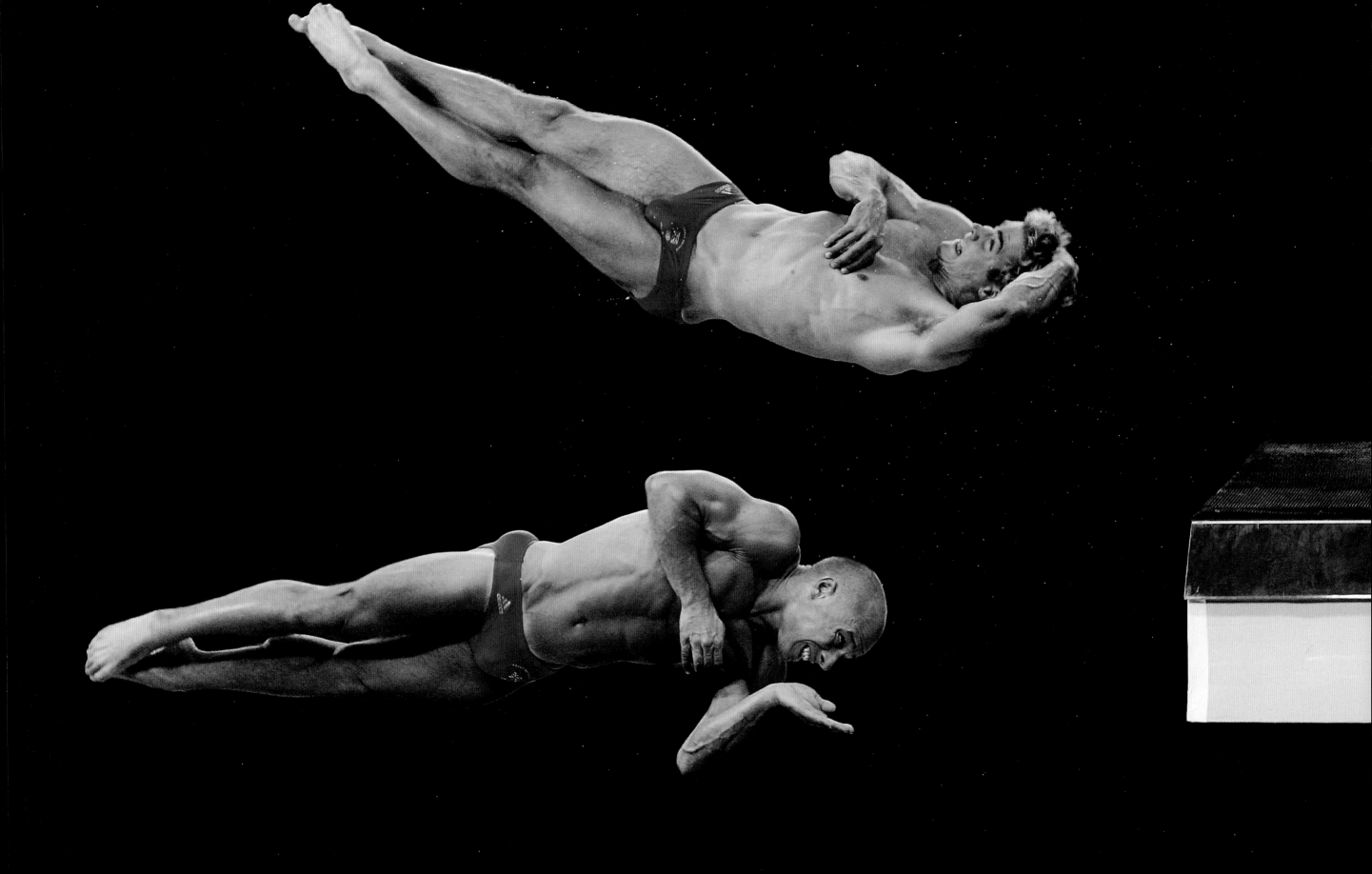

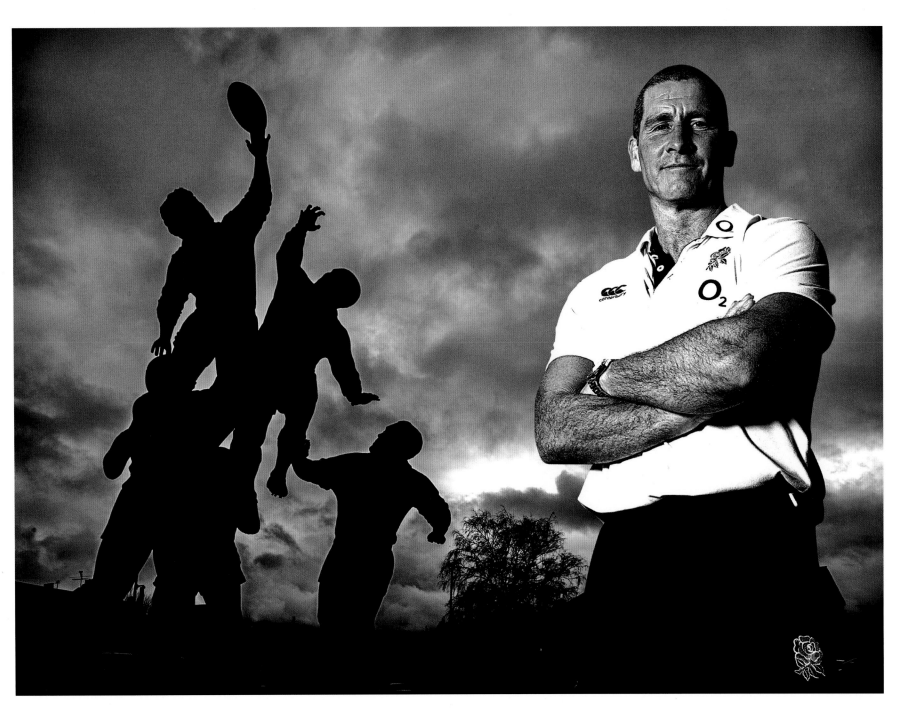

Previous pages:

SKI JUMPING

Before the Turin Olympics there was a lot of controversy about the use of floodlights, which had basically been brought in to bring the event times into line with American time zones for television. The photographers were very worried about the lack of light, but in fact it made for some really interesting, contrasting pictures – especially at sunset on one foggy evening for the ski jumping.

TAYLOR AND WATERFIELD

I like this picture because it's funny – the British divers in the synchronised diving competition at the Athens Olympics appear to be completely out of sync, unlike the perfect Chinese pair. Actually I think it does them an injustice because they are in fact spinning in different directions and they did go on to win the silver medal.

STUART LANCASTER

Just before the 2015 Six Nations, *The Times* asked me to do a portrait of the England rugby coach. I turned up at Twickenham on a freezing cold and wet January morning and there was no way I was going to get him to hang around outside for a picture. So I took the shot of the statue outside the stadium against the sky, then a separate shot of him just outside the covered entrance of the hotel at the ground, and put the two together. I was told that he loved the shot, and was amazed I'd only needed him for about three minutes.

LLEYTON HEWITT

I got this shot as the last of the sun was leaving the Rod Laver Arena at the Australian Open. I was in the roof looking down and pre-composed a frame to include the ball boy, hoping that Hewitt would lunge to his left or come to the net for a volley. Amazingly he dived out of the shadow to create an almost perfect composition, which is completed by the ball boy who is watching intently.

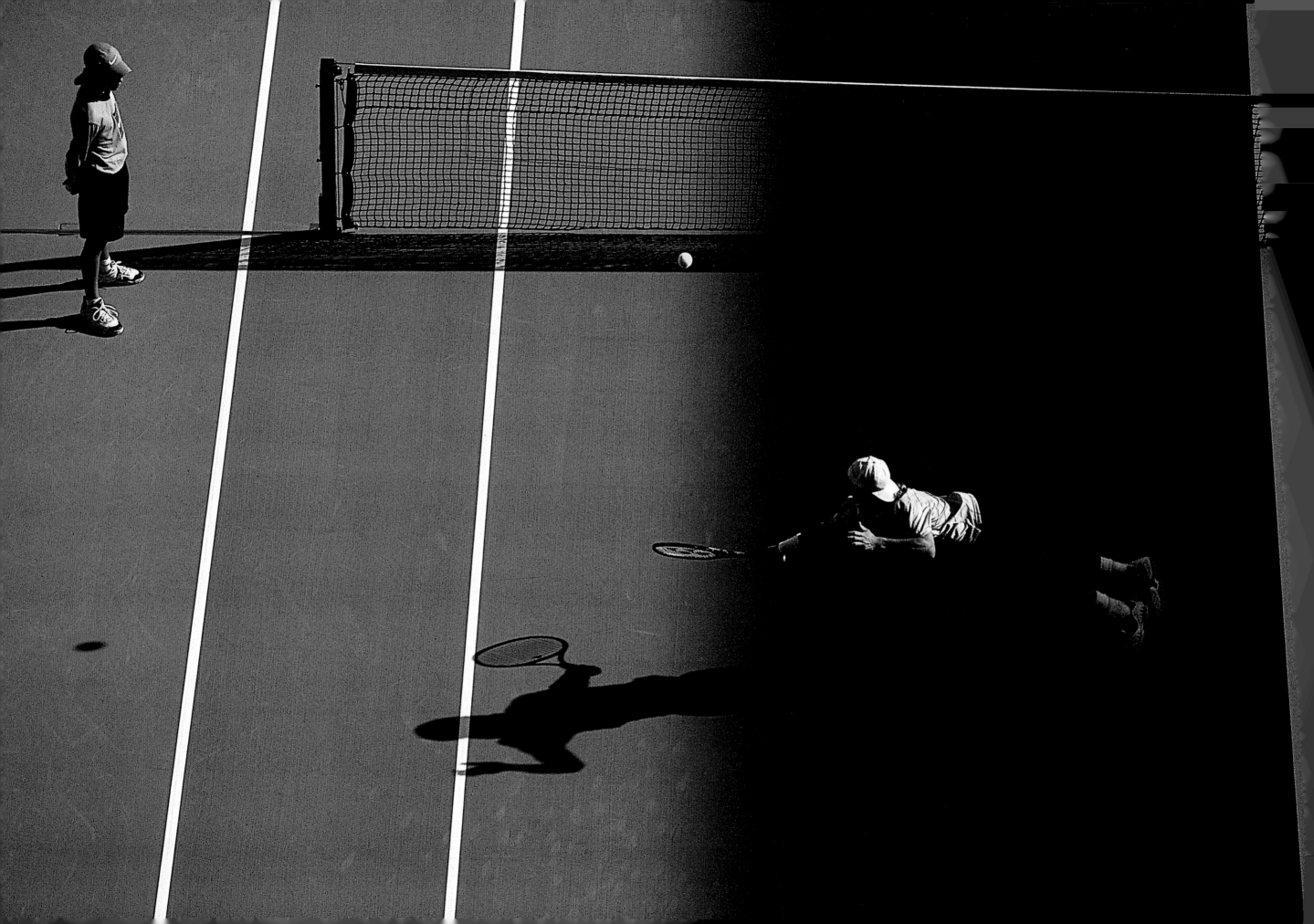

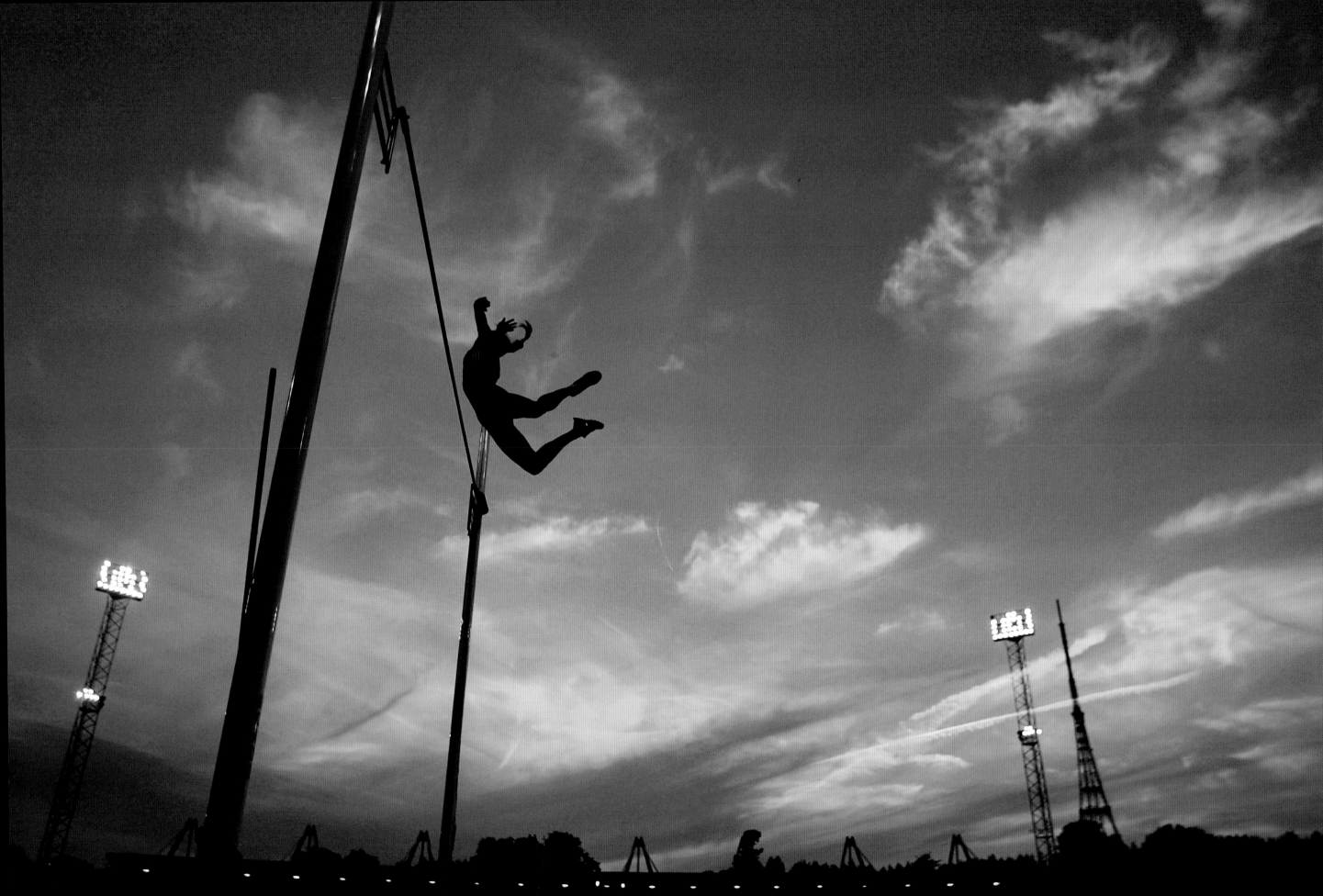

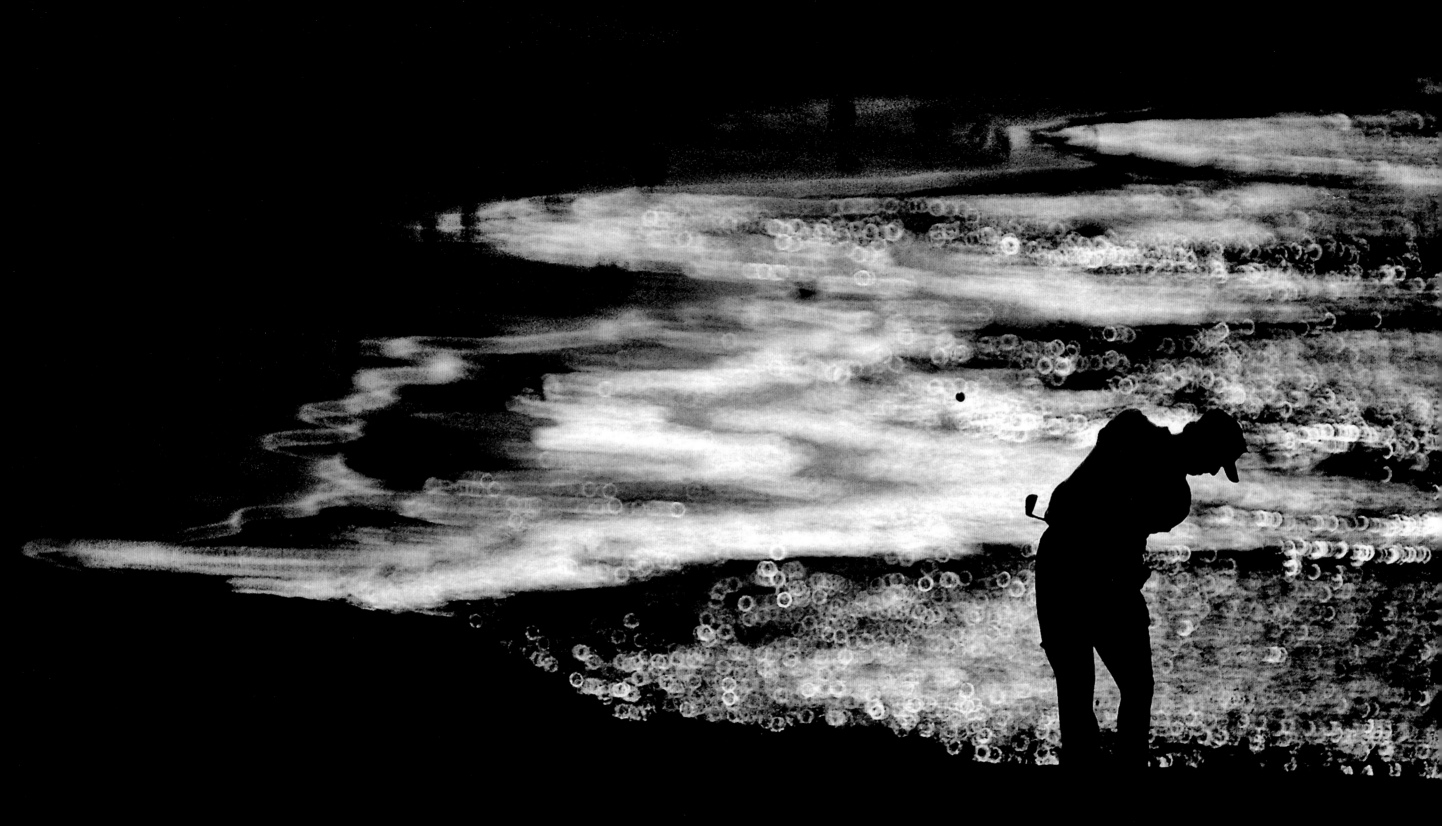

Previous pages:

YELENA ISINBAYEVA

This was an average athletics night at Crystal Palace until they announced over the tannoy that there would be a world record attempt in the women's pole vault, a relatively new event. So I trotted over just in time as a sunset started to develop and captured the moment when the record was broken.

PAUL STANKOWSKI

This is the famous view of the 9th fairway at the picturesque Pebble Beach course, but taken with a mirror lens to create the 'doughnut effect' in the sea behind the golfer's silhouette. I really like using this lens, which turns the background highlights into circles – one of my favourite effects.

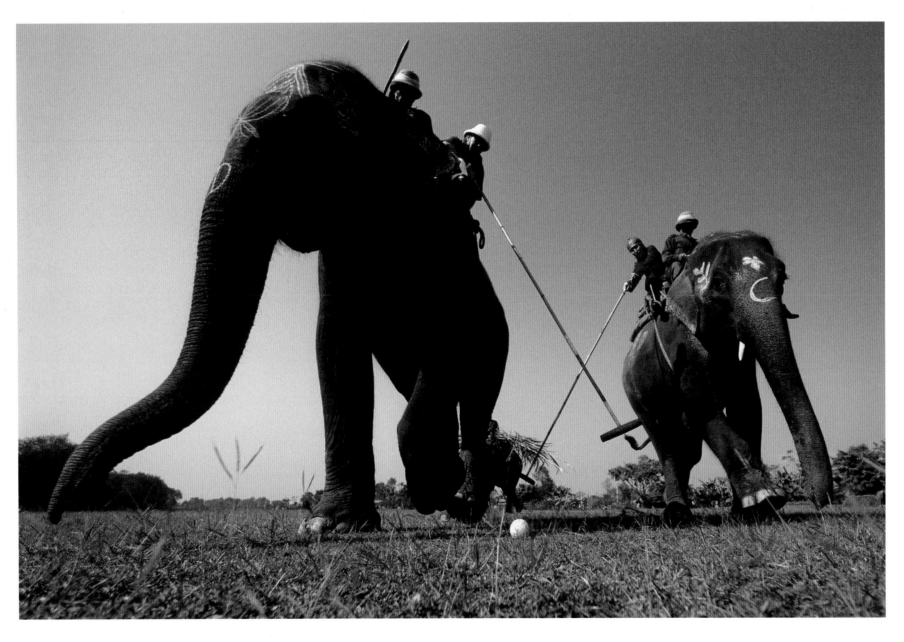

ELEPHANT POLO

Always looking for oddball events, on my way to Australia to do the golf I stopped off in Nepal to shoot elephant polo. The only way to make the elephants look big was to get down really low. However, I had to get up rather quickly and run away as soon as I got the shot.

SCARBOROUGH GOLF COURSE

Whilst covering the Australian Open tennis, I saw a story on the local news about kangaroos that had invaded a local golf course. There was a drought on and they had worked out they could get water from the sprinklers. So I jumped in a car and drove 200 miles to take a look. When I got there, in the early evening, I went out in a golf buggy and there was no sign of any kangaroos. But then, as soon as the sprinklers came on they all appeared. It was amazing, they seemed to know exactly which sprinklers were going to come on next. And the best thing of all was that, in true Aussie spirit, the golfers just carried on playing.

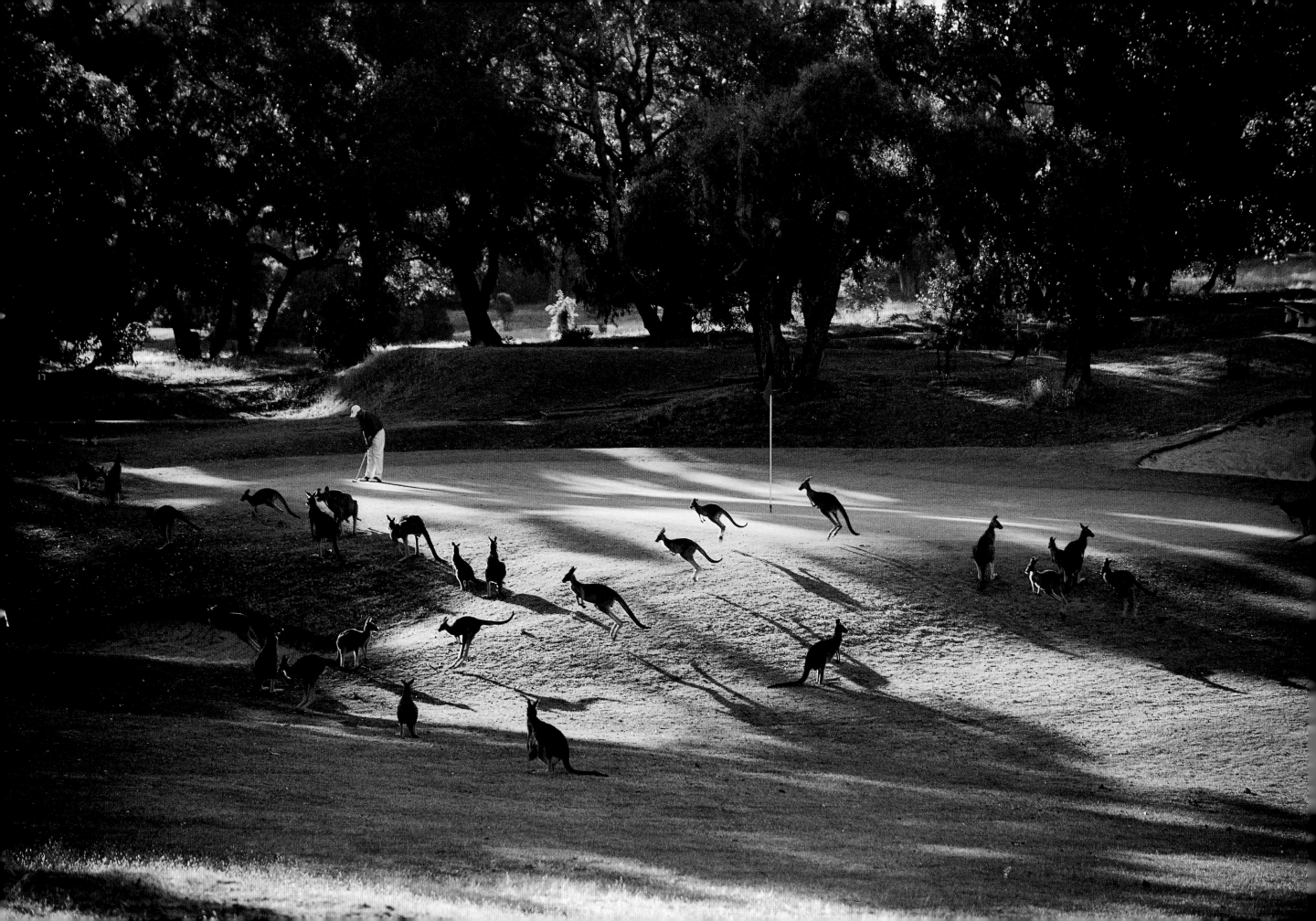

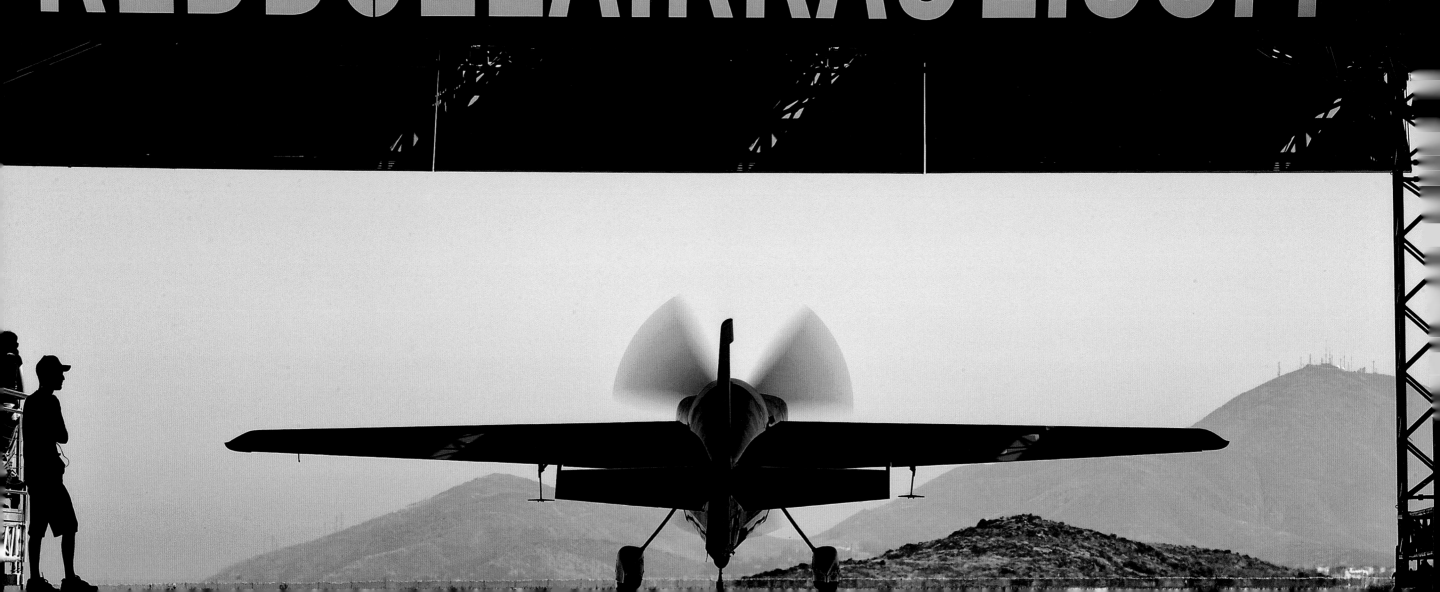

RED BULL
AIR RACE

I covered the Red Bull Air Race for a whole season during 2009, which made it a challenge to get something different at every event. In this picture from Abu Dhabi a plane is about to set off from the shade of the hangar while I am outside on the other side sweltering in the heat. The big sign on the outside of the hangar is a great graphic feature which helped to make the shot.

HIDEHARU
MIYAHIRA

To get this shot from under the lip of the ski jump ramp at the Salt Lake City Winter Olympics in 2002, I had to listen to the sound of the skis above me and guess when to fire the shutter. If I'd waited until I could see the skis they would have been gone before I could get the shot. This was the days of film, so you wouldn't know what you had got until you got your film back from processing a few hours later.

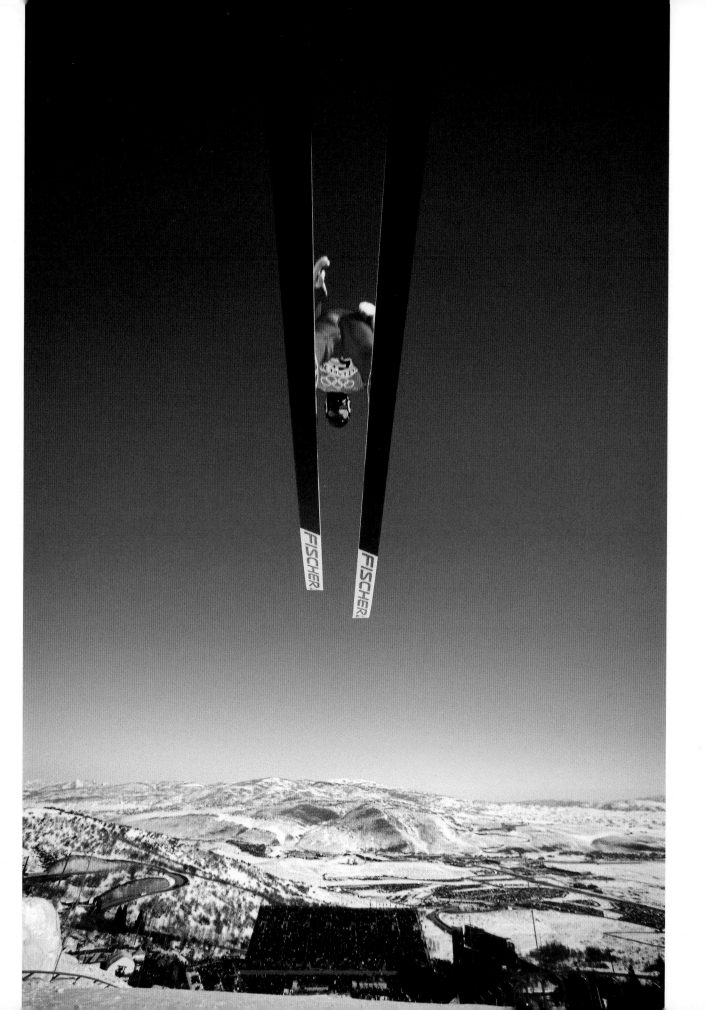

Following pages:

ARCHERY

I took this picture in the early days of my career when I was looking to shoot more graphic pictures. The archer is a friend of mine who ran an archery shop near Bushy Park in London. While we were shooting the pictures we were nearly arrested by the park's police who thought we were there to shoot the royal deer!

ENGADIN
SKIMARATHON

With 42,000 cross-country skiers competing in this event in Switzerland, I knew it would get pretty chocker at the first bend. I was shooting from a helicopter and, unusually, the picture is better because it was a cloudy day. If it had been sunny, the shadows would have made the shot extremely confusing.

41

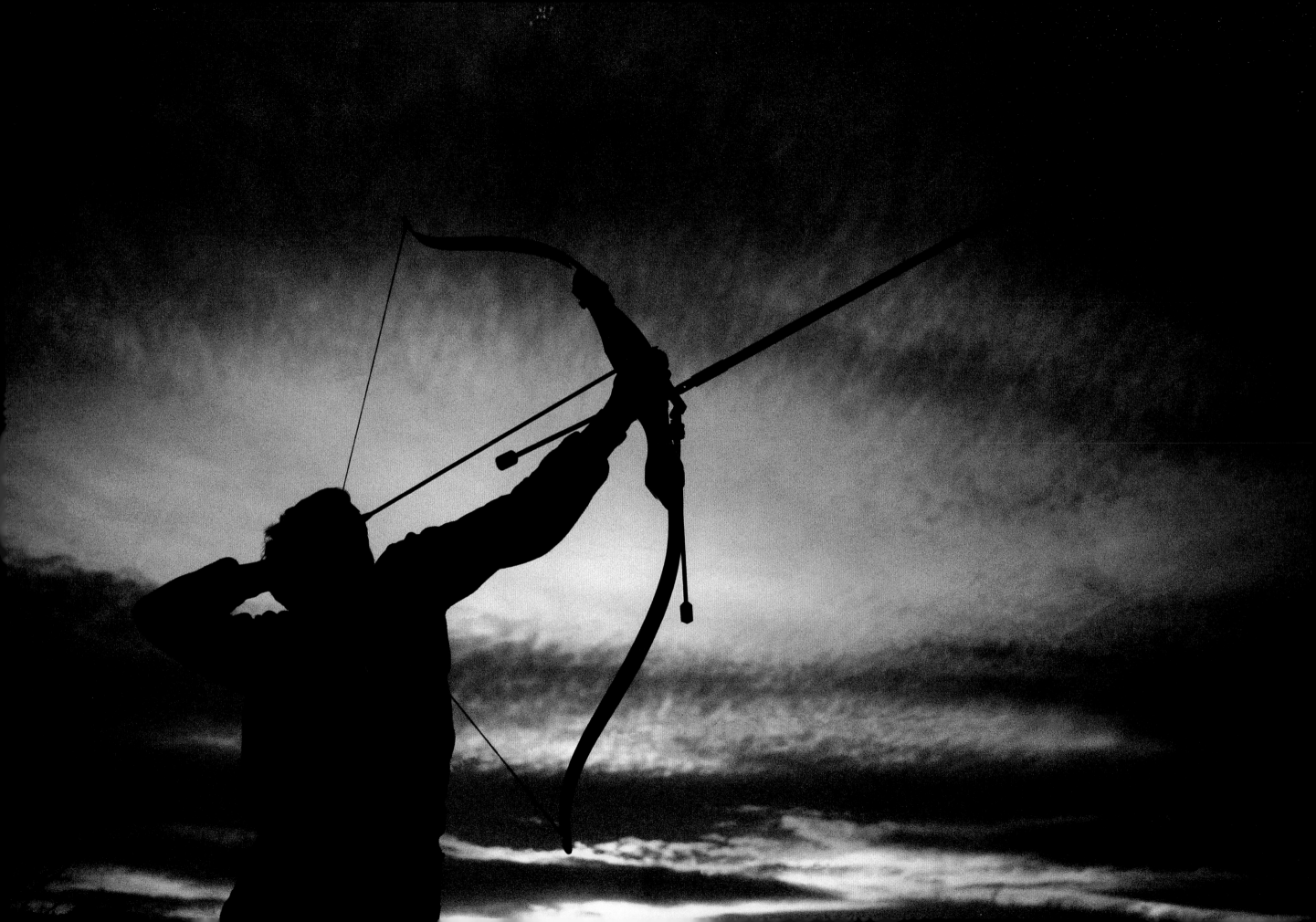

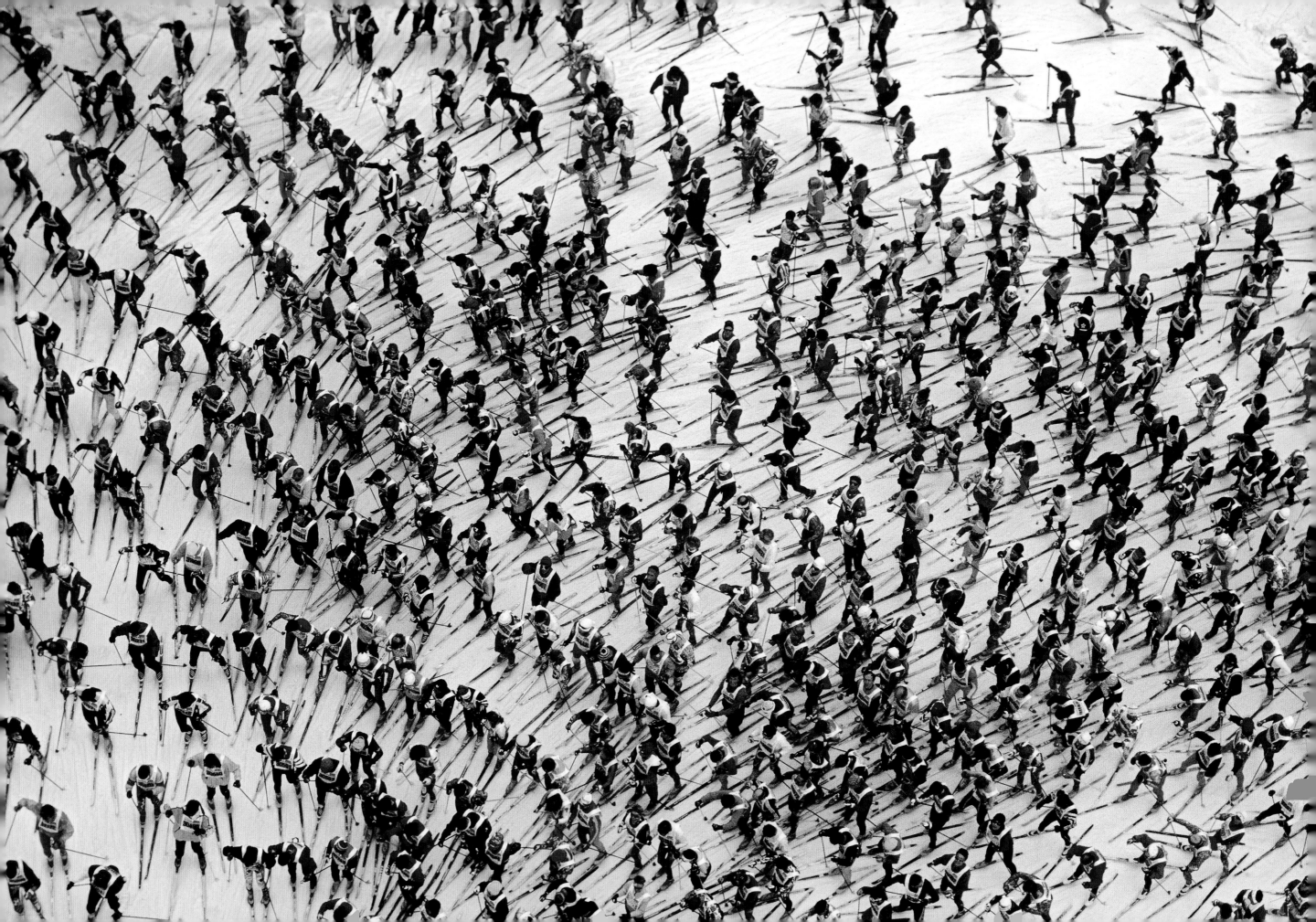

CROSSING THE DIVIDE

BY SL PRICE

The divide between writers and photographers is one of journalism's grim little secrets. This always comes as a surprise to outsiders, and who can blame them? After a century of seeing word and image (seeing *us*, that is) laid out side-by-side, page-by-page, in newspapers and magazines and books, it's only logical to think that such intimates would be fierce allies. And yet, though we circle the same subjects, experience the same glamorous/ awful locales, want essentially the same damned thing, the dynamic is a bit cat and dog. A friendship is not impossible. But let's just say the two species have some issues to work out.

Much of this is due, of course, to the writer's basic inferiority. We who bleed ink are an insecure and suspect lot, trafficking as we do in pesky questions, vague memories and slippery, unreliable words. Photographers, on the other hand, are incredibly fun creatures to be around, despite hauling heavy and delicate equipment, marshalling assistants, and positioning or chasing subjects beneath an ever-fading light. Athletes, especially, like shooters because they sense a kindred breed: Action junkies honed to excellence by years of repetition, judged daily by the relieving certainty of result. You won or lost. You got the shot or didn't.

Such simplicity makes it easy to forget that – as in athletics – there lurks a world of complex preparation, hard-eyed logistics, physical training and luck before that clean result appears before the eye of the beholder. A great photographer is equal parts diplomat, mechanic, con man, competitor, artist and fiend. That he or she can capture, in one millisecond flick of the finger, what pages of words never can is just another reason writers are so miserable. That he or she usually insists on buying the first round, though, helps matters. Some.

I've worked with Bob Martin on four continents over the last 20 years. He has tolerated my nattering through the blasting summer heat of Australia, the dodgy vagaries of Belgrade, a string of rain-soaked Wimbledons and some late-night menacing in a Paris strip club. Subjects trust him. Strangers like him. He is a stout, grinning English mountain of a man, and for much of this time possessed a fearsome gut that somehow, as it made him even larger than life, also made him more approachable. That helped, I like to think, when we dropped together into one of the most combustible spots on earth.

The spring of 2004 was hardly a welcoming time for Westerners in the Muslim world. The looming anniversary of the US invasion of Iraq made global terrorism a constant: The French rail network shut down amid bomb threats, Al-Qaeda killed 200 commuters in a Madrid train attack, and in Pakistan, America's ostensible ally but a haven for Islamic extremists, some 61 percent of the populace felt suicide bombers were justified in attacking US troops. Pakistan is where journalist Daniel Pearl had been beheaded. When Bob and I decided to go there to cover a cricket match of all things, a US

continues on page 46

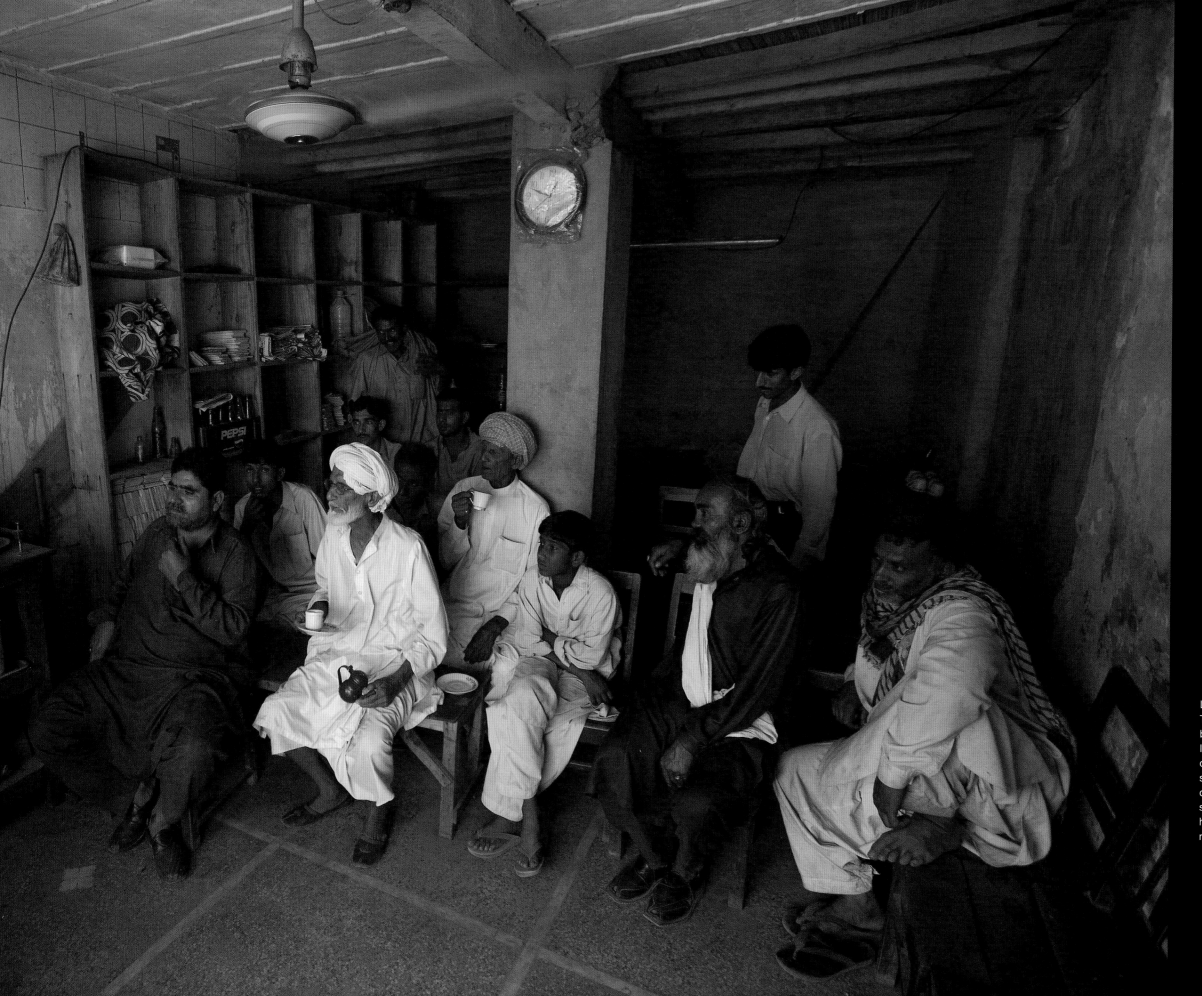

Left: During the deciding Test Match of the series between Pakistan and India, I spent a number of days looking for street scenes. This tea room was quite daunting to enter, but strangely calm considering how much the match meant to the supporters.

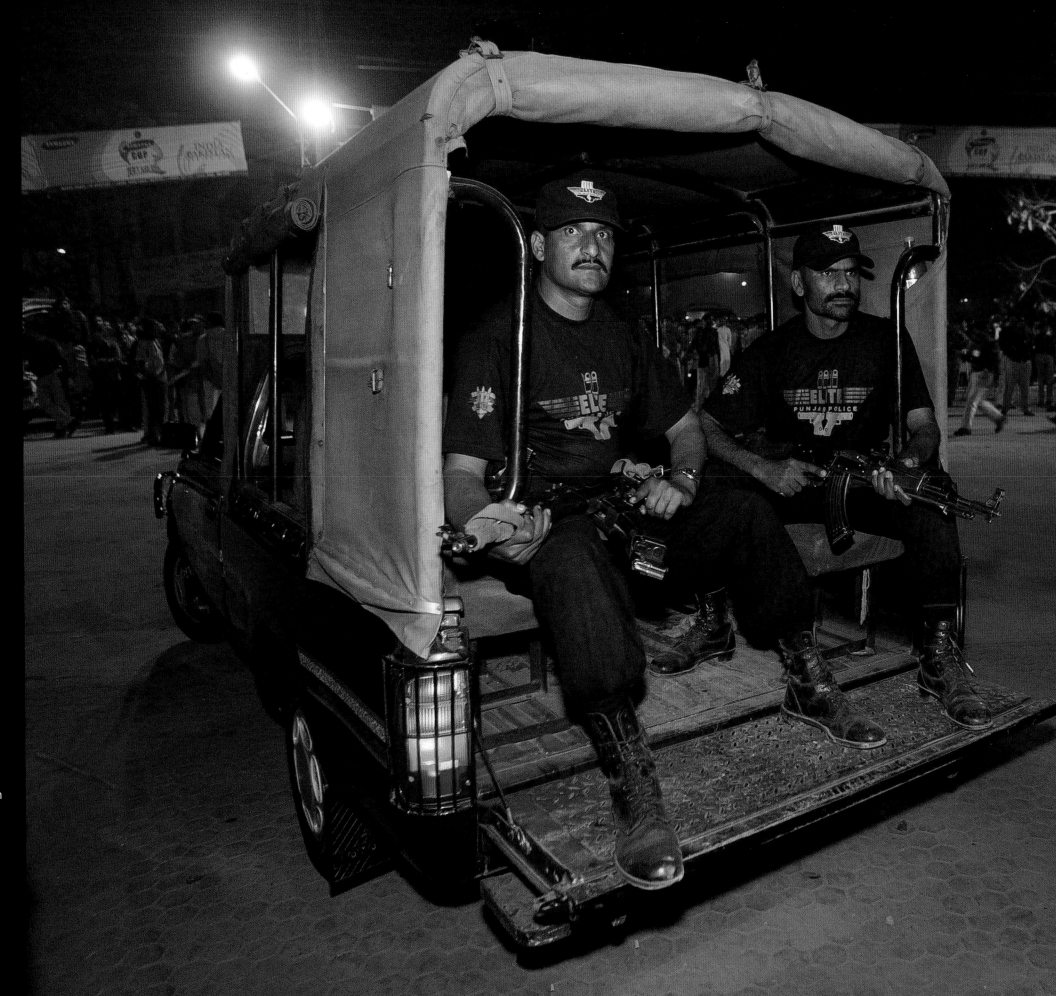

official wondered, for God's sake, why? Then she urged us to identify ourselves as Canadian.

Yet all that was, actually, beside the point. For that was also when India's cricket team, for the first time in 14 years, was touring Pakistan – and everyone was sure that it would get very ugly, very fast. The nuclear-tipped rivals had been to war four times since 1947, and during India's last tour a Pakistani fan ran onto the field and grabbed the Indian captain by the throat. This time, a few days before the tour's start, Pakistan launched a test of its nuclear-ready Shaheen 2 missile, capable of incinerating any corner of India. When Bob and I arrived at Lahore airport – me blockheaded and fair-skinned, Bob blond and red-faced and towering above the thick crowd – no one smiled back. A cold male voice recited the call to prayer.

Thousands of police and Pakistan Army rangers patrolled stadia and streets with Kalashnikovs, sawed-off shotguns, Uzis. On each floor of our hotel, a uniformed man glowered in the hallway with a submachine gun in his lap. Thousands of Indians had streamed into the city, returning for the first time since the blood-drenched 1947 partition. "We're probably overreacting," the desk clerk explained. "But there are Indians in the hotel now."

We had our scares, discomforts: A flight in a creaky Fokker airplane that seemed sure to break apart. The worst hotel in history, on the edge of the Thal Desert, complete with clouds of bedbugs, brown tap water, power outages and gut-wrenching bangs in the middle of the night. Our taxi driver ran over a

continues on page 49

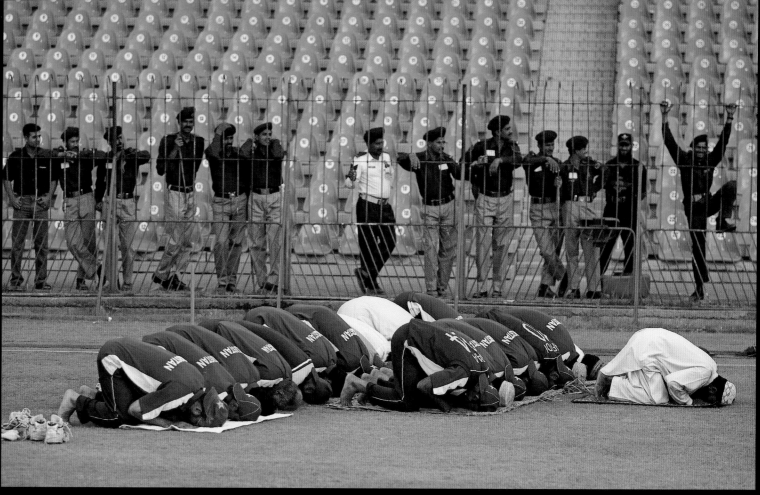

Left: Elite Commandos of the Pakistan Army who were tasked with protecting the Indian team during the tour. The unit's motto was 'No Fear' so you can guess which brand of clothing they favoured!

Above right: The Pakistan team pray before batting practice in the nets at Lahore while the security guards look on. The guards provided a backdrop to the whole story.

Right: Pakistan's Shoaib Akhtar is the fastest bowler in history. This picture shows him hurling down a bouncer at Indian batsman Sourav Ganguly.

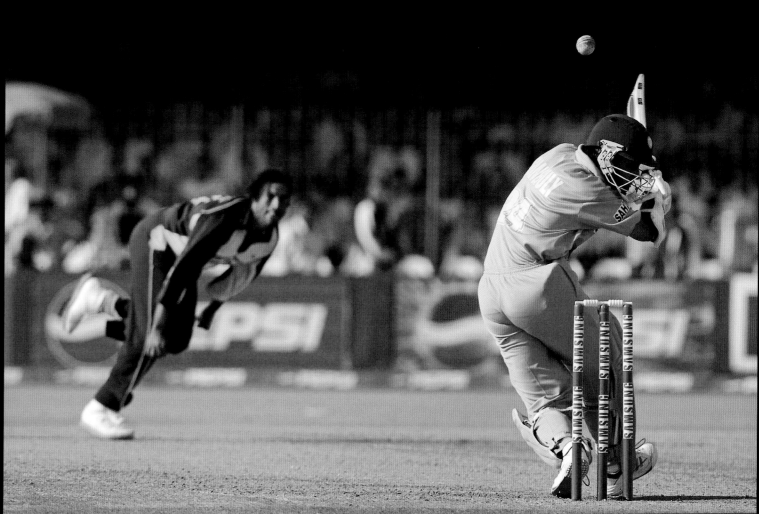

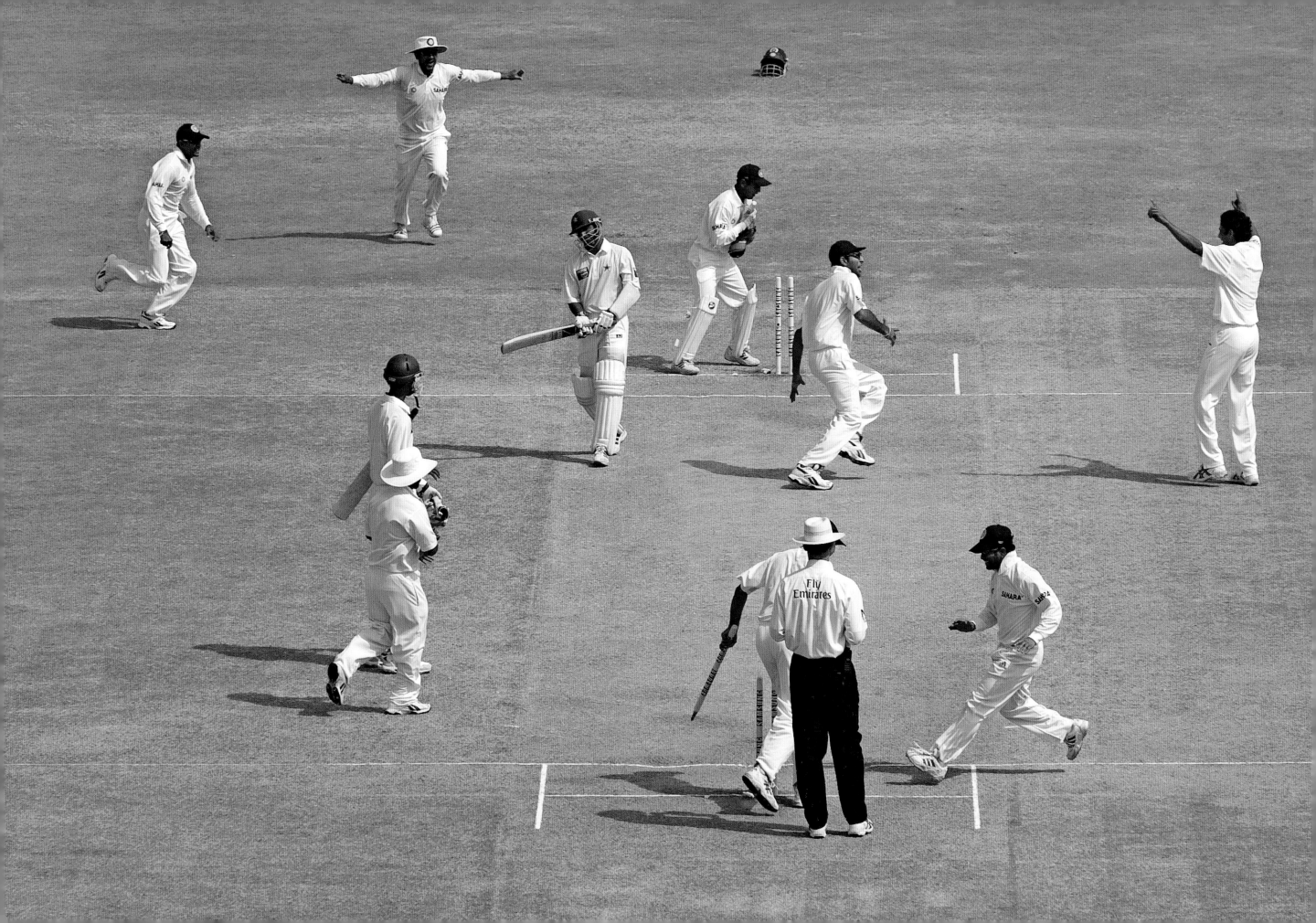

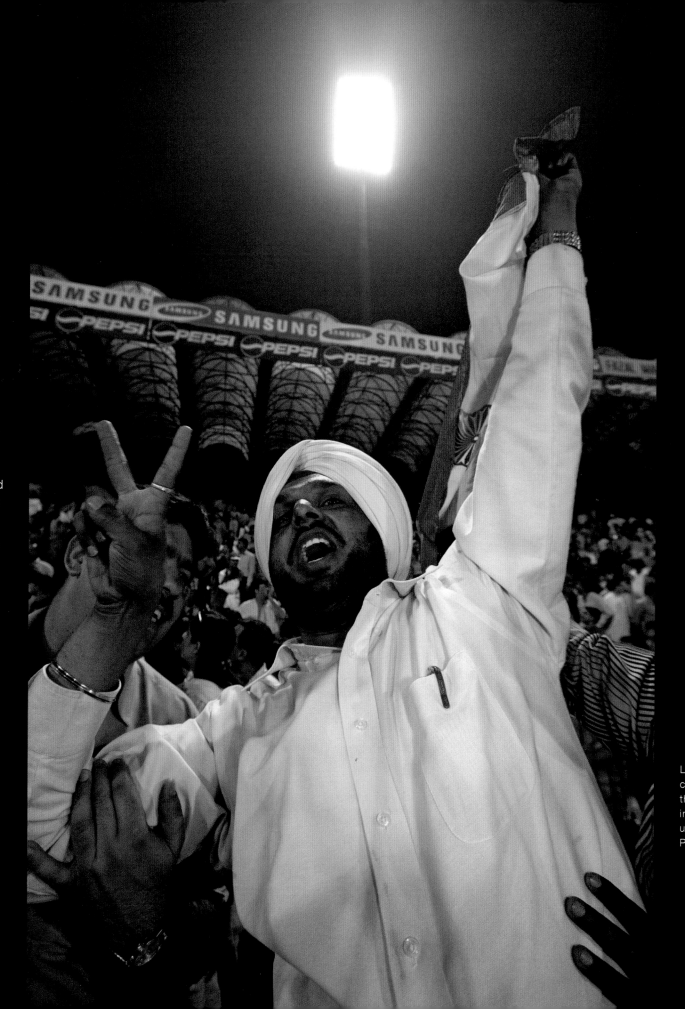

cyclist, who calmly dusted himself off and pedalled away. Signs warned of terrorists, and we couldn't have looked more infidelish, but very quickly Bob became a kind of folk hero. The locals found his resemblance to a famous cricket groundskeeper endlessly fascinating, poking, giggling, surrounding him with grins as he walked snapping through the worst neighbourhoods. I scribbled away, for all they knew the big guy's dim – but quite devoted – lackey.

And, in the end, nothing happened. By that I mean plenty happened, but not in the way anyone expected: India ended up winning the tour; their fans were greeted warmly; no bombings or riots marred the matches. Bob and I were forced to recalibrate our reporting to reflect the unlikely news – Peace Breaks Out! – that is, always, welcome but hardly hops off the page.

In truth, his images saved the story. Bob nailed the insane tension of the day and a struggling, riven nation's deep devotion to its dearest sport, but better than anyone he saw and seized the stunned relief – no, joy – in Pakistan when the expected strife *didn't* occur, when Pakistan behaved like a good host at a time few thought it could. Anyone can shoot conflict. Anyone can photograph disaster. It takes true talent to capture the absence of violence, a small spasm of nothing, really, and make you feel its power.

But, then, Lord knows you don't need a writer to tell you all this. Turn the pages. Just look. The proof is in your hands.

SL Price is a senior writer at *Sports Illustrated*

Left: The moment when India won the Third Test in Multan, and consequently sealed an historic series win.

Left: A Sikh Indian fan celebrates in the stands at the one day international in Lahore, surrounded and unthreatened by the local Pakistan supporters.

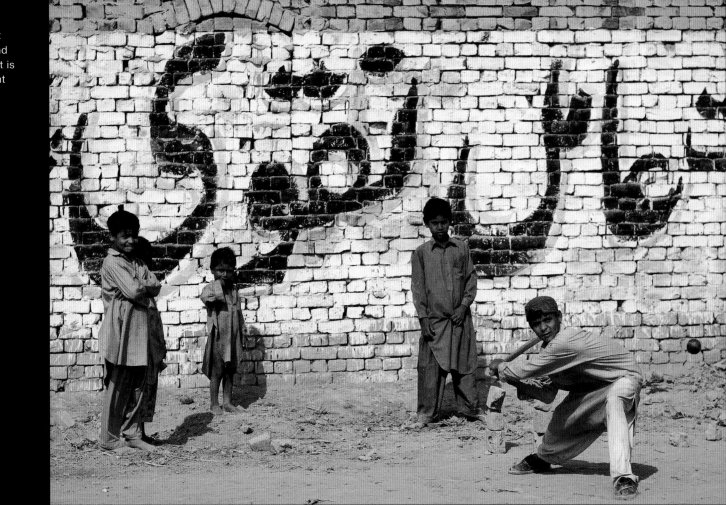

Right: Kids playing on the streets of Multan in front of what you might imagine to be some kind of extremist slogan, but is in fact an advertisement for a soft drink!

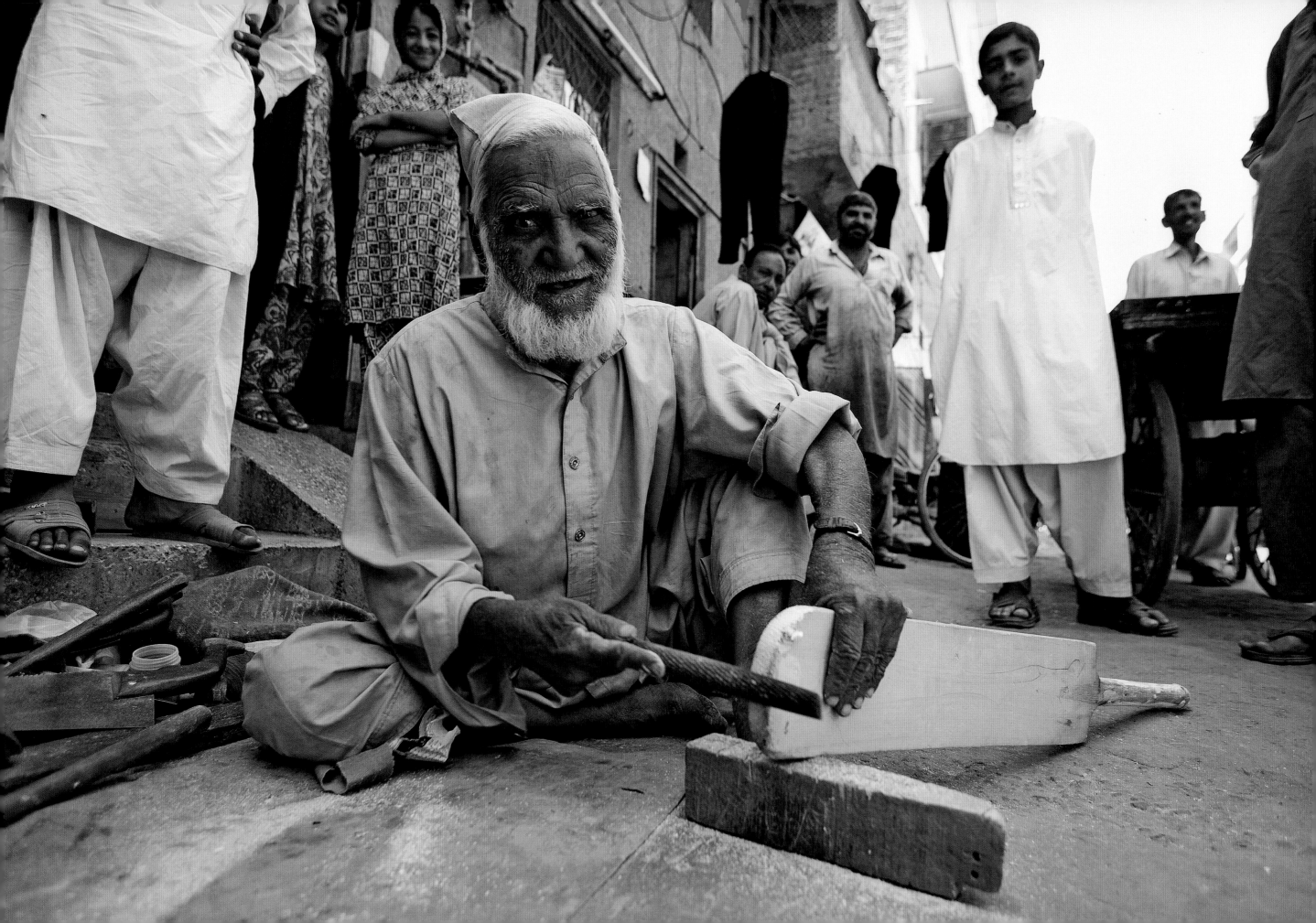

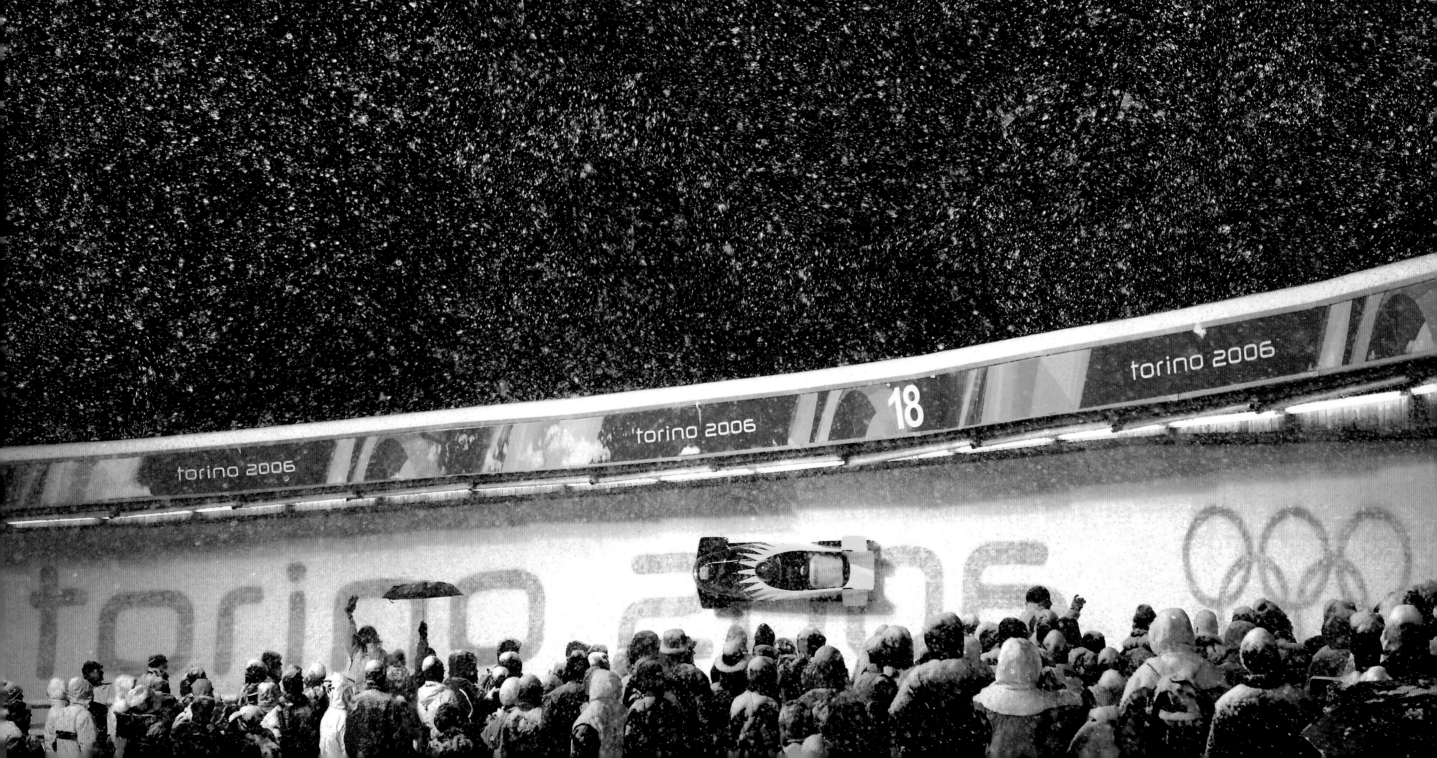

02

SPEED & PRECISION

JAMAICAN
BOBSLEIGH TEAM

I love this picture, taken in
the heaviest snow I have
ever seen at a sports event.
A lot of photographers
would have given up but
the black sky – along
with the bobsleigh being
positioned right in the
centre of the logo – make
for a great shot, and the
umbrella sticking up from
the crowd is the icing on
the cake. When we got
back to the car park our car
was buried in a snow drift
and we had to be pushed
out by the Swiss bobsleigh
team's supporters' club.

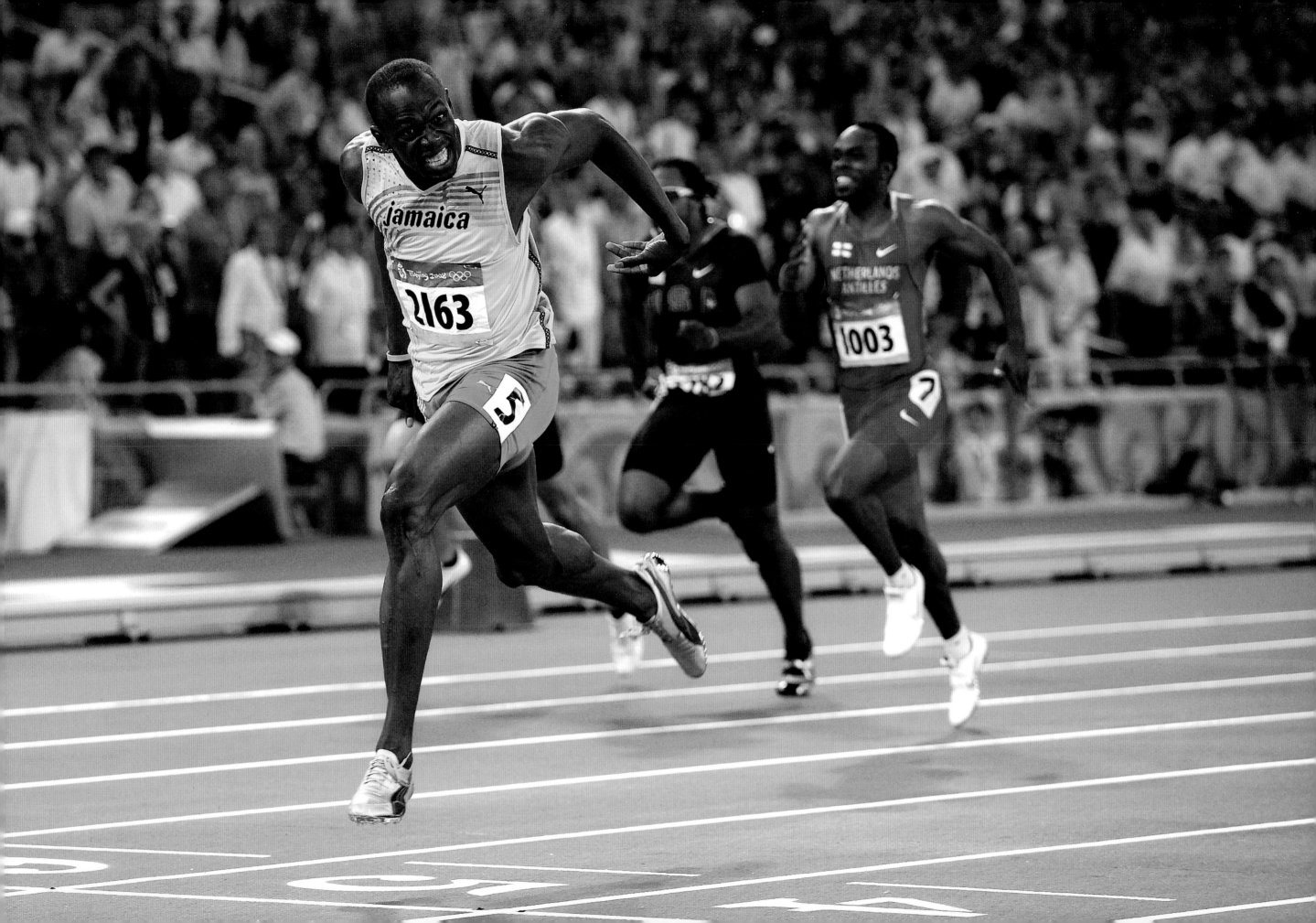

VENUS WILLIAMS

When I started working for Wimbledon in 2005, one of the first things we managed to negotiate was moving a commentary box which was right at the back of the stand, opposite the Royal Box, so that we could put a photographic position there. This means you can get shots like this, with just the grass as a background, which is what Wimbledon is all about. Many of the great Wimbledon pictures, like this one of Venus in 2007, are taken from this position and the photographers will always thank Wimbledon for this.

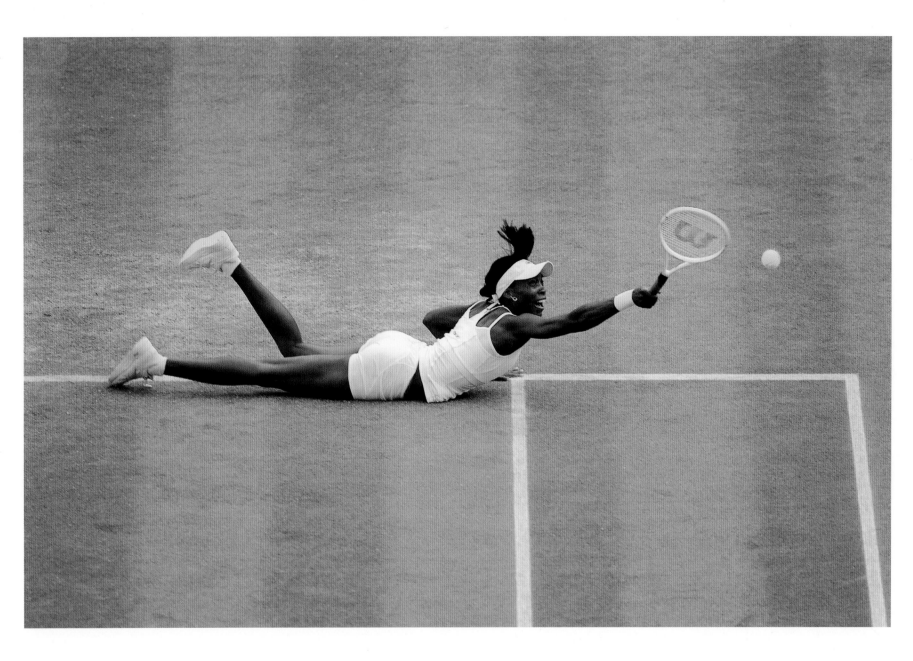

USAIN BOLT

I noticed that whenever Usain Bolt was going for a record, as he crossed the line he would look straight at the timing clock. So I started sitting down right next to it. This is when he broke the world record in the 200 metres final in Beijing and it appears that he's looking directly at me. In fact, every time he broke a world record I was always the first person he saw!

SWIMMER'S FEET

I was a bit bored during the swimming heats at the Atlanta Olympics – waiting for the next American superstar to win their next race – so I started to experiment shooting close-ups of various body parts. When you are struggling you should always keep taking pictures, don't start chatting, because you will always begin thinking outside the box if you keep shooting and often end up with something different.

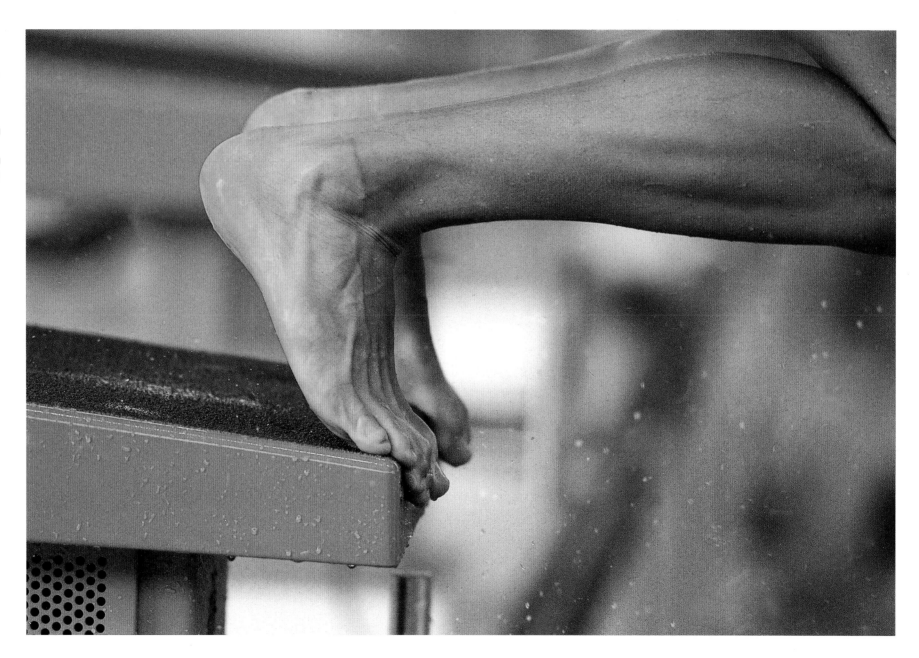

THE CHAMPION HURDLE, CHELTENHAM

I never used to like taking pics of hurdle races until I realised just how much debris is thrown into the air when the horses jump. This shot – taken from a remote camera in 2011 – is a real 'in the heart of it' picture which I am very proud of. It won Sports Picture of the Year in America.

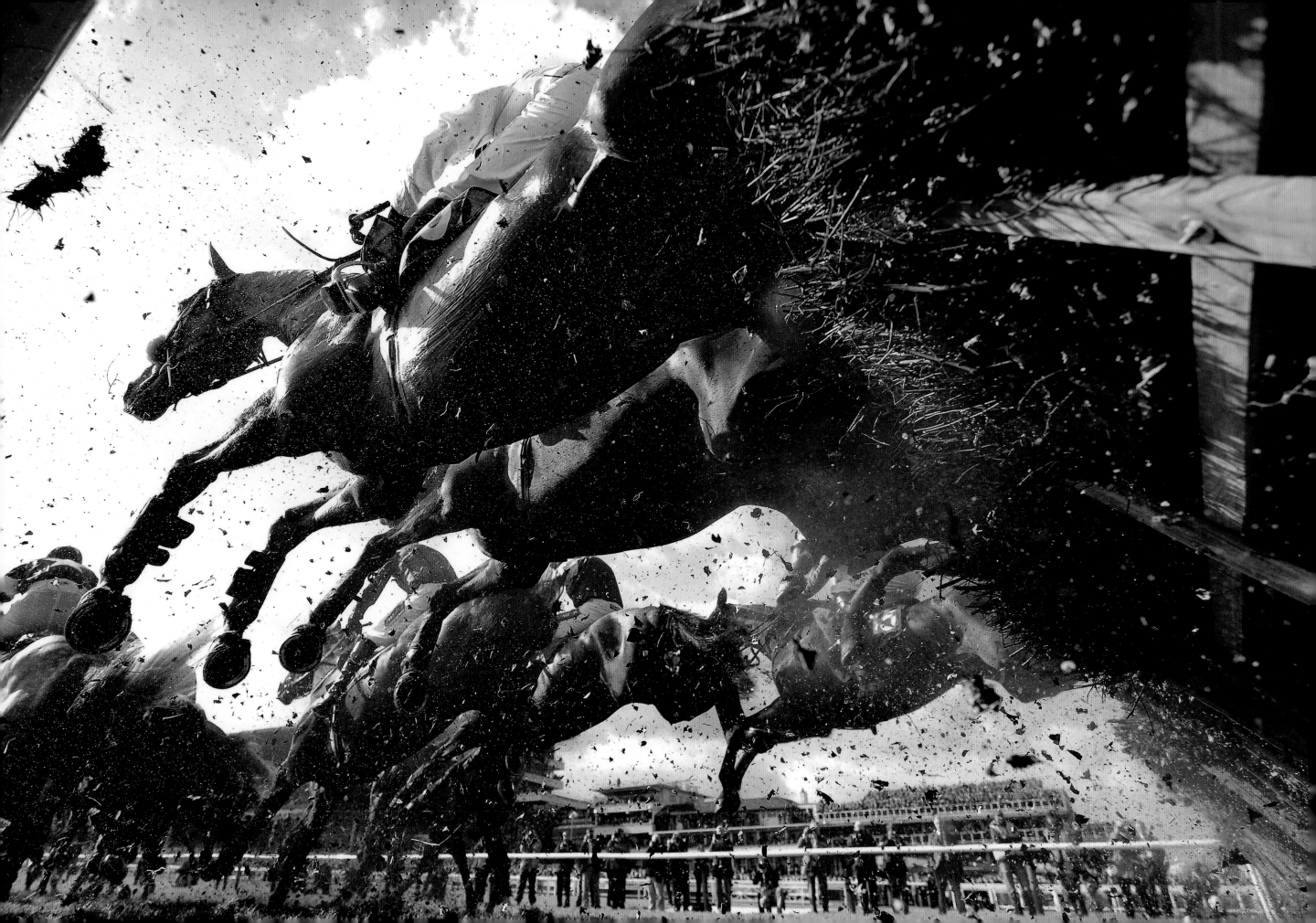

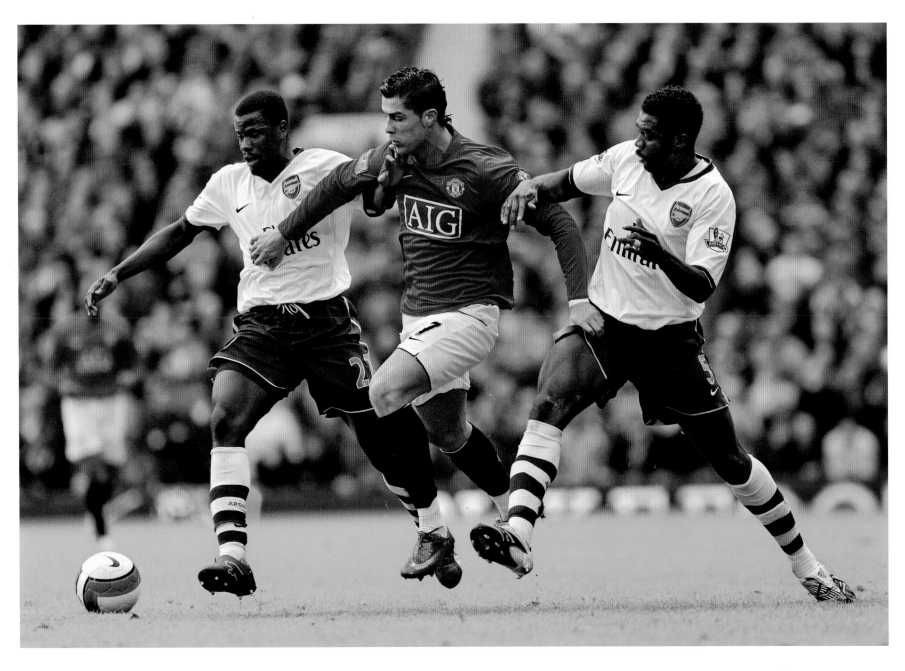

CRISTIANO
RONALDO

Even though I was on
assignment to get shots
of Manchester United's
American goalkeeper, Tim
Howard, I was really pleased
to get this frame of Ronaldo
in full flow. I think it illustrates
how good he is that even two
huge Arsenal defenders are
struggling to hold him back.

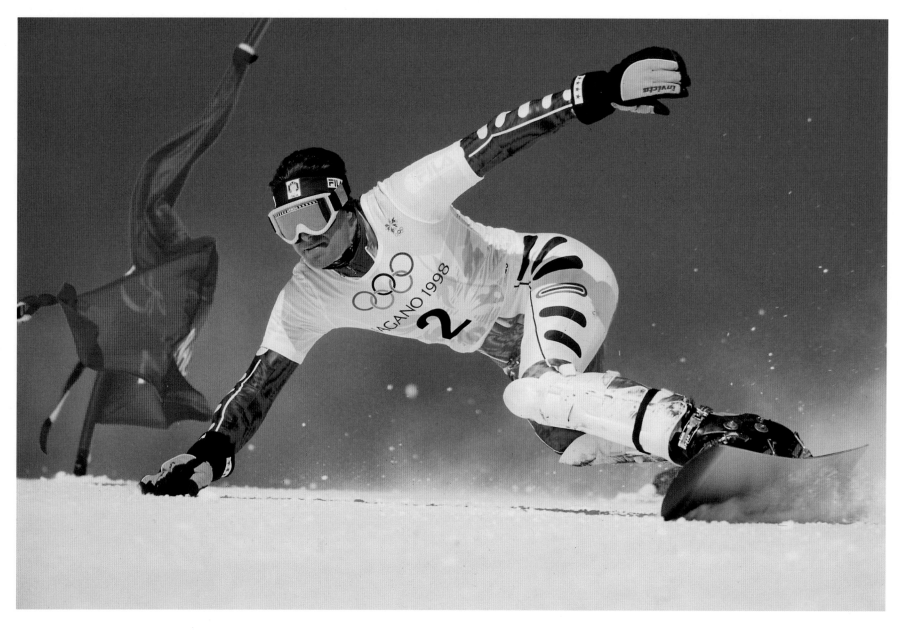

MATHIEU BOZZETTO

On the day I got this shot at the Nagano Winter Olympics in 1998 I was in a bad mood because I'd been sent to the men's parallel slalom snowboarding which clashed with the main event of the whole Games, the men's downhill skiing. However, the downhill was cancelled due to fog while on the other side of the mountain it was completely clear. *Sports Illustrated* used this shot as the page opener for their coverage of the Games.

100 METRES FINAL, SEOUL OLYMPICS, 1988

The first 'mega moment' that I ever photographed was the ultimately controversial 100 metres final at the Seoul Olympics featuring Ben Johnson, Carl Lewis, Linford Christie and co. It was the beginning of my career using remote cameras, too, when I would have to use a certain amount of guesswork when shooting the picture. The frame has become more significant with the passing of time and the facts that later emerged about this race.

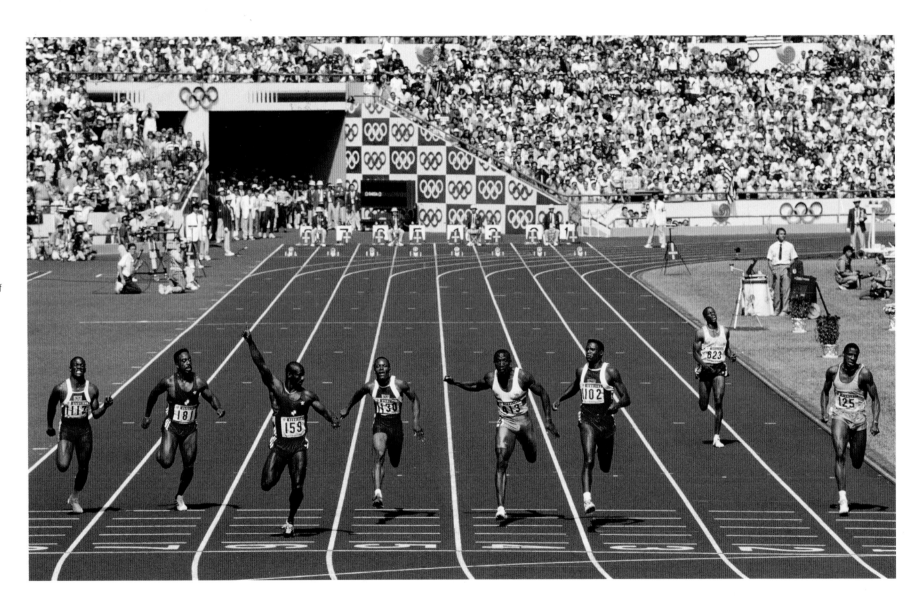

DRUGS TESTER

This is a portrait of the chief drugs tester for the Sydney Olympics, Graham Trout. We set up a studio in the corner of his lab and it's not actually urine in the test tubes, it's Lucozade.

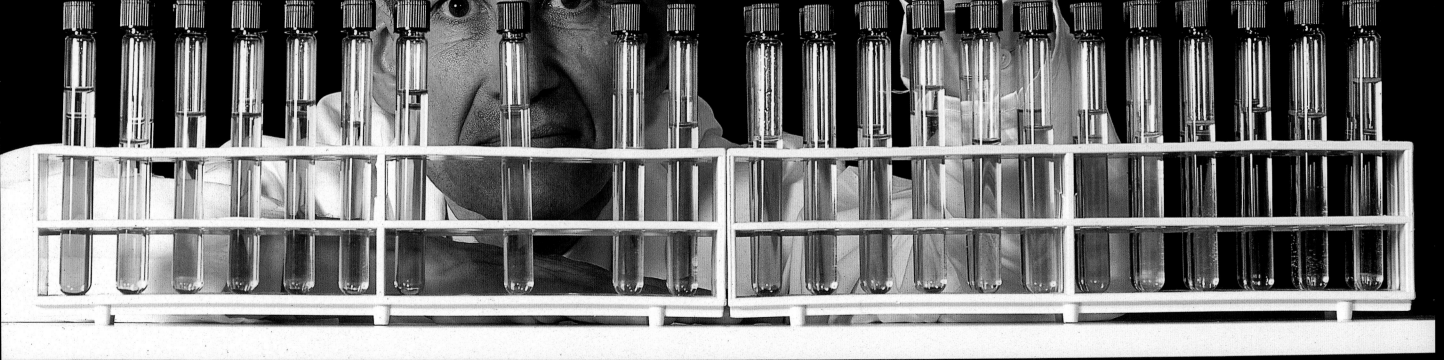

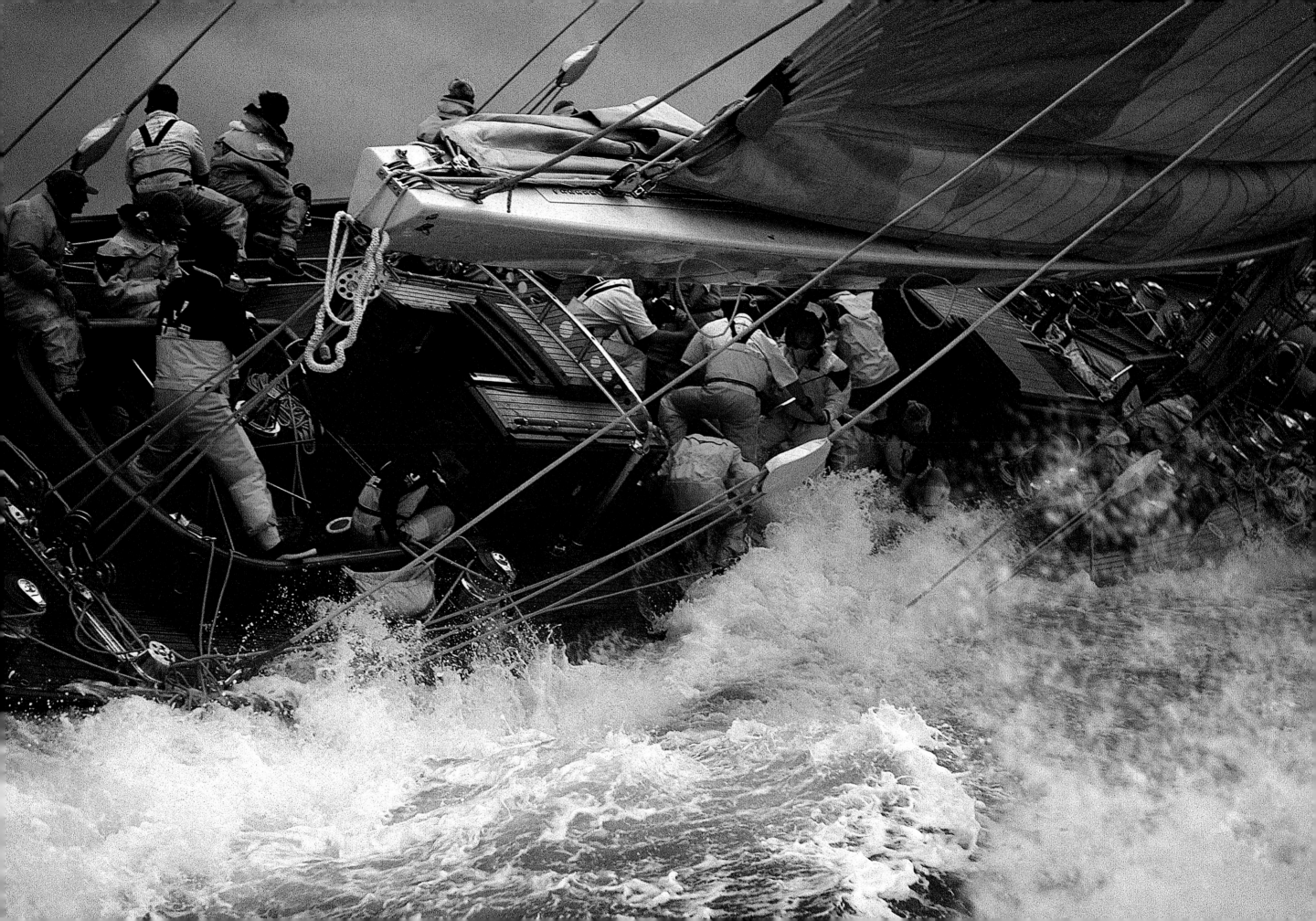

COWES WEEK

People look at this picture and they think I must have been hanging on for dear life as the waves crash around me. In fact I was sitting with my feet up, gently bobbing up and down. It was a very boring, dull day with very little wind during a race for J-Class yachts, which I love because they are all old, sleek and wooden – no wires or logos. But because of the poor conditions I said to the boat driver that it was a waste of time, we may as well go in. But he explained that the boats would soon come to a point where the two tides from either side of the Isle of Wight meet and where the water always gets rough and dirty. Sure enough, when we got there the sea was like a washing machine and the crew were getting thrown all over the boat, struggling to control this 130 foot yacht, while I was shooting gently from 40 yards away on the calmest sea you could possibly imagine.

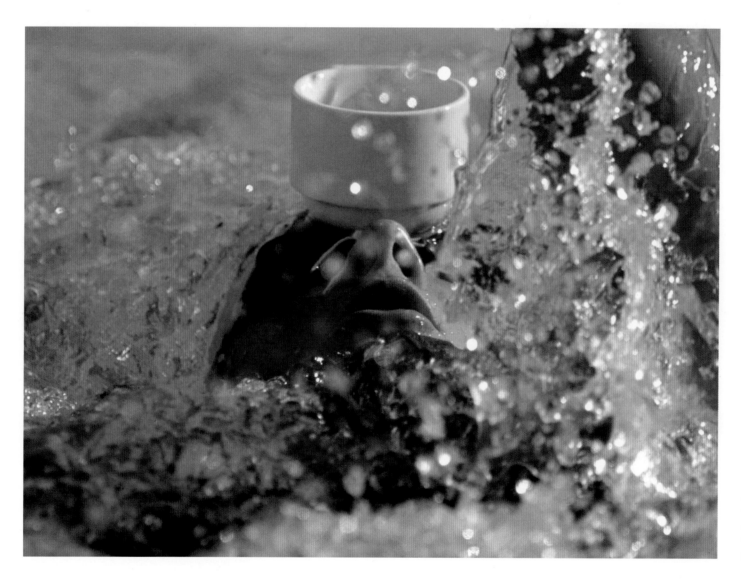

DAGMAR HASE

I had never seen this before and I never have since. During a training session, Dagmar Hase of Germany balanced a teacup on her head and proceeded to swim at least 20 lengths with it sitting there. Her coach said it was a fun way for her to make sure she kept her head still.

LILLEHAMMER
OLYMPICS

The atmosphere at the
Lillehammer Winter Olympics
was wonderful and the
Norwegians embraced the
Games with this incredible
enthusiasm. I like this
picture, with all the flags
and the pine trees behind,
because it captures the
spirit of the Games.

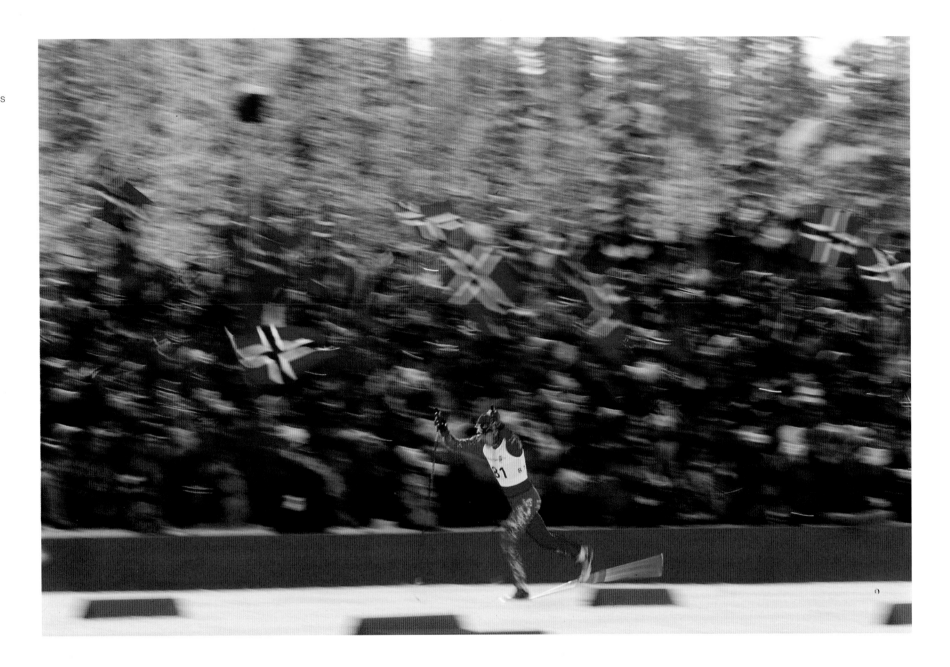

CAMPBELL
WALSH

For the white water kayak
at the Athens Olympics I
picked a position where the
water was churning and
rough. Scotland's Campbell
Walsh – who went on to
win silver – got into a spot
of trouble and ended up
right in the thick of it, which
made the picture for me.

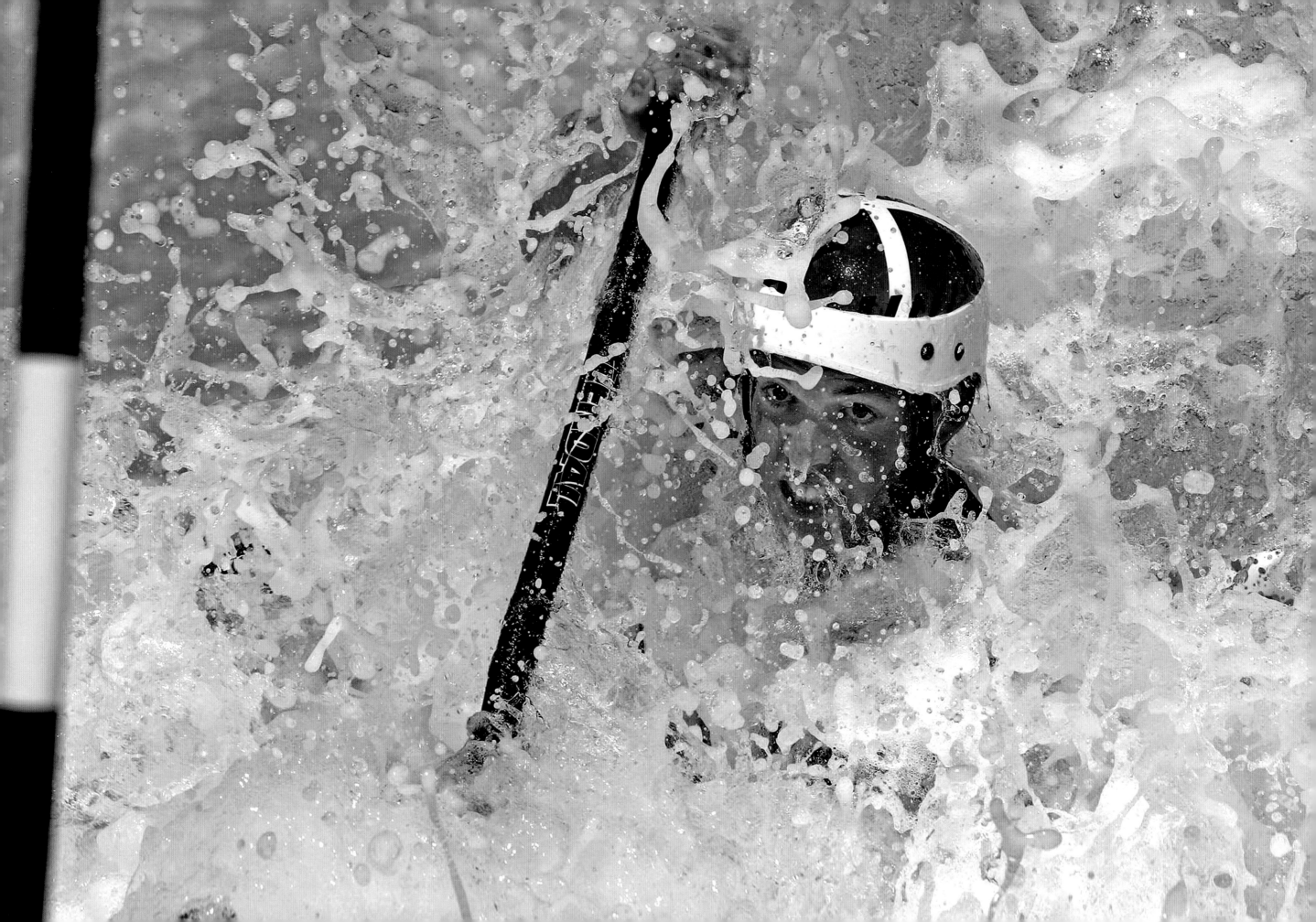

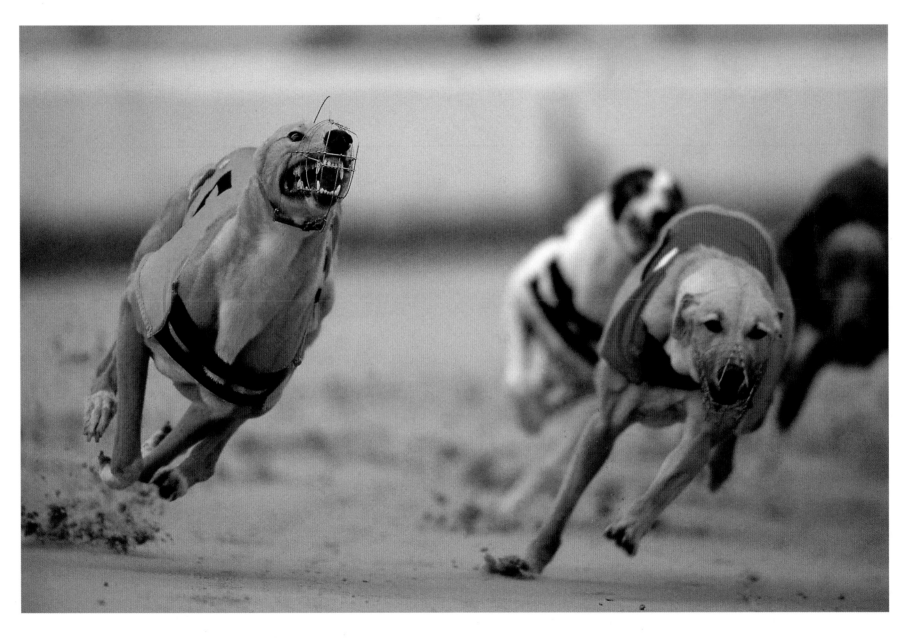

GREYHOUND RACING

Taken at the old Hackney dog track, which once occupied the site where the Olympic Stadium was built for London 2012, this picture won second prize in a competition for sports feature pics in the US. It looks like one of the dogs is a real athlete and the other is just some old mutt who doesn't want to be there.

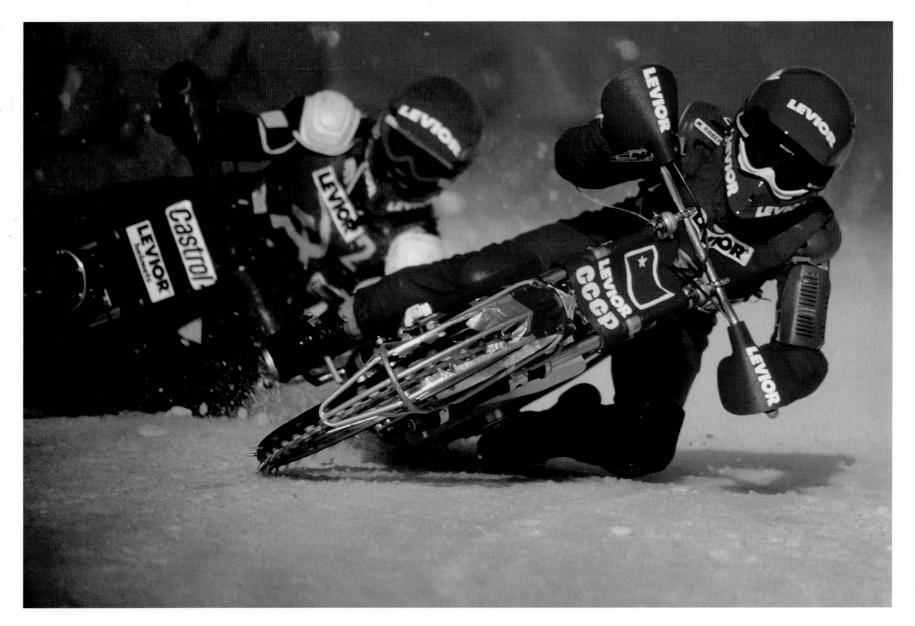

ICE SPEEDWAY

I was safe behind a bale of hay with a long lens at the 1991 Ice Racing World Championships in Frankfurt when taking this shot. The light was perfect and I love these two Russian riders with their great bikes and all the old Soviet branding.

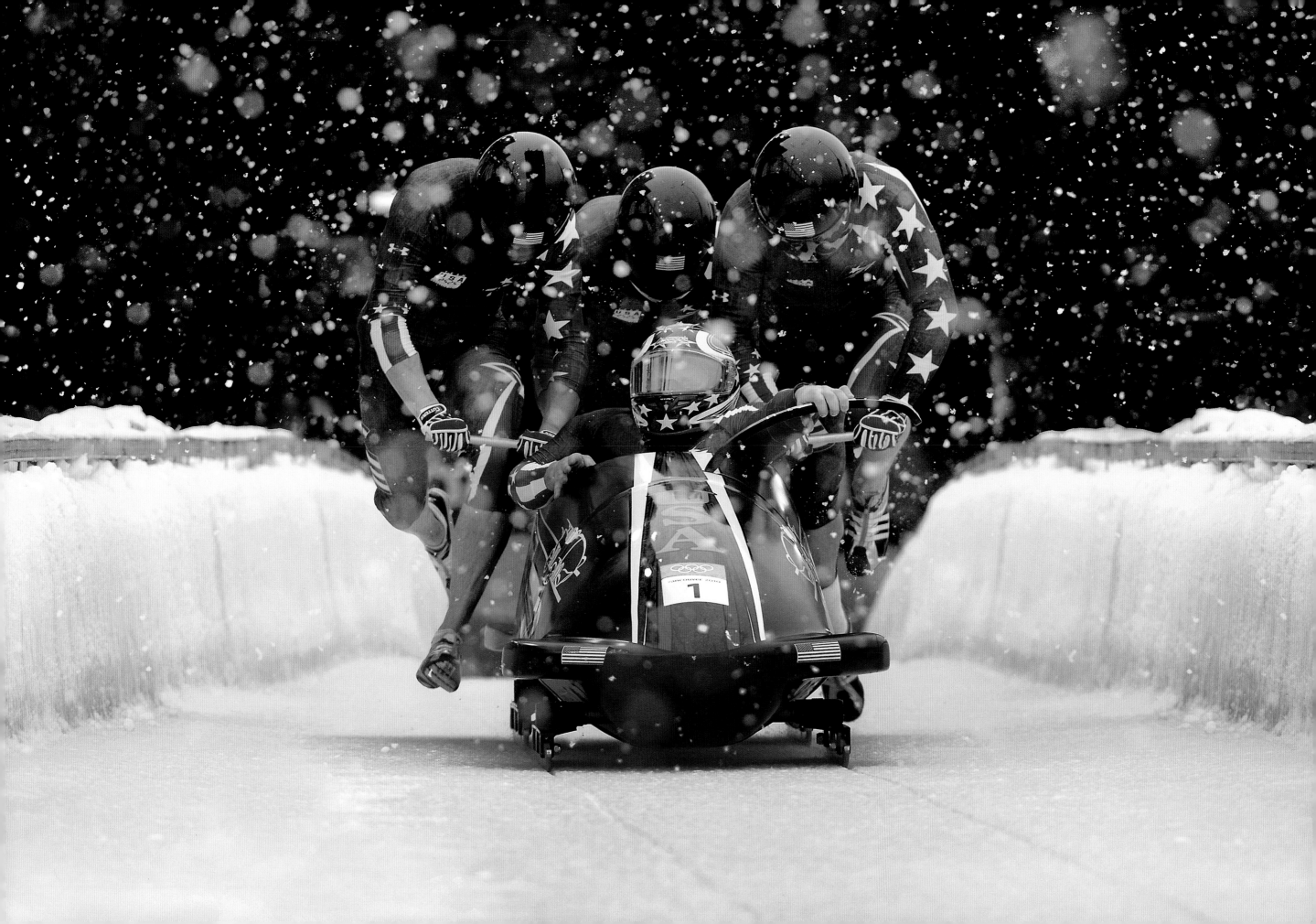

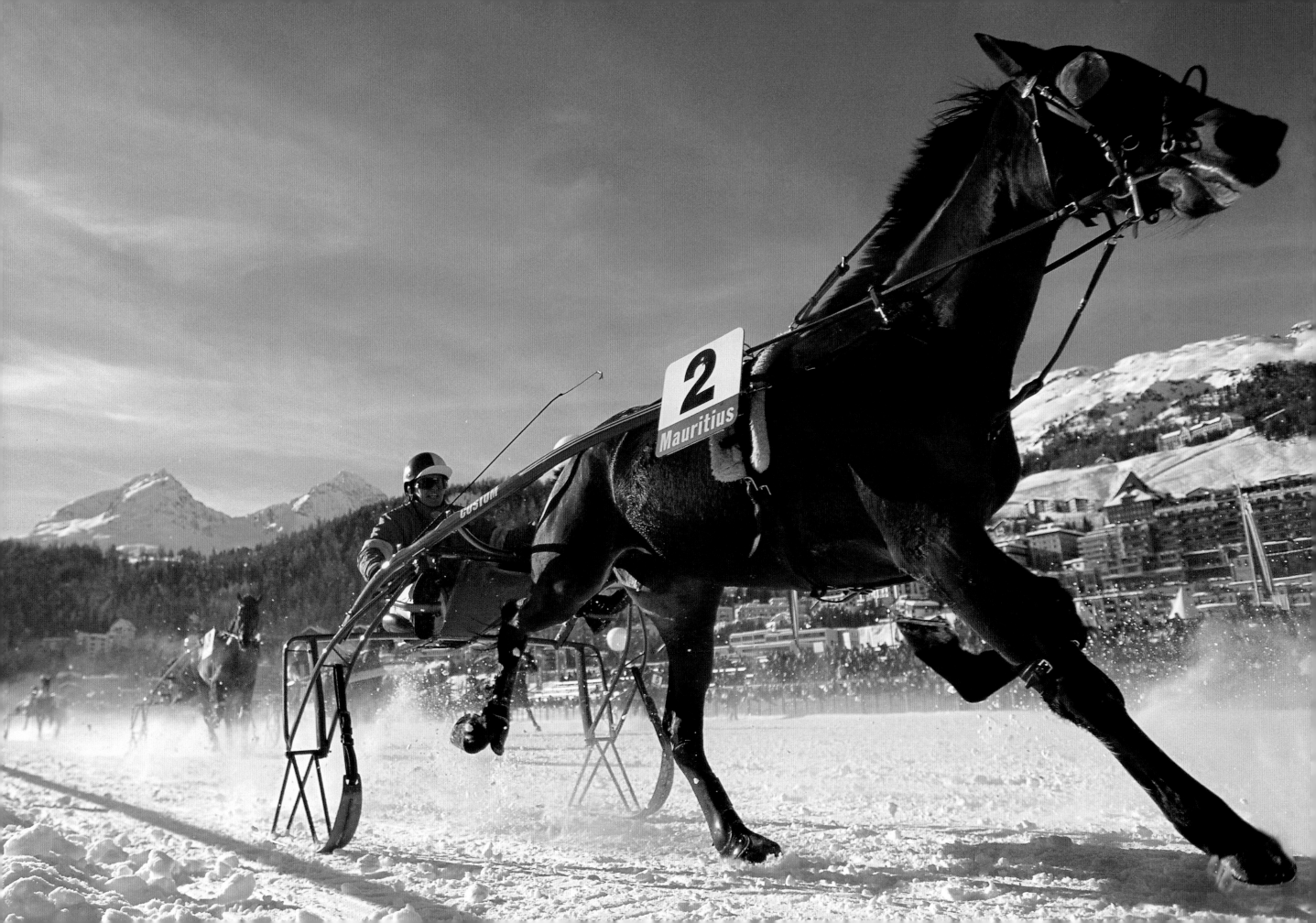

Previous pages:

US BOBSLEIGH TEAM

I had to crawl under the bob track to get this picture, trying to find a nice, contrasting background on a dull, grey day. Then it started to snow and, with a big telephoto lens picking up the flakes in the foreground, it just all came together.

WHITE TURF

I had heard about the horse racing festival on the ice at St Moritz in Switzerland so decided to take a look, and it was fantastic. This picture is so dramatic because the camera angle is right under the rail, looking up. I ended up going back to the white turf three times, always getting great shots.

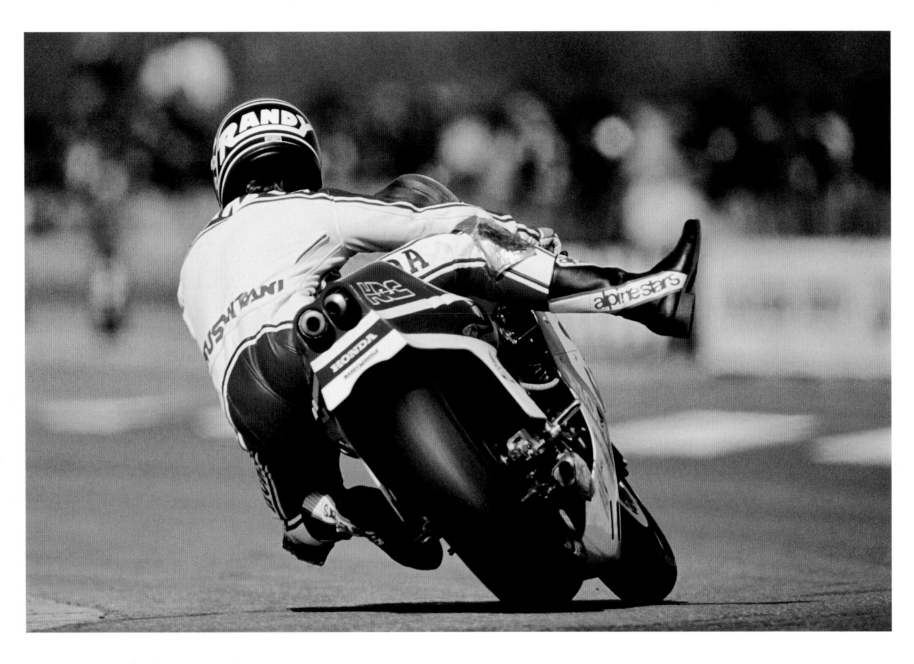

RANDY MAMOLA

The great American rider Randy Mamola was indicating, with his leg, to riders behind him that he was pulling into the pits at Donington. It just makes for a really cool shot, especially when you see his name – 'Randy' – on the back of his helmet.

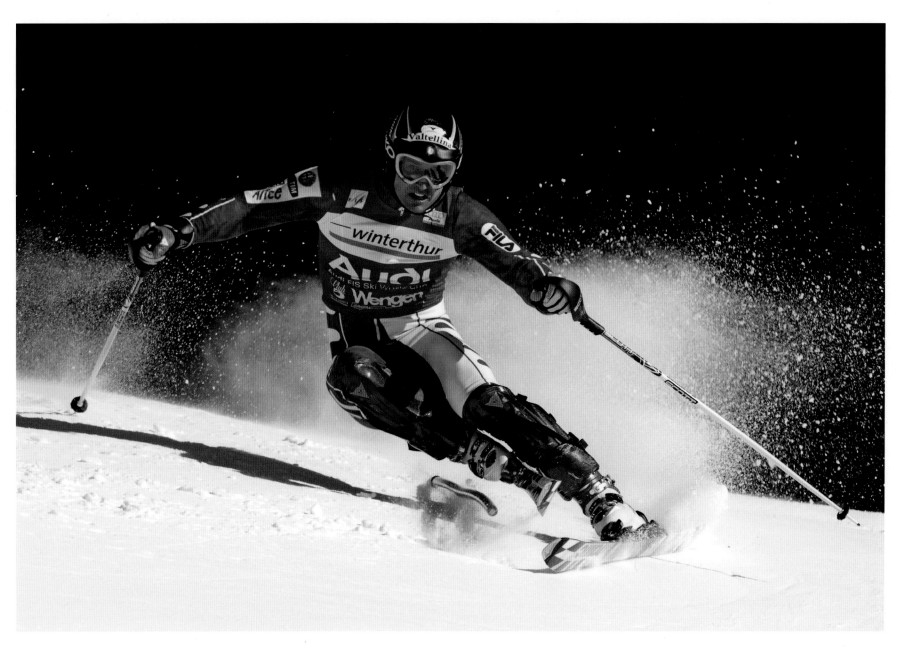

FRITZ STROBL

This is the best slalom skier at the time in action at Wengen, Switzerland, my favourite place to shoot skiing. This background of trees in shadow is one of the best on the circuit – the light is perfect – and I think this picture illustrates the Austrian's fantastic technique. I remember this day because, being greedy, I shot the Super G event in the morning and then hiked three miles across the slopes using crampons before sliding down half of the slalom track which was sheet ice. After I'd got into position I discovered that there was a ski lift that would have taken me to this exact location!

GREENWICH PARK EQUESTRIAN EVENT

It's not often you see a showjumping picture with an urban background, which made this one of the most photographed positions at the London Olympics. I took this at the pre-Olympics test event which shows the importance of preparation, specifically scouting venues before the main competition. I like the fact that the rider is jumping into the city, and the horse is leaping directly between two skyscrapers.

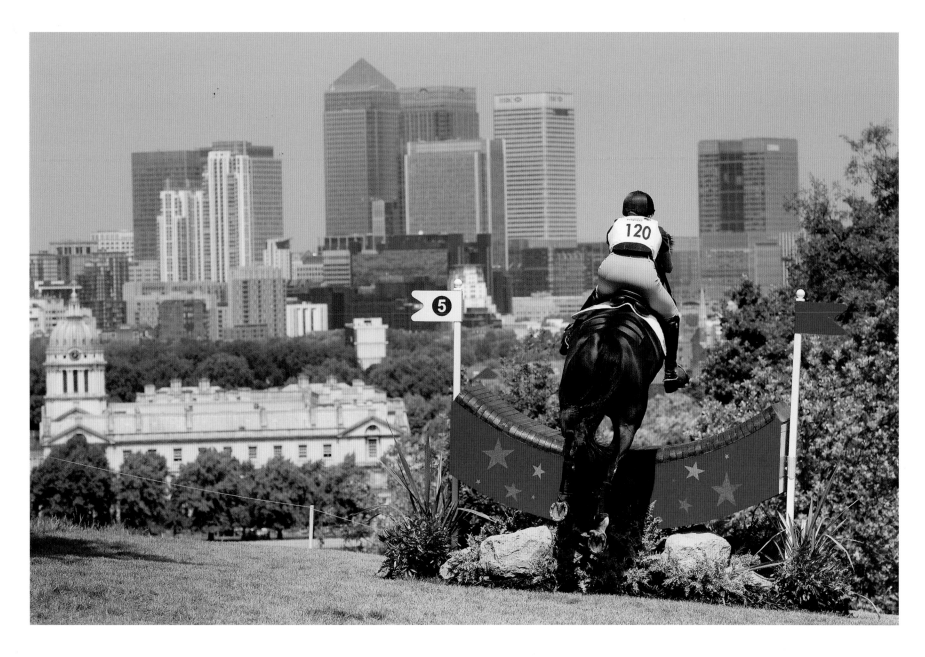

BEACH VOLLEYBALL, LONDON

What is great about this picture – taken at another test event before the London 2012 Olympics – is the sky. I only photographed for about 20 minutes because once the dark clouds had gone I knew I wasn't going to get anything better than this.

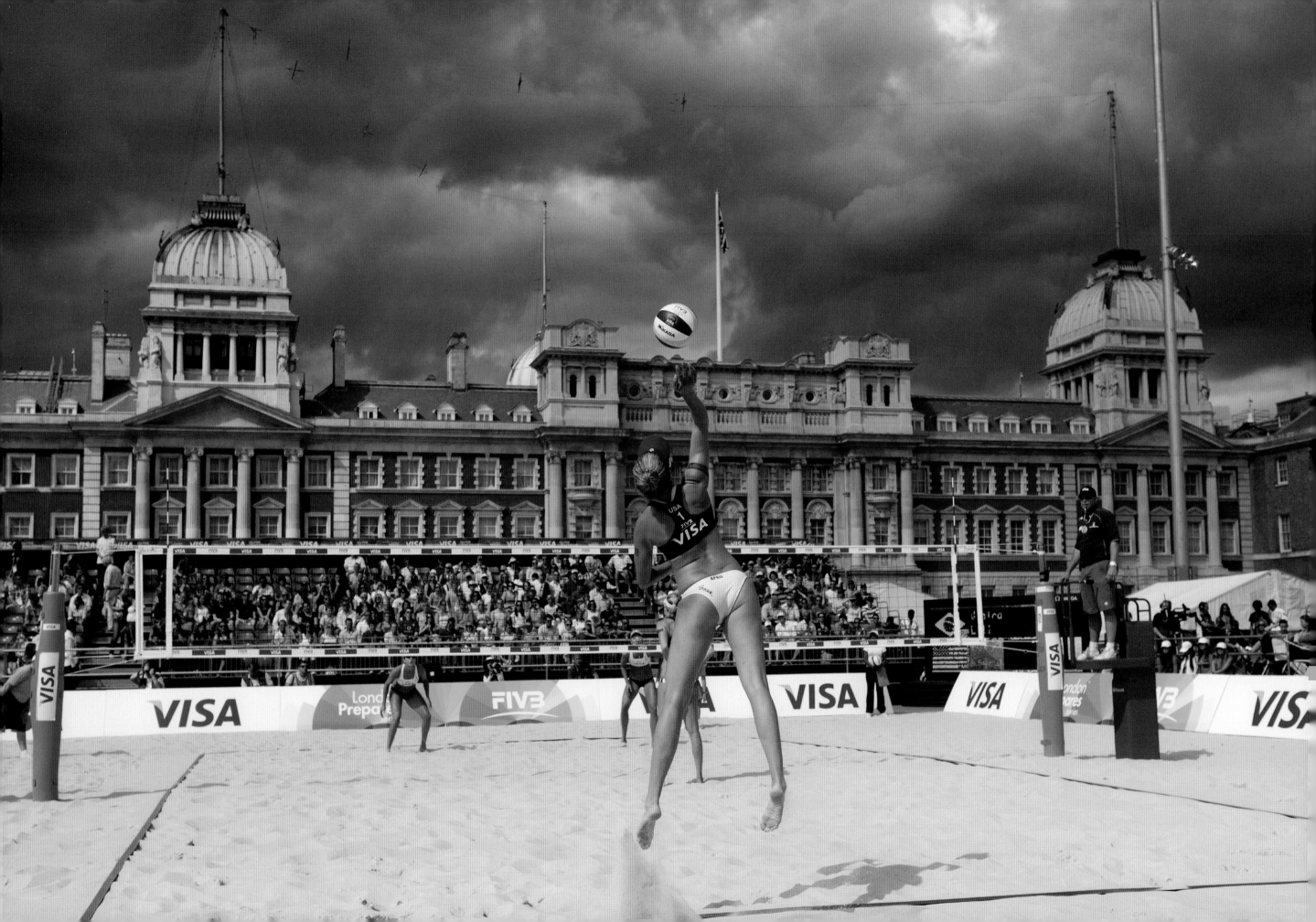

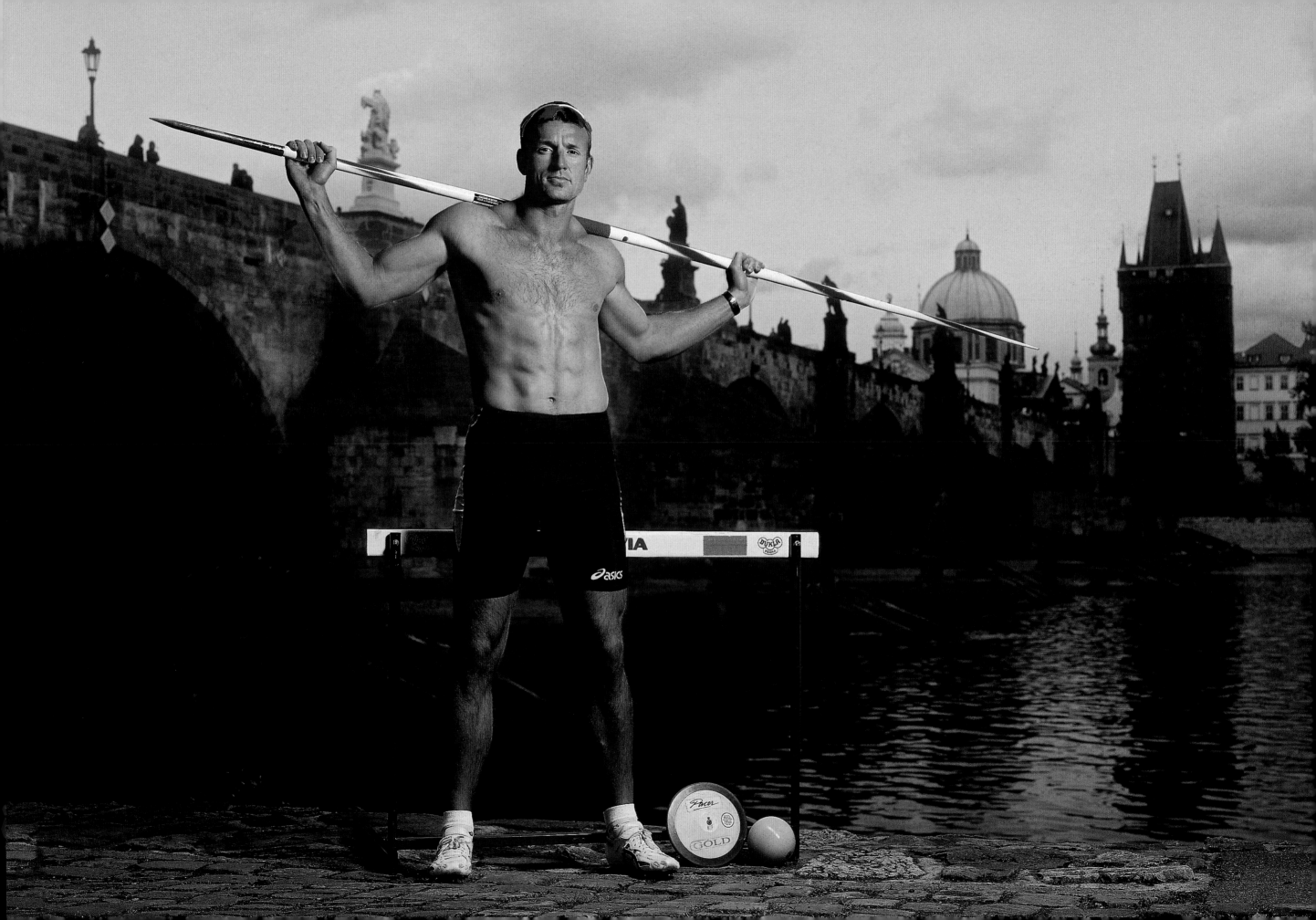

THOMAS DVORAK

The decathlon legend was
a pleasure to photograph
in his hometown of
Prague. Nothing was too
much trouble, he showed
us some of the city and
took us for dinner.

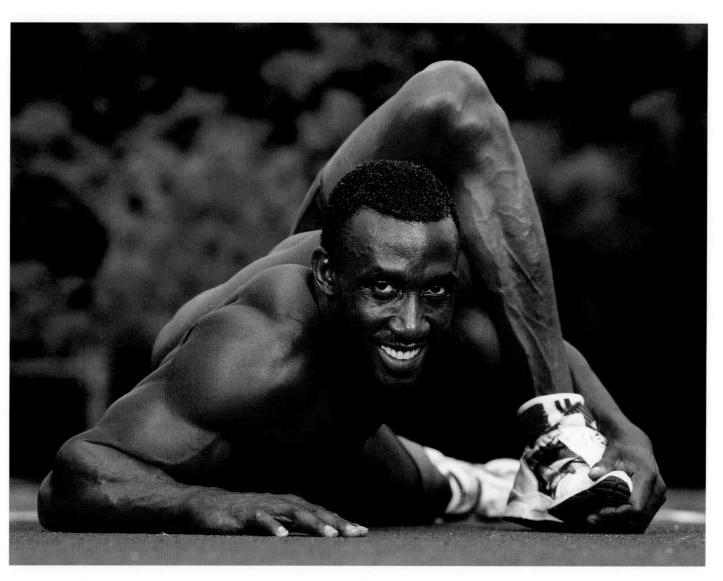

LINFORD CHRISTIE

The great British sprinter
had a reputation for being
difficult, but I always found
him a pleasure to work with
and fantastic to photograph.
This shot was taken before
the Atlanta Olympics at
a training camp in South
Carolina. I turned up to
take some portraits and he
started warming up on the
track, doing these incredible
stretches. So I quickly lay
down onto the track and
started shooting and, as you
can see, he's laughing at
me. I took all sorts of shots
under lights later on but
this was easily the best.

EDDIE EDWARDS

Sports Illustrated were running a 'Where are they Now?' feature and we discovered that Eddie the Eagle was supplementing his income as a radio host by abseiling down buildings and opening supermarkets – that sort of thing. He was delighted to do a picture. In fact he was so extrovert he wanted to do it in a busy Cheltenham High Street, but I persuaded him it would look much better from the side of this quiet, empty multi-storey car park with the church spire in the background.

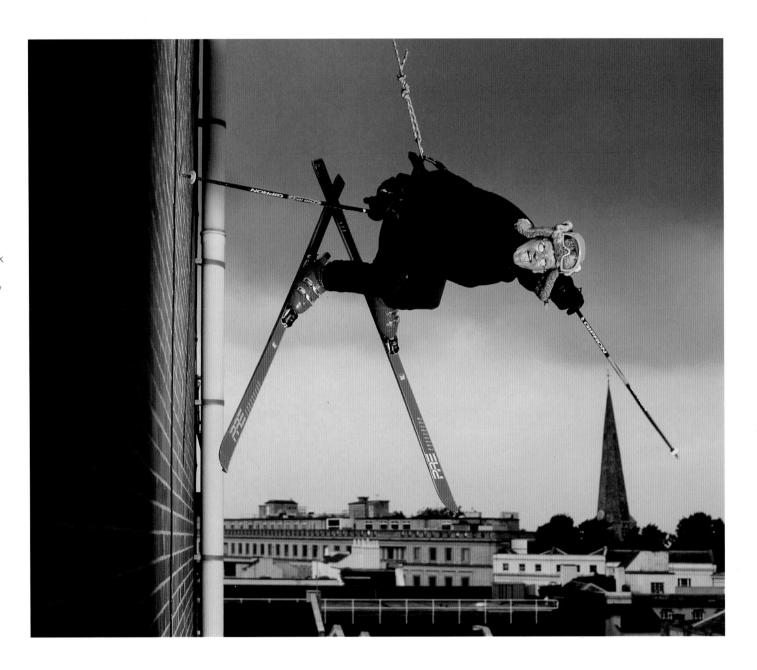

RED BULL
AIR RACE

The beautiful city of Porto made a fantastic backdrop for this round of the Red Bull Air Race season, but this shot is particularly good because the plane has just cut through the gate. It perfectly demonstrates how tight the courses are and how skillful the pilots have to be.

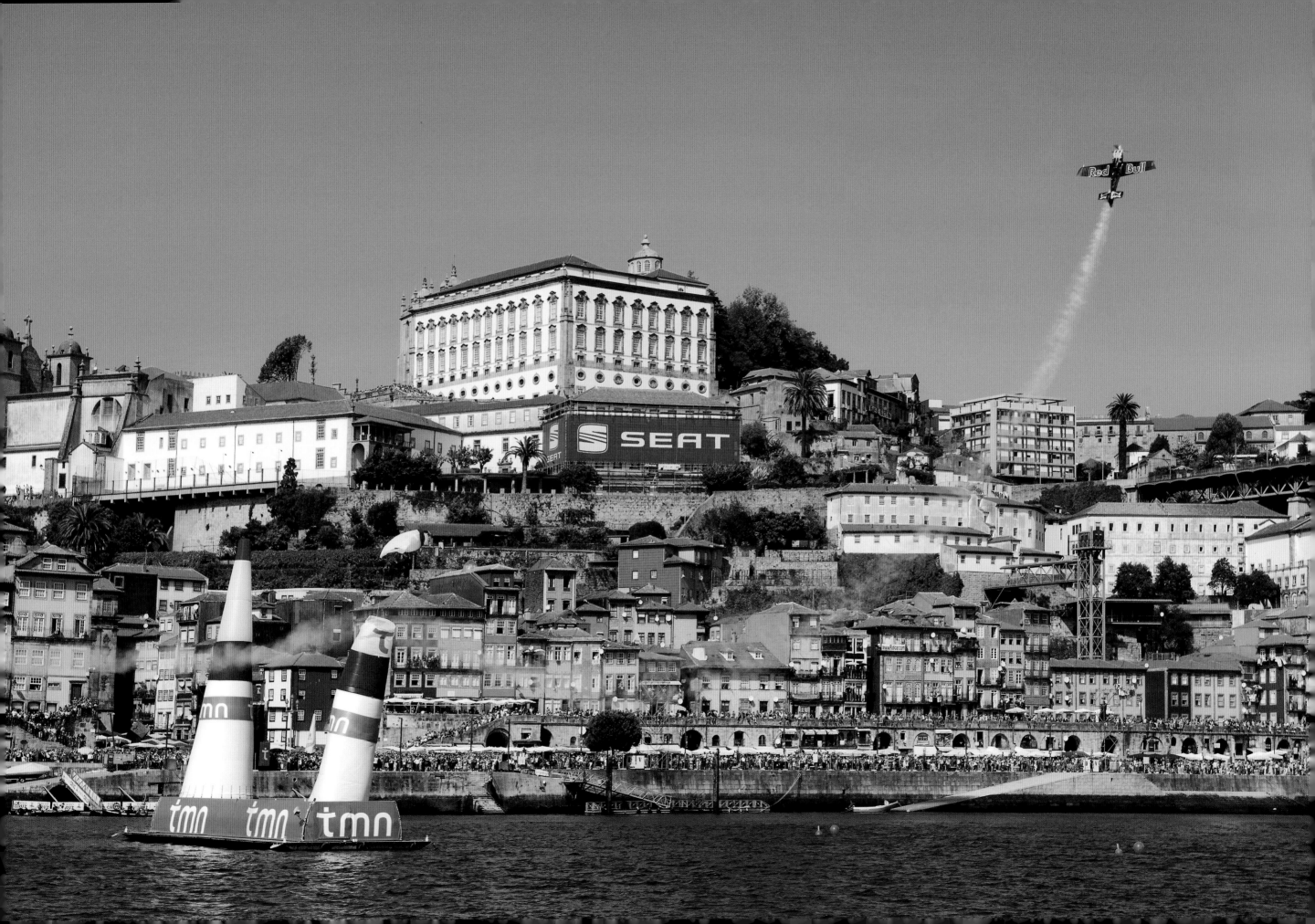

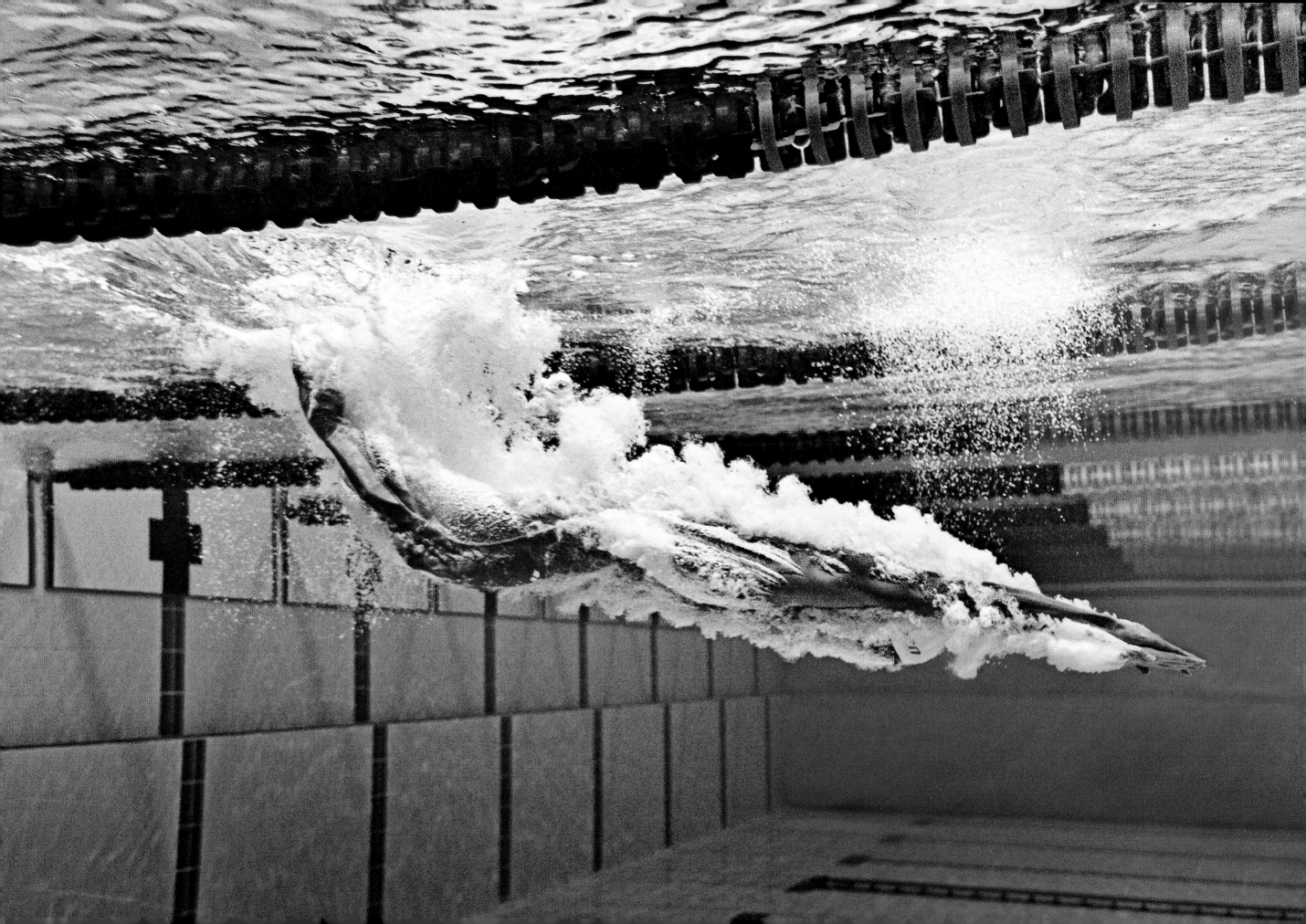

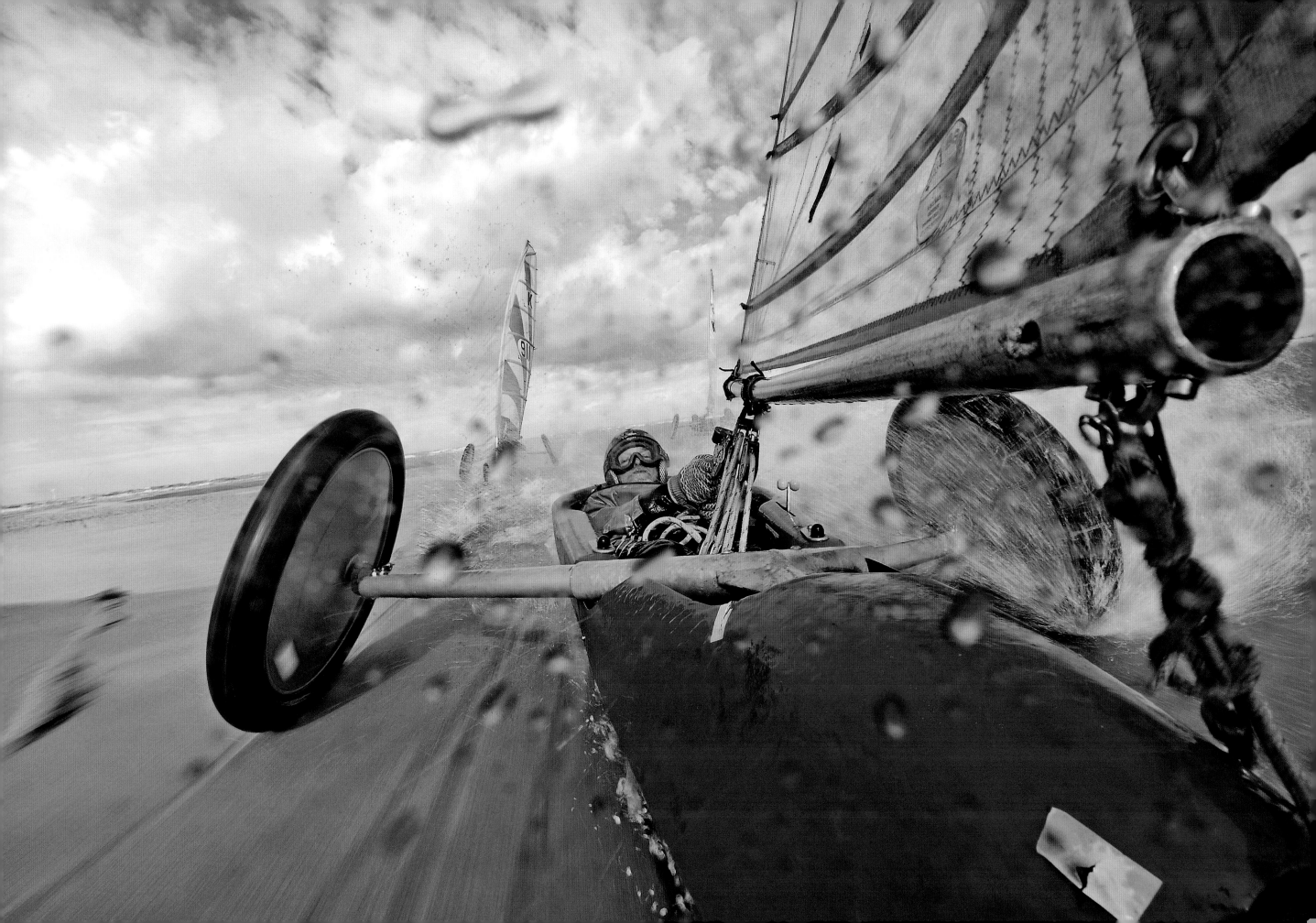

Previous pages:

TAKAMITSU KOJIMA

This picture is taken from an underwater window at the 2006 Asia Games in Doha and I like it because the bubbles distort the swimmer's body so that he looks almost like a dolphin. It was taken during the relay when you get more bubbles when a swimmer dives in because the water is already disturbed. I like this particular frame because there are no other swimmers in view as Japan were out in front on their way to winning the gold in the 4x200 metres freestyle relay.

CHRIS WRIGHT

I chose Chris for this picture because of his brilliant wizened looks and moustache – he looks like Biggles! I set up a remote camera on the front of the yacht which I operated from a 4x4 that was speeding along in front of him. I kept my eye on the yachts behind so I could choose my moment to fire the remote. I used a slow shutter speed to get movement in the water on the ground and the splashing around the wheels.

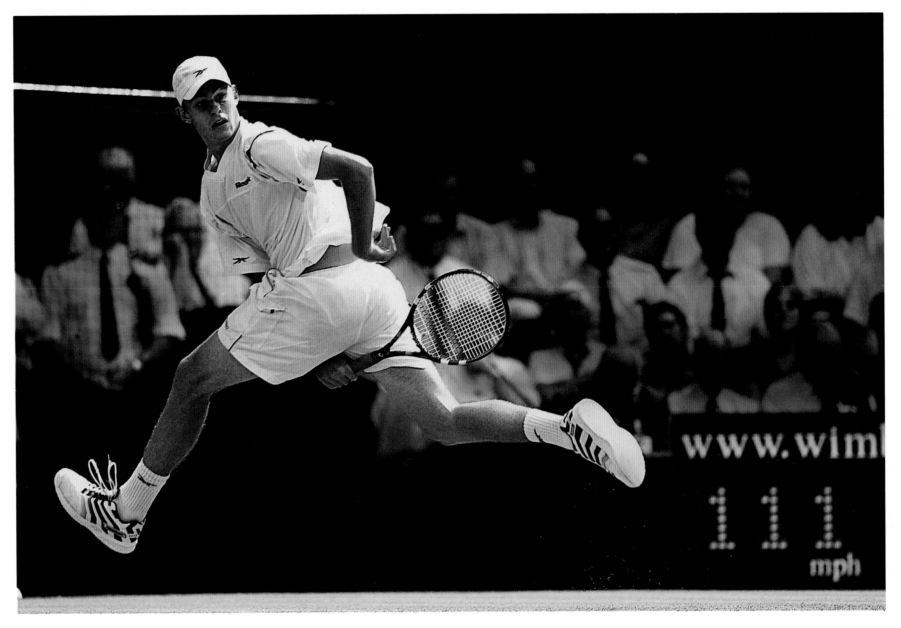

ANDY RODDICK

A great shot that captures the unusual moment when Roddick played a ball from between his legs at Wimbledon in 2003. He managed to get the ball back over the net and continue the rally. I did get a frame where he is actually hitting the ball but this one is better because the racket is higher and he is looking up and back towards the net.

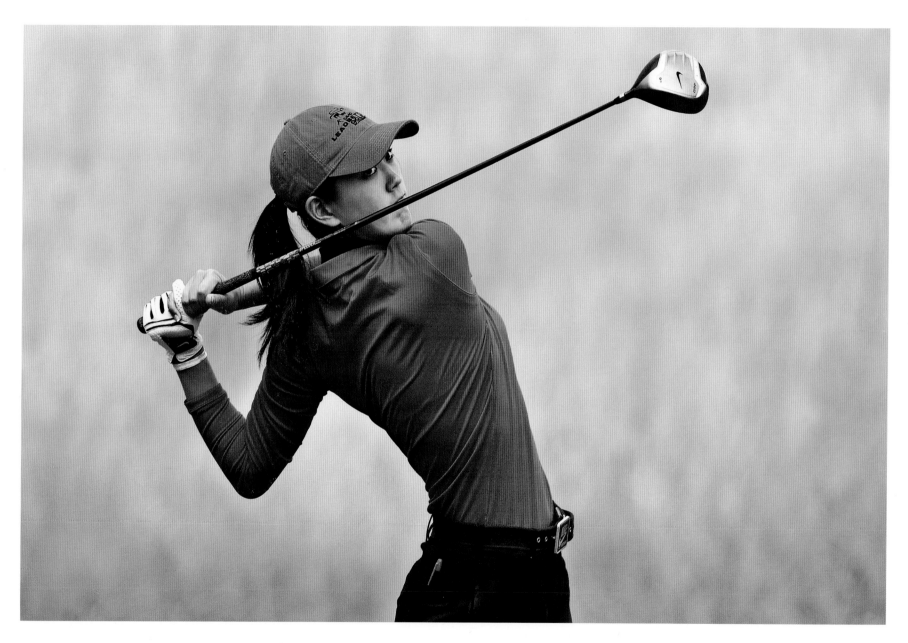

MICHELLE WIE

I was covering the Women's British Open in 2005 when Michelle Wie, who went on to become one of the best female golfers in the world, emerged from the clubhouse in this stunning pink outfit. She just looked sensational and from that moment on I didn't take a single photograph of another golfer all day.

RYAN LOCHTE

This shot from the World Swimming Championships in 2013 shows the huge strength these swimmers have to power themselves through the water, and the reflection in the goggles adds that extra bit of intensity.

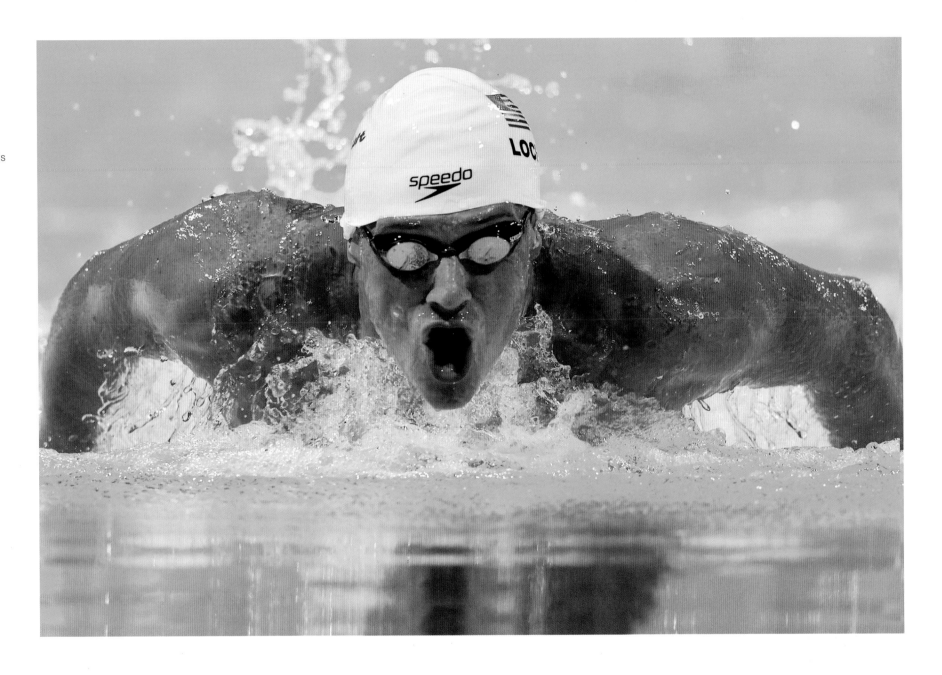

LE TOUQUET ENDURO BEACH RACE

I took this shot safely from behind a huge rock in the middle of a gully at the first bend of this amazing race in France, where hundreds of motorbikes race four miles along the beach. At one point a motorbike drove up the rock and almost jumped past my head. They have since banned the race from going through the sand dunes for environmental reasons so you couldn't get this picture now.

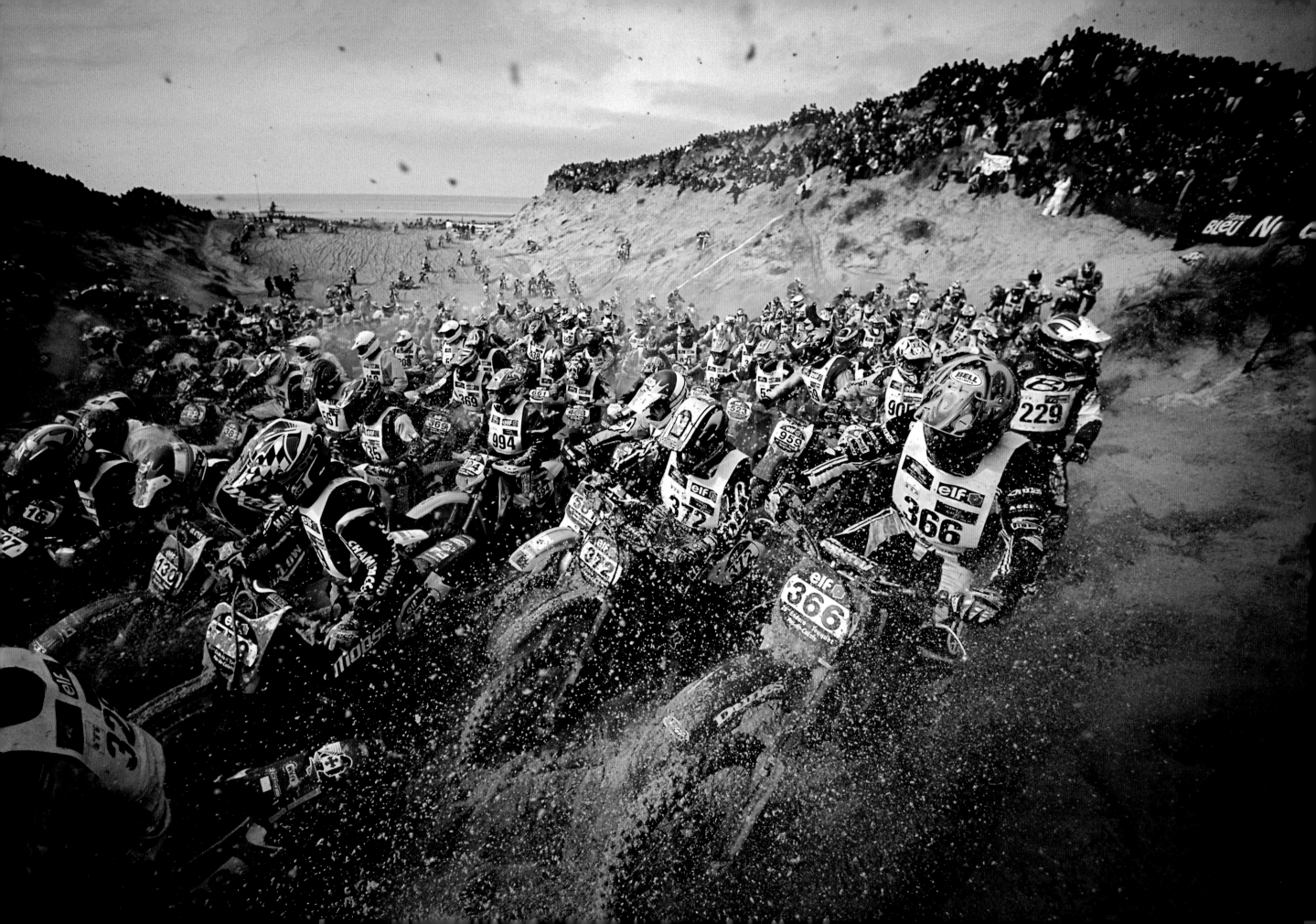

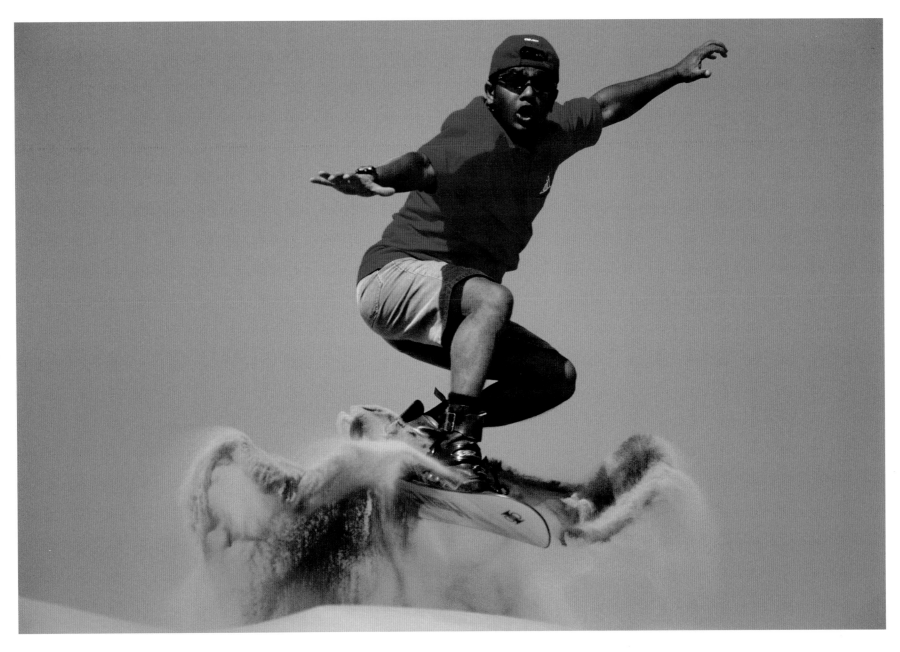

SANDBOARDING, DUBAI

Whilst I was in Dubai for the Desert Classic golf tournament, I heard about these locals who went snowboarding in the sand dunes. So I tracked down this guy and arranged to take some pictures. They picked me up in a 4x4 and took me out into the desert, which was quite an experience as you have to go flat out to make sure you don't sink into the sand.

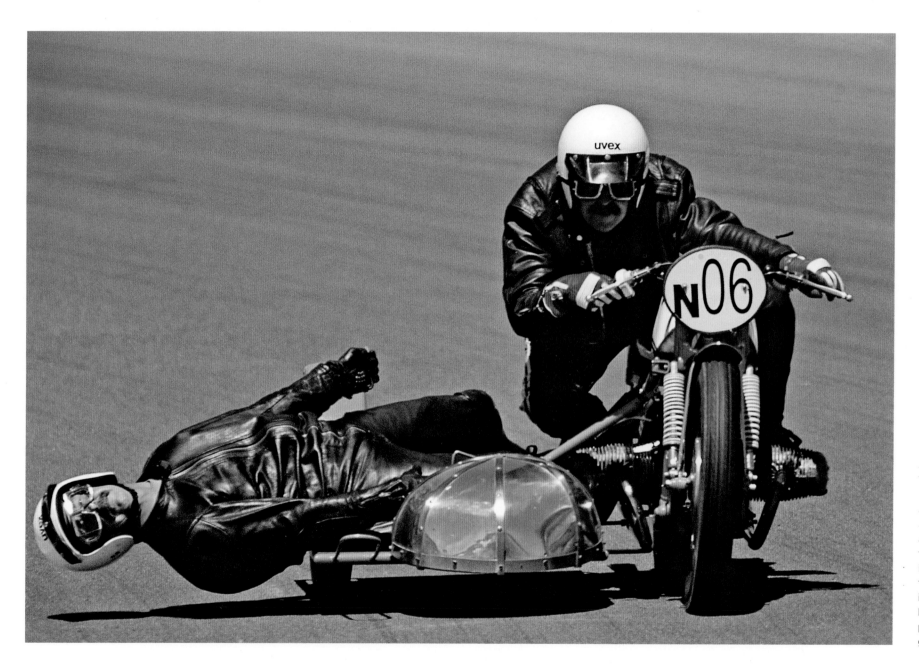

VINTAGE MOTORCYCLE RACING

These two guys on a vintage BMW, with their old leathers and handlebar moustaches, stood out from the crowd at a classic bikes and cars festival at the Nurburgring in Germany. The guy in the sidecar in this picture is not falling out, he's leaning out on purpose to provide balance as they go round the corner.

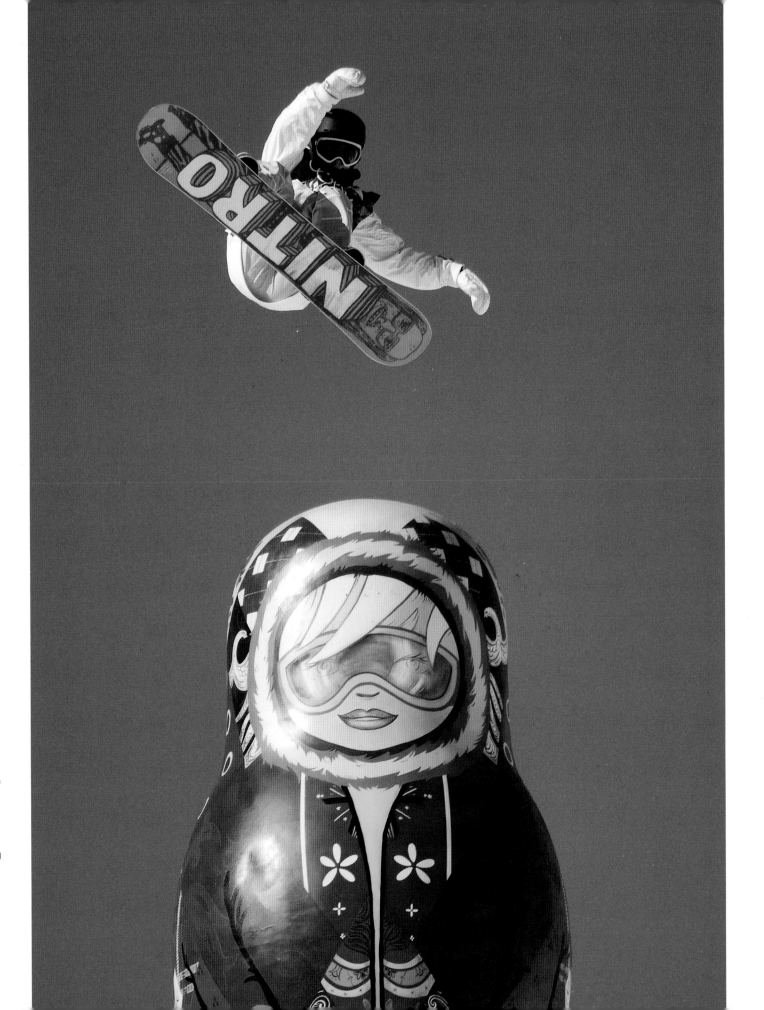

ALEA VALENTA

I'd climbed the hill above the course for the Freestyle World Ski Championships in Meiringen, Switzerland, so that I could get shots of the skiers in the air above the mountains. It was more by luck than judgement that a helicopter came through the valley and into frame at just the right time. It looks like the chopper and the skier are really close but it's an optical illusion caused by the telephoto lens which compresses everything – in reality they are far apart.

SNOWBOARDING, SOCHI

It seemed a bit corny at first, but the idea of placing a huge Russian doll in the middle of the snowboarding 'slopestyle' course, which the riders had to jump over, was a stroke of genius and gives the pictures a sense of place which you usually don't get with skiing and snowboarding as all snowy mountains look the same. I shot it head-on to keep the whole picture graphically simple.

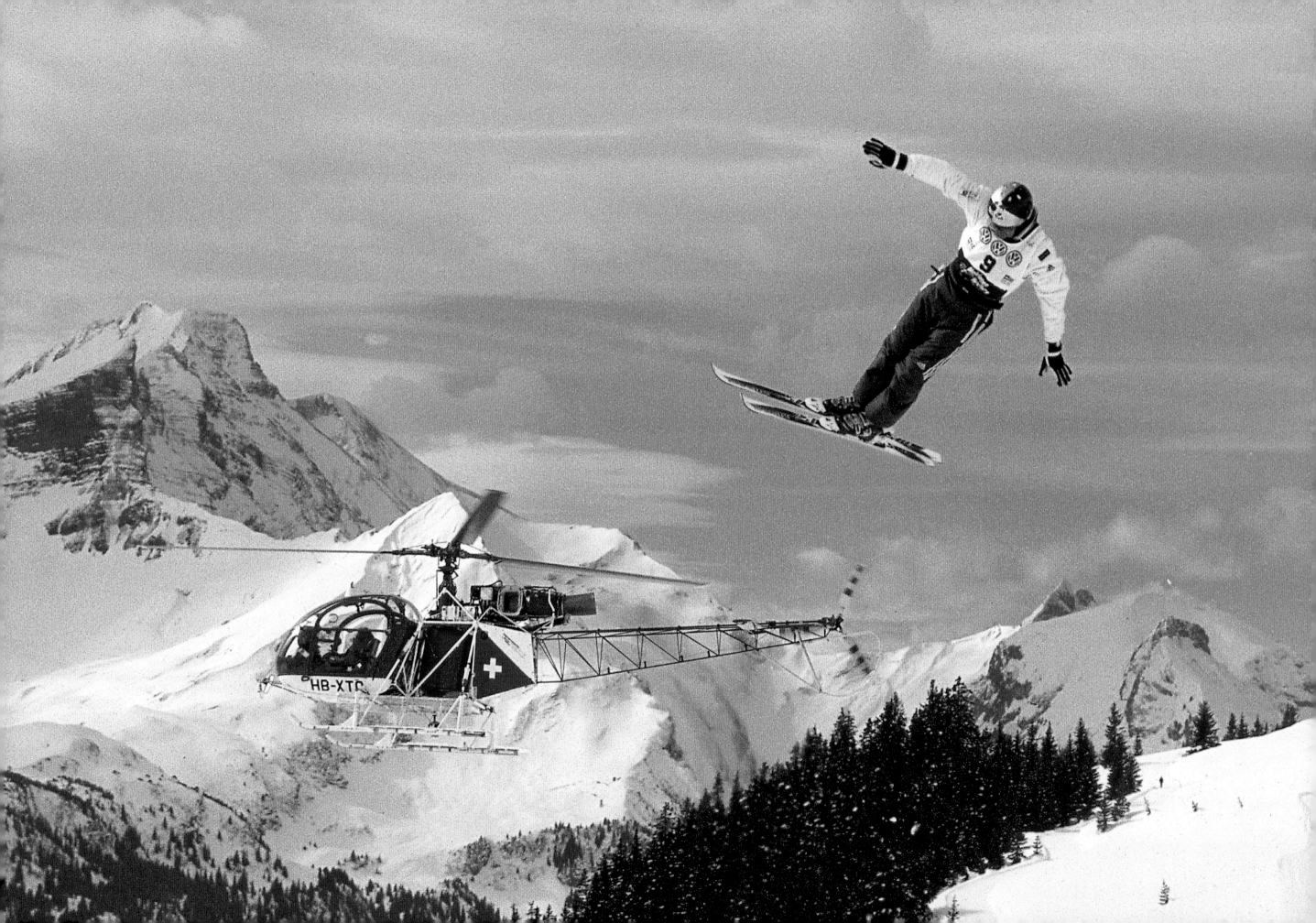

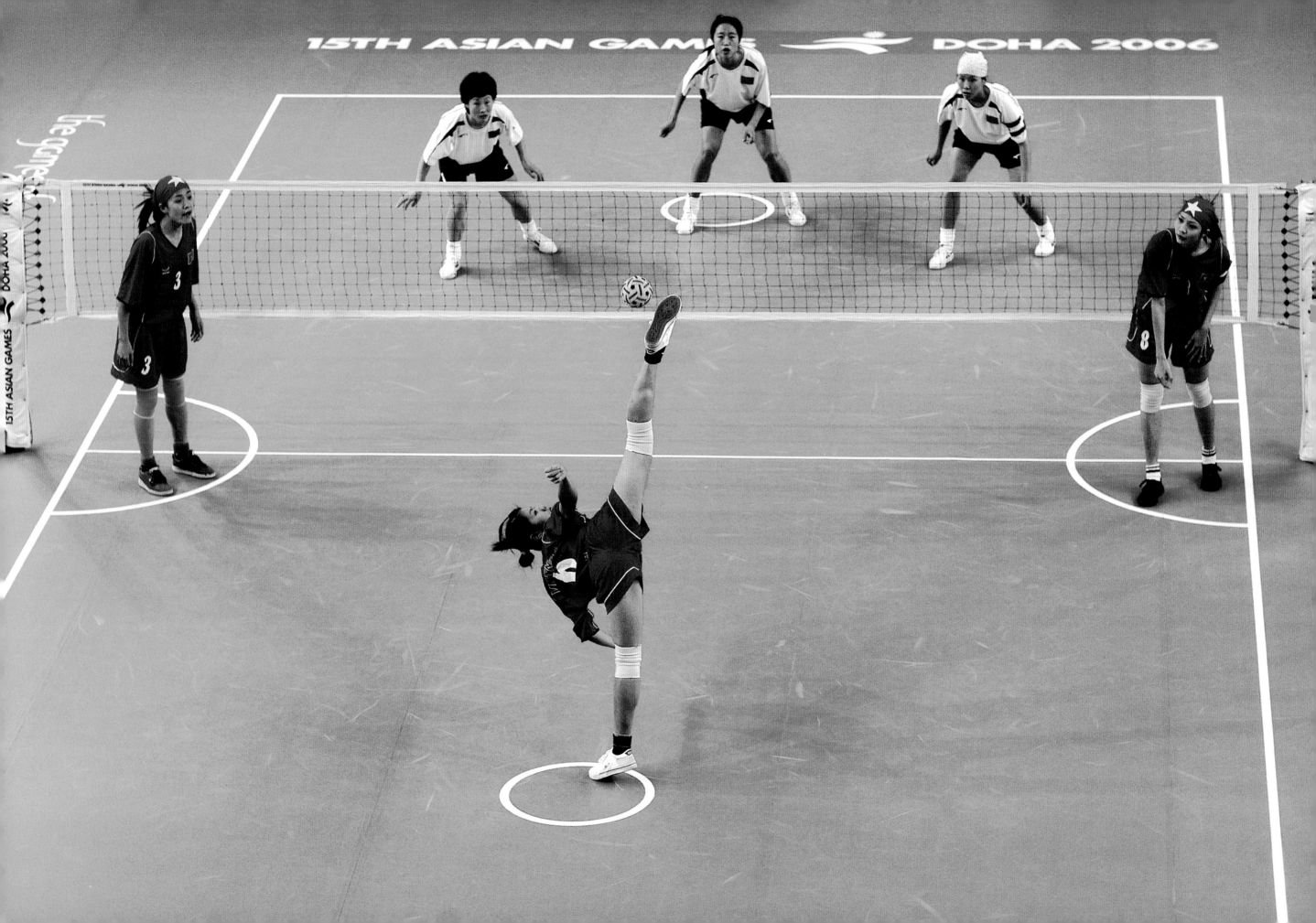

WATFORD v MAN UTD

This is just a great football picture. I was at the game to cover Watford's American player, Jay DeMerit, but he was off the pitch at this time so I just kept shooting for the hell of it and ended up with one of my best football pics ever.

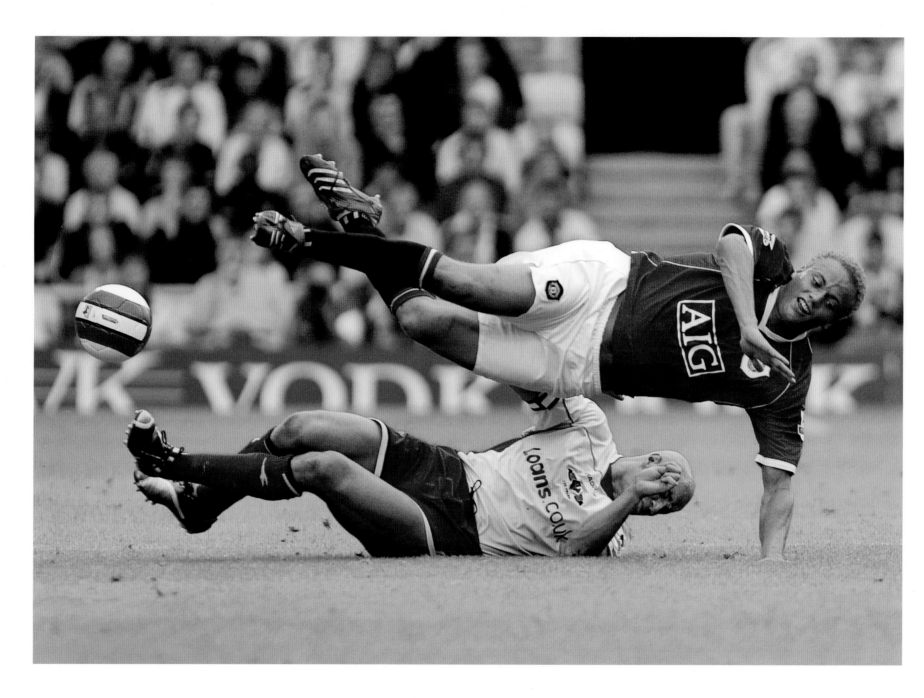

KICK VOLLEYBALL

This is a game of *sepak takraw*, or kick volleyball, between Vietnam and China at the 2006 Asian Games in Doha. It's one of the most spectacular sports I have ever seen. This one Vietnamese girl was so tall and it looked amazing when she served, and I also really love the Vietnamese headbands.

OLYMPIC ROAD CYCLING, ATHENS

I scoured the entire course of the road cycling race to find somewhere that had a background that was obviously Athens. Eventually I found this bend with the Pantheon on the hill behind, and negotiated with the local organisers to remove an advertising hoarding so that I could lie down on the edge of the road. They were great, and even provided me with a foam mat to lie on.

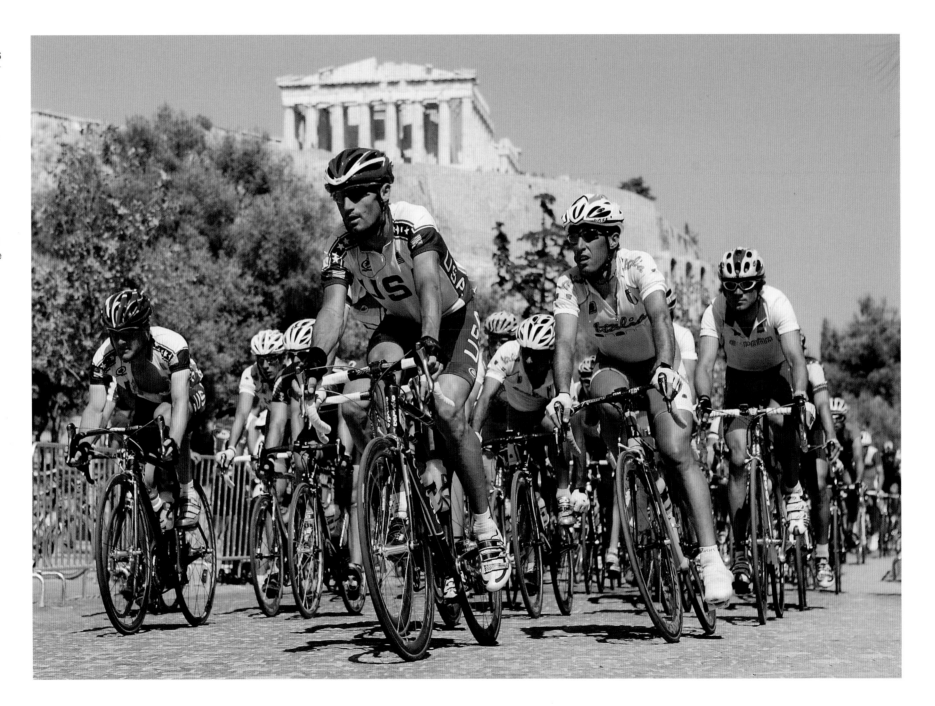

BRITISH OPEN, ST ANDREWS

Although this shot is of the South African golfer Louis Oosthuizen, the real stars of the show are the famous old course and the crowd. I took it using 'polecam', a five metre-long carbon fibre pole on which I attach the camera, using a monitor – these days it's an iPad – linked to the viewfinder. It gives me a unique perspective and I think I am the only sports photographer to use this technique.

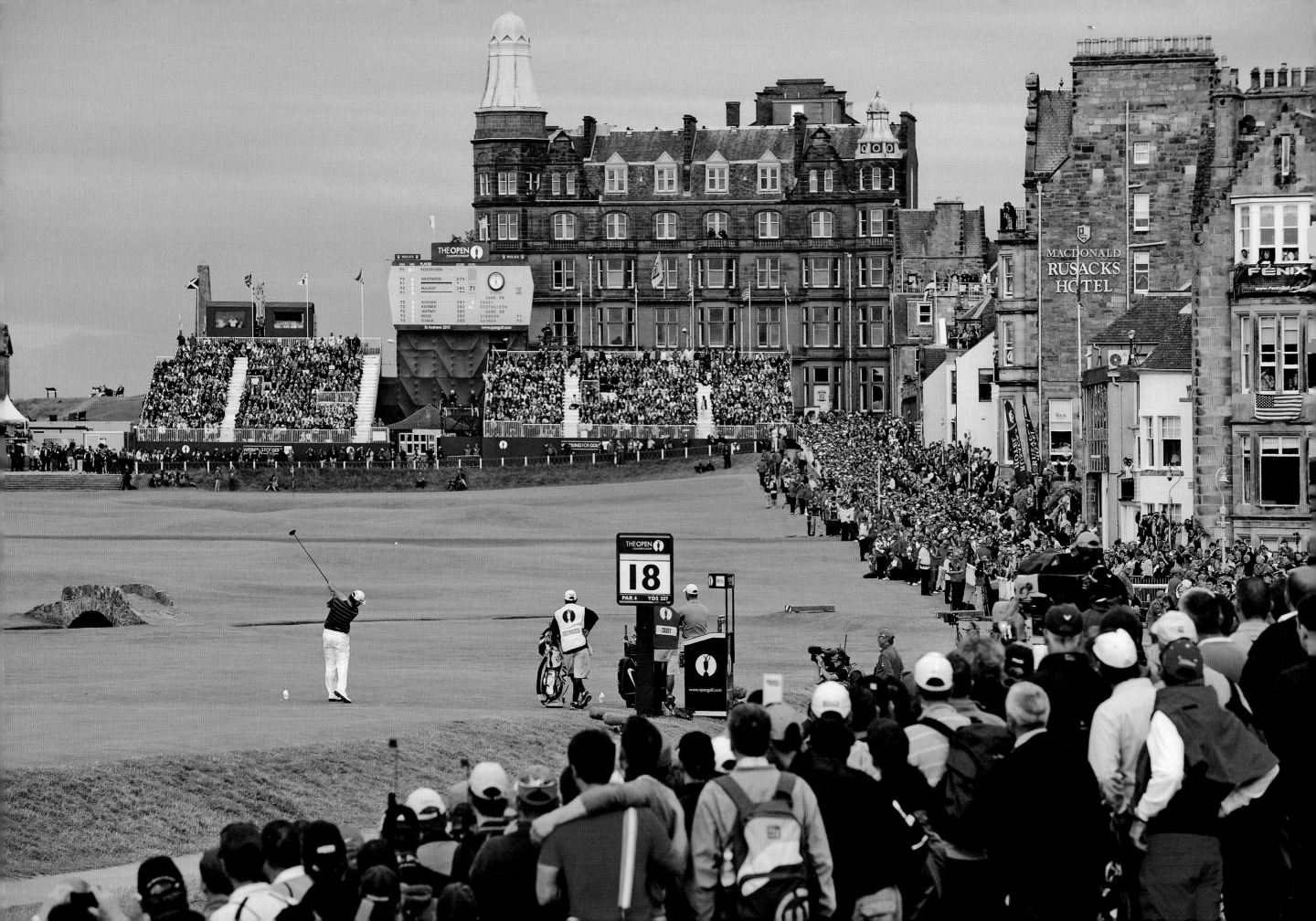

THE CONSUMMATE MAGICIAN

BY ROBERT PHILIP

A s well as being a consummate magician with a camera in his hands, Bob Martin is also something of a master illusionist blessed with the uncanny ability to materialise as if from nowhere in the most unexpected of places.

Return with me, if you will, to 1995 as I drive northeast from Milan through torrential rain, violent thunder crashes and a spectacular lightning display to pitch up over an hour late at Bergamo Golf Club, nestling in the foothills of the Alps. Awaiting me is Italian golfer Costantino Rocca, who has recently lost the Open Championship to John Daly in a play-off at St Andrews and who will subsequently amass three vital points from his five matches in Europe's heart-stopping 14½–13½ triumph over the United States in the 31st Ryder Cup contest at Oak Hill Country Club in Rochester, New York.

Signore Rocca, as I swiftly discover, does not give interviews, he hosts lunch parties under a gazebo on the clubhouse terrace in the convivial company of a few old friends who cheerfully squeeze up to make room for this new arrival at their table. "Hey, relax. You are in Italy, *si*? Have some *prosciutto e melone*. A glass of *Amarone*, perhaps?"

Out of the corner of my eye (I told you he could appear from nowhere) I espy a familiar figure emerging from the bar carrying a tray of drinks. "Hello, Rob. Costantino told me you would show up at some point today." Not only has Bob beaten me to the punch by arriving in Bergamo several days previously to begin working on a photographic

spread for *Sports Illustrated*, he is already firmly established as a member of the Rocca family.

So much so that when he splits his trousers while bending down to find the perfect angle for his latest shot, Mama Rocca is summonsed from home with her sewing basket, positively simpering in her desire to tend to 'Roberto's' every need. I swear the great lady curtsies when she blushingly returns the restored corduroys into Bob's keeping.

Thereafter, Bob and I continued to meet in all the old, familiar places: Roland Garros and Wimbledon... St Andrews and Muirfield... Longchamp and Epsom... Summer Olympics and Winter Games... athletics meetings and world title fights... World Cup football and World Cup rugby.

Wherever and whenever we are thrust together, it is always a delight to come across his beaming smile; for on top of being one of the finest photographers on the planet, once the assignment for the day is finished, Bob can be relied upon to party every bit as hard as he works. And, boy, does he work hard. Aye, you can always depend upon Bob knowing about a superb out-of-the-way restaurant or a wonderfully atmospheric bar that the rest of the hack pack have yet to discover. At the end of a long day at the journalistic coalface, there is no finer companion with whom to wind down than Bob.

That is why I was both delighted and surprised to find a message waiting for me when I checked into my Athens hotel a few days before the 2004

Right: All the pictures over the course of the next few pages are from Athens. This is Jessica Long, the US Paralympic swimmer who was just 12 years old at the time. She was only 18 months old when her legs were amputated and she learned to swim in her grandparents' pool. "I used to pretend I was a mermaid," she once said. Long won three gold medals in Athens and in 2015 held world records in ten events.

continues on page 95

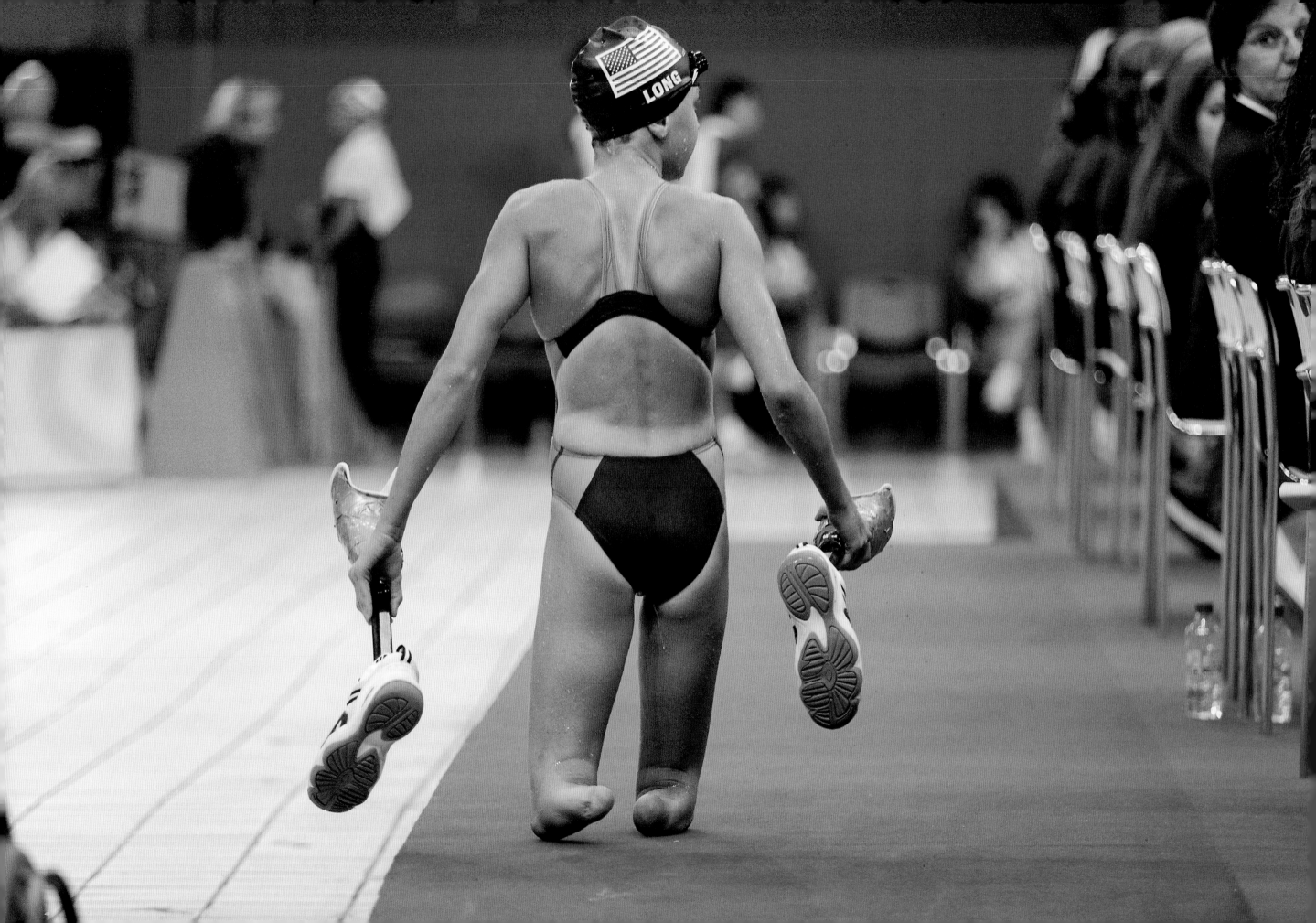

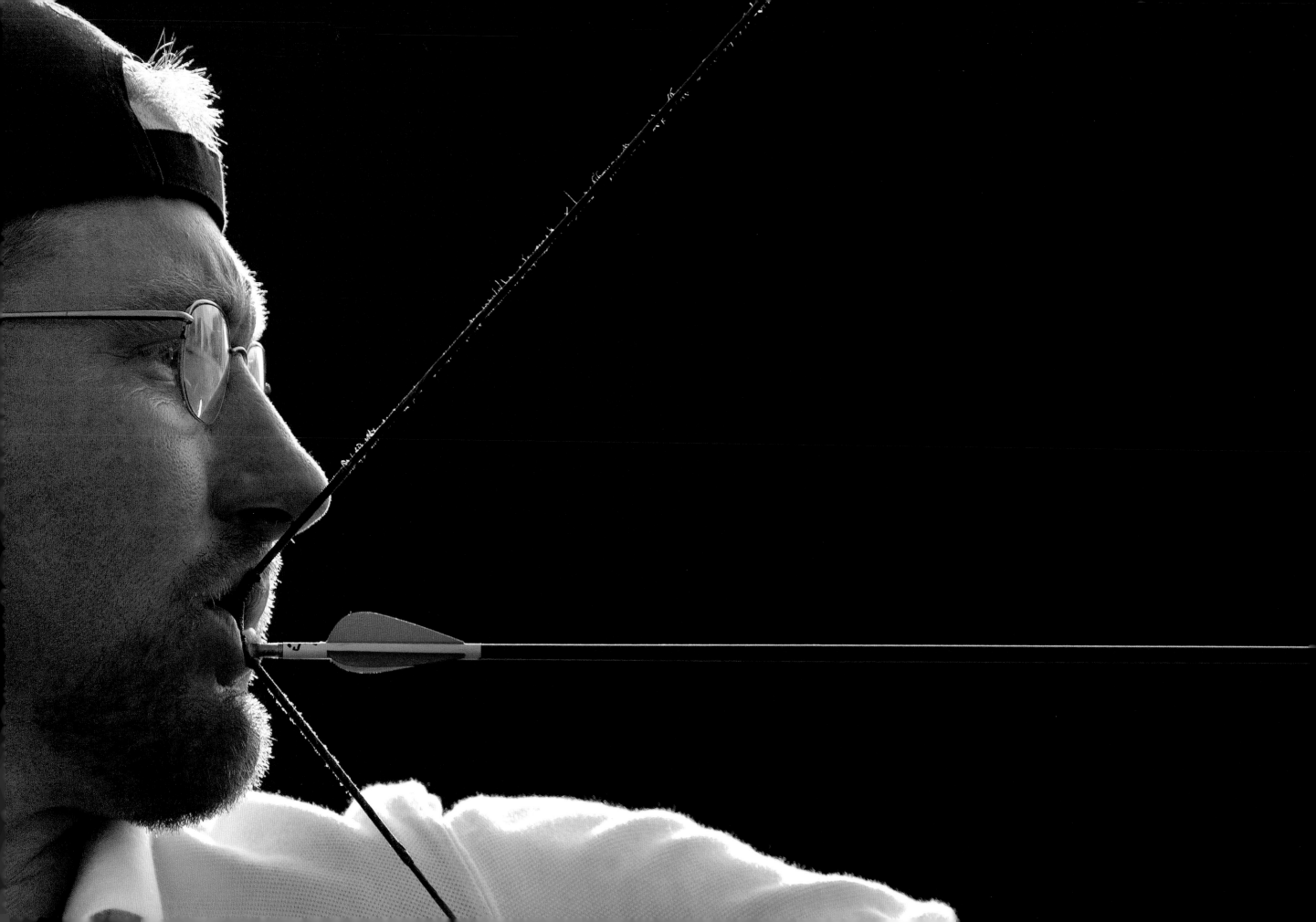

Paralympics commanding my presence that evening at *Taverna Platanos* where they have been serving *retsina* and *moussaka* under a massive plane tree situated on a back street off a back street in the Plaka neighbourhood since 1932; delighted for all the above reasons but surprised because apart from my own newspaper at the time (the *Daily Telegraph*) most other publications treated the Paralympics as little more than a curiosity tagged on at the end of each succeeding Olympic Games.

Unlike the majority of his colleagues, Bob was quick to appreciate that here was an event brimming with photographic opportunities, an event that had come a long, long way; at the inaugural Paralympic Games in Rome in 1960, local hospital nurses acted as referees, doctors handed out the medals (which were awarded to each and every competitor lest anyone should be made to feel like a loser), hoopla was one of the featured sports and the athletes received a special blessing from Pope John XXIII at the Vatican. China was among a number of countries that did not send a team for the simple reason, so they claimed, that its massive population did not include any disabled citizens.

The Paralympics of 2004 were destined to become one of the biggest sports events on earth, due in no small part to the emergence of a host of global superstars; athletes such as Oscar Pistorius,

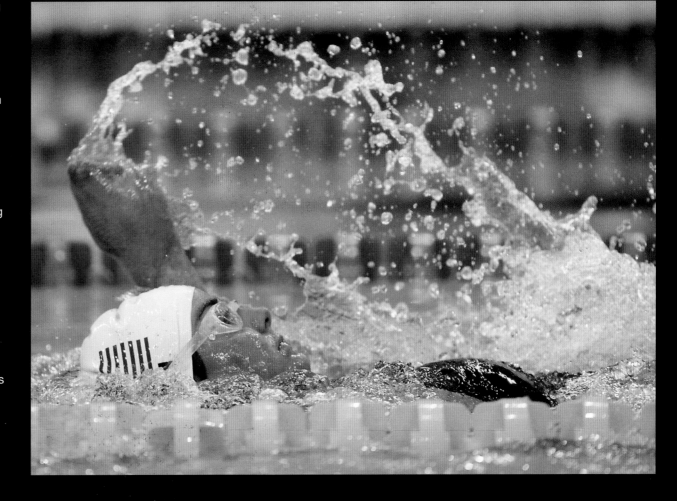

Left: Paralympic archer Jeff Fabry lost an arm and a leg in a motorcycle accident when he was 15.

Left: For me, this incredibly powerful picture sums up the spirit of the Paralympics.

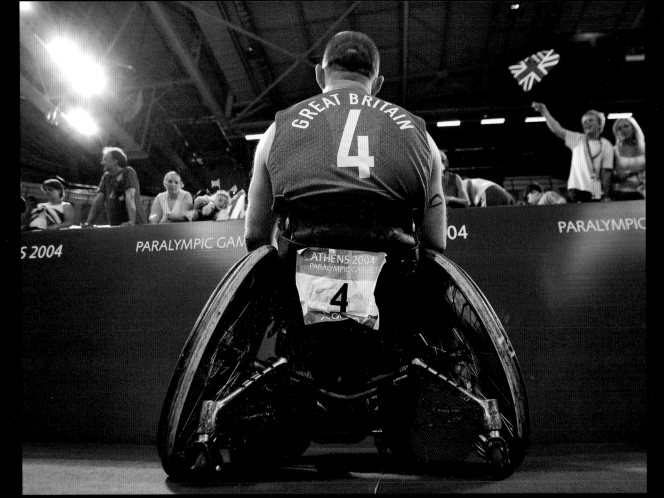

who won five swimming gold medals in the Athens pool after making history by qualifying for the final of the 800 metres freestyle event at the 2002 Commonwealth Games in Manchester... and Hou Bin, the single amputee 'Leg-End' from Shanghai who would have won every Olympic high jump gold medal from 1896–1908.

As Dame Tanni Grey-Thompson, who won her 10th and 11th Paralympic golds in Athens, put it: "The Rome organisers were probably acting with the best of intentions but I hated all that 'oh bless' stuff. It is always refreshing when you meet a reporter or photographer who doesn't treat you with kid gloves. A few Paralympians win gold medals, most don't. Hey, that's life."

Not once did Bob Martin exhibit a shred of that 'oh bless' attitude; as his stunning series of photographs show, he saw the Paralympians as athletes with an impairment, not impaired athletes – and there is a world of difference between the two images. When you study his selection from Athens, you see them first and foremost as athletic photographs. It is usually only at second glance that you notice the athlete concerned might be missing a limb or two.

But that is exactly what you expect of Bob; a wonderful photographer but an even more wonderful person and friend...

Robert Philip is a former Chief Sports Columnist on the *Daily Telegraph*

Left: I was touched when the Great Britain wheelchair rugby player, Tony Stackhouse, made his way over to the crowd after a match – he was in tears as his family waved to him.

Below left: I think this picture is powerful because of the contrast between the athlete's incredible arms and the spindly wheels of the wheelchair.

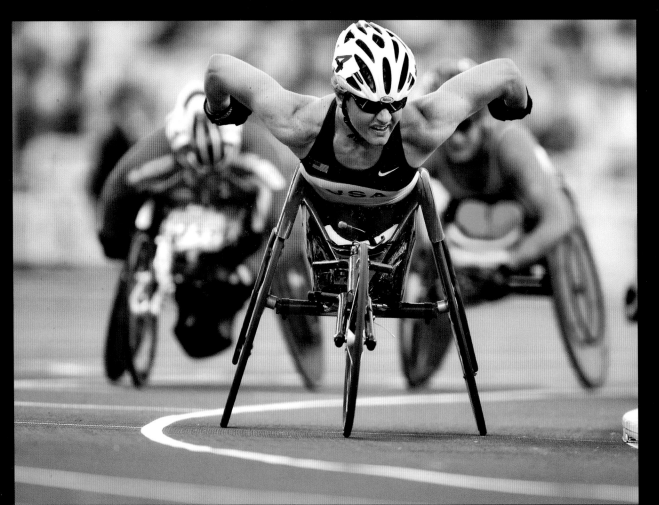

Right: The thing I love about this shot of Victor Marquez of Venezuela powering round the velodrome is that you don't realise it's from the Paralympics – first and foremost it's just a great action picture.

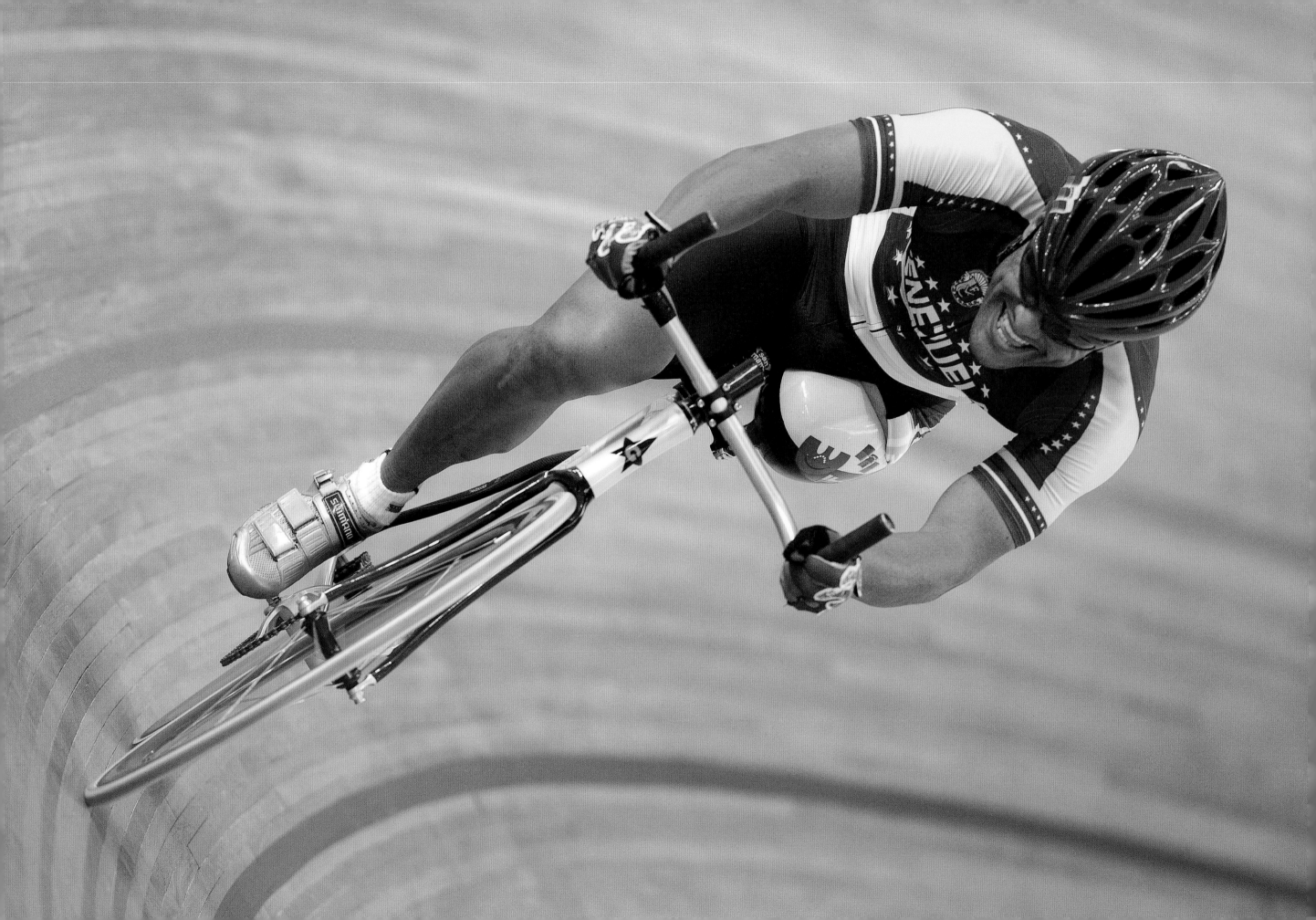

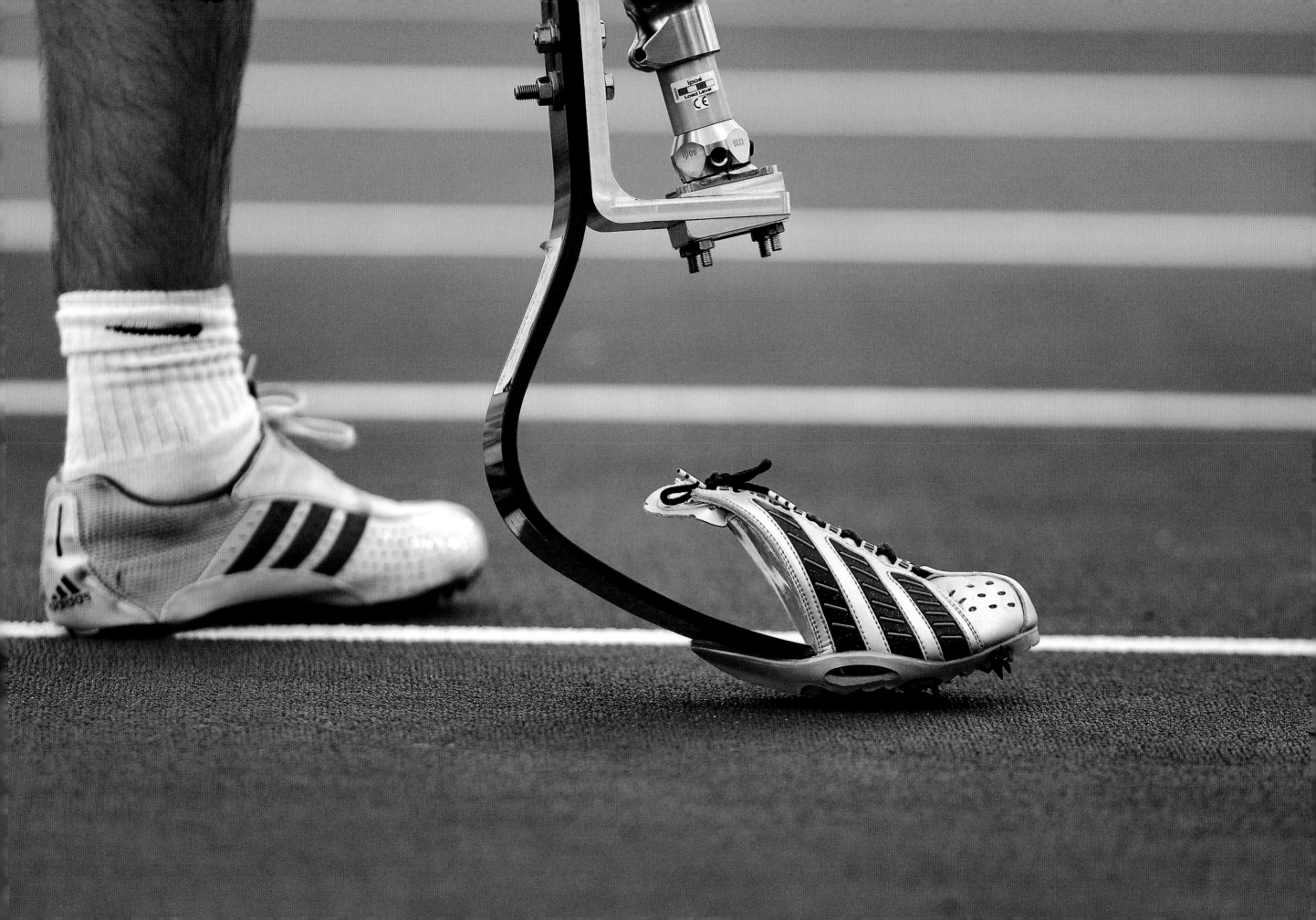

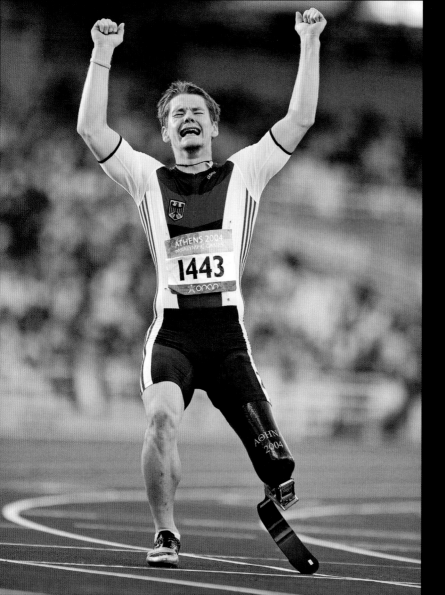

Left: Wojtek Czyz of
Germany celebrates
his victory in the
200 metres final.

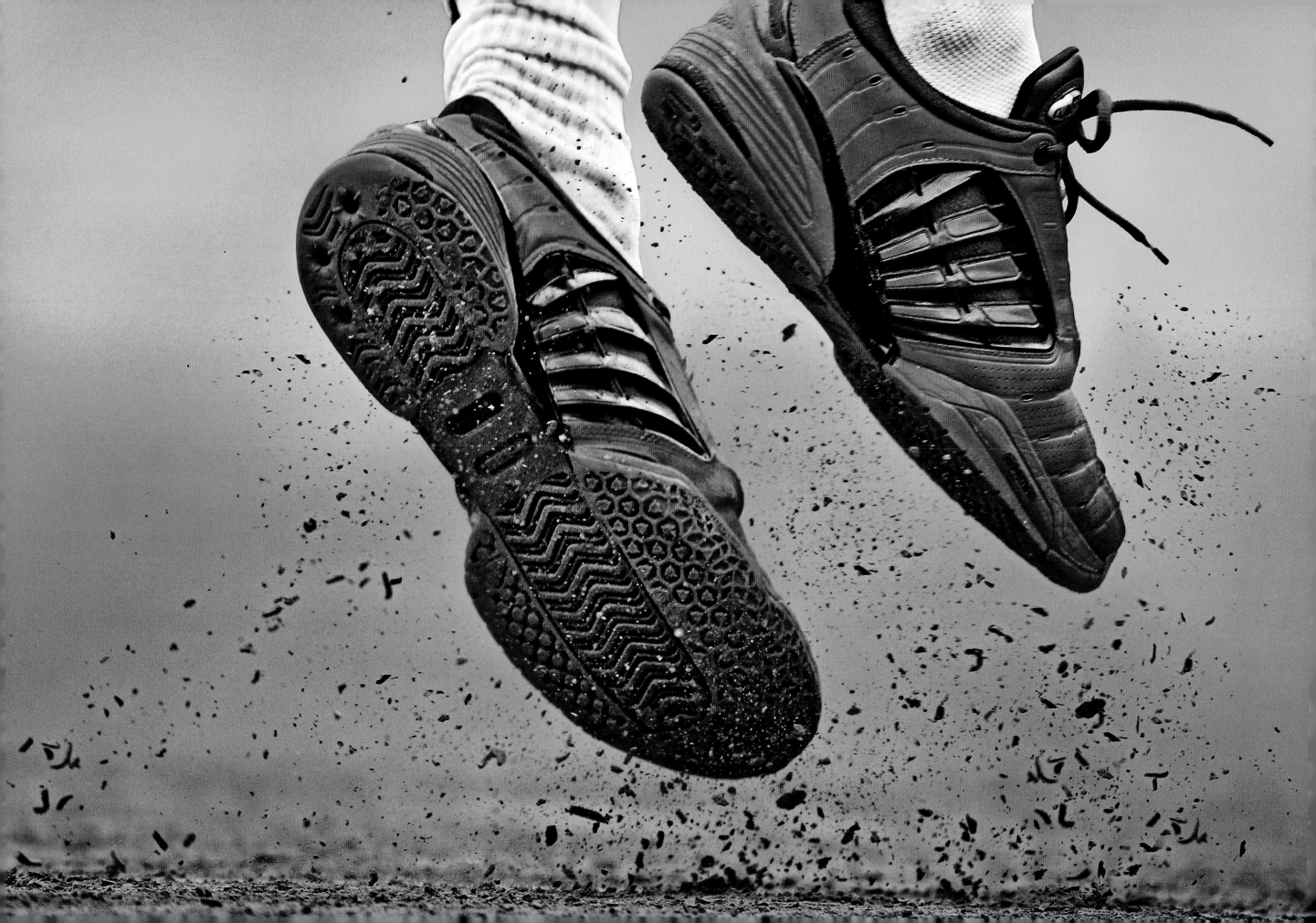

03

GRASS & CLAY

GUILLERMO CORIA

As soon as I saw Coria's red shoes I knew they would look great against the clay at the 2004 French Open. I used a long telephoto lens from the pit at ground level and shot the picture just as he served.

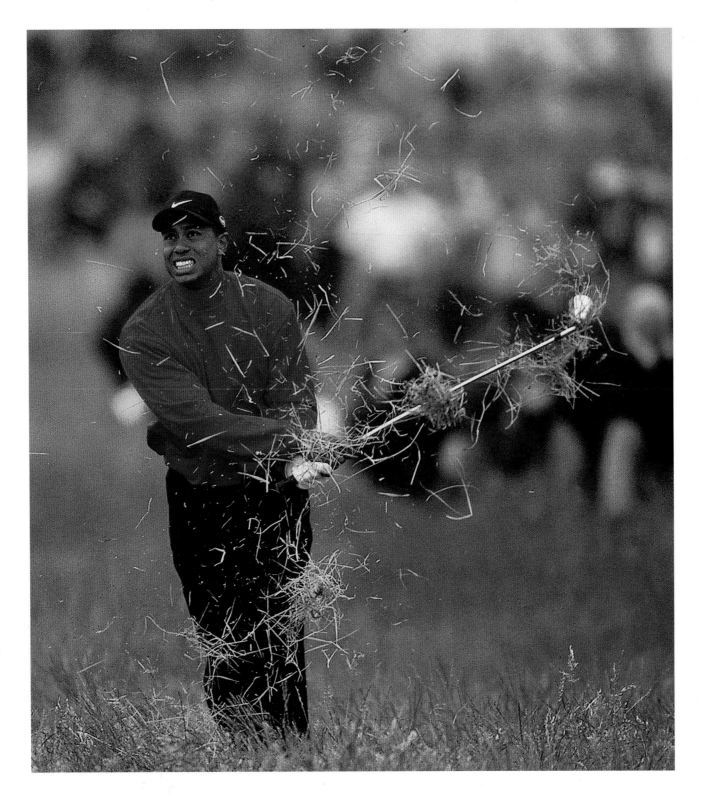

TIGER WOODS

In 1999 the British Open was held at Carnoustie but the course was too difficult for many of the golfers, so to capture Tiger Woods – the man of the moment – struggling to get out of the rough was the perfect illustration of the event. I had realised that many of the players were hitting into the rough at this hole so I set up and waited here and was lucky enough to get Tiger. In those days you never saw his face like this, and I don't think I've ever seen a picture of Tiger with so much grass in the air.

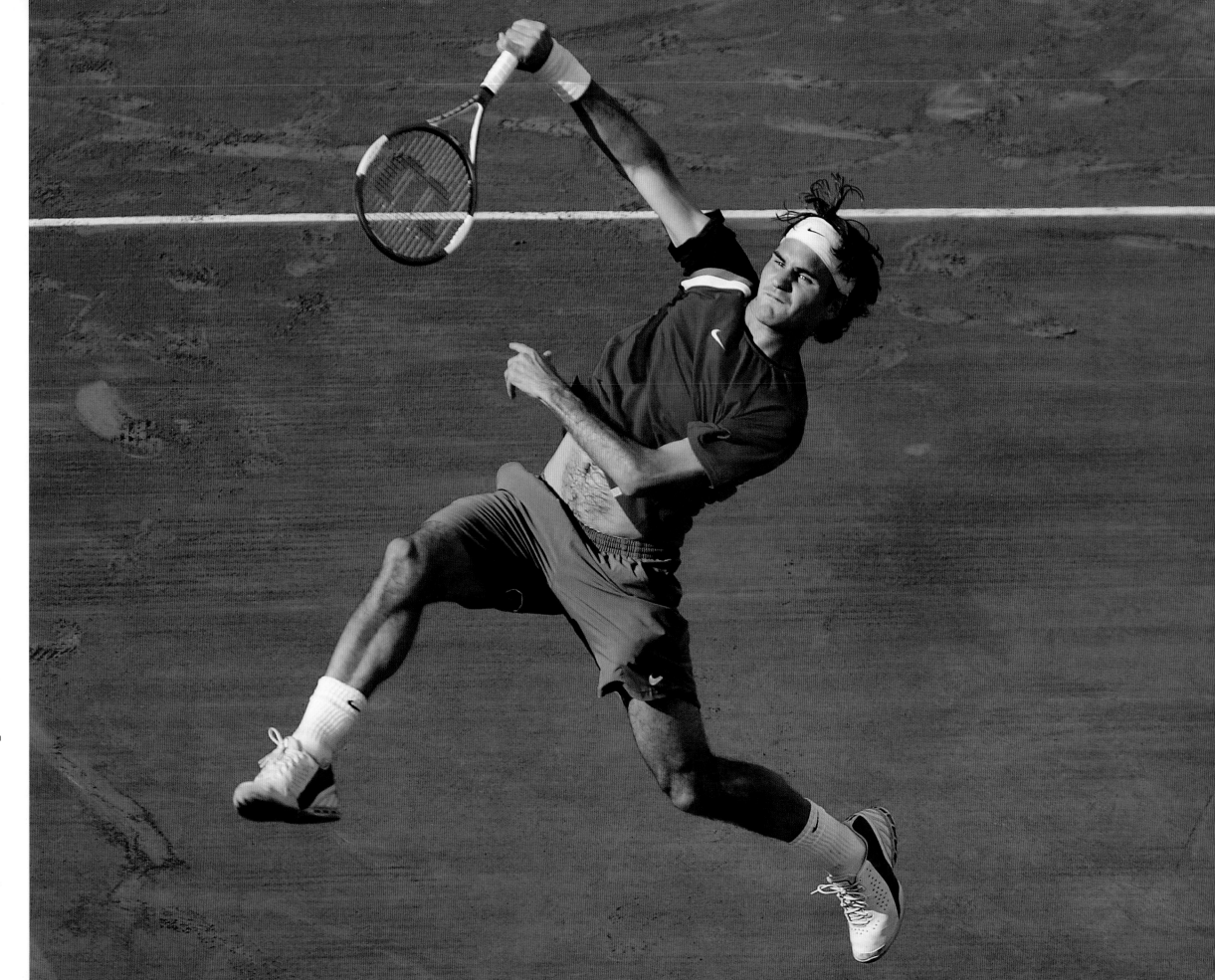

ROGER FEDERER

Even when he is diving around or stretching to reach the ball, Roger Federer always looks so graceful. Even in full flow his face is never contorted and he always looks in complete control. Add to that the fact that clay is just about my favourite background for any picture, anywhere, and you've got all the ingredients for a half-decent shot.

Previous pages:

SERENA WILLIAMS

At the 2007 French Open, during a change of ends, I was trying to get a headshot of Serena using a very long lens when she bent over to tie her shoelace and I saw the sweat on her back glisten and honed in. I'm always trying to capture this kind of detail and I love how only the beads of sweat are sharply in focus.

RAFA NADAL

Also at the French Open, Rafa replaced his headband and gave me the perfect opportunity for an impromptu portrait.

COLIN MONTGOMERIE

I was wandering around the US Open, desperately looking for a different picture. Monty was in contention but he was struggling so I shot him through the scaffolding beneath one of the temporary grandstands. It almost looks as if he is in jail, behind bars.

ROGER FEDERER

When the previous year's champion plays the first game on Centre Court at Wimbledon the grass is, of course, immaculate. This is Roger Federer's first serve of the 2008 Championships, shot from a high position to capture the perfection of the grass and his shadow.

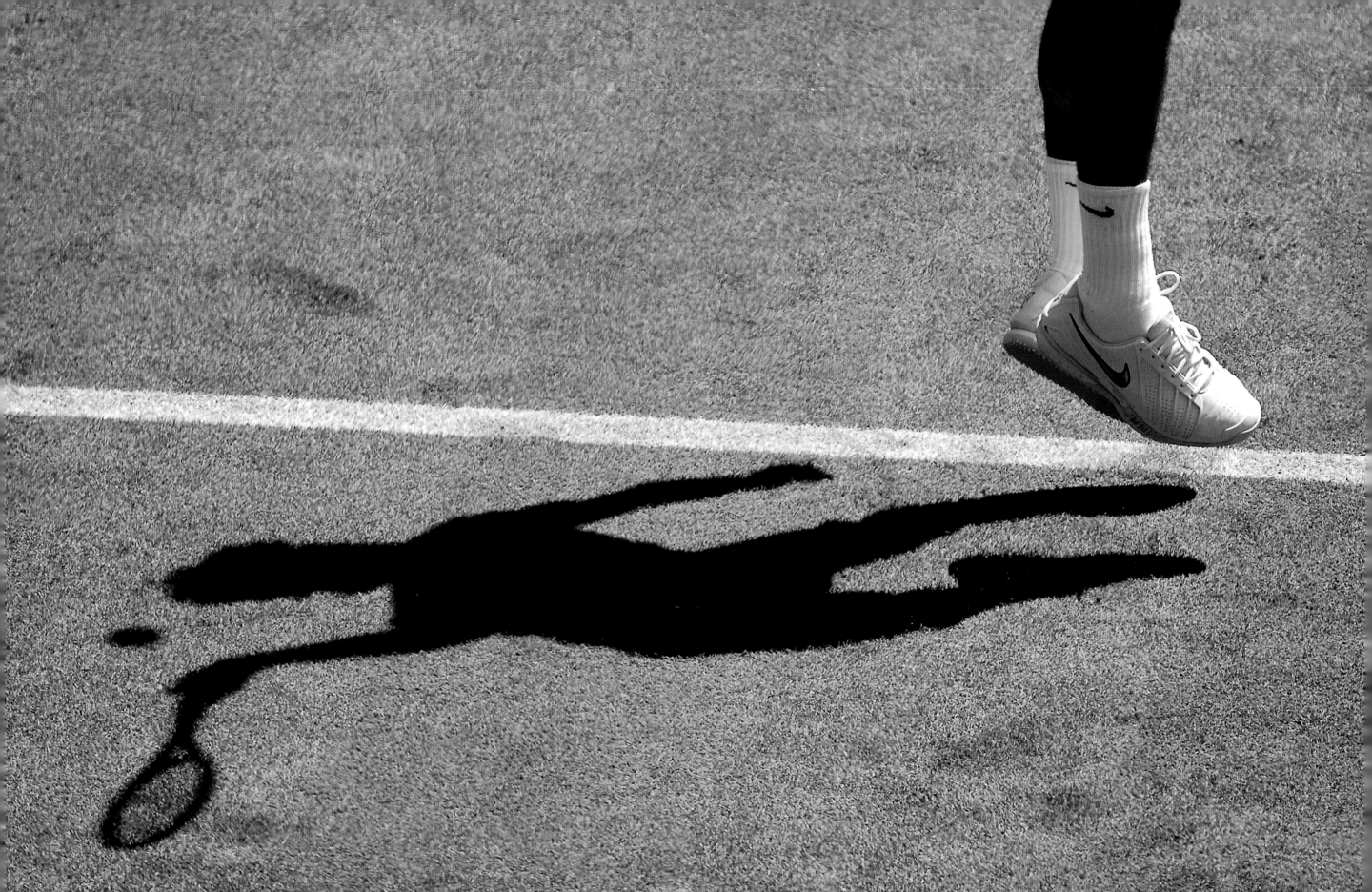

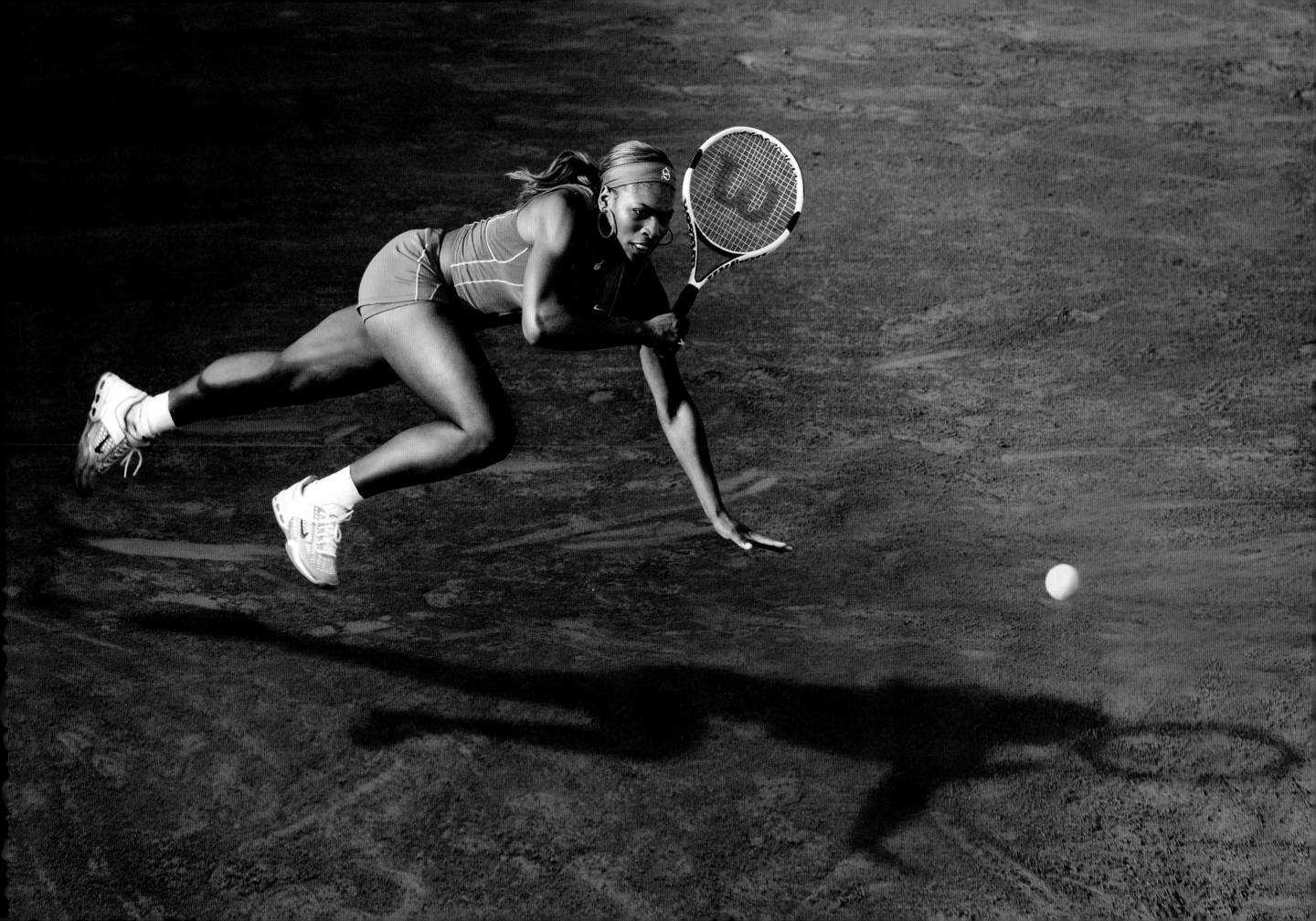

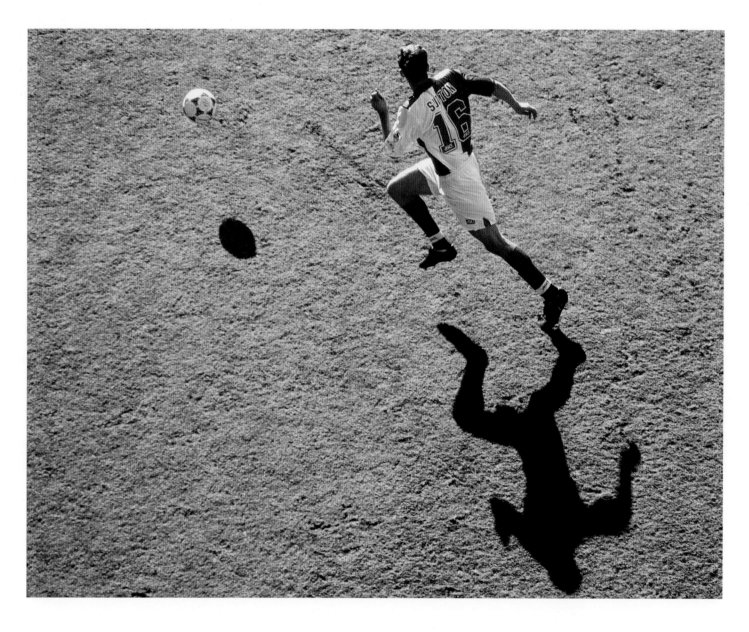

CHRIS SUTTON

I took this shot from the television gantry at Anfield on the day that Blackburn won the Premier League in 1995. I had special permission to shoot from there but it wasn't long before the health and safety brigade kicked me off. It's very unusual to see a football picture taken from overhead like this and obviously the shadows make it. It's a while ago now but it's a picture I still love.

SERENA WILLIAMS

The French Open has amazing positions for photographers and this shot was taken from one near where the television commentators are stationed. The clay looks simply wonderful.

BORIS BECKER

This picture was the start of me becoming well known as an international photographer after *Stern* magazine used it across two pages in 1989. I had scooped all the German photographers at Wimbledon by trying to get something a bit different. It's always nice to get one over the Germans!

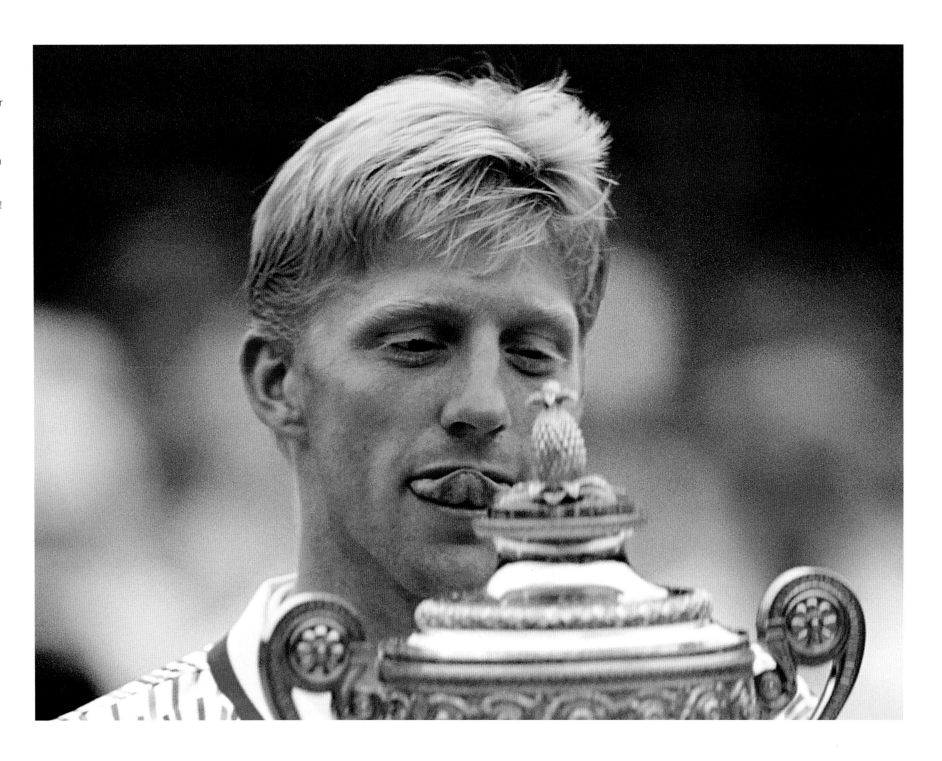

DUBAI DESERT CLASSIC

In Dubai for one of the first Desert Classic golf events in 1995, we went up in a helicopter to take some shots of this amazing golf course in the middle of the desert. Apparently it takes a million gallons of water a day to keep it green. You wouldn't be able to take this picture today because the course is now completely surrounded by skyscrapers.

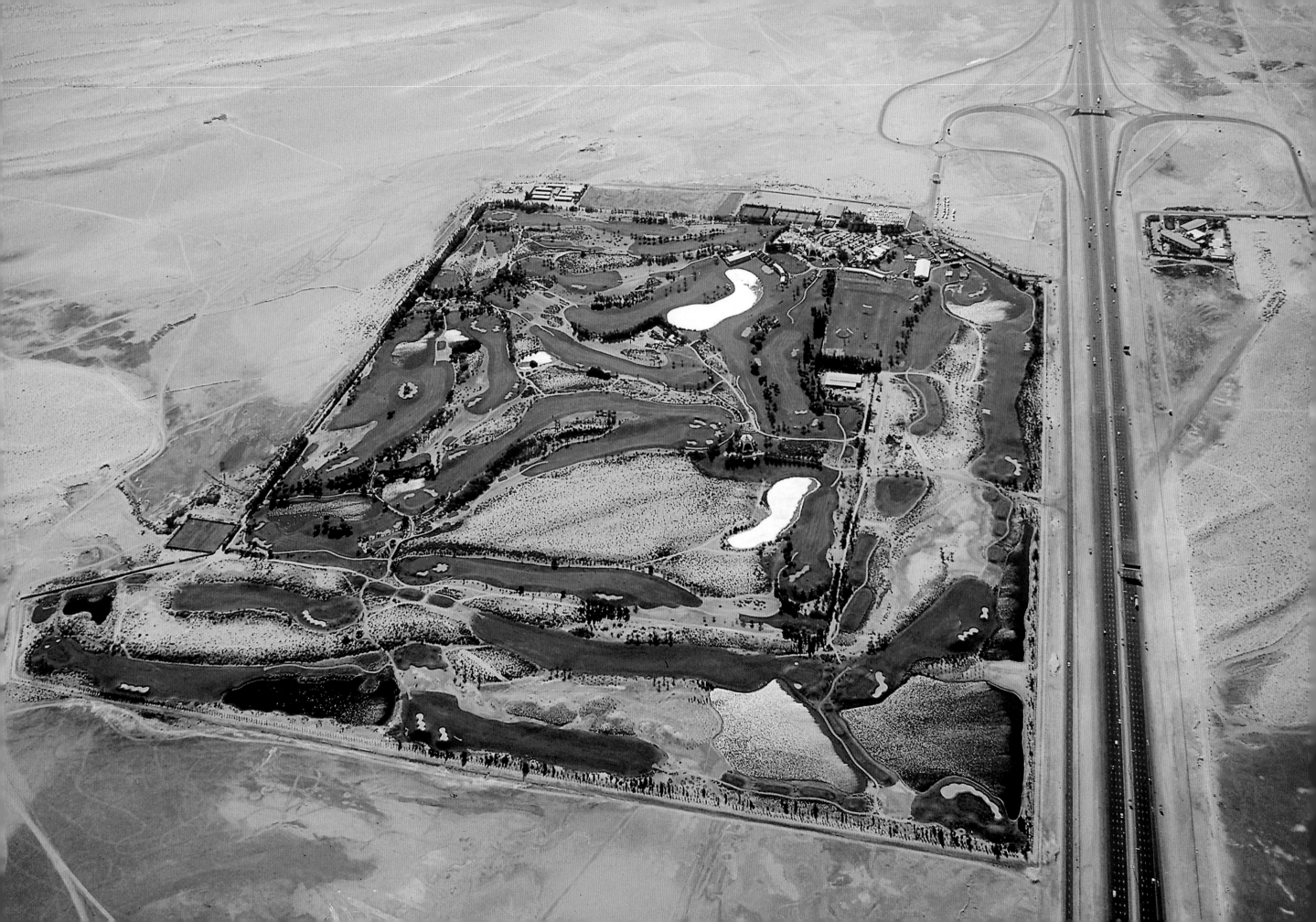

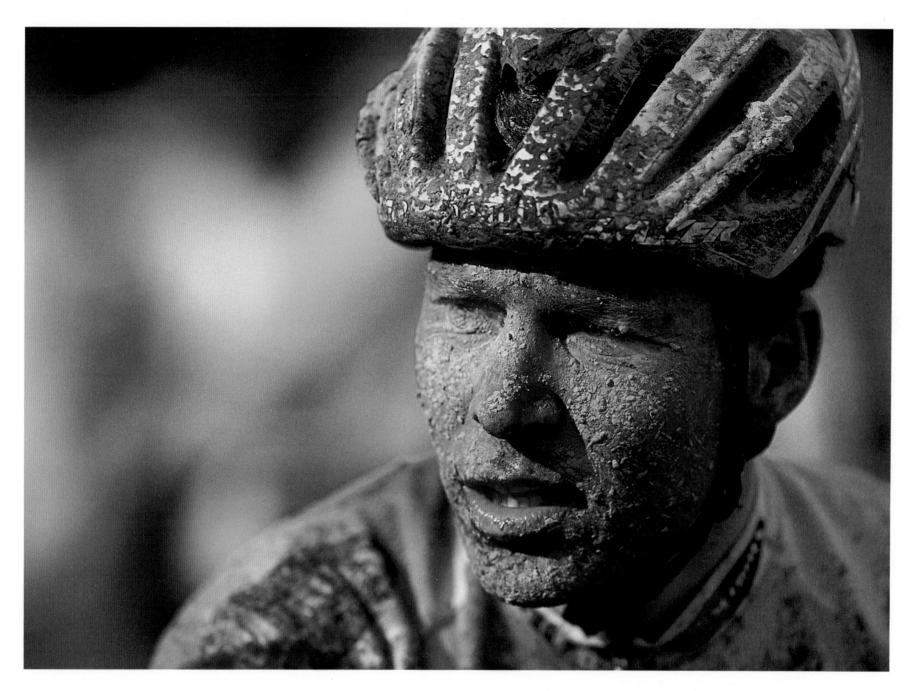

MAX VAN HEESWIJK

Covering the Paris–Roubaix cycle race from the back of a motorbike was the most harrowing experience of my life. We almost crashed twice when the bike slipped on the cobblestones and I could hardly walk at the end of the race. To cap it all I got my best picture when I was walking through the finish area at the end. If this is how the riders ended up, you can imagine what I looked like!

ALEXI LALAS

Lalas had just become the first American 'soccer' player to sign for a Serie A club, so I shot him at various Italian locations like in a gondola in Venice. For this one he was actually walking back from where he had originally been posing but then I saw him, with his hippy-style long hair and beard in amongst all these bushes and flowers, and realised it would make a better picture.

DAVID DUVAL

I was following David Duval – at the time the best player in the world – but it had been a long day and I'd struggled to get a picture. This was one of the final fairways with a great background of these huge trees in the lovely late afternoon light, but it's the backlit sand and huge divot which makes the shot.

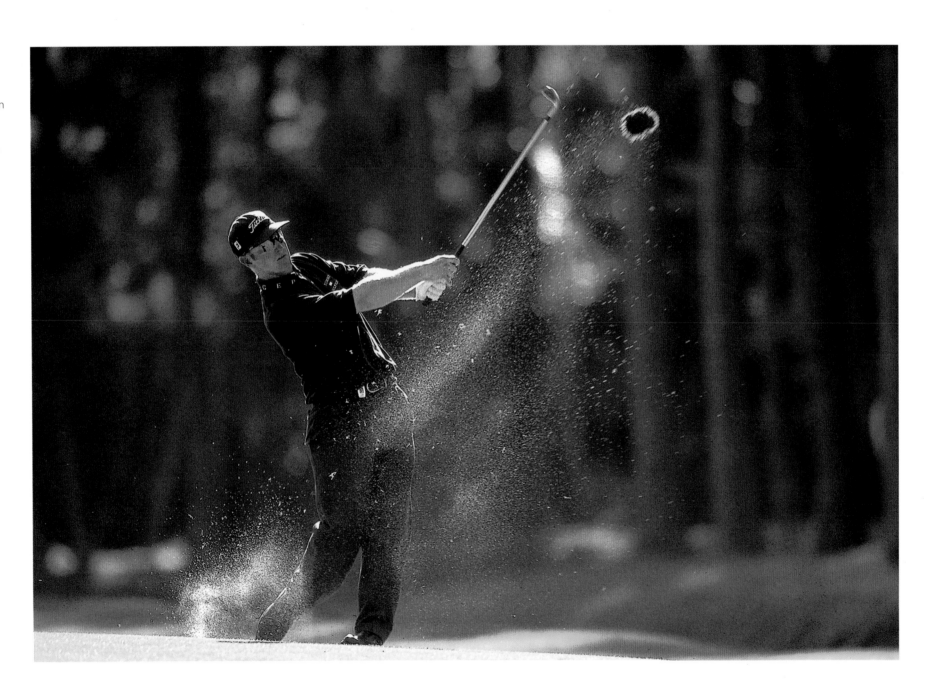

ROGER FEDERER

In 16 years at the French Open this is the darkest sky I have ever seen, and to have sunshine at the same time makes this a once-in-a-lifetime picture. Everything about it is just perfect – the position, the fact that there are no empty seats, the wind in the flags, and of course the fact that it's Federer in the foreground. I was working from the pit on Court Suzanne Lenglen, which is level with the clay, and as the sky darkened I managed to squeeze myself into the most central position. I put on a wide-angle lens to get both the towers in the picture and just waited for the right moment, which came just before it started to rain.

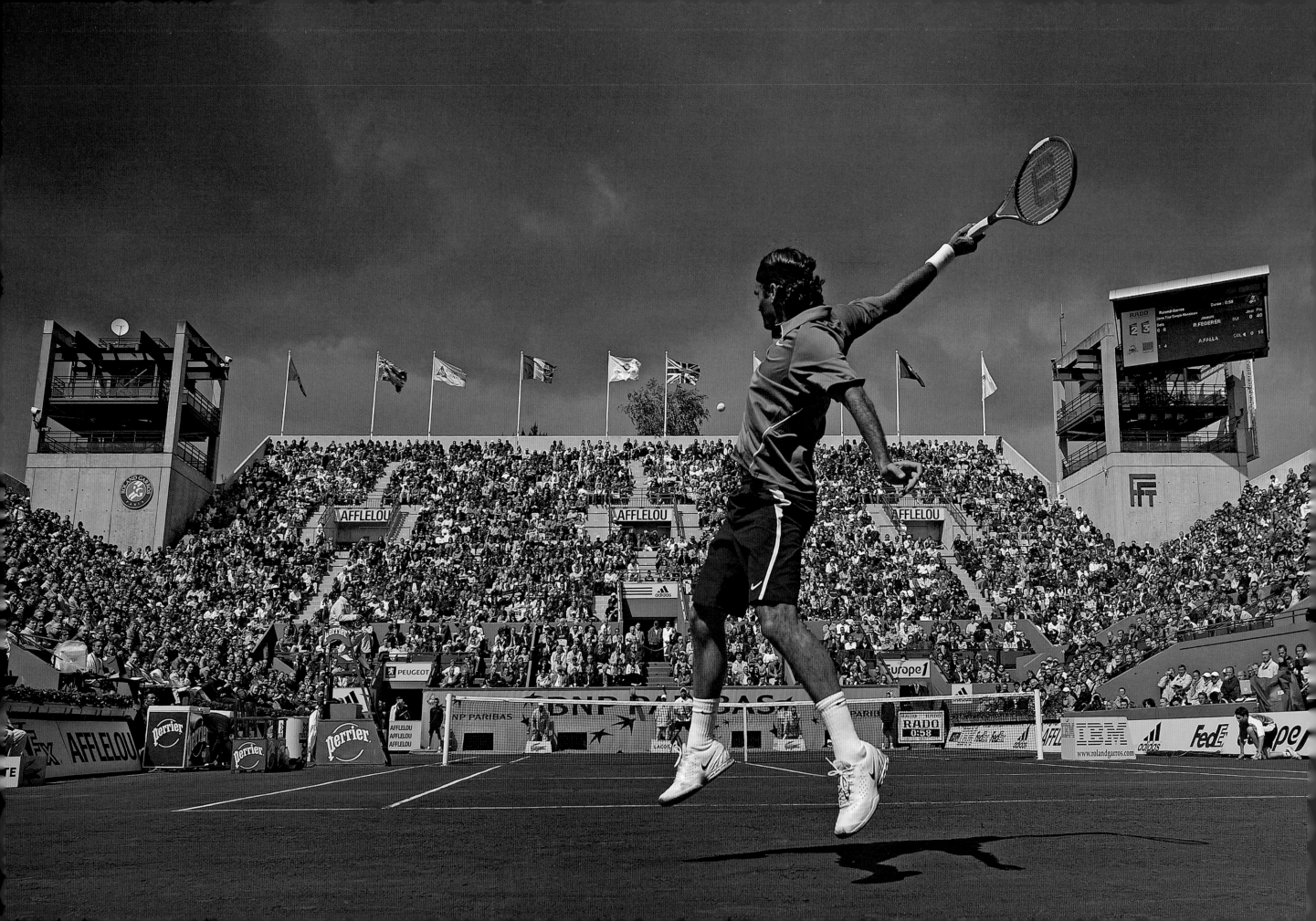

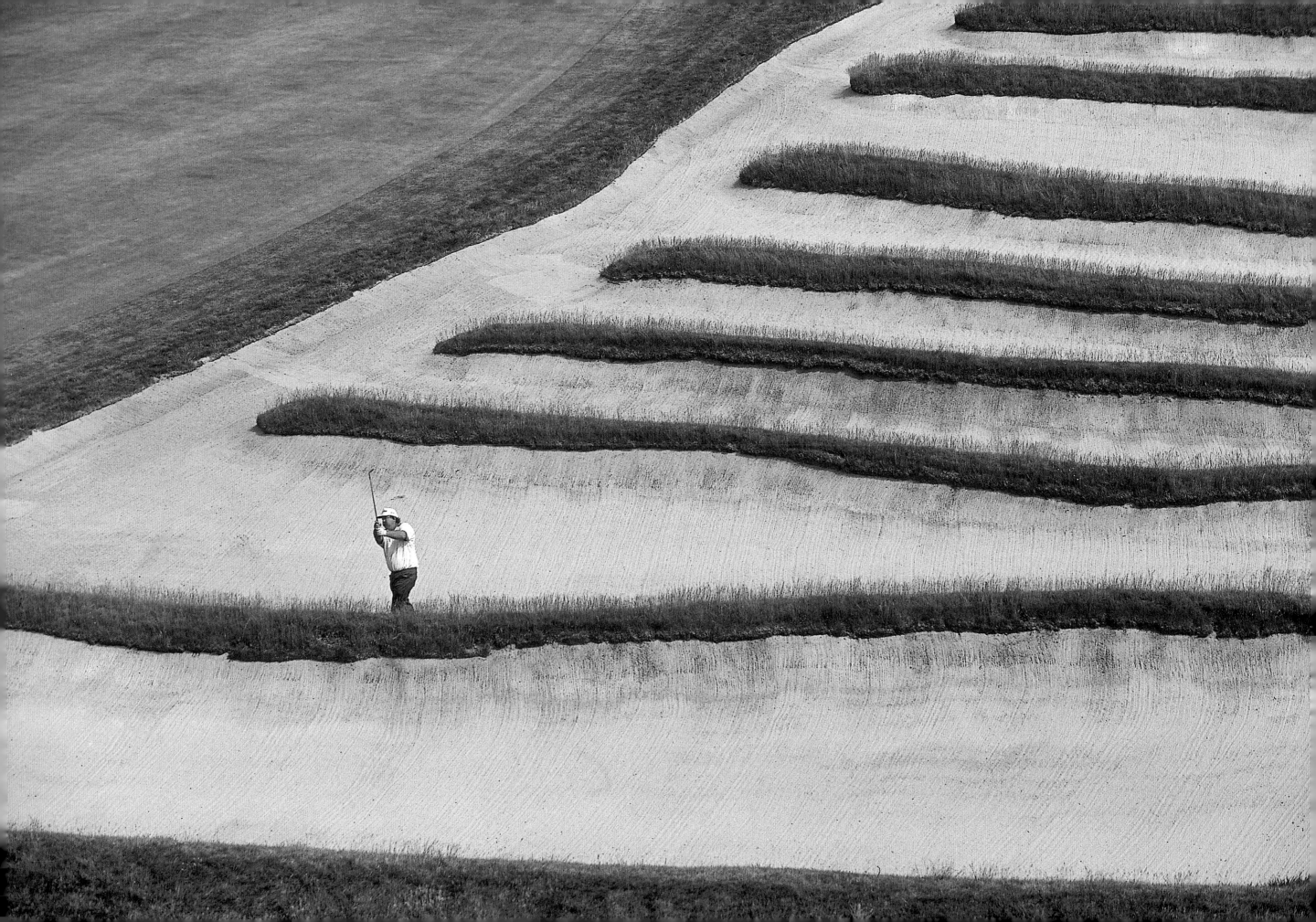

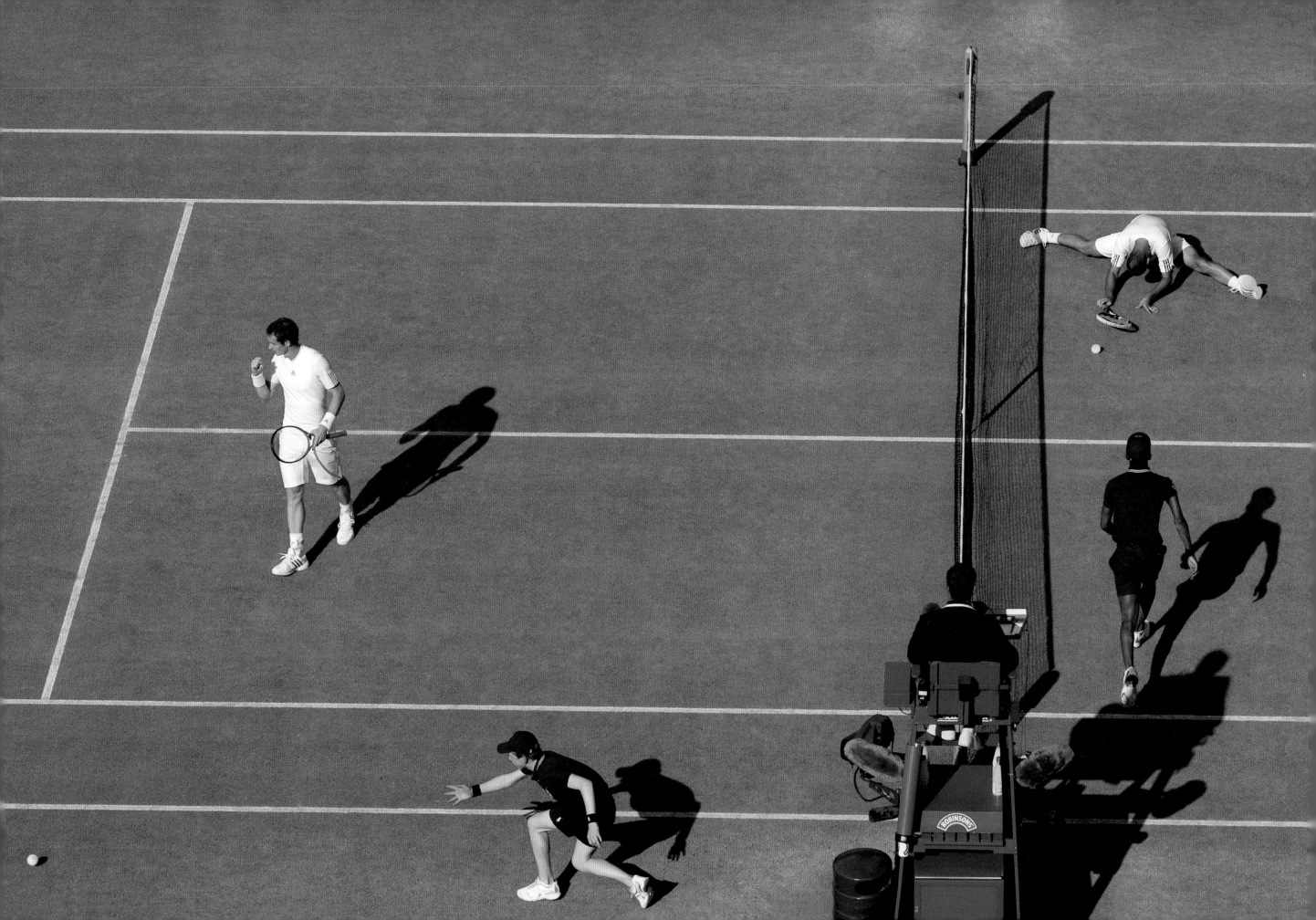

Previous pages:

CRAIG STADLER

I spent three hours up a crane to get this picture of the famous Church Pews bunker at Oakmont Country Club during the 1994 US Open. I think it's the hottest I have ever been – it was 100 degrees and 100 percent humidity – but it was worth it. I gave Craig Stadler a print and he told me he would put it above his fireplace.

ANDY MURRAY AND MIKHAIL YOUZHNY

I am always striving to find new angles, and in 2013 we installed a prototype robotic camera, developed with Nikon UK, on the roof of Centre Court at Wimbledon. Operated from a computer screen back in the media centre, this was the first time such a camera had been used to its full potential at a live sporting event.

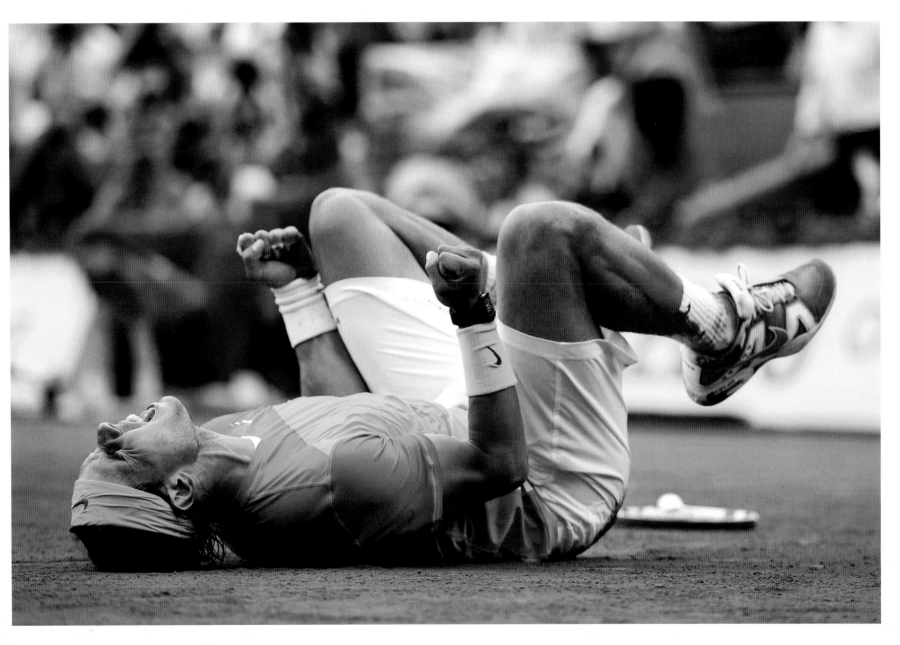

RAFA NADAL

The thing about Rafa Nadal – here at the moment of winning one of his many French Open titles – is that you never know what he is going to do when he wins. He might jump up or fall – anything – so you have to be ready to recompose in an instant. The more you know about your subjects and their sport the better chance you have of getting a great shot.

YANNICK NOAH

This was for a 'Where are they Now?' feature but Yannick Noah hardly seemed to have changed from when he was playing. He was focusing on being in a rock band which meant that – unlike most sports stars I photograph who are not professional posers like film stars, musicians or politicians – he was very extrovert and comfortable in front of the camera.

THE BIGGER PICTURE

BY STEVE FINE

I was sitting in my cubicle at *The New York Times* in 1991 when a mountain of a man, with a massive red face and a great shock of blonde curly hair (that I would later learn was the origin of his nickname, Bubbles), strode in with his boss, Steve Powell – the two of them like gunslingers in long, black rider coats – and told me he was going to change the way I thought about sports photography. Hours later, after dinner and more than a few drinks, Bob Martin and I began working together to bring Allsport's magazine-quality images to the newspaper. This was the UK-based agency's first foray into the US, and it would alter the landscape of still-image sports coverage.

Several months later, after I had returned to *Sports Illustrated*, we found ourselves on the steps of the Royal Palace in Oslo, discussing a more personal plan of action. Bob was tired of sitting behind a desk, explaining to other people how to make decent sports pictures. His burning desire was to get back behind the camera and follow in the footsteps of Walter Iooss and Heinz Kluetmeier, legends at *SI*. We talked for hours about the way they shot sports so that the sense of place took on a much greater emphasis. Too many pictures were long lens, tight images, often shot from the same angle. We thought about ways to create pictures so compelling that captions were not required.

From that moment, we embarked on the journey that would change Bob's life and make him an invaluable contributor to what I believe was the golden age of photography at *Sports Illustrated*. We put him on contract in 1994, after he left Allsport, and soon thereafter he was made a staff photographer, the first and only one based in Europe.

Bob sought to break out of the straight news-oriented approach he had previously used for shooting action. The loos in Bob's house were papered with awards he had won for tennis, golf and auto-racing photos. Now, he wanted to take a sports picture that made you feel like you were sitting right next to him at the event. He wanted you to get a taste of the atmosphere amid the tears and cheers on the field of play.

So we looked for stories that allowed him to display a sense of place without necessarily focussing on the finish line. Bob became the king of Leading Off, the front section of the magazine that showcases, in three double-truck spreads, the kind of photography that made *SI* famous. He travelled to Engadin, Switzerland, to shoot cross-country skiing, to Nepal to shoot elephant polo, and to the top of the world to shoot golf courses in the Arctic Circle. Bob went wherever pictures wanted to be made. He brought a distinctively European flair to a magazine that was firmly entrenched in football, baseball, hockey and hoops.

In 1995, we sent Bob on a mission to post-apartheid South Africa to do a story on kids playing sports in Soweto. He and the writer, Rick Reilly, were there for the travel portion of the swimsuit issue and turned in a great piece on how the spirit

continues on page 123

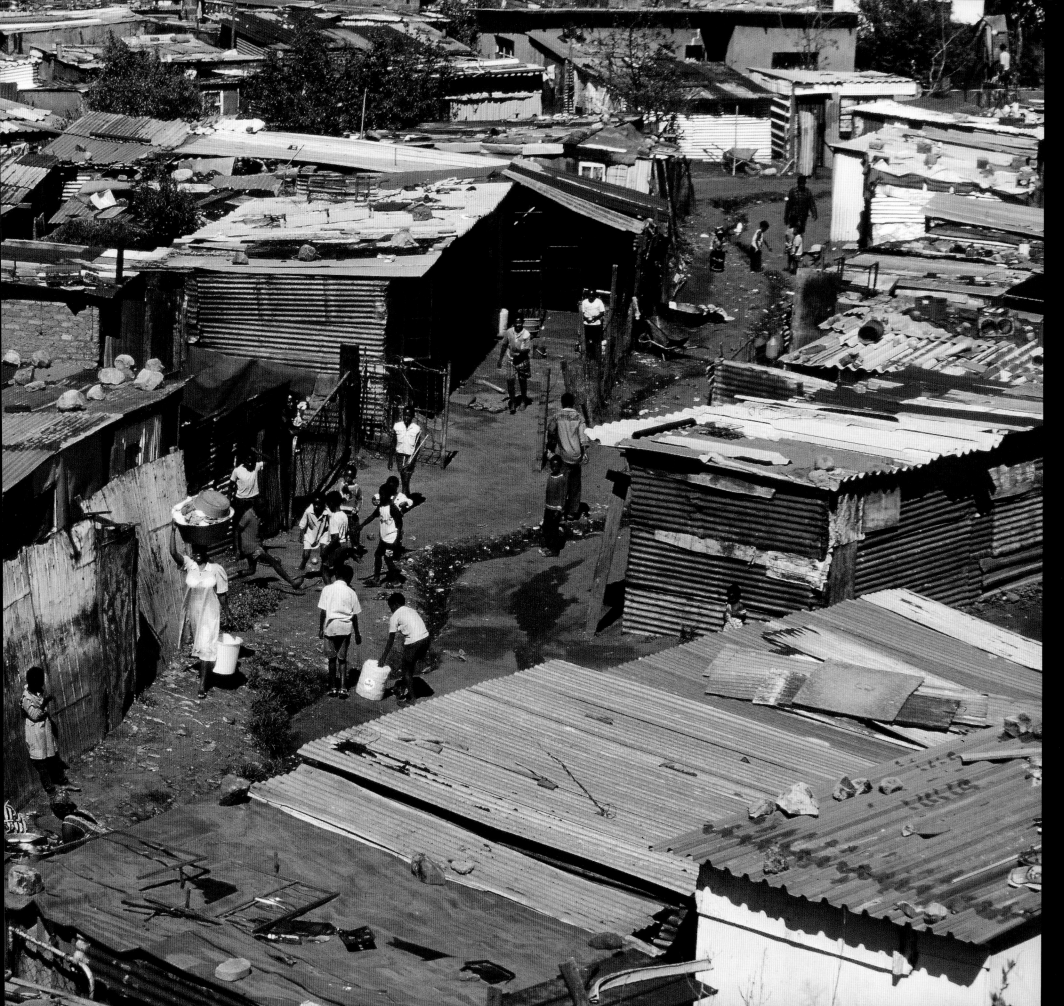

Left: The Johannesburg township of Soweto. Shortly after we'd set up to take this picture we had to pack up in a hurry and jump back into our car and get out of there as we'd been spotted and our minders feared there was trouble heading our way. That happened a lot on this trip.

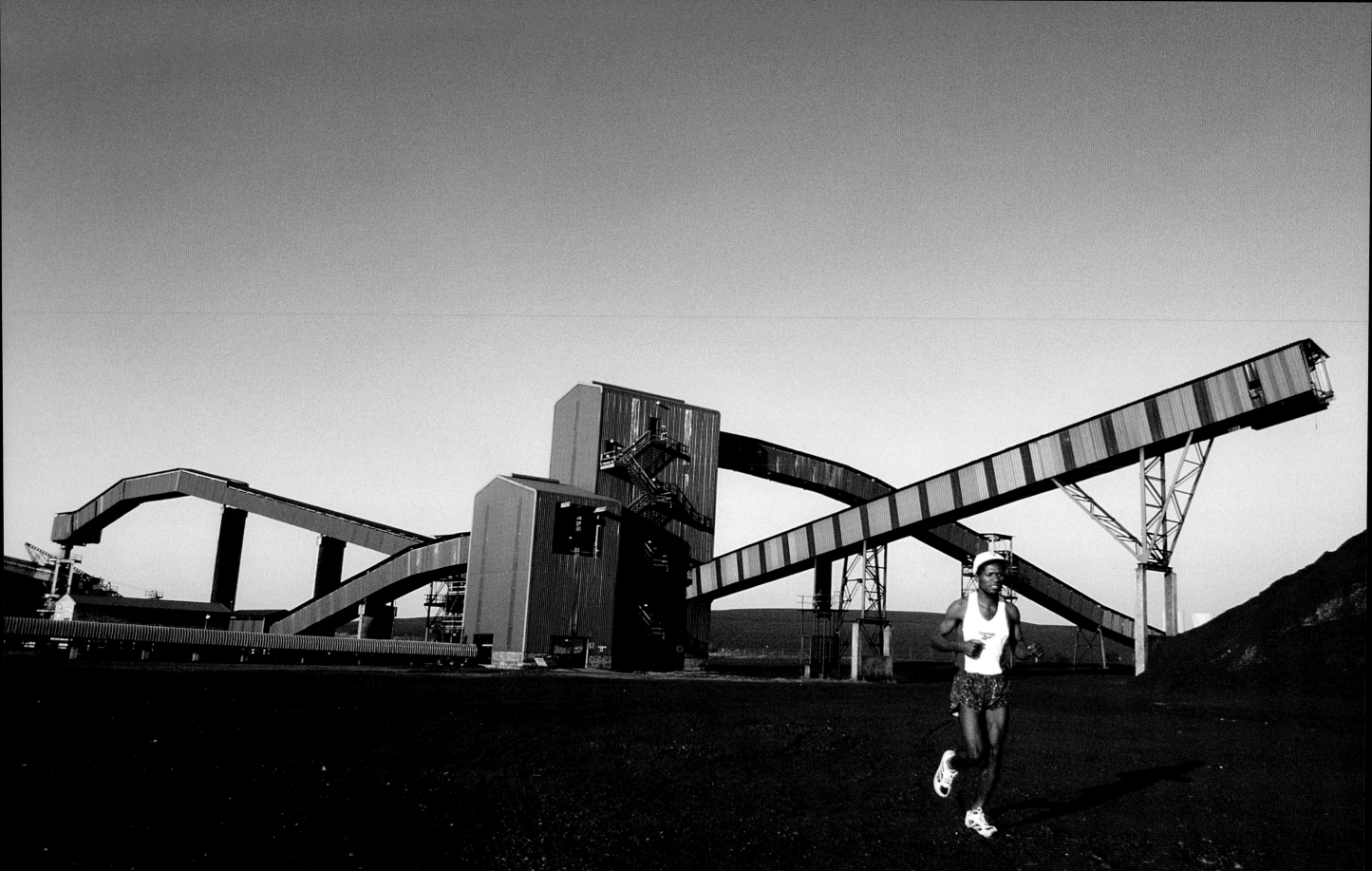

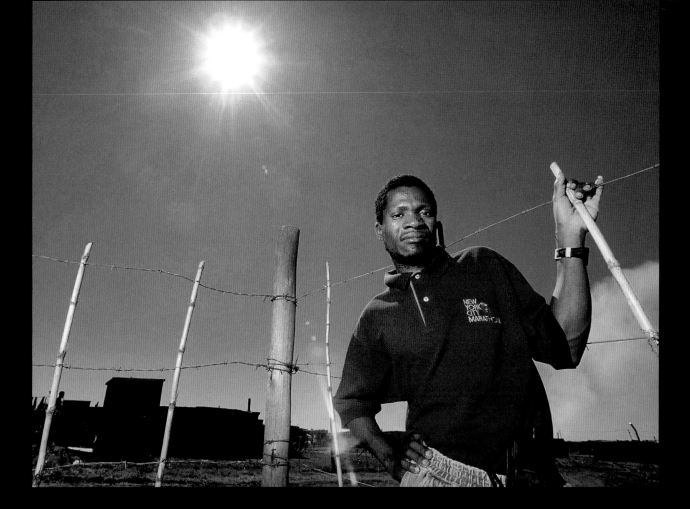

of the kids might one day transform South Africa into a sports power. Against a background of a shantytown filled with corrugated tin shacks, we saw kids playing basketball barefoot, a cricket field lined with barbed wire, and a homemade four-hole golf course that was one entire unplayable lie. As Reilly described it, "Outsiders come to Soweto, see the barbed wire and the kids – that's what you take from the township, the memory of those unsinkable children playing against a backdrop of dread." But from Bob's pictures, we saw hope.

Almost every week there was a 'Bob' in Leading Off, and you could tell it was his picture without reading the credit line. He just saw things differently. He combined light and shadow in a way that elevated his pictures to an art form. His knowledge of sport was unparalleled, and he insisted on separating himself from the pack. If the swimming pool was 'the' place to be at the Olympics, Bob disappeared into the three-day equestrian event and brought back gorgeous horse-jumping pictures. If everyone put down their stools at the 18th green at Augusta, Bob found an elevated position near the third tee to spotlight Tiger Woods in a sea of fans. He was a master of the 'up' – his overhead shot of a swimmer at the Athens Paralympics which won the World Press Photo award being a fine example. These pictures required planning and patience, and sometimes a little luck with the weather. But he came back with iconic images every time.

For me, though, Bob was much more than a

continues on page 124

Left: This is Josia Thugwane, the gold medal-winning athlete from the marathon at the Atlanta Games – a race he won despite having been shot in a car-jacking just five months earlier – pictured running past the Soweto coal mine where he used to work. He would pass the mine every day in training.

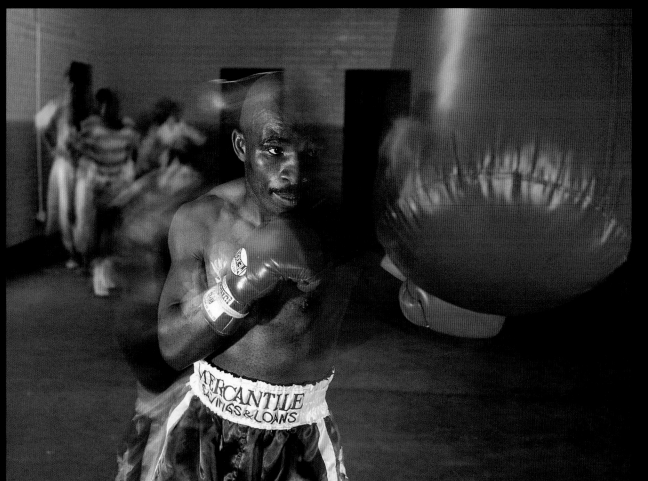

Above: Thugwane again, this time outside his house in Soweto.

Left: 'Baby' Jake Matlala, the shortest man ever to win a boxing world title when he won the World Flyweight Championship, pictured in his gym in Soweto. Matlala and Thugwane were the two biggest sports stars ever to come out of the township.

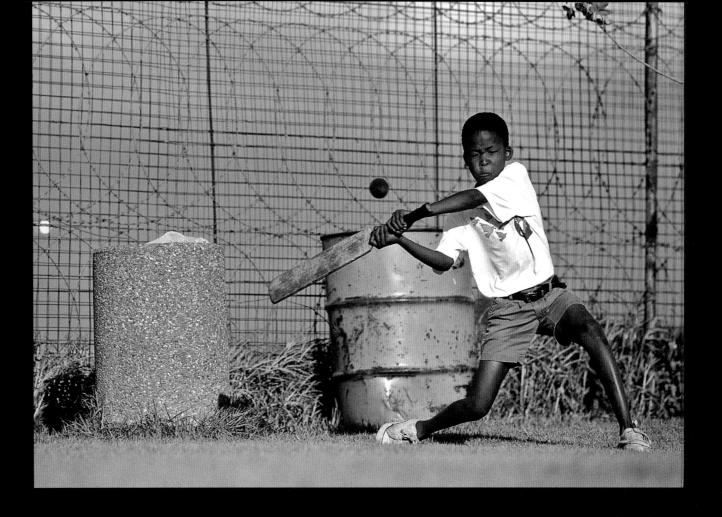

photographer. He was my guide, my mentor, my chief negotiator, my bodyguard, my eyes and my ears. We set up every Olympics for the magazine from 1996 to 2014. This was Bob at his best, sharing information with the team to make us all better. We climbed a hill across from the ski jump in Lillehammer to figure out what would be the signature picture from those Viking games. We travelled to Sydney and looked down from the fourth deck of the 120,000-seat Stadium Australia, imagining what it would look like if Cathy Freeman were to win gold in the 400 metres. We assayed the first snowboarding competition in Salt Lake City – Bob proceeded to own the event for a week. We went to Athens five times to sort out logistics for road cycling, the marathon and the fireworks near the Parthenon. In Beijing, we mapped out the photo positions for the opening ceremony in and around the Bird's Nest; found the unique spots in the Water Cube for Michael Phelps' unprecedented eight-gold-medal performance; and even hiked the Great Wall to mark unusual angles for road cycling. On Bob's first visit to Sochi he became friends with a Russian businessman who promised to sort out hotels and transport during the Games in 2014; unfortunately the self-proclaimed oligarch was shot 10 times in the chest and we lost a connection. Along the way we ate and drank at the best places in town and played spoof, a game of chance, for the bill. Bob hated to lose at spoof (or any game, for that matter) and rarely did. And no Olympics could properly

continues on page 126

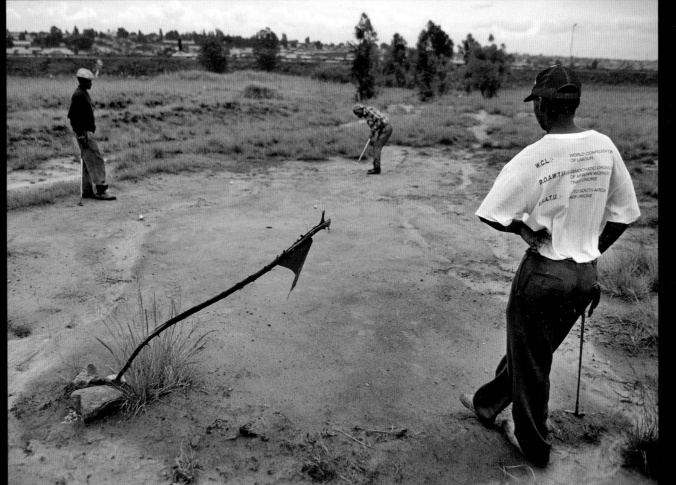

I really like these shots because it shows how kids don't need expensive equipment or facilities to do sport – they will always find a way. These children (right) were having a blast, bouncing off a rusty old mattress to perform these amazing gymnastics tricks while a muddy patch of ground doubled as a putting green (left) and an oil can became a set of cricket stumps (above left)

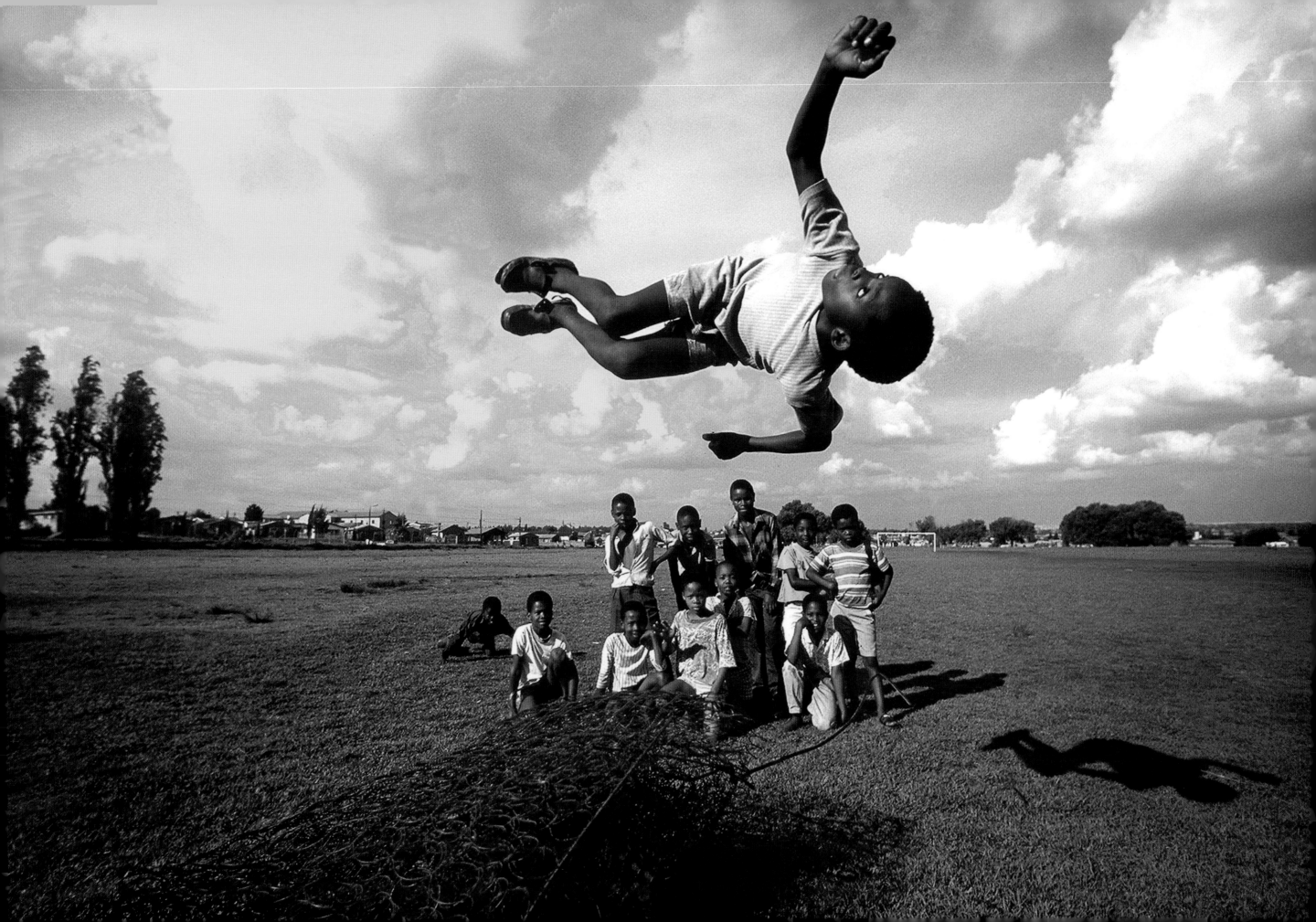

begin without Bob affixing a Union Jack to his car's antenna, signifying that royalty was in the house.

In every city Bob arranged for private meetings with the photo chief and convinced them to create good photo positions for all photographers. He believed that competition in photography should be what you created in the camera, not about who got the best positions. In later years, Bob took his knowledge of where to shoot and applied it to his job as photo chief for London 2012 and then on to Rio for 2016. Bob believes in never taking eggs from someone else's basket. In his current role as the IOC

spokesman for all things photographic, he is making it possible for all accredited photographers to make great pictures at the Olympics.

This book is about high-risk/high-reward sports photography by a shooter who strived to forge his style. Anyone can capture a moment in sport. Putting the entire package of event, environment and emotion together in one frame, with context and perspective, has always been Bob's genius.

Steve Fine is Photo Editor at *Flipboard.com* and former Director of Photography at *Sports Illustrated*

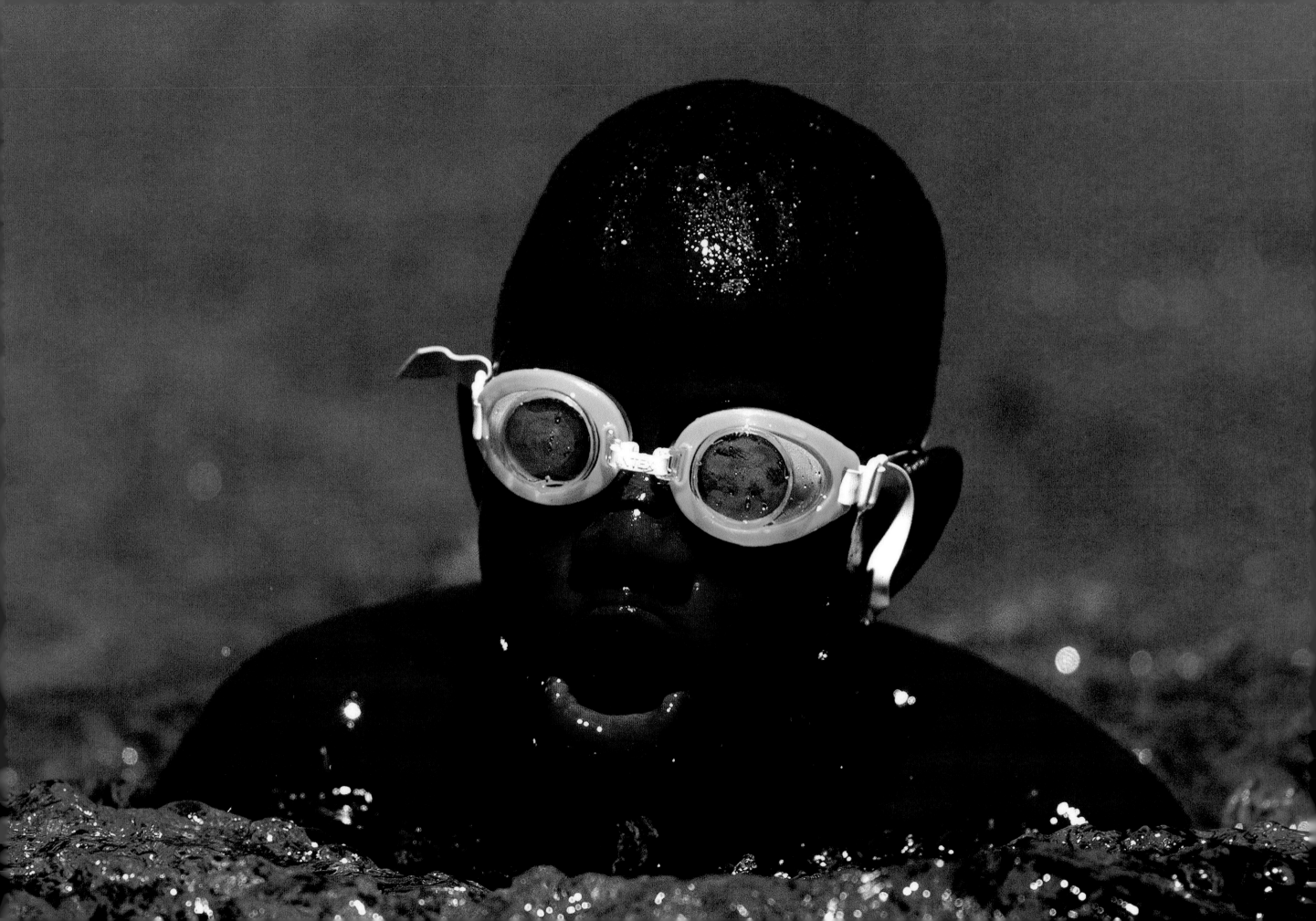

04

HIGH & MIGHTY

JENNIFER CAPRIATI

Over the years I took a lot of pictures of Jennifer Capriati, and I noticed that when she hit a high, double-handed backhand, the muscles in her arms were huge. So I found a position at the Australian Open that would give me a nice, clean background that would show this best. As always, it was a case of knowing your subject and the right position to get the picture you are looking for.

RUGBY WORLD CUP

This is simply an out-and-out, good, hard action pic from England v the USA at the 2007 Rugby World Cup in France. My biggest challenge was to take a picture that made the USA look good – after all they were under the cosh for the whole game.

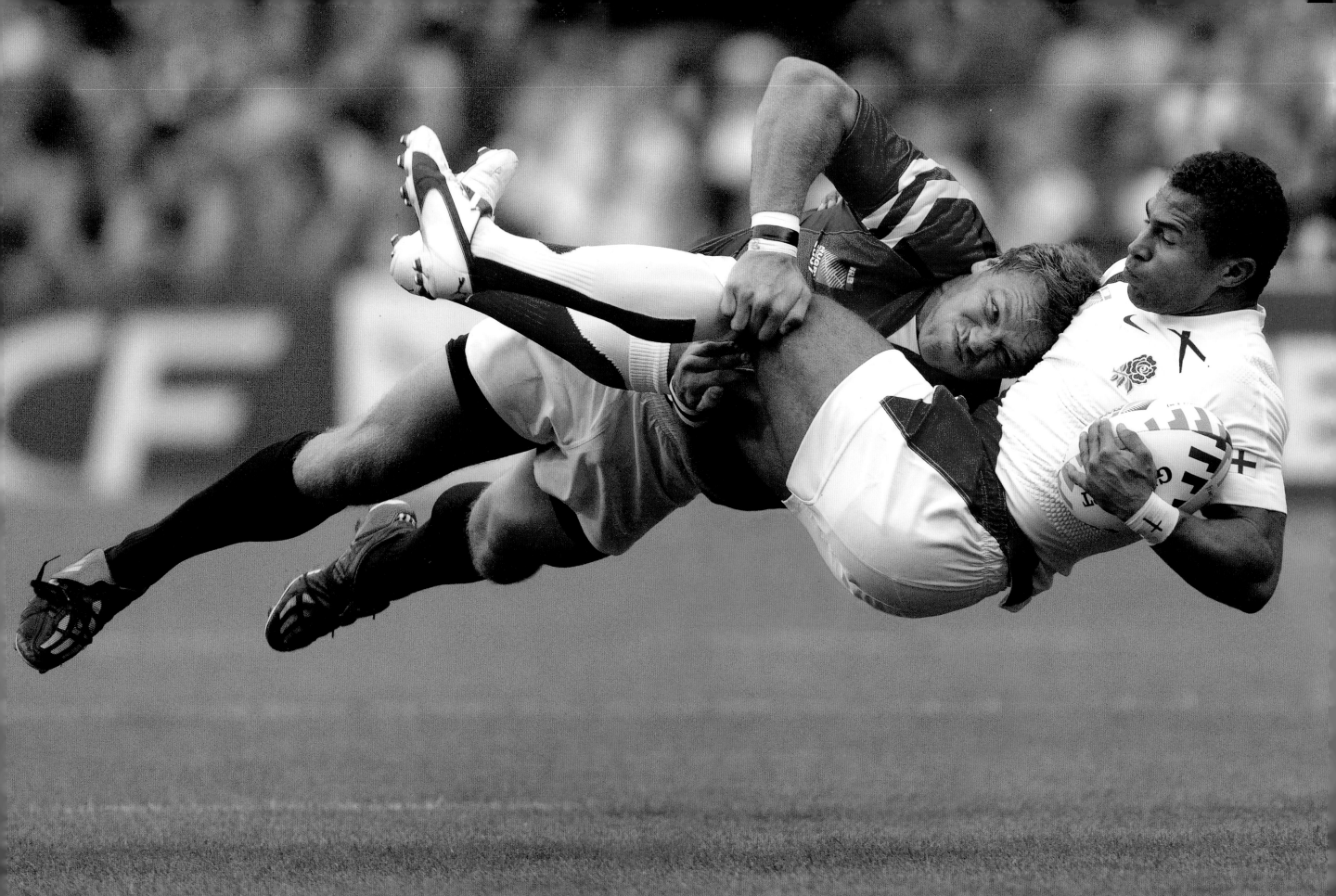

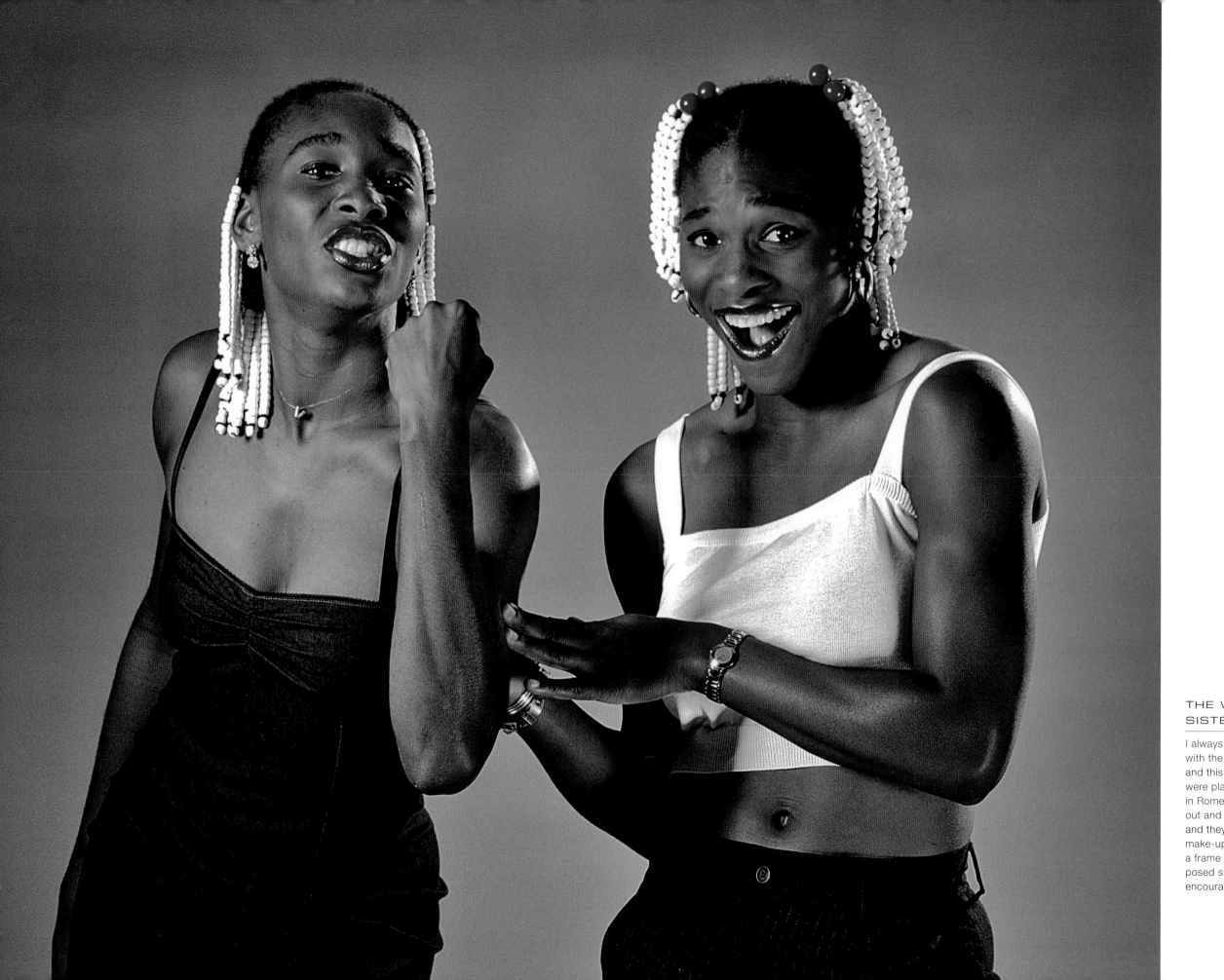

THE WILLIAMS
SISTERS

I always got on really well with the Williams sisters and this is a fun shot. They were playing in a tournament in Rome so we had to go out and buy some clothes and they did their own make-up. This is actually a frame taken between posed shots and Venus is encouraging me to hurry up!

MARCO MATERAZZI

Not long after the infamous World Cup final when he had his run-in with Zinedine Zidane, I was sent to photograph Materazzi. I did all these moody, hard man pictures of this guy who was seen as a sporting villain, then his daughter showed up and he turned out to be a gentle, loving father. I shot some pictures of him and his little girl, just for him, and they turned out to be the best pictures of the lot.

BECHER'S BROOK

I am proud of this remote camera picture but, of course, it is a bit horrific from a horse's point of view and I am glad that, since this fence was reduced in size, we don't see scenes like this at the Grand National any more.

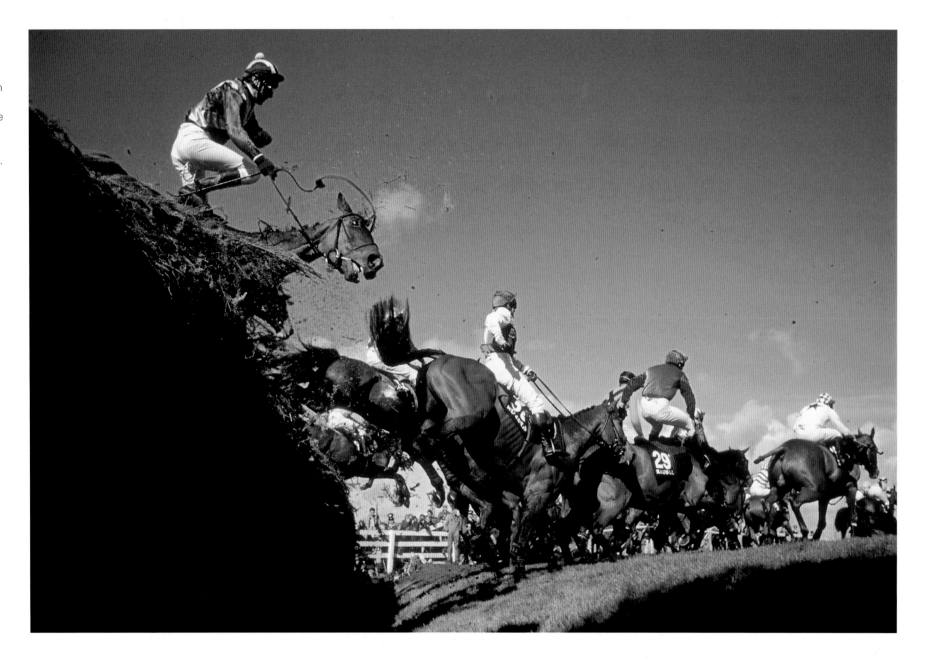

WORLD ATHLETICS CHAMPIONSHIPS, HELSINKI

To get this shot I was lying down right next to the triple jump track, having worked out the optimum position during the heats. It is a good example of what you can do from the privileged position of the infield.

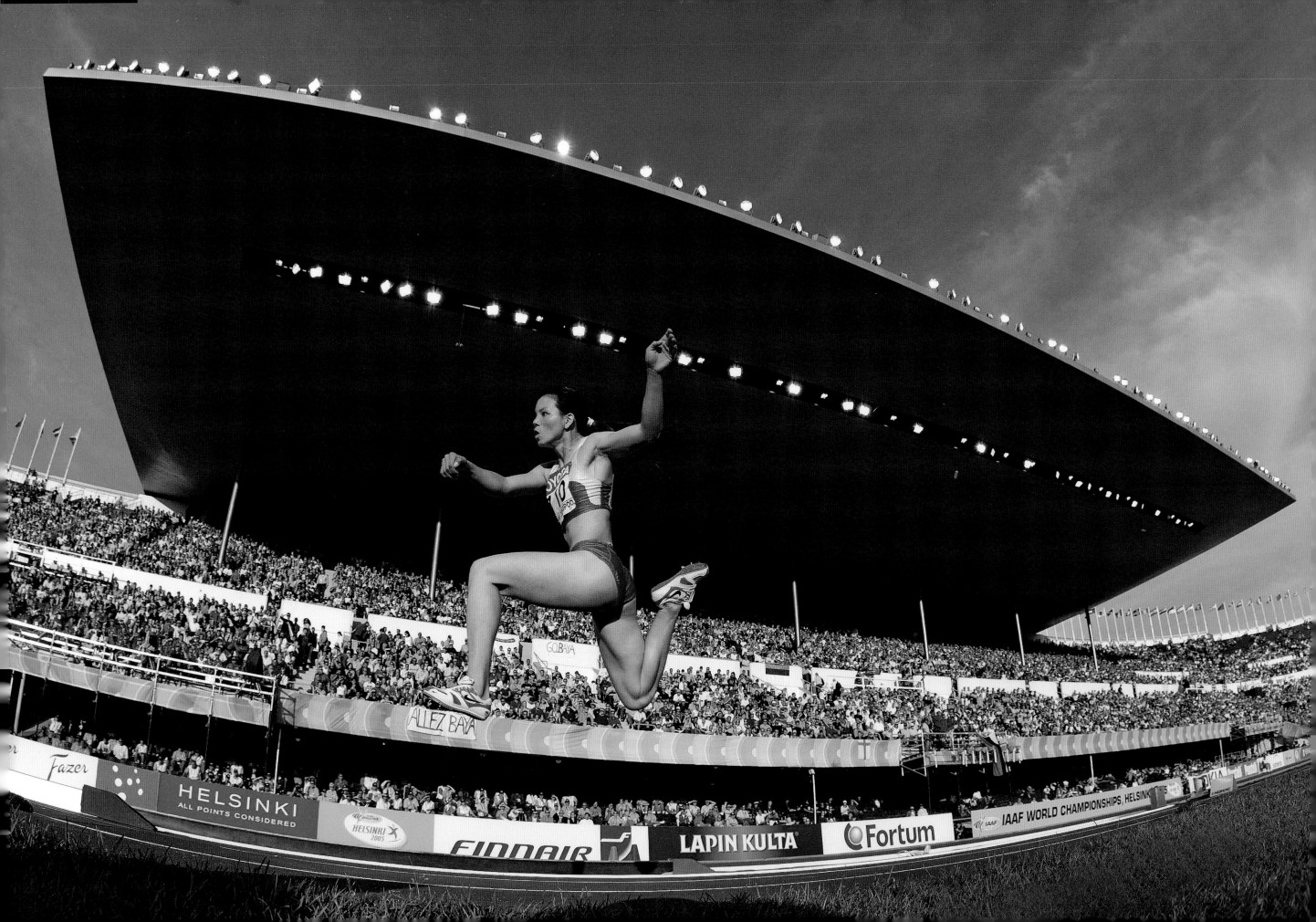

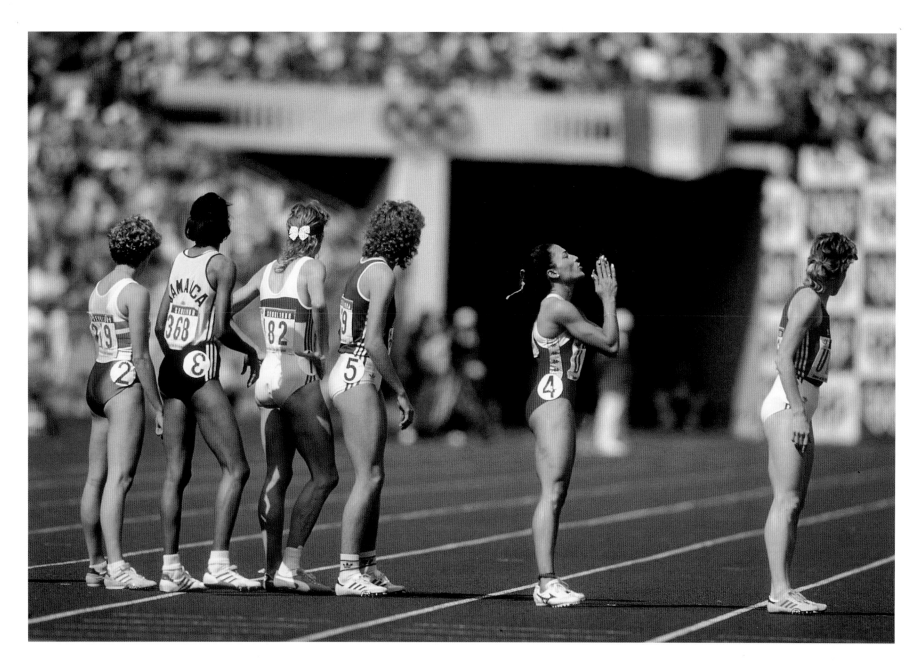

FLORENCE GRIFFITH JOYNER

I was set up at the finish at the Seoul Olympics during the 4x400 metres relay when Flo Jo started praying, before the baton came round to her. I quickly repositioned myself to put her in the black doorway and captured the moment.

HOSSEIN
REZAZADEH

I got to the final of the
heavyweight weightlifting
competition at the Athens
Olympics too late to get the
best, most central position.
However, I got lucky because
Rezazadeh staggered to
his right after making the
gold medal-winning lift and
ended up directly in front
of me. The huge Olympic
rings behind him make the
picture, as they are perfectly
symmetrical to where I ended
up after my late arrival.

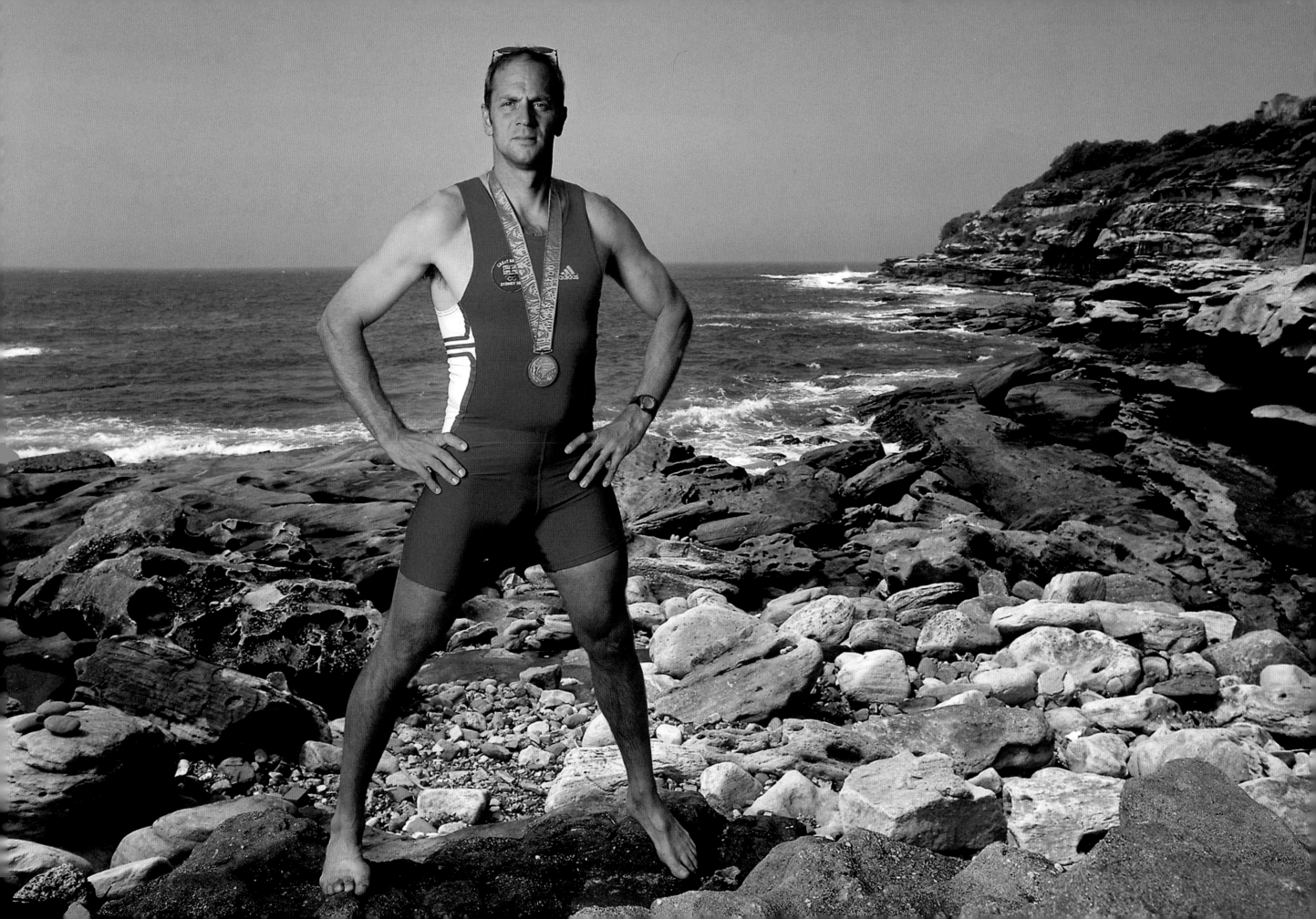

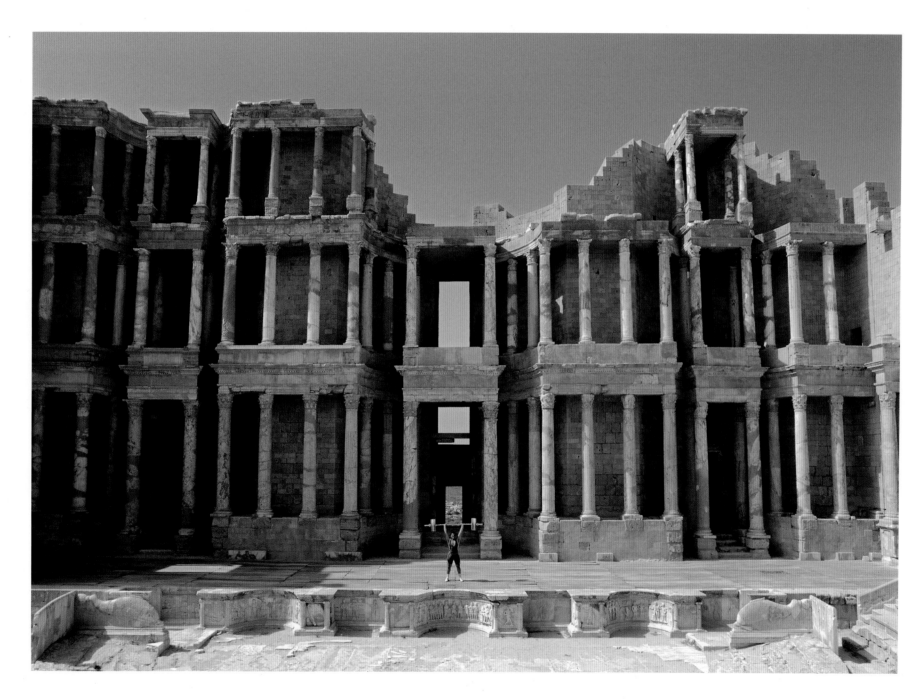

LIBYAN WEIGHTLIFTER

Always looking for pictures of sport in unusual locations, we managed to persuade the Libyan authorities to let us photograph their top weightlifter in front of a ruined ancient Roman theatre at the famous UNESCO World Heritage site of Leptis Magna. General Gaddafi's son was head of the Libyan Olympic Committee, which was ironic as in his father's 'Green Book', which was a guide to how Libyans should live their lives, there was a line saying that they shouldn't compete, even in sport. And I ended up with one of these Green Books signed 'to Mr Bob, my best regards' by Gaddafi himself.

STEVE REDGRAVE

When I took this shot of Steve Redgrave on the rocks next to Bondi Beach, just after he had won his record fifth consecutive gold medal, he was the hottest property at the Sydney Olympics. We were mobbed by all the Brits on the beach and there were loads of people behind me, watching as we shot the picture.

DIDIER DROGBA

As is usual with the big stars,
I only had five minutes in a
hotel room to get a good
portrait of Drogba before
the 2010 World Cup in
South Africa. When he left
I didn't think I had anything
outstanding, but luckily there
was this one where I think he
looks incredibly statuesque.

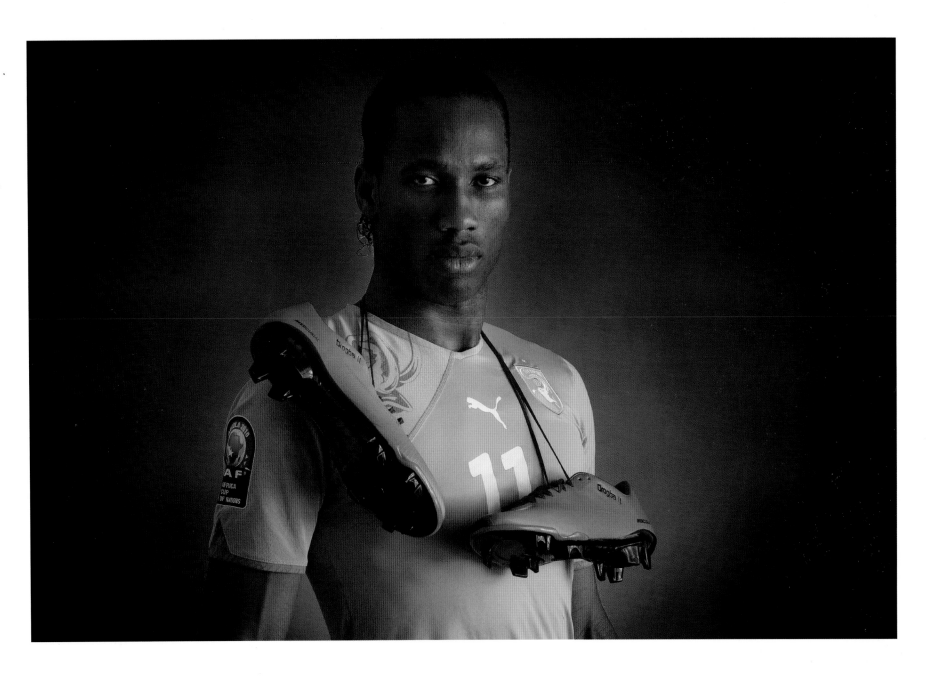

ROGER FEDERER

Wimbledon asked me to take
this shot of Roger Federer for
a book on Centre Court and
it was quite a coup because
very few pictures had ever
been taken inside the men's
locker room. We had about
three minutes, but Roger
was fantastic as always.

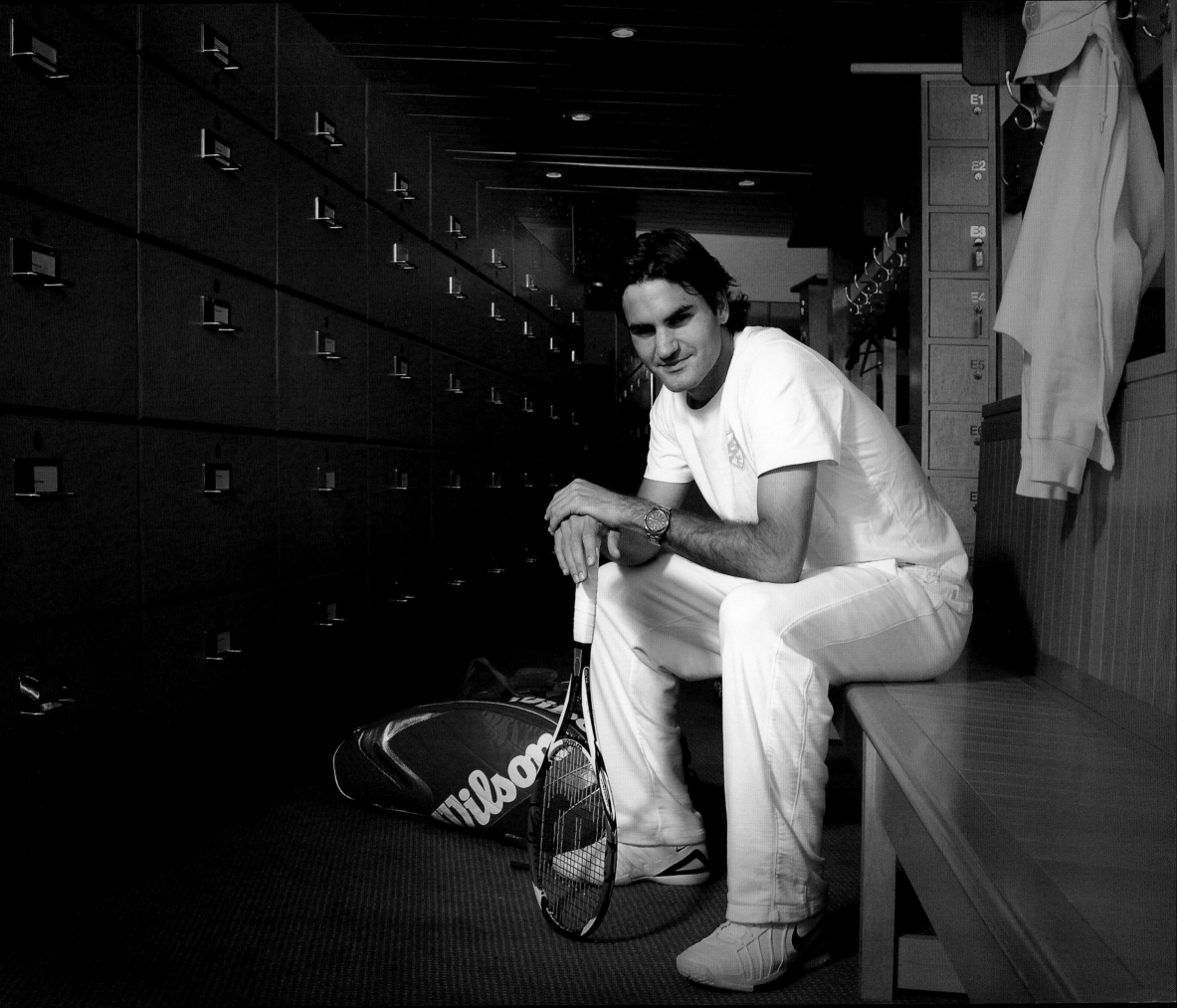

BADMINTON HORSE TRIALS

This is a good set of pictures anyway, but the fact that they show Princess Anne falling into the water at the Badminton Horse Trials in 1982 obviously takes them up a level.

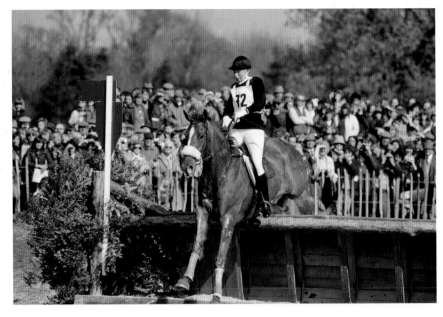
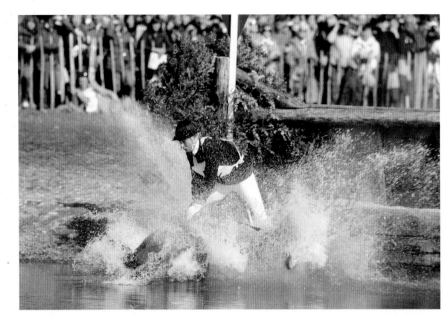
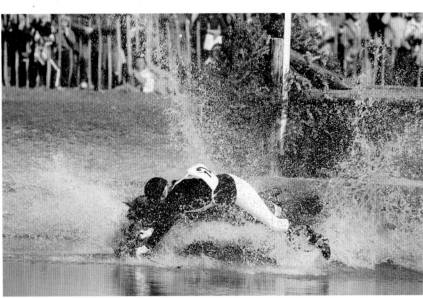
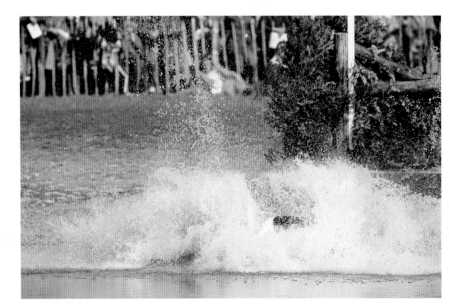

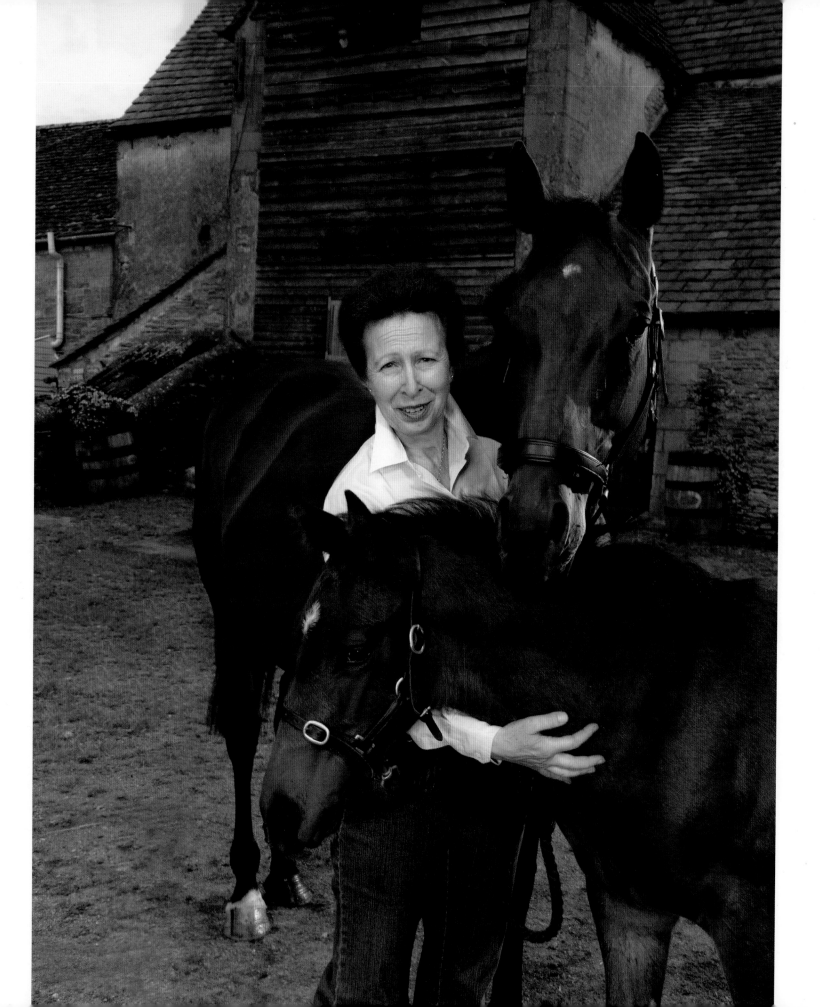

PRINCESS ANNE

I don't think Princess Anne fully realised how tricky it was to get this portrait for the front cover of the 100th anniversary edition of *Horse & Hound*. But I wasn't sent to the Tower and beheaded so hopefully she liked the picture.

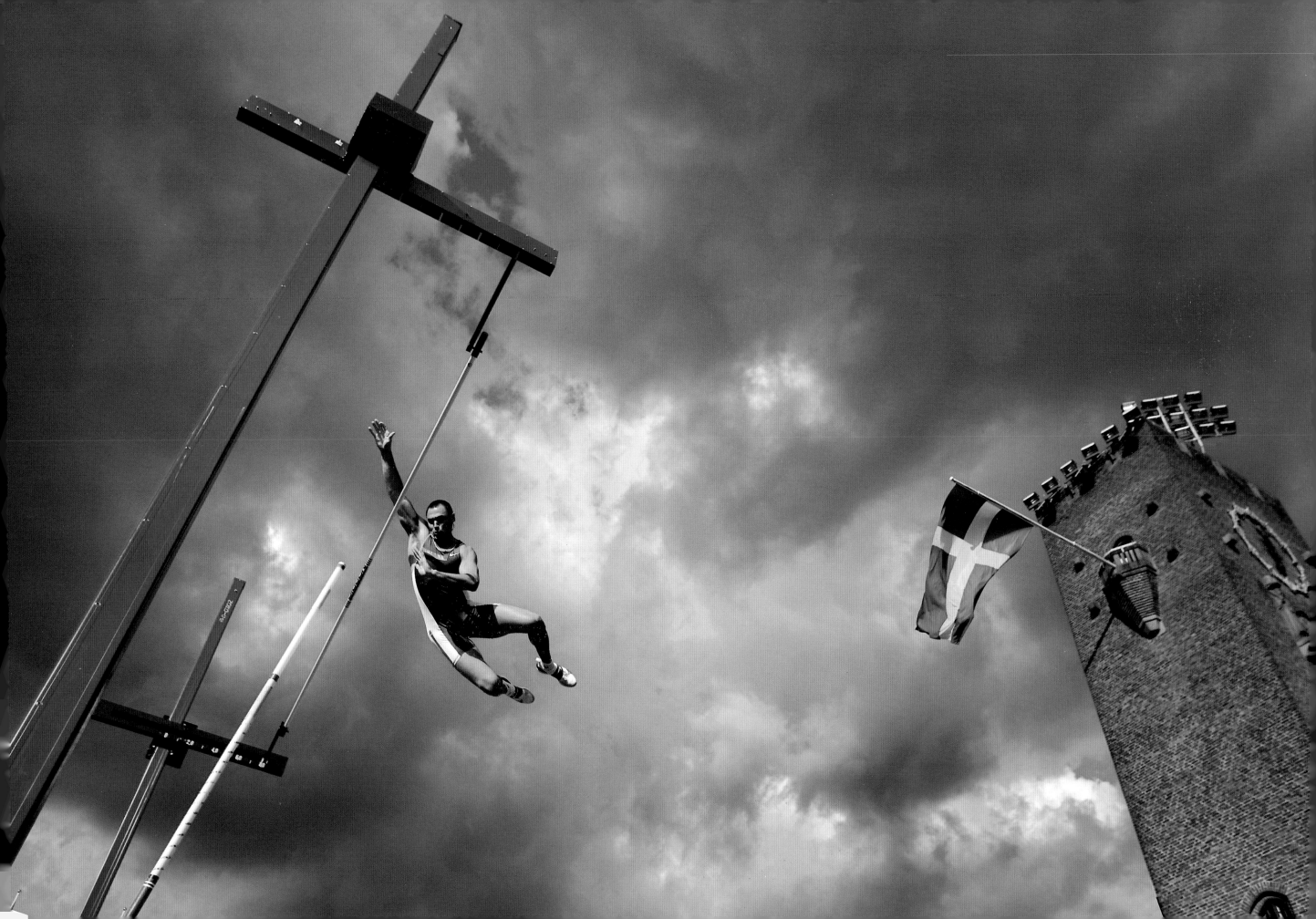

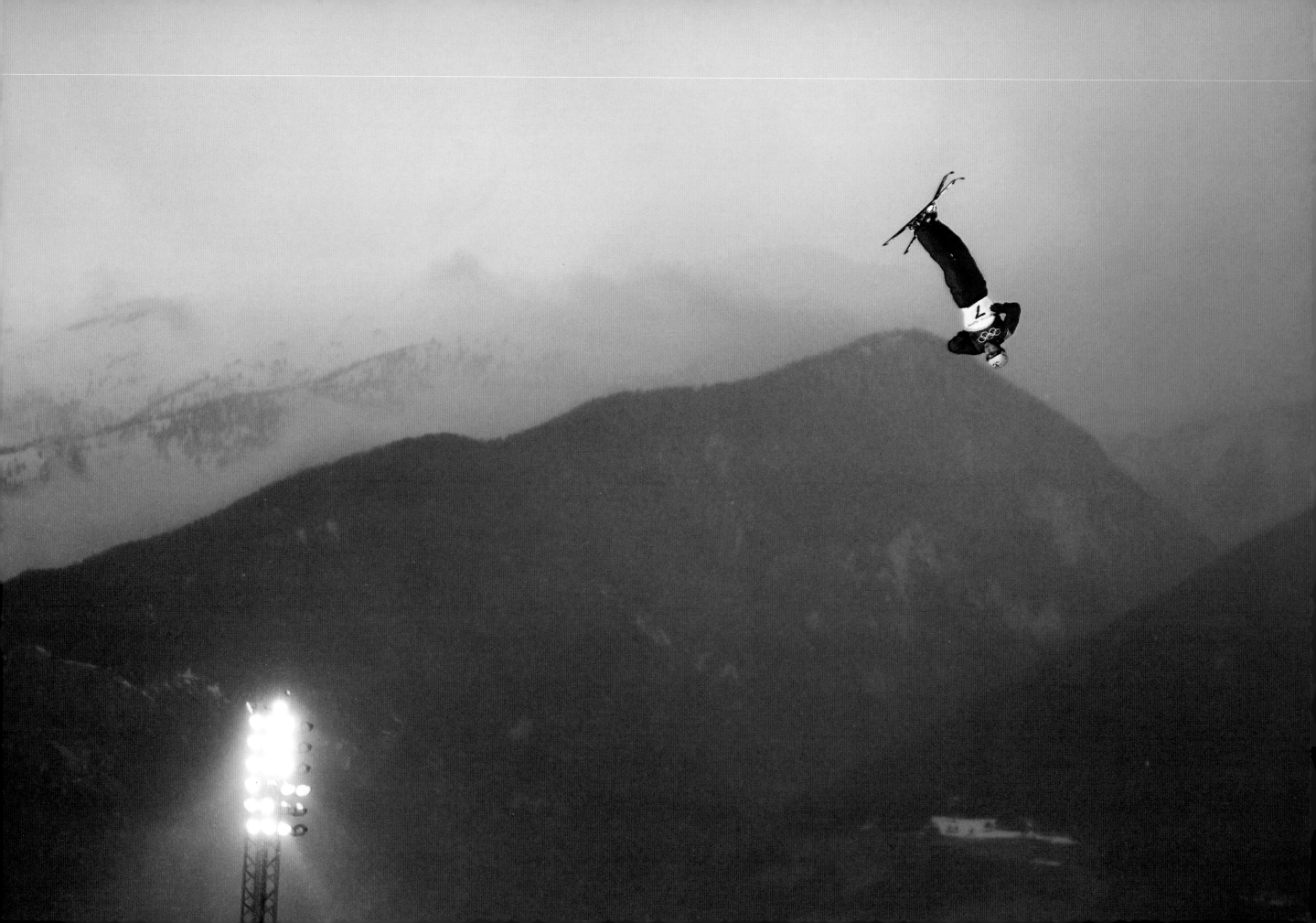

Previous pages:

STOCKHOLM
GRAND PRIX

I was one of the privileged
few photographers to get
access to the infield at major
athletics events, enabling me
to get this shot of Australian
pole vaulter Dmitri Markov
in the beautiful old Olympic
Stadium in Stockholm. When
you are working so close to
the action you have to be
acutely aware of exactly how
the sport is played, and if
you were to do anything that
affected the sport you would
be putting your livelihood
at risk. I've never taken any
risks in the infield but I've
seen some idiots who have.

HAN XIAOPENG

I had not managed to
get a single picture of
note on this dull,
foggy day at the Turin
Winter Olympics but finally,
as the floodlights came on
just before dusk, I got this
shot of Han Xiaopeng of
China winning the men's
freestyle aerial competition.

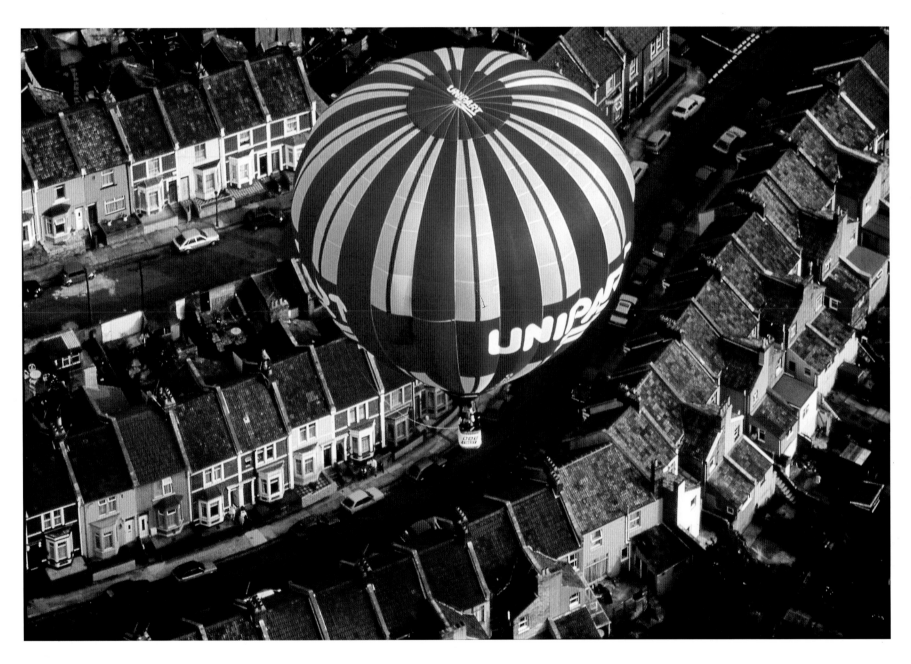

BRISTOL HOT
AIR BALLOON
FESTIVAL

Because hot air balloons
travel faster in the thermals
when you are higher up,
it took me four days while
shooting from another
balloon to get it just right
so we were above this
balloon as it went over the
terraced houses of the city.

TURIN WINTER
OLYMPICS

I took this shot of the
freestyle mogul skiing from
the woods behind the car
park, using a long telephoto
lens. The effect of the lighting
on the snow is created by
the flickering floodlights
which each flash on and off
more than 200 times per
second, creating a slightly
unusual light pattern on the
snow. I love the symmetry
of the picture, although
I could not get myself
perfectly central because
there was a great big tree in
the middle of the car park.

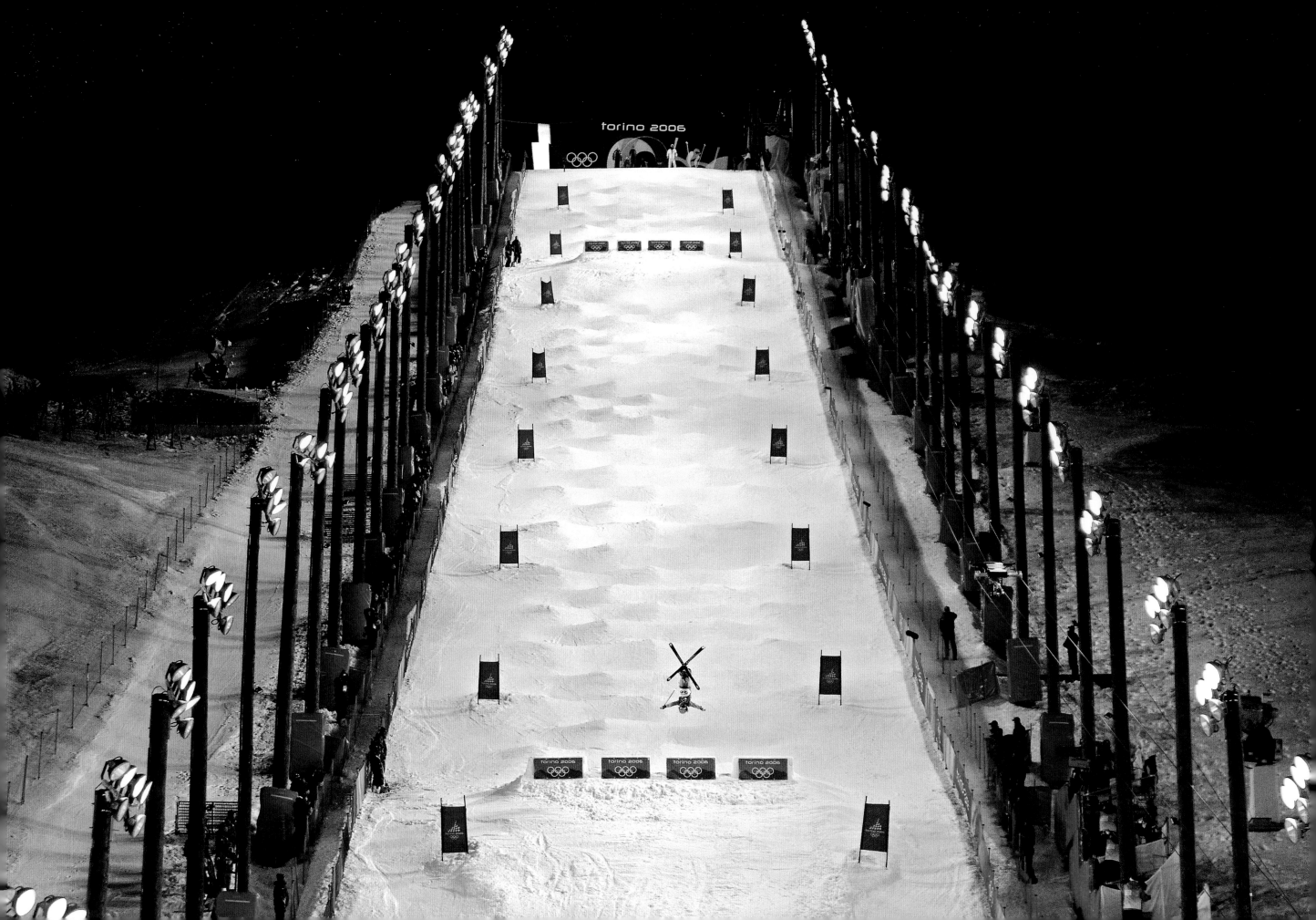

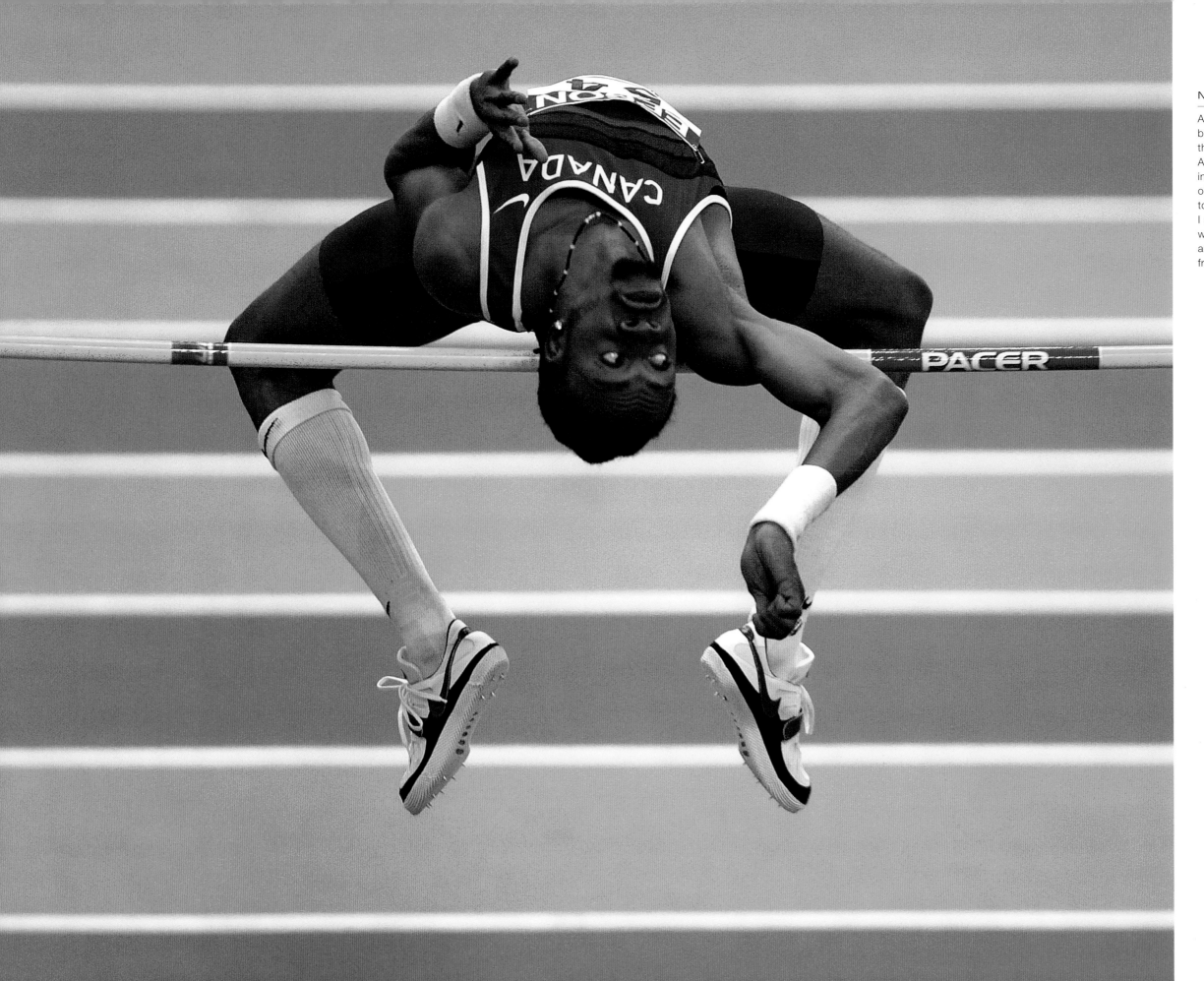

MARK BOSWELL

As soon as I saw the
blue running track at
the 2003 World Indoor
Athletics Championships
in Birmingham, I became
obsessed with finding a way
to use it as a background.
I spent the whole event
wandering around the
arena, and finally got this
from a seat in the crowd.

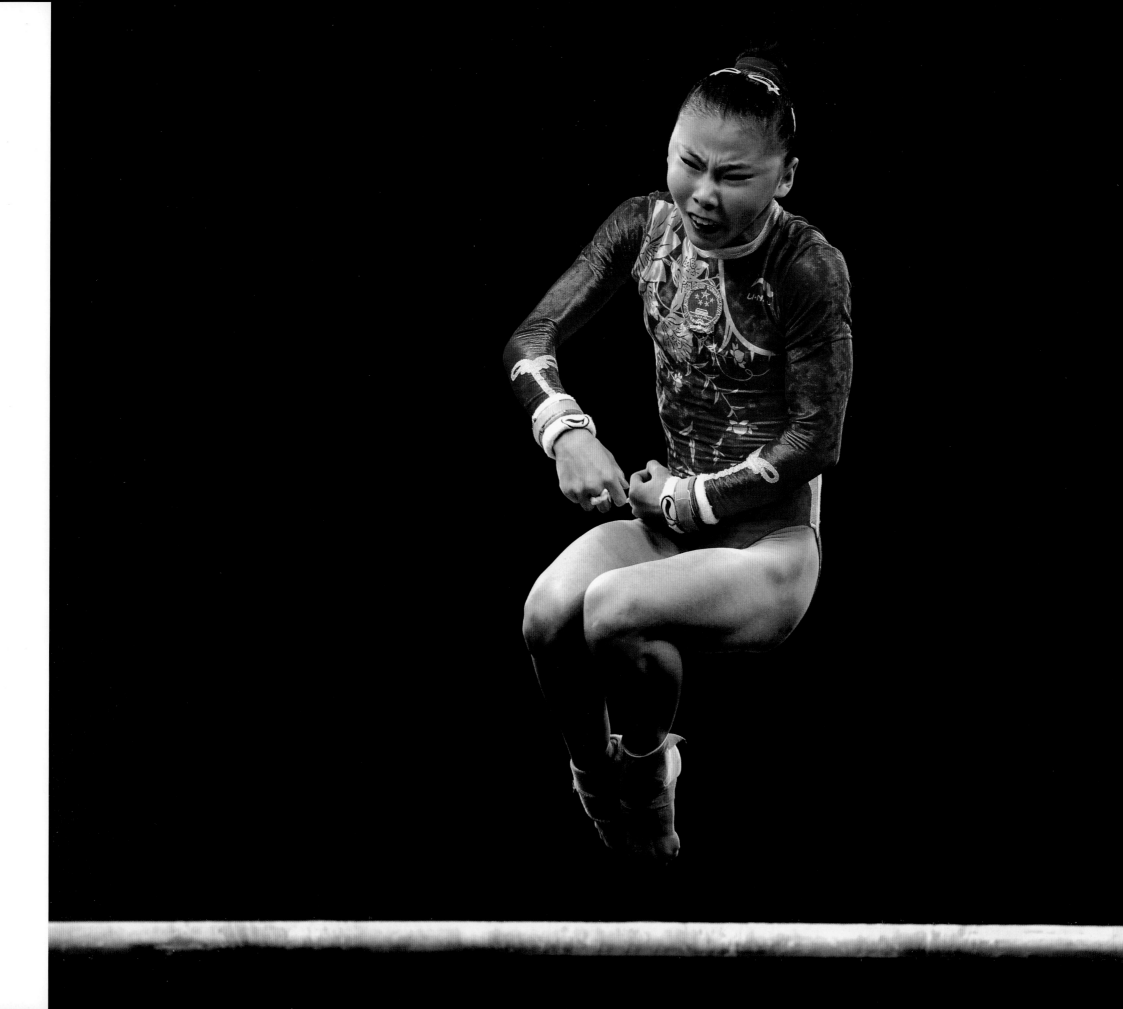

YANG YILIN

A nice action shot from the Beijing Olympics. It's the clean background that makes this picture.

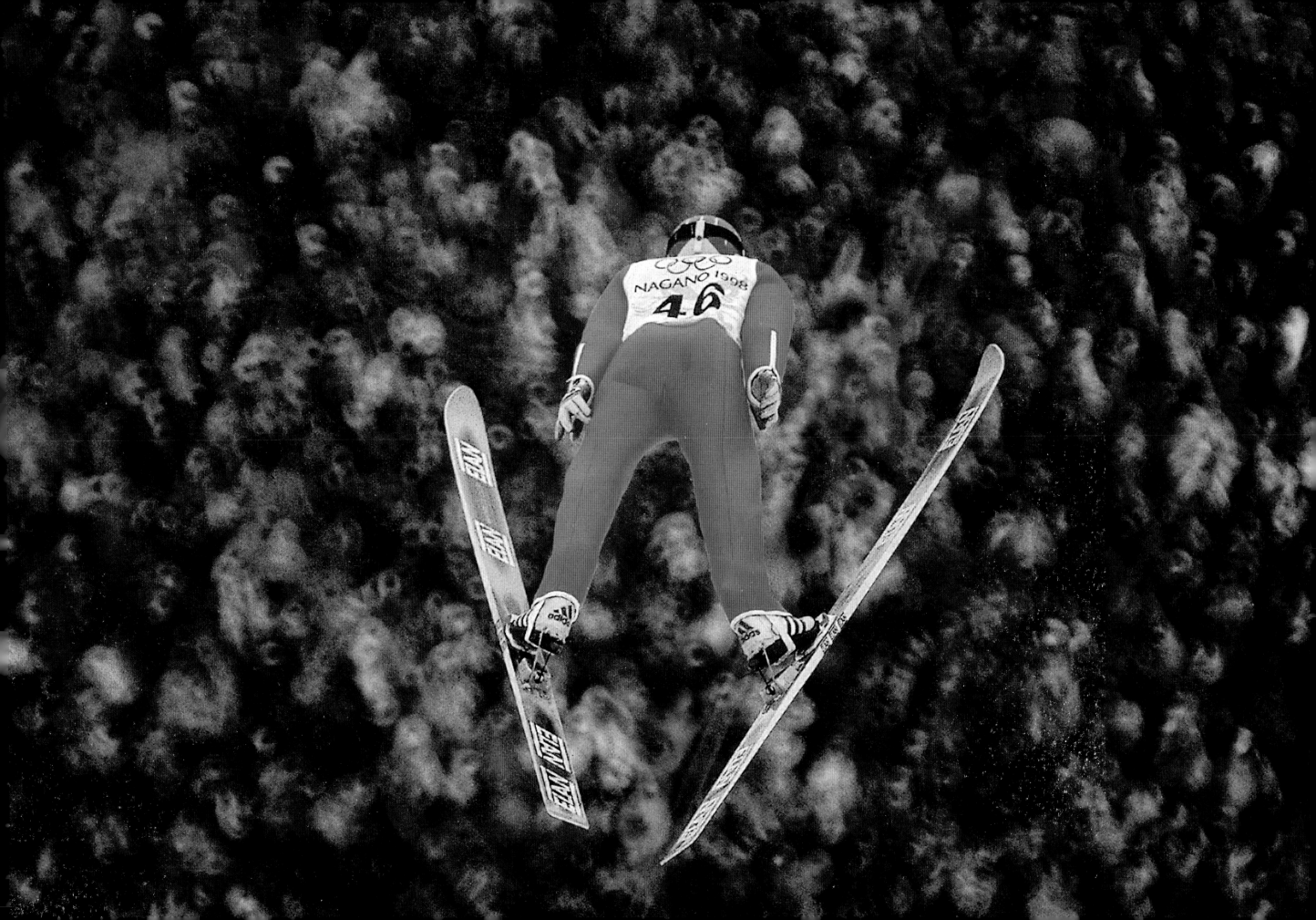

JAPANESE SKI JUMPER

This is another mirror lens picture, taken from the side of the ramp at the Nagano Winter Olympics in 1998. It was a very dull day so I used the colourful, 100,000-strong crowd as the background – on a clear day I'd probably have shot against the sky – and of course the bright pink suit of the Japanese competitor helps.

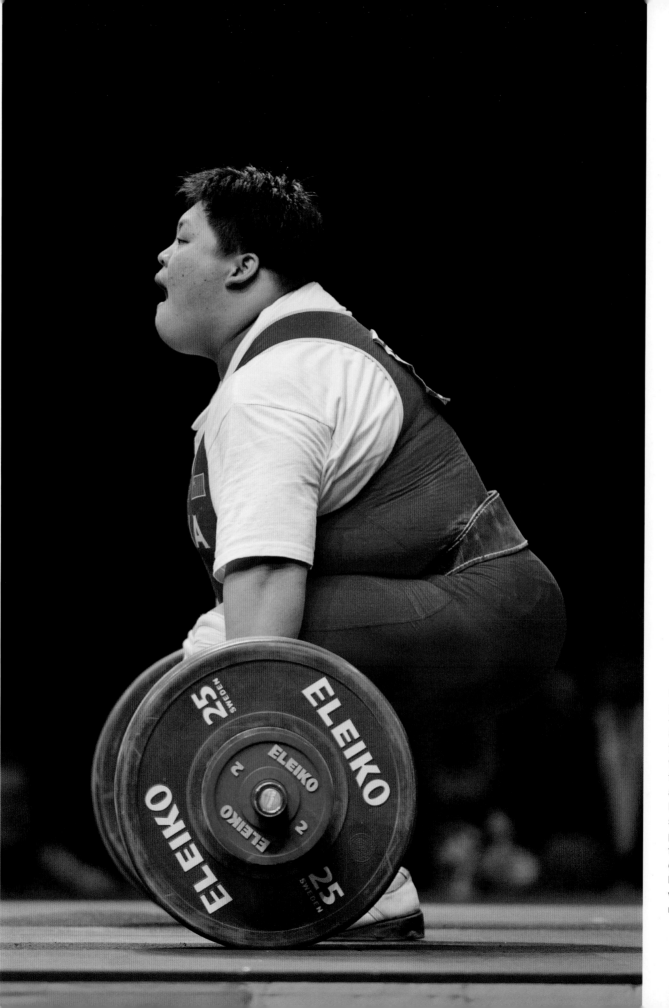

MU SHUANGSHUANG

Shuangshuang was the favourite and gold medal-winning Chinese athlete in the women's weightlifting at the 2006 Asian Games in Doha, and I realised that to show her incredible size and power the shot worked better from the side – I was in the crowd using a telephoto lens – and shot when she was taking the strain, rather than actually lifting.

BODY BUILDERS

I have to say that when I first saw these body builders at the 2006 Asia Games I thought they looked hysterical. This was the category for men up to 75 kilos so we had this line-up of 'midgets with muscles' all painted gold. I tried close-ups but the wide shot was the best.

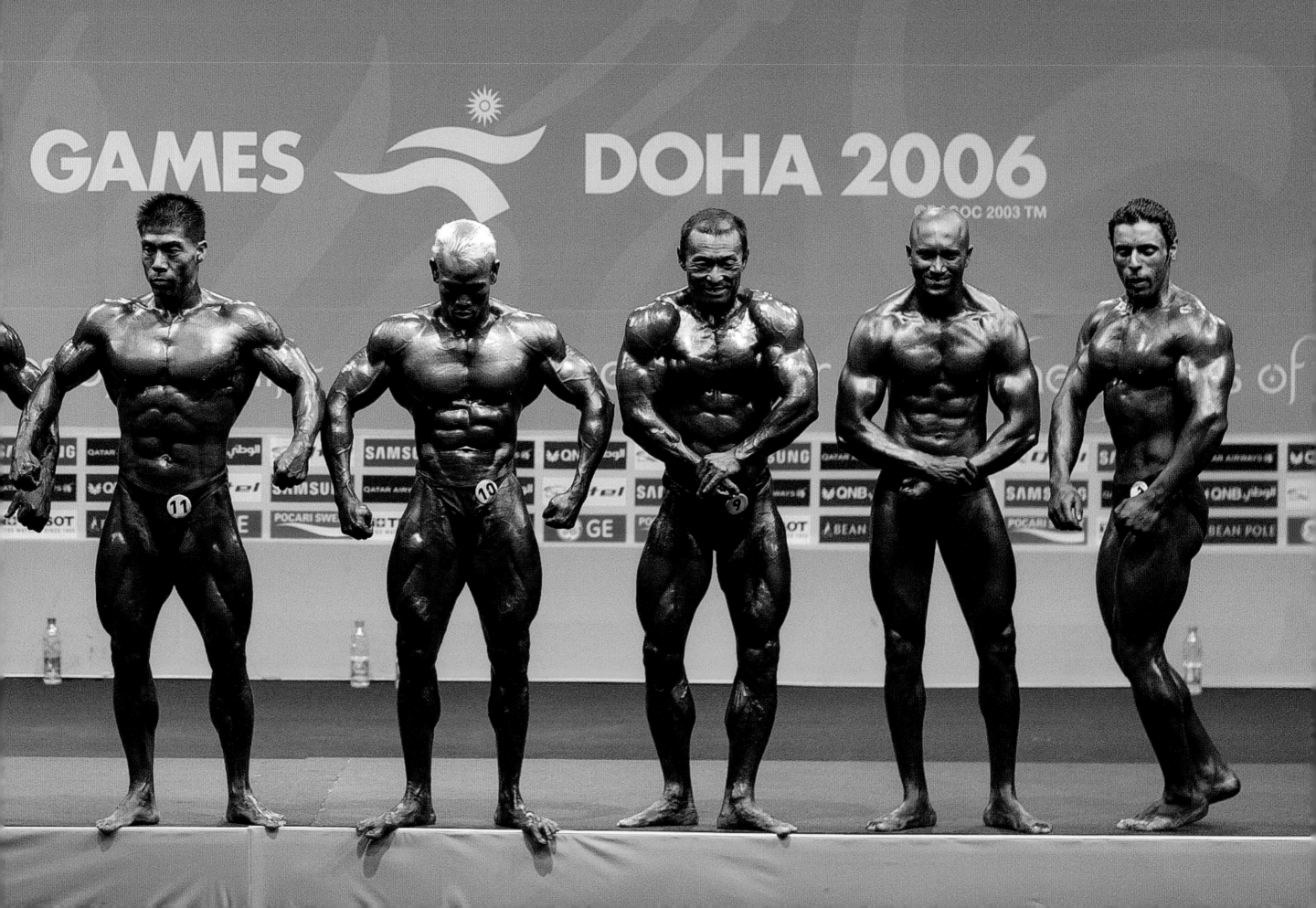

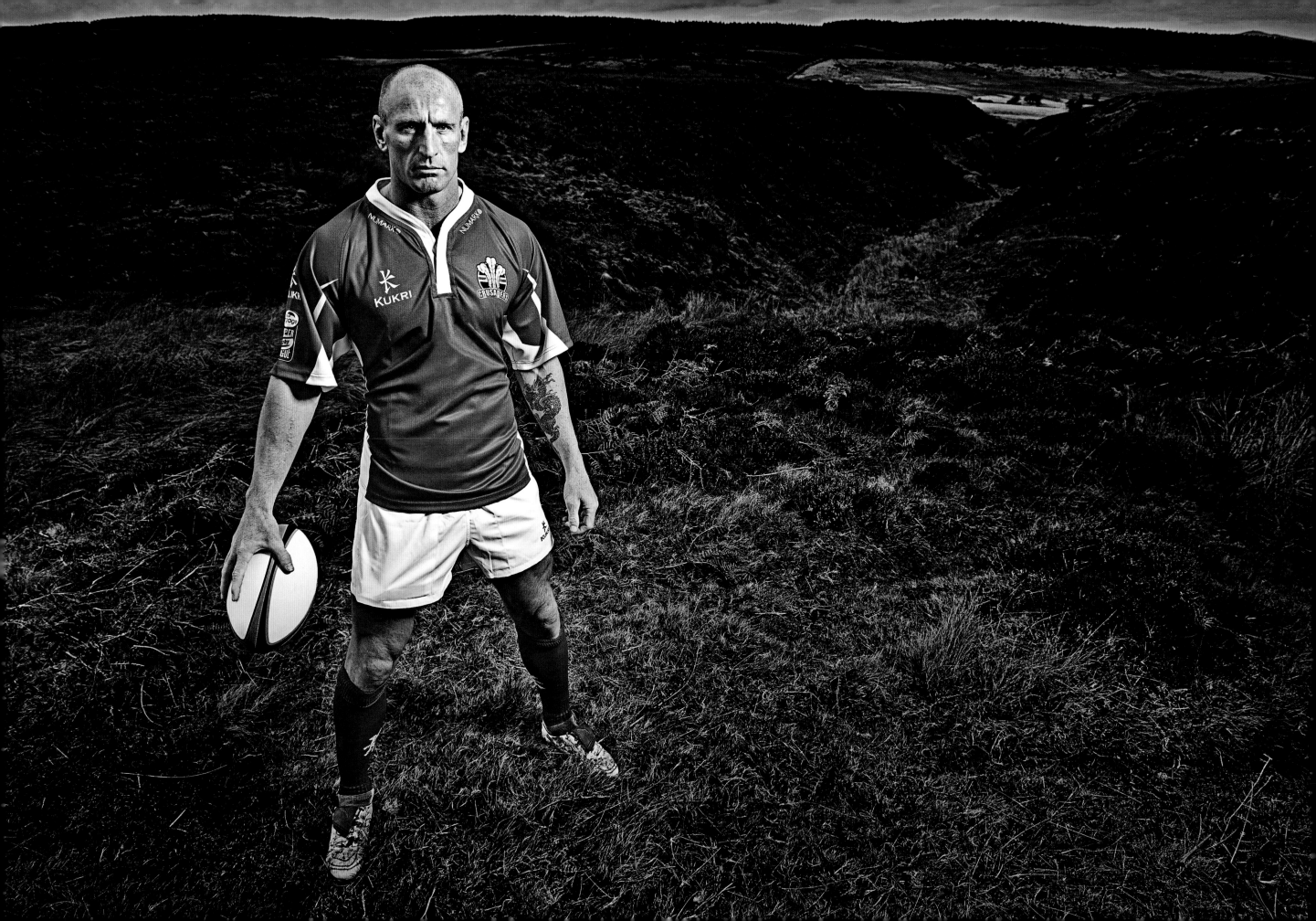

ICE HOCKEY-PLAYING MONK

For a preview of the Nagano Winter Olympics we shot pictures of four different locals. This was an ice hockey-playing Buddhist monk who, ironically, had lost all his teeth in fights on the ice.

GARETH THOMAS

I wanted this portrait of Welsh rugby star Gareth Thomas – who had just come out as gay – to be gritty and 'hard', with the red shirt against the stark landscape of the Welsh Valleys. The only problem was that we couldn't get hold of a proper team shirt in time, so we bought an XXL shirt from the Crusaders club shop and my terrified assistant, Tom, had to clip it together behind his back with bulldog clips. Gareth screamed in agony when Tom clipped his skin to the shirt!

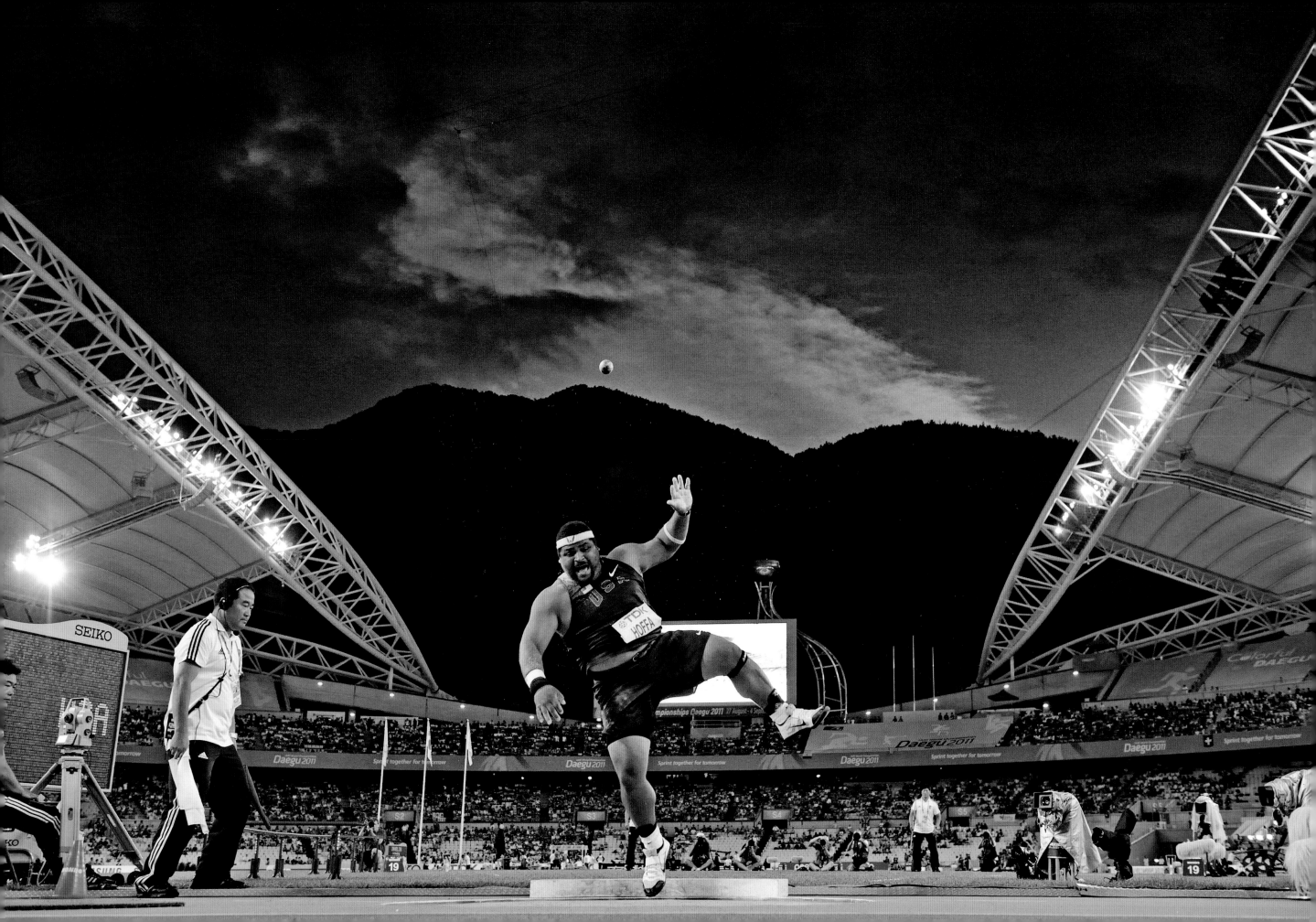

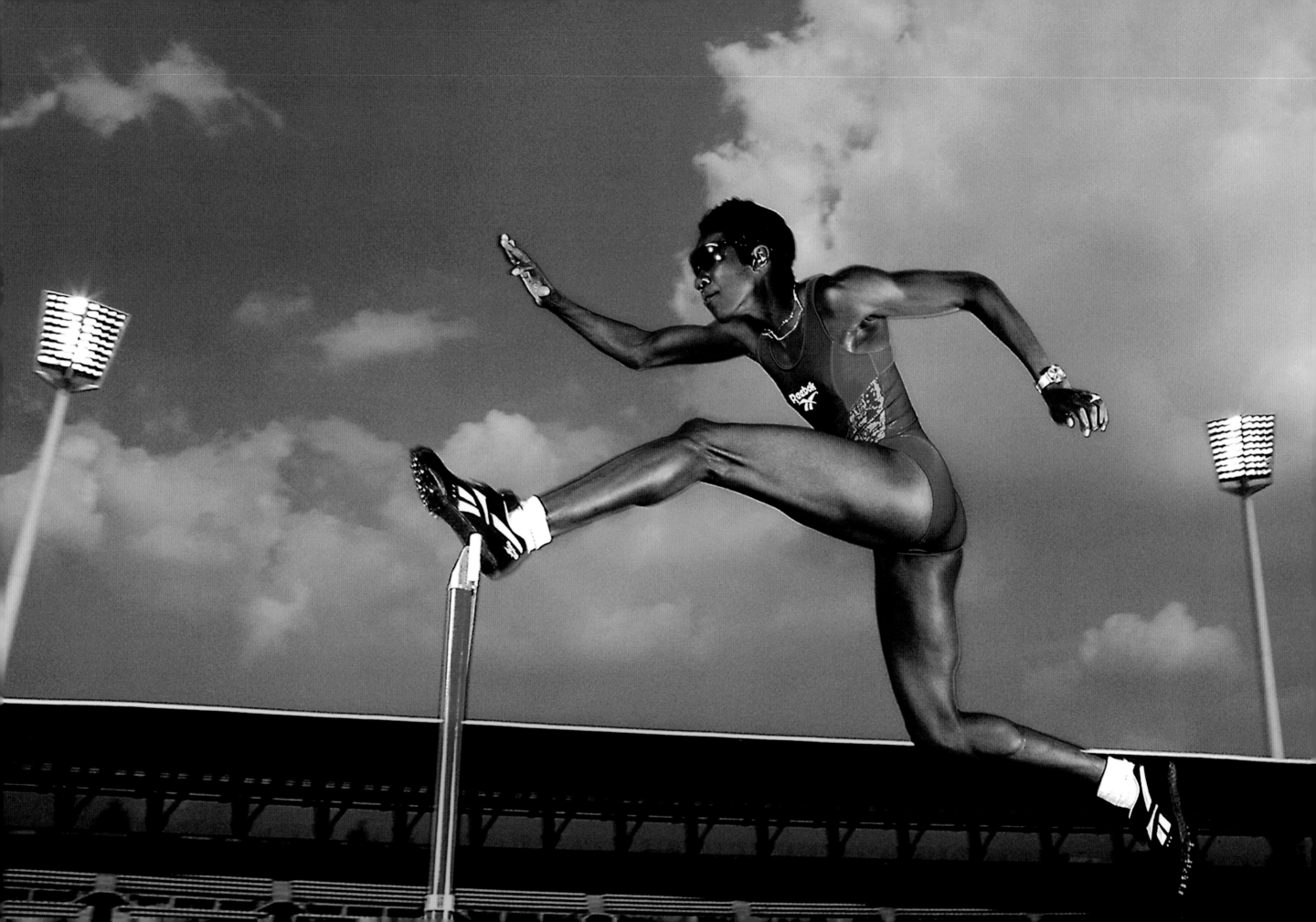

Previous pages:

REESE HOFFA

At the World Athletics
Championships in Daegu
in South Korea it had been
raining all day when suddenly
the clouds cleared and this
golden sky appeared. Then
I was panicking because I
needed to get an American
shot putter, and it really
needed to be Hoffa because
he was the only one who span
all the way round like a discus
thrower and would therefore
be facing the camera. Five
minutes after I got the shot the
sky literally turned pitch black.
All of which goes to show
that you always need the right
combination of everything
to get the perfect shot.

KIM BATTEN

I managed to persuade the
great US hurdler Kim Batten
to jump about 10 times to
get this action portrait. A
few months earlier Batten
had broken the 400 metres
world record at the World
Athletics Championships in
Gothenburg. As she was
jogging round the track
on her lap of honour I was
shooting her celebrations
from in front of her, running
backwards as I shot. But
unfortunately I had forgotten
what event it was and
went crashing into one of
the hurdles, landing on my
head and smashing about
£6,000 worth of equipment.
I was wondering if maybe
I'd got away without anyone
noticing but then I realised
the whole stadium had gone
a little quiet, and when I
finally stood up there was
an enormous cheer. Many
of my so-called friends
stopped shooting the
celebrations and started
taking pictures of me. When
we were doing the portrait
I mentioned to Kim that it
was me who had fallen,
and she laughed and said:
"I thought you had died!"

SIR ROGER BANNISTER

Taken for a *Sports Illustrated*
feature on the greatest
achievements ever, this
studio portrait of Sir Roger
Bannister was taken
against a background that
had been flown over from
New Zealand where it had
been used for a shoot with
Sir Edmund Hillary. The
two portraits were then
put together to appear as
one in the magazine.

BERLIN MARATHON

The story here was that the runners would be going through the Brandenburg Gate, shortly after the Berlin Wall had come down. But the only way I could get a shot from the air was to negotiate my way on to a French helicopter as the border was still controlled by the British, French, Russians and Americans. The helicopter was just like something out of the Vietnam war, with open sides, and I sat in the gunner's position while this French pilot with a cigarette in his mouth swooped down between buildings and I shot away like I was firing a machine gun. He had to fly like that to get me low enough to get a decent shot through the fog. The picture appeared on the front of *Life* and *Stern* magazines, and on the front page of many of the British newspapers.

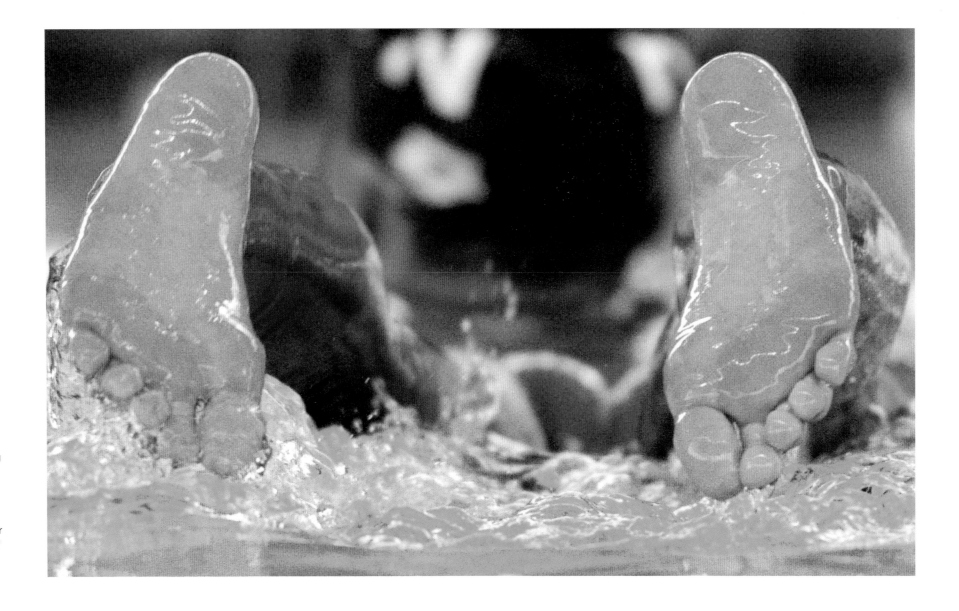

WOMEN'S
TRIATHLON

The problem with
photographing the Beijing
Olympics was that the
venues didn't really look
particularly Chinese – the
backgrounds were nearly
always of a grey, smoggy
city. But the triathlon venue
was some way outside town
so we had a rare blue sky,
and of course this pagoda
gives the shot a real sense
of place. I arrived at the
venue really early to secure
a good position, and I had
to lie down underneath a
metal barrier – half in the
water – to get the shot.

KRISZTINA
EGERSZEGI

A big star of the Atlanta
Olympics, I was following
Egerszegi as she made
her way out of the pool,
hoping to get a nice
headshot. As she swam
over the lane markers her
feet flicked up and out of
the water and I got this
unusual swimming shot.

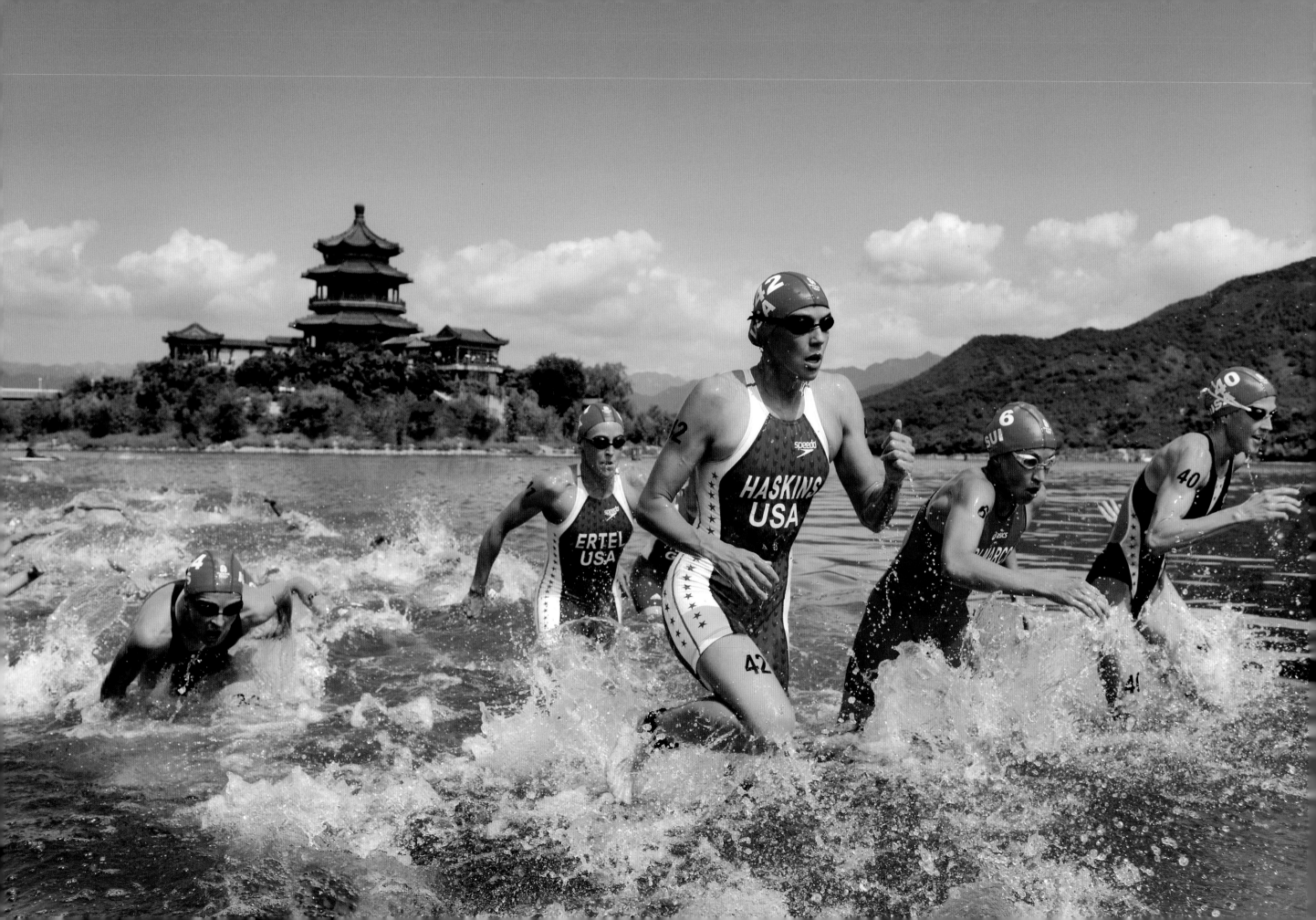

Previous pages:

ALEX HUA TIAN

Tian – the son of a Chinese airline owner and his English wife – was China's first equestrian Olympic competitor, having been to school at Eton. I needed to make him look as much like an Eton schoolboy as possible, which is why it was appropriate to shoot him in his dressage uniform.

MESERET DEFAR

I flew to Addis Ababa in Ethiopia for a few days to photograph one of the great female athletes near her home village. On arriving at 2am, we were informed that she would only be available that day, so after just a couple of hours sleep I was picked up from the hotel and driven to the village. It was a classic African village with mud huts and (perfectly behaved) goats and I realised after taking the first frame that the job was in the bag. I was back on the plane home that afternoon. If only it was always that easy.

PRINCE NASEEM HAMED

I waited for six hours for Naseem to show up at his gym in Sheffield, then he gave me two minutes. He was not in a great mood but I think that maybe contributed to a great, moody portrait. He was a larger than life character with a serious attitude and you can see that in the action shot (left) where he is taunting his opponent, 'Boom Boom' Marco Antonio Barrera.

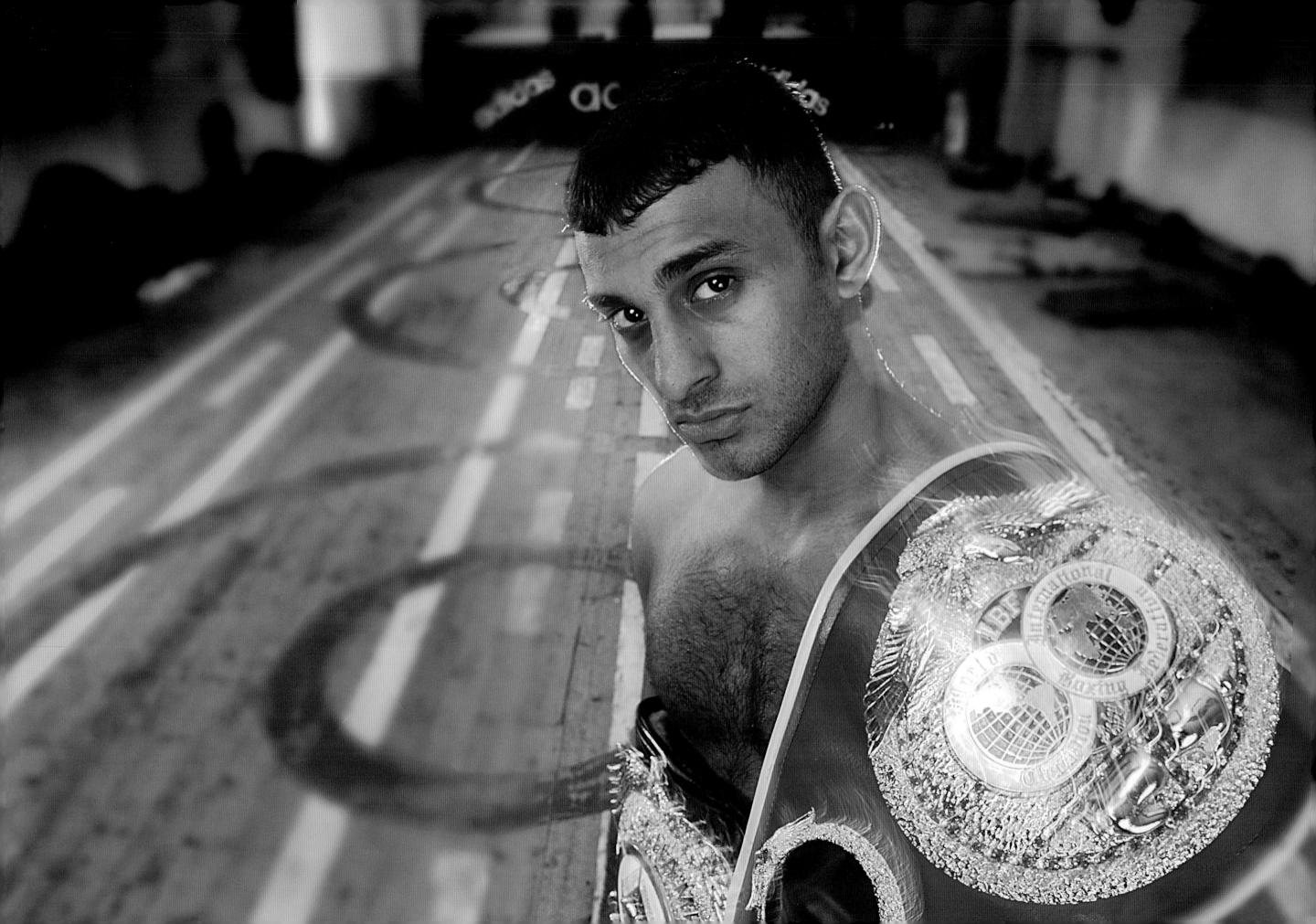

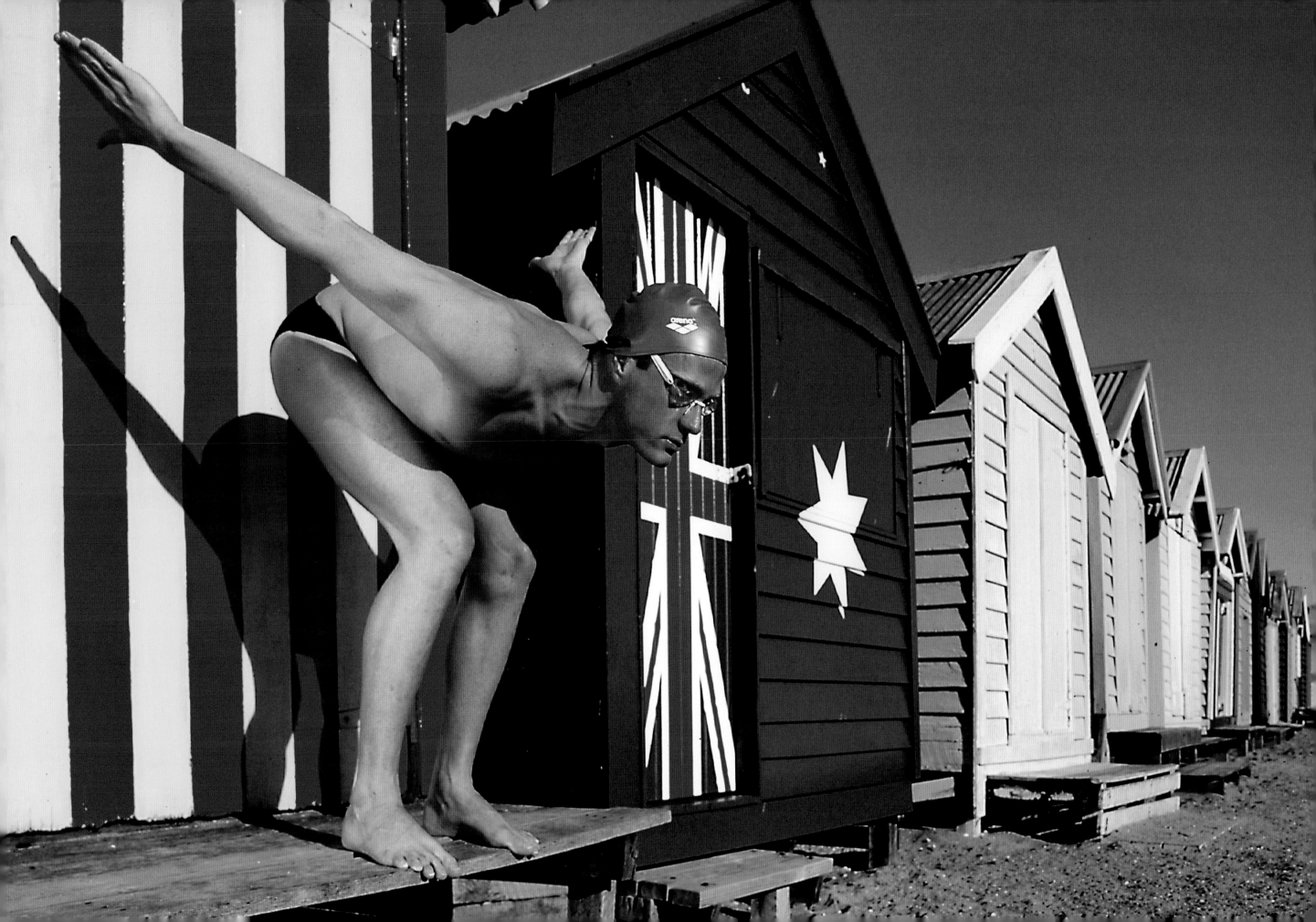

ON TOP DOWN UNDER

BY JOHN FRENCH

I first met Bob back in 1990 when we were both covering the Commonwealth Games in Auckland. He was heading up a team of photographers for Allsport and I was doing the same for *The Age* newspaper in Australia. We were kind of bouncing off each other every day, and by the end of the two weeks we had become good mates.

For many years we were rivals whenever he came down to Australia, mainly for the golf or the Australian Open tennis. We were always in competition with each other but still stayed the best of friends. I knew I could beat most of the agency guys when it came to getting the best pictures, but when Bob walked in – usually all hot and flushed just off the plane – I knew I had serious competition.

By the time he was working for *Sports Illustrated* I was really admiring his work. He was always looking to do something different. Not just sitting there shooting, he was always trying to beat everybody by getting the picture that no one else had.

When we were covering events together you would always look where Bob was walking and you'd think, 'What the hell is he going there for?' And you'd rack your brain. It was no use just walking up there and standing beside him because you still had no idea what he was shooting. It was very nice when Bob wandered up beside you – with his man carrying all his camera gear, the blighter, while we were all carrying our own – and started shooting away. You thought, 'Ah well, I must be doing something right.'

I think this set of pictures of the great Australian swimmers of the early 2000s is a brilliant example of what sets him apart from the rest of us mere mortals. Mind you, the fact that he was doing it in my backyard, getting these incredible pictures from right under my nose, was enough to drive me insane.

Take the portrait of Daniel Kowalski in front of the beach huts. If I had sent one of my guys to take that portrait I can guarantee he'd have come back with a nice picture of him in his togs, sitting on the step looking down at the camera. Who would have thought of having him in his swimming gear in a prone position, ready to dive off? Only Bob. Immediately you see it, it makes you go, 'Ooh' and start thinking.

Most people look at a picture like this and they don't really know why they love it. But the thing you need to realise is that Bob would have worked out that shot in his head three or four days earlier. He would have scouted the location, worked out the best time of day for the sun, and what lighting he would need. That's one big side to his craft. He's made the shadow nice and clean and hard but also lit it so you get all the detail of the background. He's an expert at that and probably had to haul a ton of gear miles down a beach – or got someone to do it for him!

It all comes from this perfect understanding of the light. At the Australian Open tennis there's one shot that we do from high up above the court, looking

Left: A portrait of Australian swimmer Daniel Kowalski in front of the beach huts on Brighton Beach, Melbourne. I'd seen the huts in a postcard whilst researching locations, and when I got down there and saw that one of them was painted with the Australian flag I knew it was the perfect location

down on the players serving. The shadow comes in each day at about five to five and it is perfect for getting the server coming out of the shadow and into the sunshine for literally about five minutes. You'd be up there every day and then, just as the light became perfect for the shot, in would walk Bob, barge a couple of people out of the way and, bang, bang, thank you very much. Totally calculated.

The picture of the Cronulla Surf Club guys is another classic. This scene is synonymous with Sydney and Australia. It's a timeless photograph. It could have been taken 100 years ago or yesterday. The sky is so strong and rich and the shadow isn't too hard. Again it's all about taking the shot when the light is perfect. No compromise. Plan it and get it spot on.

Because of his reputation and because he was working for *Sports Illustrated*, by this stage of his career people trusted him. They knew that whatever he asked them to do he was going to make them look good. I'll never forget when he managed to get Cathy Freeman to pose in front of the Twelve Apostles rocks right down in the south of Australia. That would have taken some organising.

But the picture in this set that really sums up what Bob is about for me is the shot of all the great Australian swimmers of the time, posing on the beach and the rocks with aborigines with didgeridoos. This was a picture that every picture editor in Australia would have dreamed of getting at this time. Apparently Channel Seven television got wind of it and were running around everywhere trying to find out where the shoot was taking place. But most of us knew nothing about it until we saw it

Left: I spotted the lane markers lying all messed up in the pool and thought it would make an interesting picture. Susan O'Neill looks a bit like, 'What the hell am I doing here?'

Right: I'd seen these surf clubs marching at the life saving festivals they have in Australia which are timeless events – they've hardly changed for 100 years or so – but I wanted a nice, clean background. So I went to North Cronulla, one of the biggest clubs, and asked them if they'd mind posing for a portrait. They were delighted and they came marching over the sand dunes like something out of the 1920s.

continues on page 171

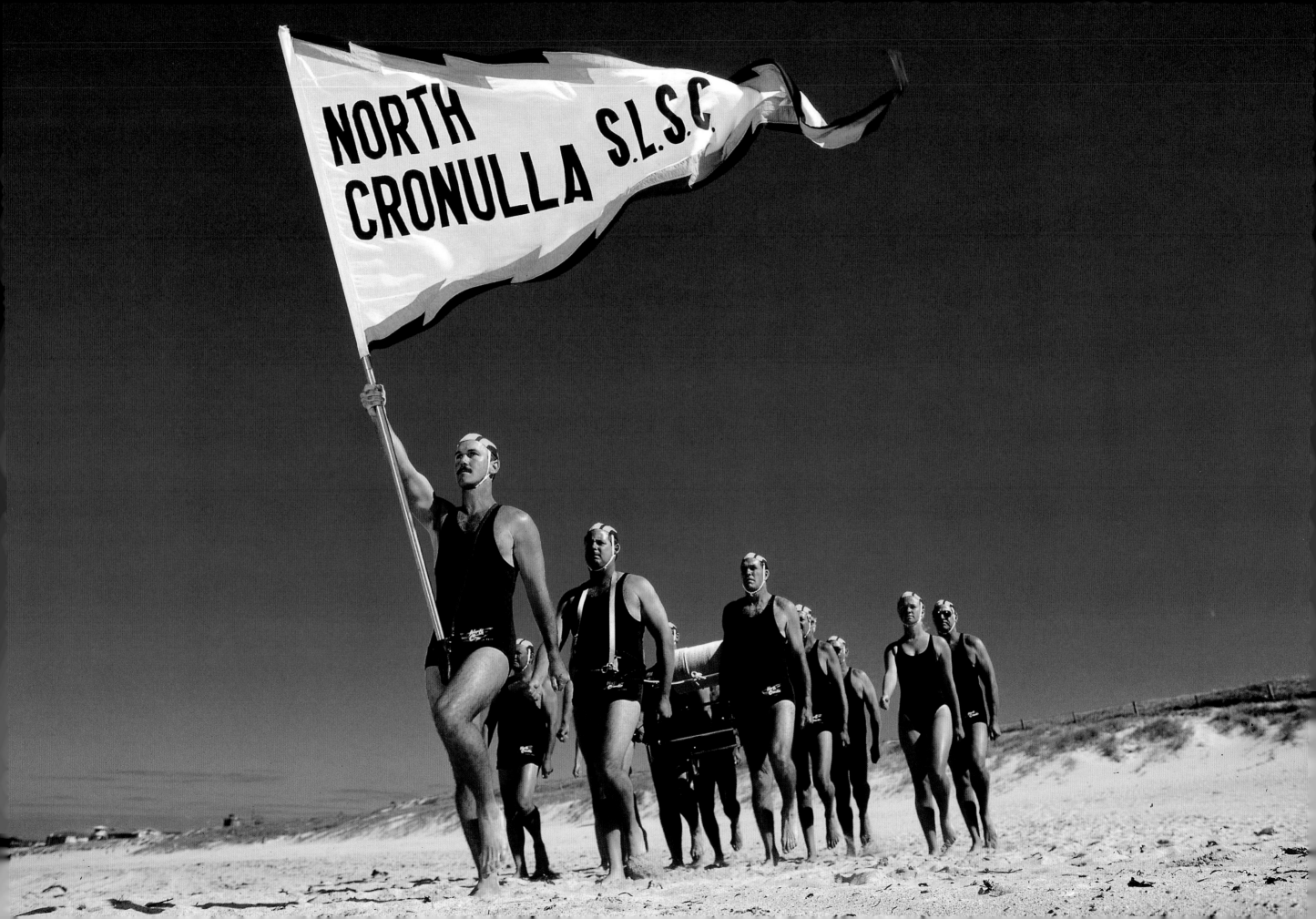

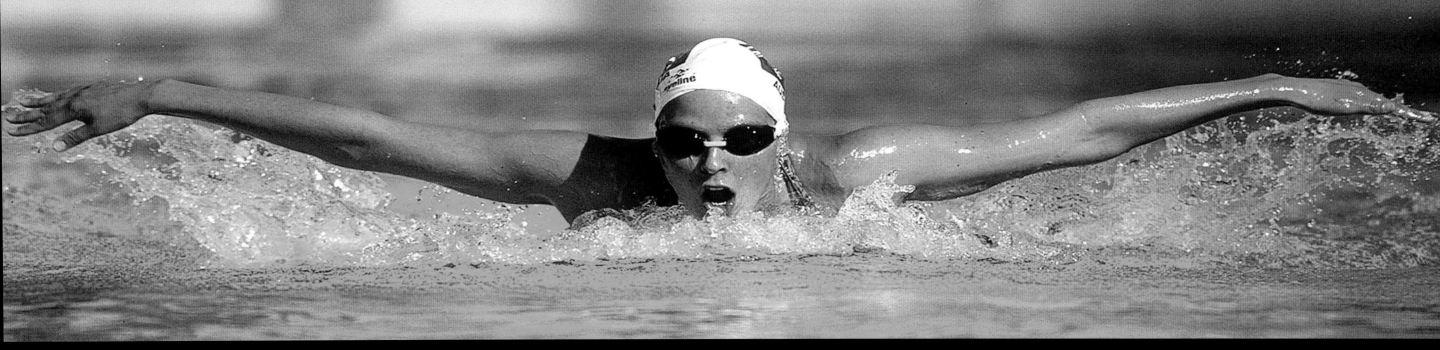

Above: Susan O'Neill
was a world champion
and world record holder
for 200 metres butterfly.
Hardly surprising with
that wingspan!

Right: Kieren Perkins
wasn't happy about posing
in his trunks in downtown
Brisbane. We managed it
by finding a quiet spot on
top of a Brisbane hotel.

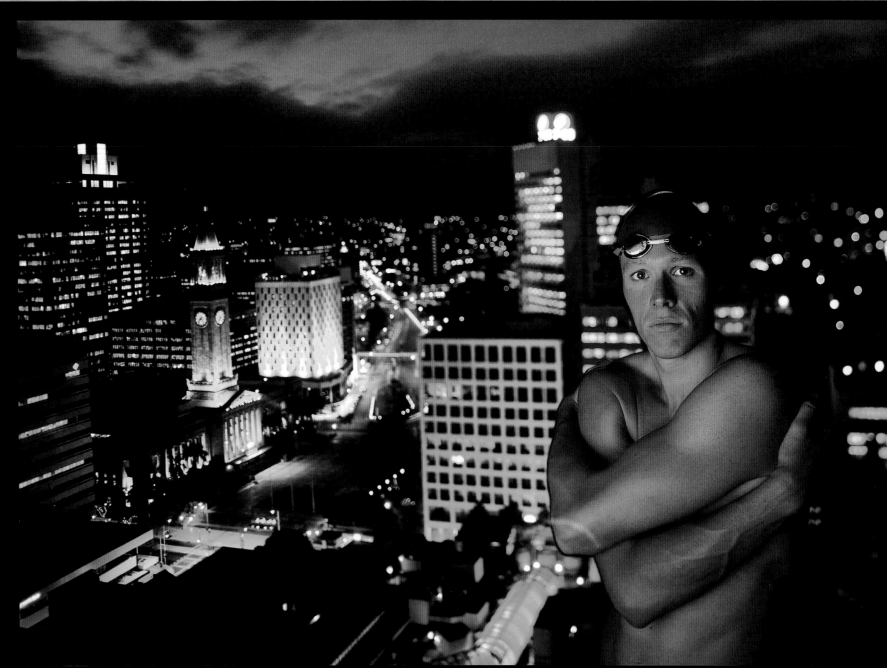

in *Sports Illustrated* a few weeks later. I could have murdered him. To go and do a picture like that, with all those swimmers in one group and with all that other stuff too, I mean people would have killed for that picture. I would have stood back 300 metres away with a 600mm to shoot that.

For Bob to have persuaded the Australian Swimming Federation and the swimmers to do a picture like this, and to keep it quiet from all of us, just shows you the lengths he would go to get a single picture. I can only imagine what the logistics of arranging this around the swimmers and their training schedules would have been like. God it would have been hard. To persuade them he would never have drawn anything out on a bit of paper or anything like that, he'd just have said, "This is how it's going to be, trust me." Bob just has this big presence but he's also very polite and well mannered. He is very persuasive and, as you can see from what he has got some of the sports stars in this book to do, people listen to him.

I think the best way for me to express the impact Bob has had on sports photography is to explain that in my last job before I retired I had 40-odd photographers working for me on a suburban newspaper group, and I made sure that all the guys who shot sport sat down and looked at Bob's website. I'd say, "Just have a look at this." And they'd say, "Oh wow, but look he's doing the Olympics and that." But I'd say, "You don't have to go to the Olympics to take great pictures. You can do them on your local sports field. It's probably even better." With the right background you can make a six-year-old child at a sports day look like a megastar.

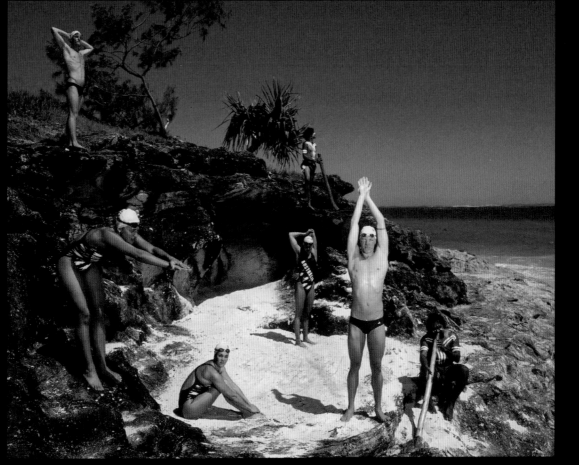

Left: When I phoned up an aboriginal society to see if I could get hold of a couple of extras for this picture they weren't very keen on the idea, but the fact that one of the swimmers – Samantha Reilly – was of aboriginal descent helped convince them. Then all we had to do was organise for five world champion swimmers to be flown from their training camp in Brisbane to Kangaroo Island, just off the coast not far from the city, by helicopter. All the Aussie snappers were amazed that I'd pulled this off.

And that was great because they could instantly see that you could do something amazing by thinking differently. I told the guys to think about their pictures, plan them and be open to new ideas. "It will work," I said. "Have half a dozen ideas running through your head and one might just work." Start thinking. Start doing something different.

John French is former Picture Editor of *The Age* newspaper, Melbourne.

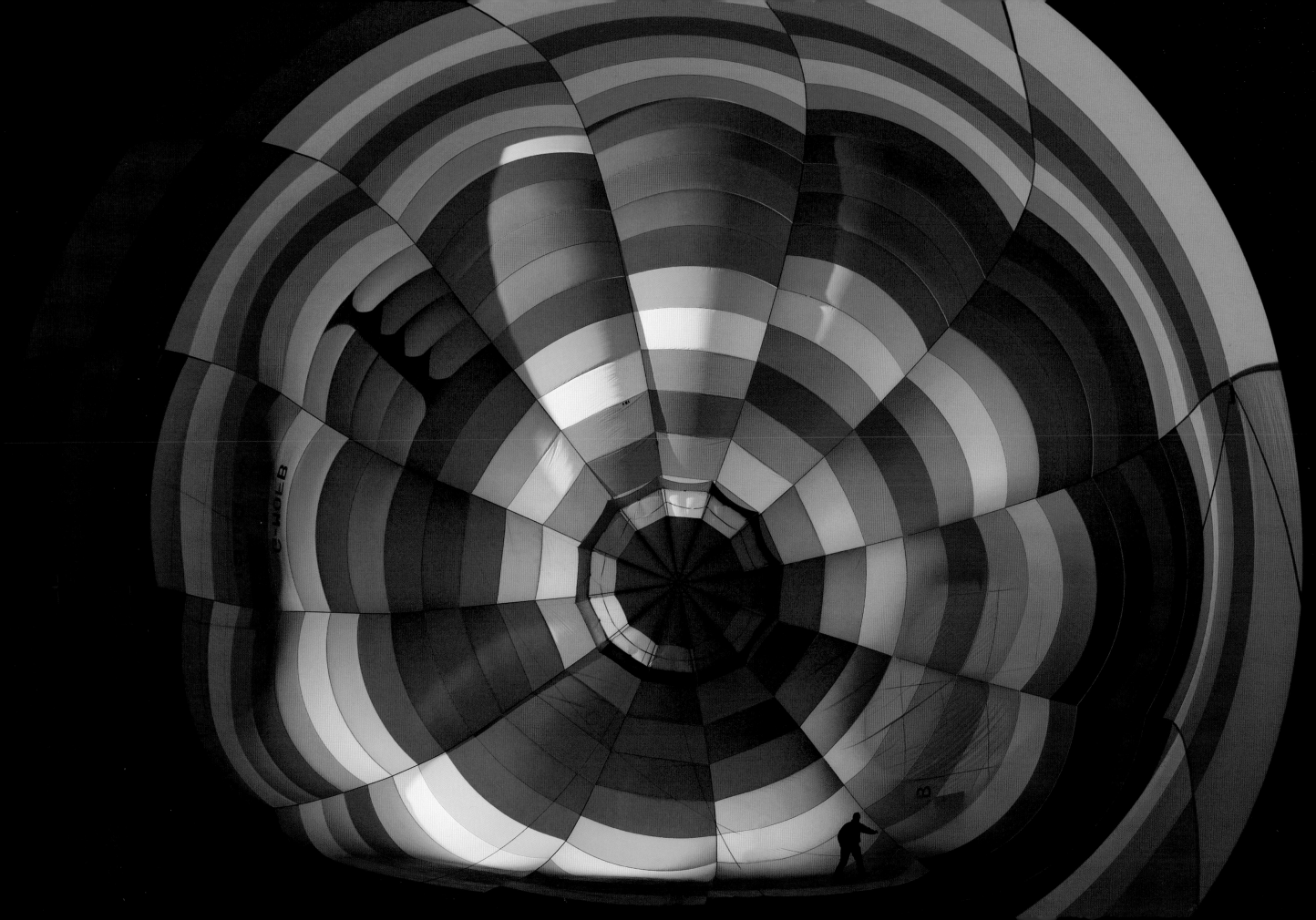

05

COLOUR & LIGHT

**CHATEAU D'OEX
HOT AIR BALLOON
FESTIVAL**

I went to Switzerland to
shoot beautiful balloons in
front of snowy mountains,
but when I arrived there was
no snow. Even the grass was
brown. I found some colour
by getting inside this balloon
as it was being inflated.

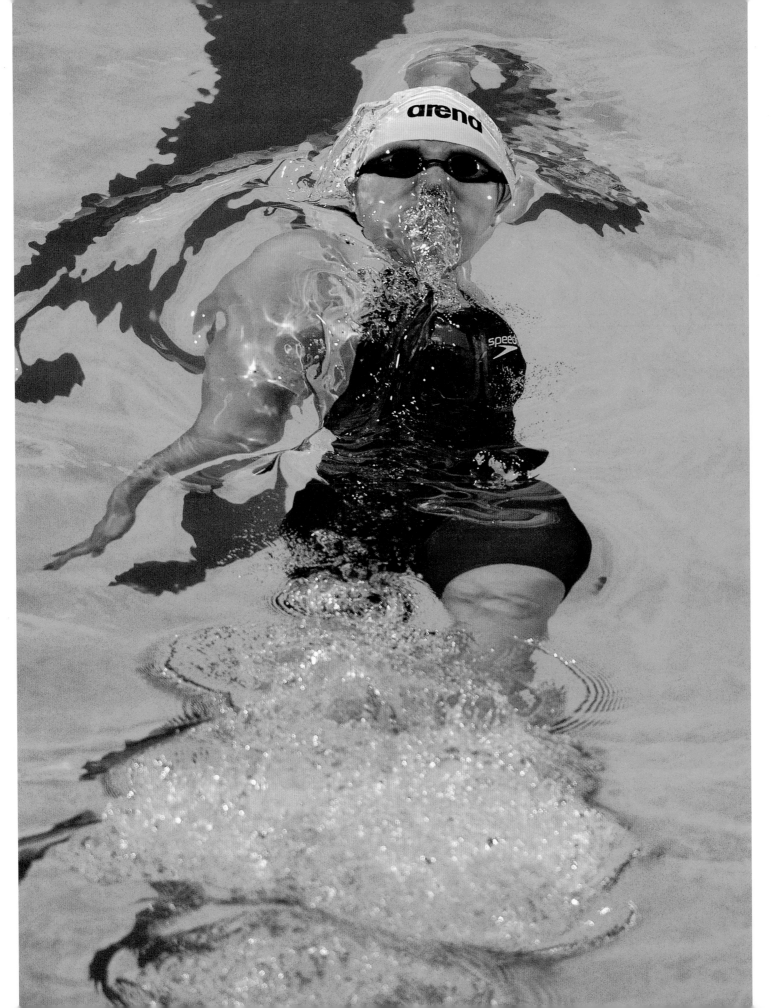

ZHAO JING

I have always loved the way water distorts the shape of swimmers' bodies, and this picture – taken after the start of a backstroke race just before the eventual gold medal winner surfaces – is a great example. I shot this on a massive telephoto lens from right up in the top tier of the stadium, and you can see that the only parts of the swimmer that are out of the water are her nose and the top of her head.

BONNIE BLAIR

Very early on in my career I was based in Florida for a winter and I was sent off to Wisconsin to do an action portrait of this up and coming speedskater who went on to become one of the greatest Olympic athletes in history. This little girl turned up in a baggy tracksuit and I couldn't believe her physique when she came out in her skin-tight racing outfit.

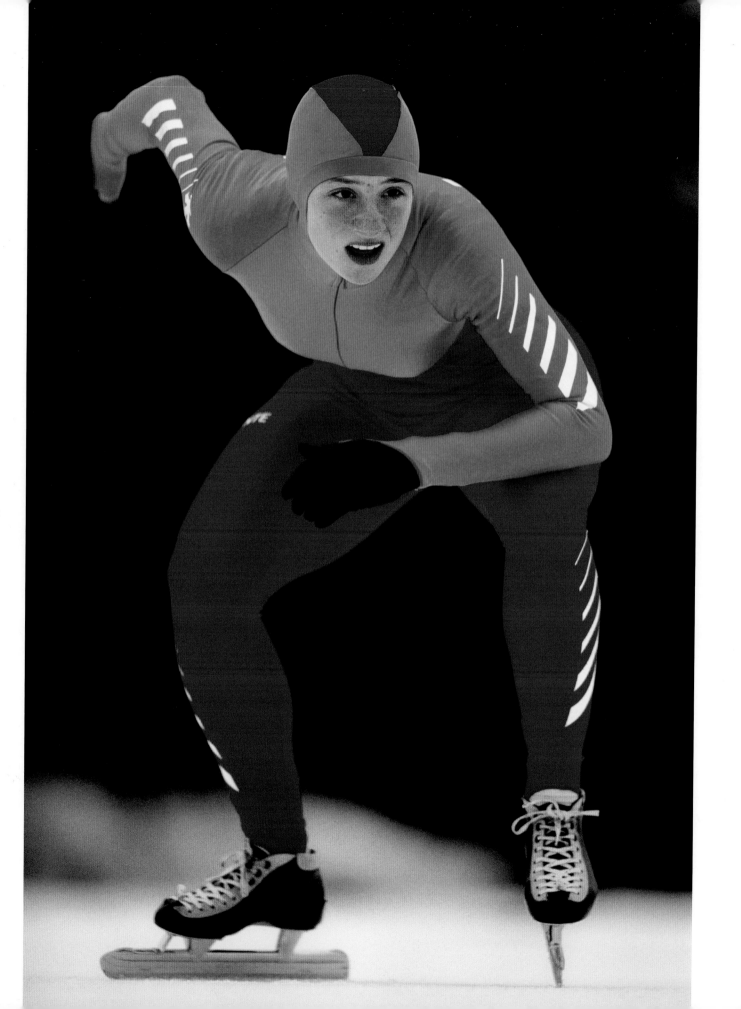

NICE TRIATHLON

As an enthusiastic, young and slightly mad photographer in the late 1990s, I was waist deep in the water to take this picture at the start of the Nice Triathlon. Today you wouldn't be permitted to get so close to the athletes.

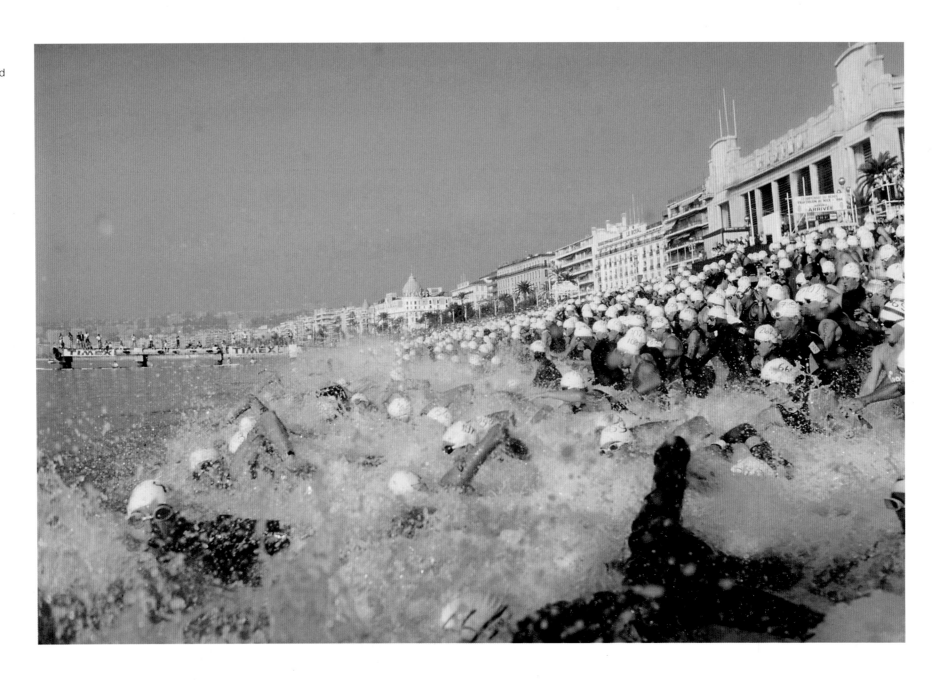

DAVE RAYNER

I went up to Shipley in Yorkshire to photograph Dave Rayner, who was the most promising British cyclist at the time. He was racing for a team called Team Raleigh Banana so I had the idea to photograph him going through the yellow rape fields. Sadly he was killed in a nightclub incident a few years later.

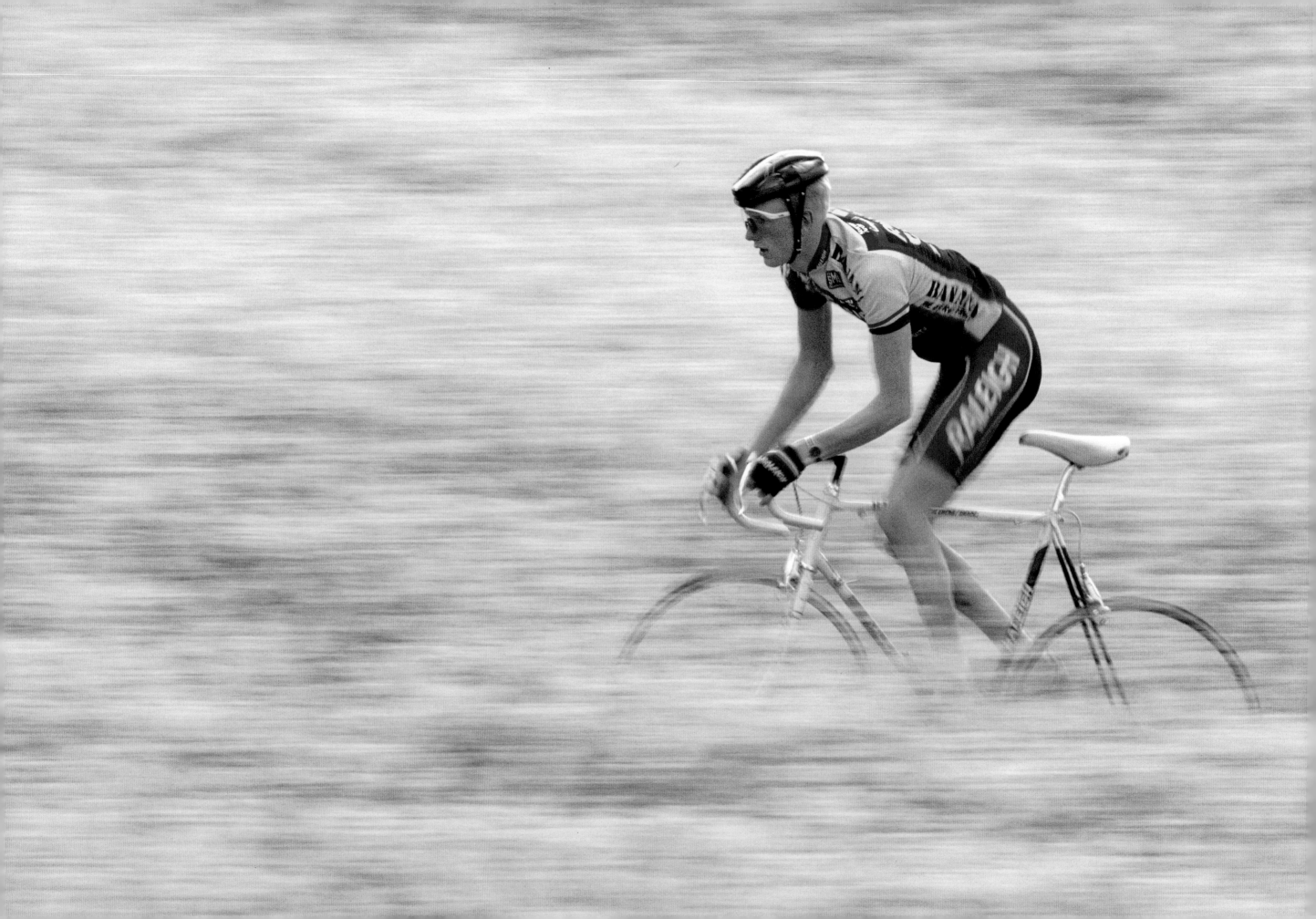

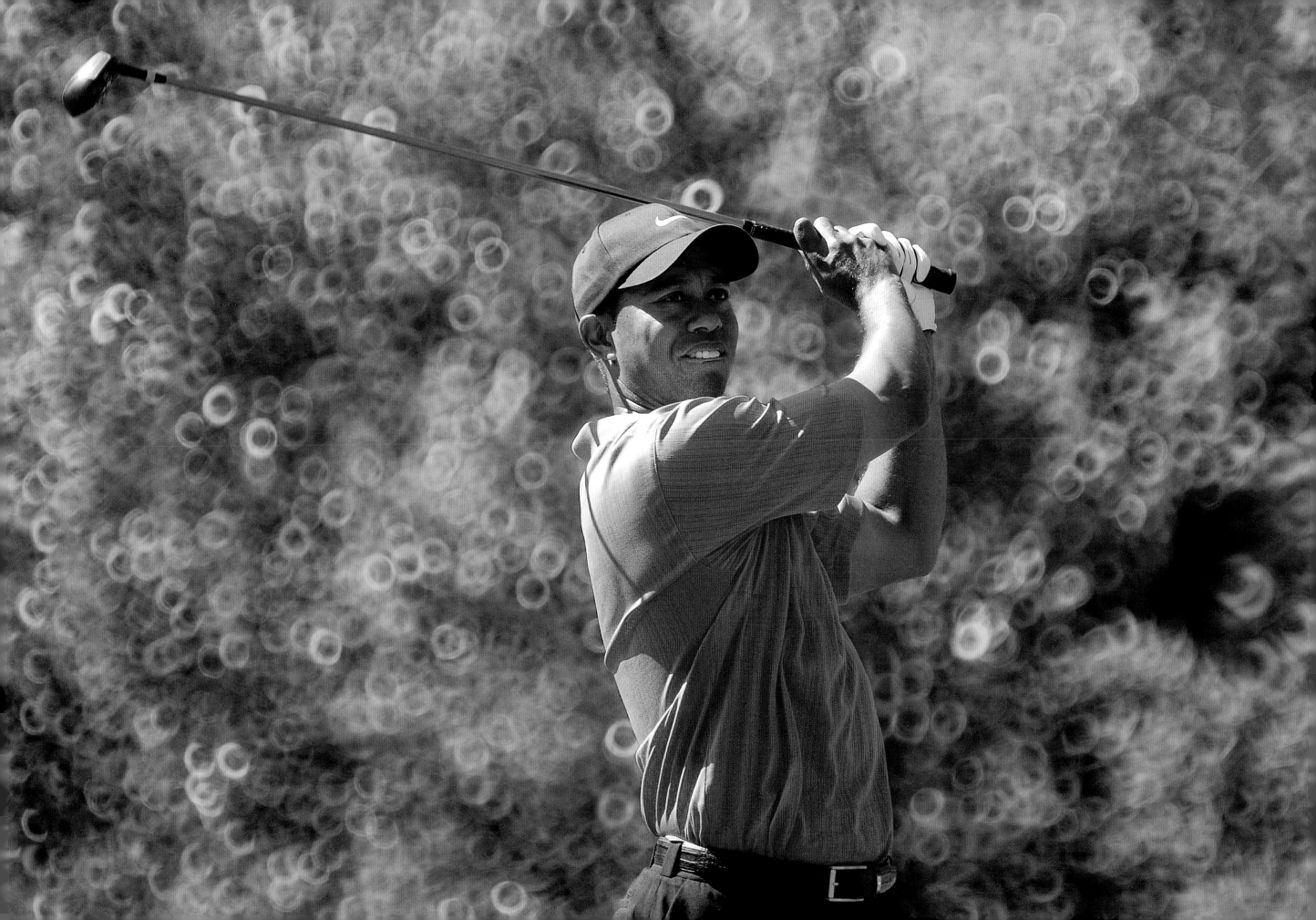

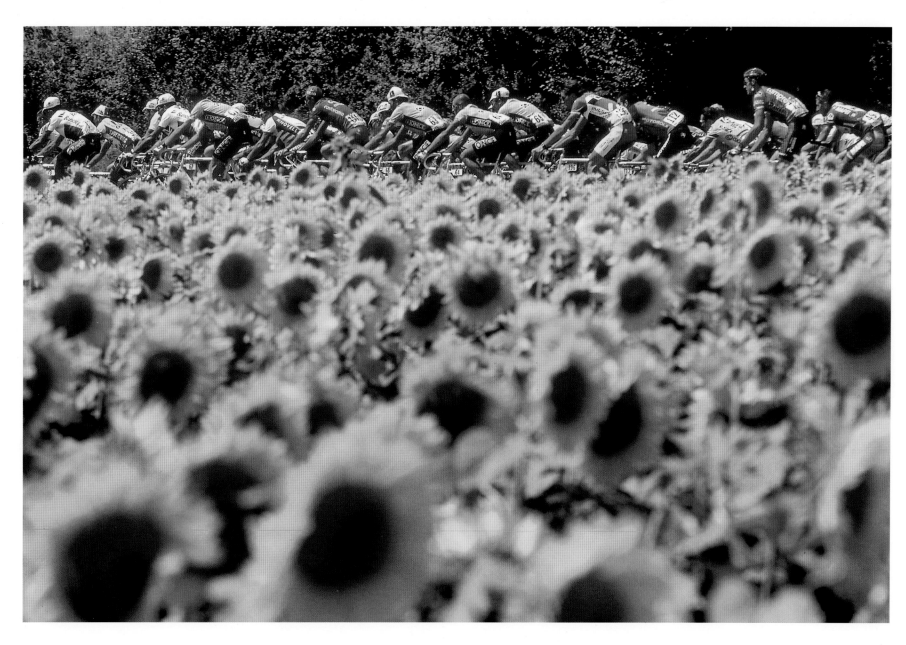

TOUR DE FRANCE

It's a bit of a cliché but when I went to shoot the *Tour de France* I really wanted to get a picture of the riders going past a field of sunflowers. We followed the race for five days without seeing a single sunflower until we were just about to go to the airport when we stumbled upon this field. I jumped out of the car and had five minutes to get into position before the peloton came through. Not only did I injure myself falling over on the rock hard ground but I suffer terribly from hay fever and, to cap it all, I emerged from the flowers covered from head to toe in yellow dust.

TIGER WOODS

Struggling to do something different at The Masters, I pulled out my mirror lens. The 'doughnut effect' worked really nicely on the unsharp highlights in the background of trees glistening in the sunshine.

SHAUN WHITE

A nice shot of the legendary USA snowboarder in action during the 2006 Turin Winter Olympics, where he won the gold medal in the half-pipe competition. To get into position to take a picture like this you need to watch the competitors in practice to see where they are getting 'air', as well as thinking about the all-important background. The snowboarders themselves actually hate shots like this because they don't show the lip of the half-pipe so they can't see exactly how high they have gone!

HORSE RACING ON ICE

Covering this event in St Moritz in Switzerland, the best picture of the day came after the leaders had come through and their hooves had thrown up a load of snow to create a cloud of white in the foreground, through which I could shoot the following pack.

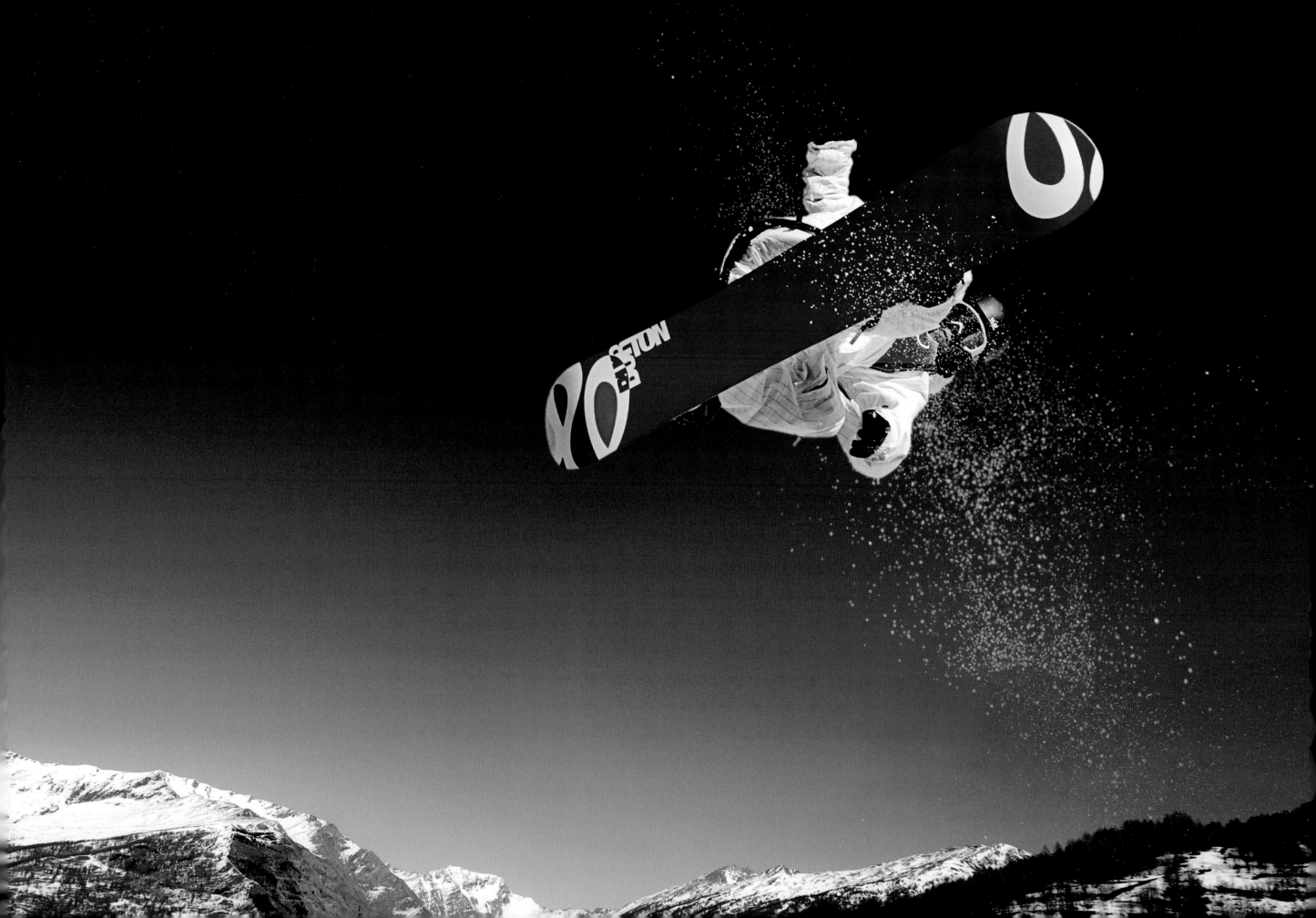

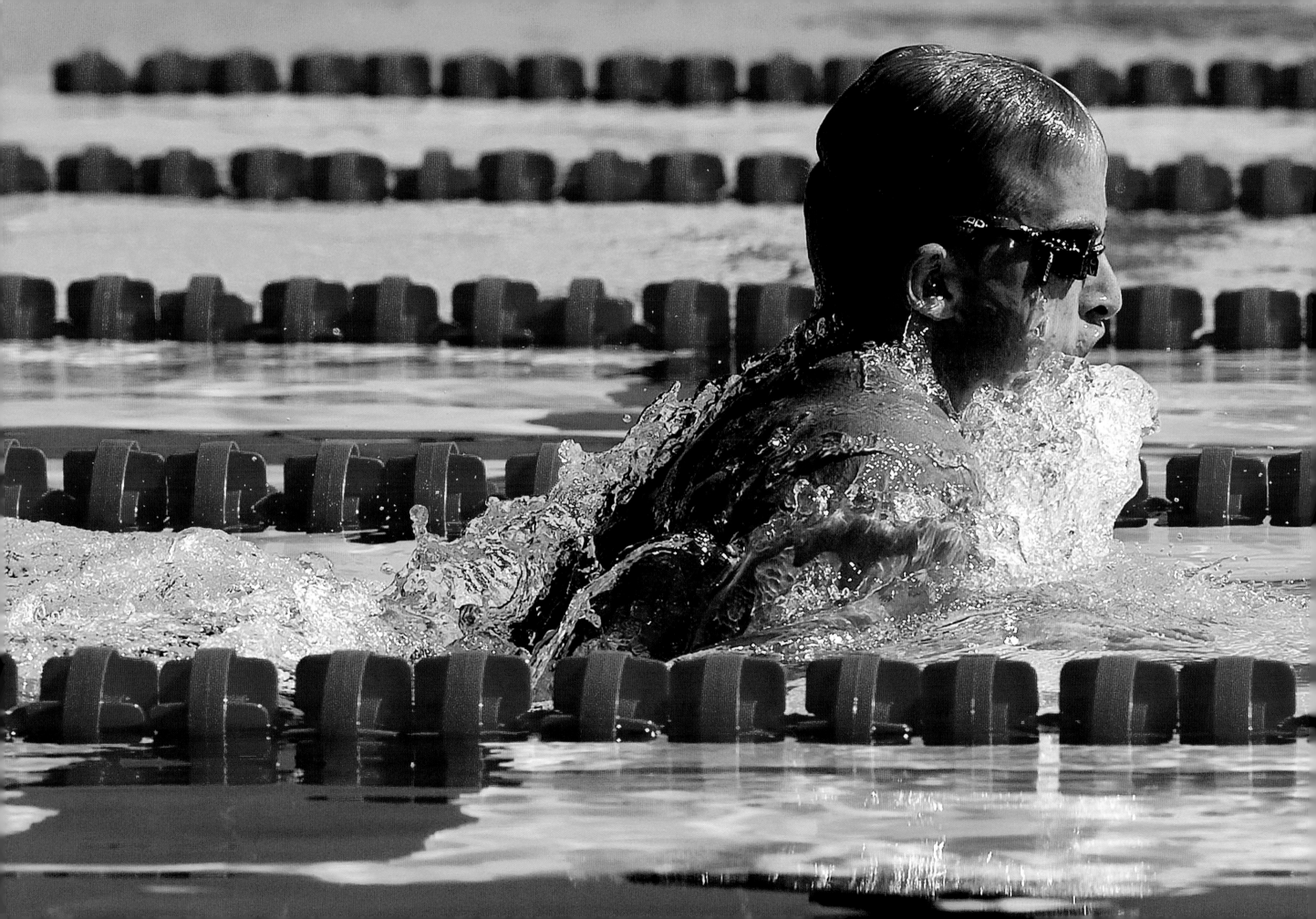

Previous pages:

LONE SWIMMER

I like this shot – taken at Fort Lauderdale in Florida where the US swimming team used to train – because it illustrates the hard work, single-mindedness and loneliness of training for an Olympics. It's a side of sport that most people never see.

OLYMPIC ROAD CYCLE RACE

Finally, a background at the Beijing Olympics that looks as if it's in China! An absolute no-brainer with that backdrop.

LONDON MARATHON

With a team of photographers, I have been shooting the official pictures for the London Marathon since 2013. The event is in April so the weather can be hit and miss but in that first year it was beautifully clear and sunny so the pictures were great. This is taken from the very top window of Tower Bridge, such an iconic London landmark, which I had negotiated special access to.

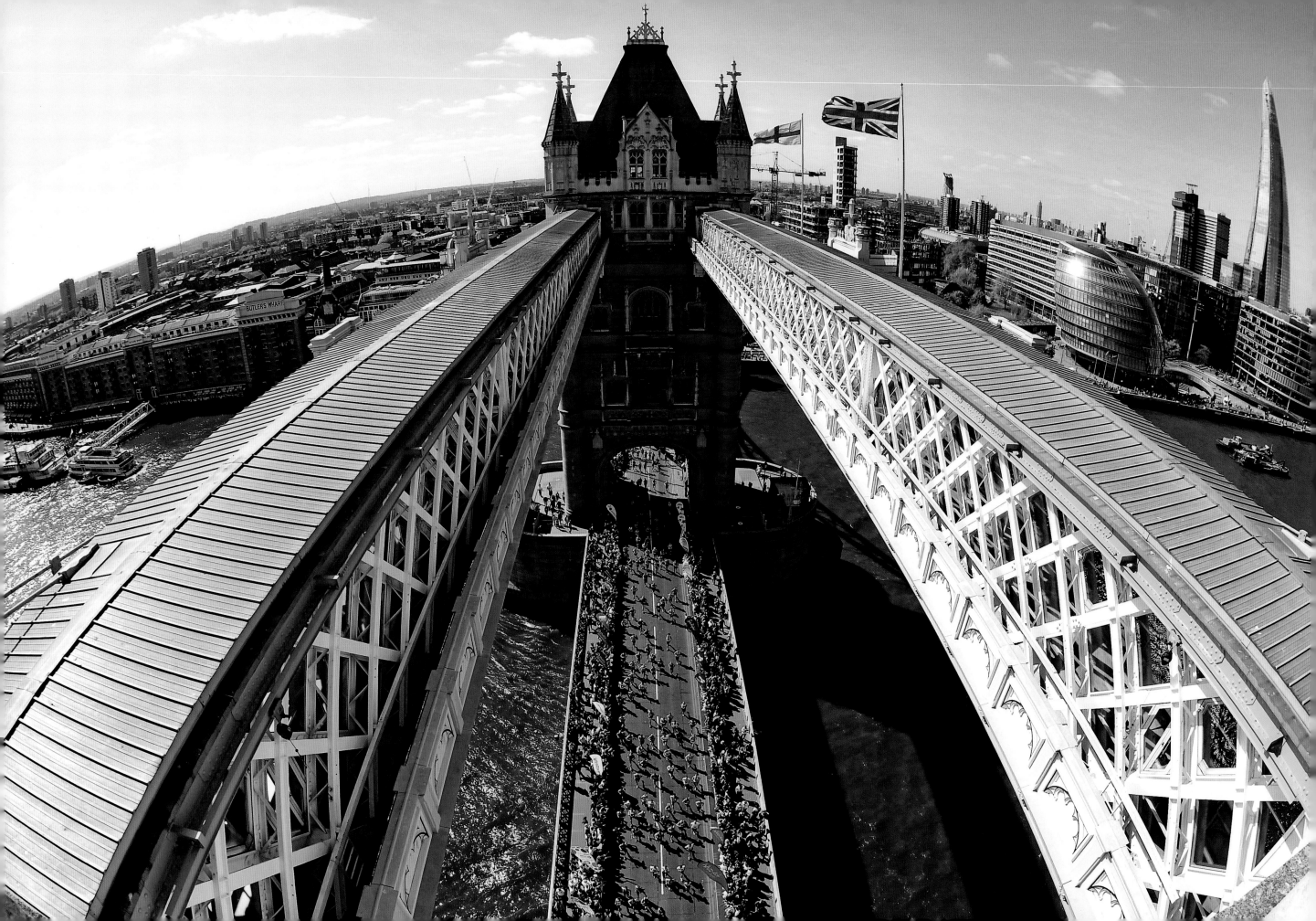

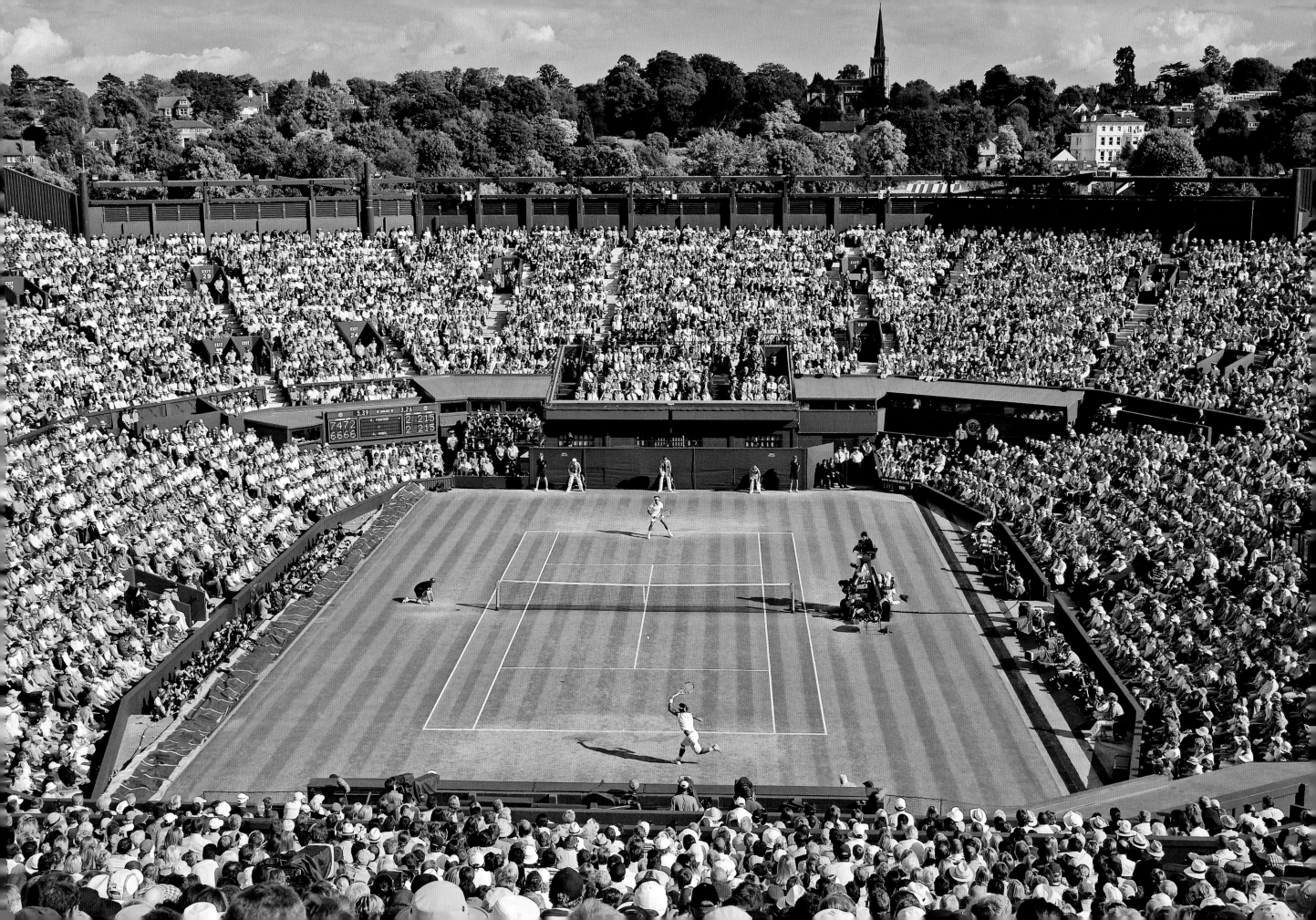

LILLEHAMMER CROWD

I can't remember what event I was shooting, but I do recall thinking, 'The crowd is actually steaming!' – it was about minus 15 to be fair – and taking a few quick pictures before going back to the action. I didn't think much more about it but this shot ended up being one of my best of the Games, getting used by *Time* and *Stern* magazines as the opening shot of their coverage.

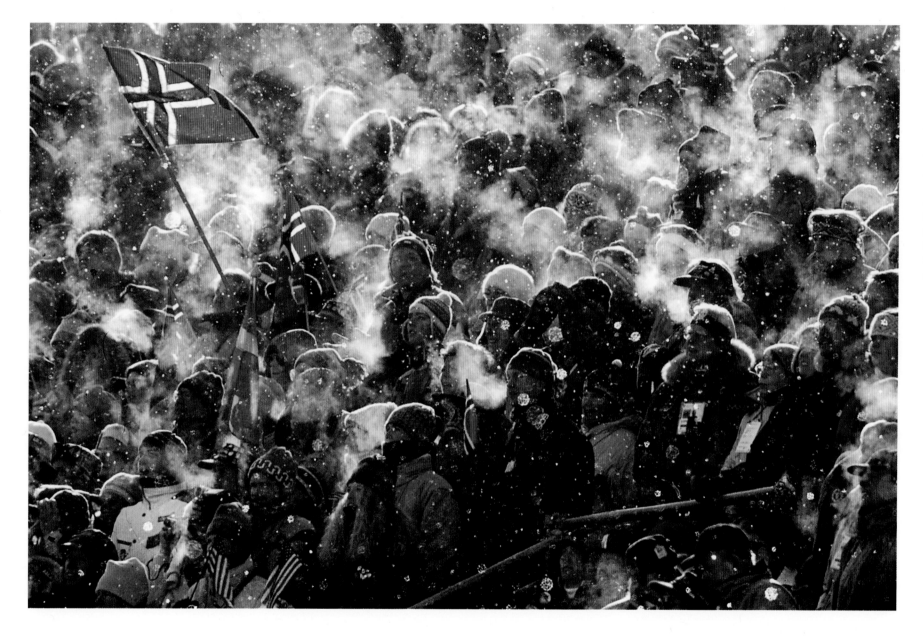

WIMBLEDON, 2007

For some people the year when there was no roof on Centre Court was the worst ever. For me it was the best. Because of the construction of the new retractable roof, the crowd had to be completely uncovered for the 2007 Championships, but that meant fantastic light and revealed this brilliant, quintessentially English background. I love this picture because it's just a great sporting scene – Wimbledon final, not a spare seat in the house, and, if you look at the scoreboard, two of the greatest players in tennis with the score exactly level.

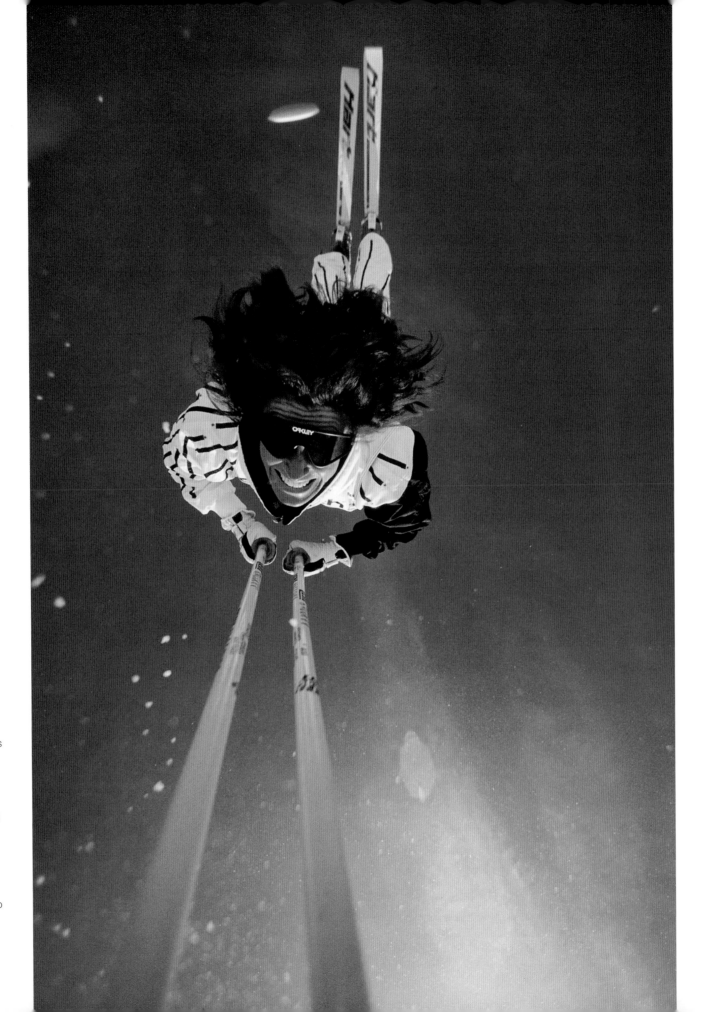

THE WATER JUMP

The reflection is what makes this picture from the Badminton Horse Trials in 2007. Luckily for me, on this day the water was unusually still.

JAN BUCHER

This was one of the first pics I did that was something a bit different, that no one had done before. It was taken with a remote control camera while I was covering the World Freestyle Skiing Championships in Tignes, France. I put the camera on the ground and then asked the skier to plant her poles either side of it and do one of her amazing flips.

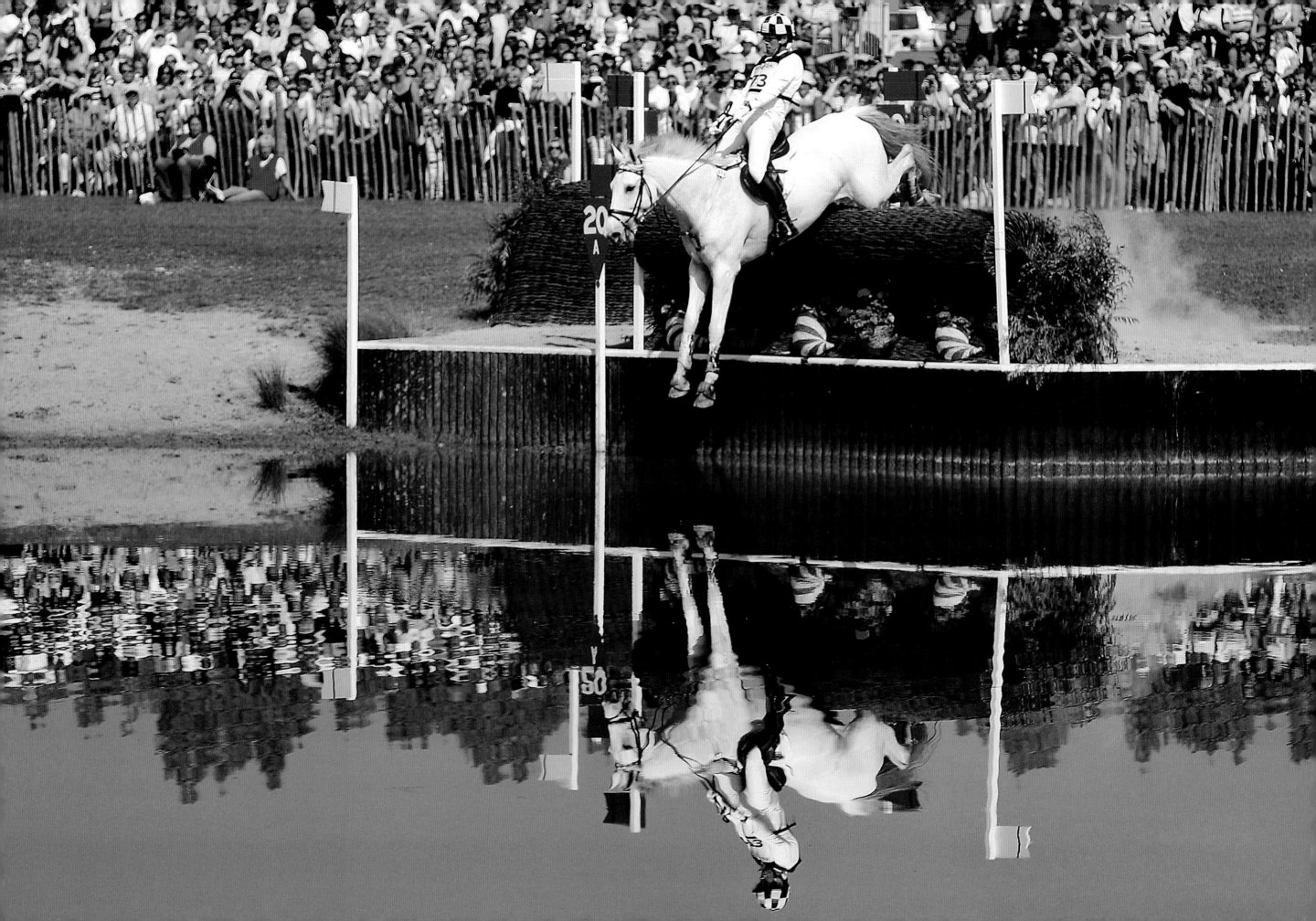

OLYMPIC FIGURE SKATING

From a position in the lighting catwalk above the skating rink at the Albertville Olympics I took a frame with a remote camera every time a skater, or skaters, crossed the Olympic rings in the ice. I took more than 2,000 frames from this position (this is back in the days of film!) and this is the best of them – the skaters are in the centre of the green ring and both are looking up so you can see their faces.

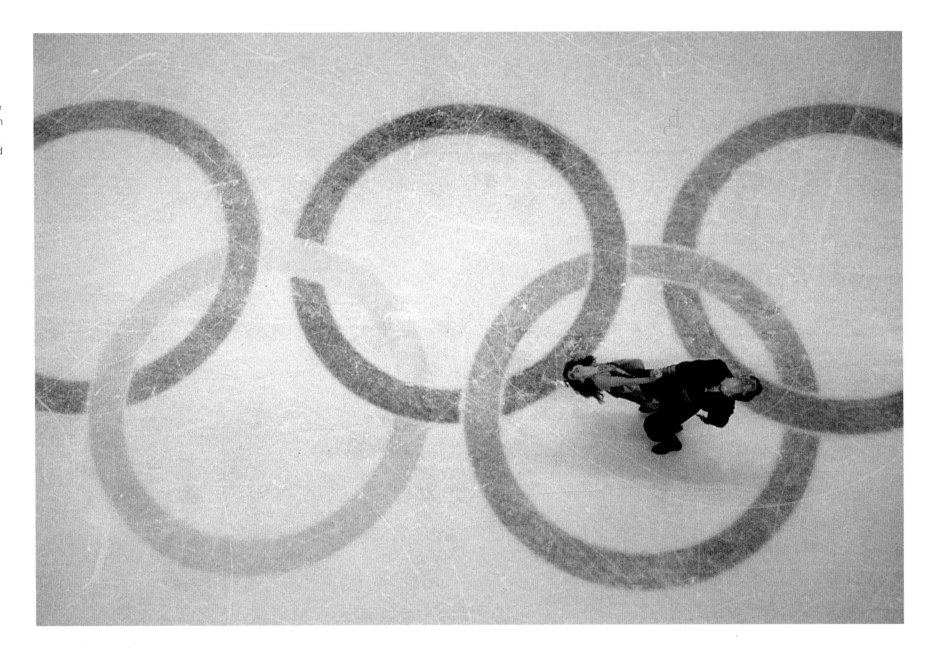

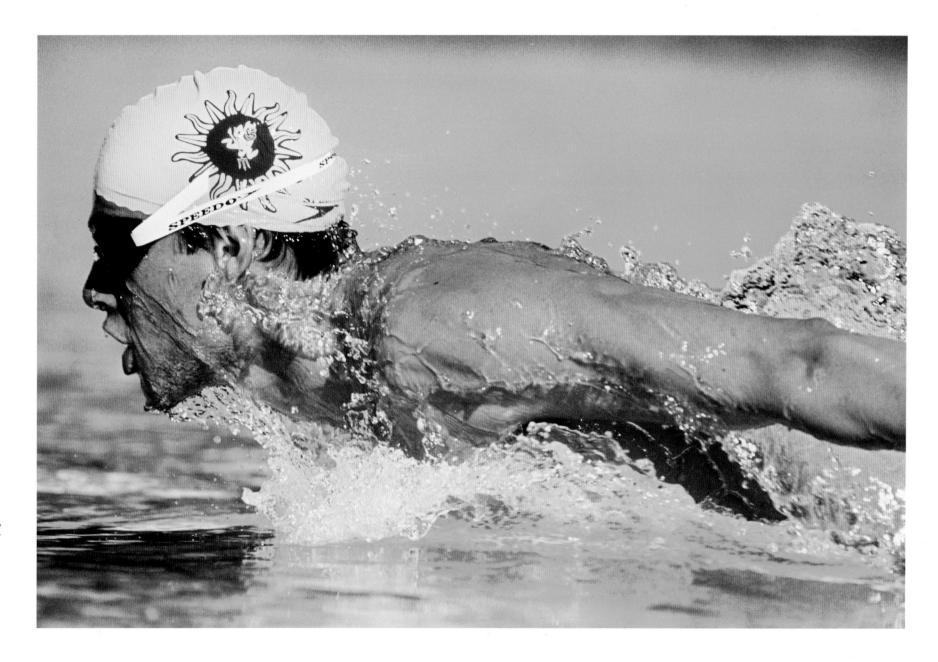

ANDREW JAMESON

An early swimming shot featuring Andrew Jameson, who is now a commentator for the BBC. Outdoor swimming pictures are always great because shooting in sunlight is so much better than under lights indoors.

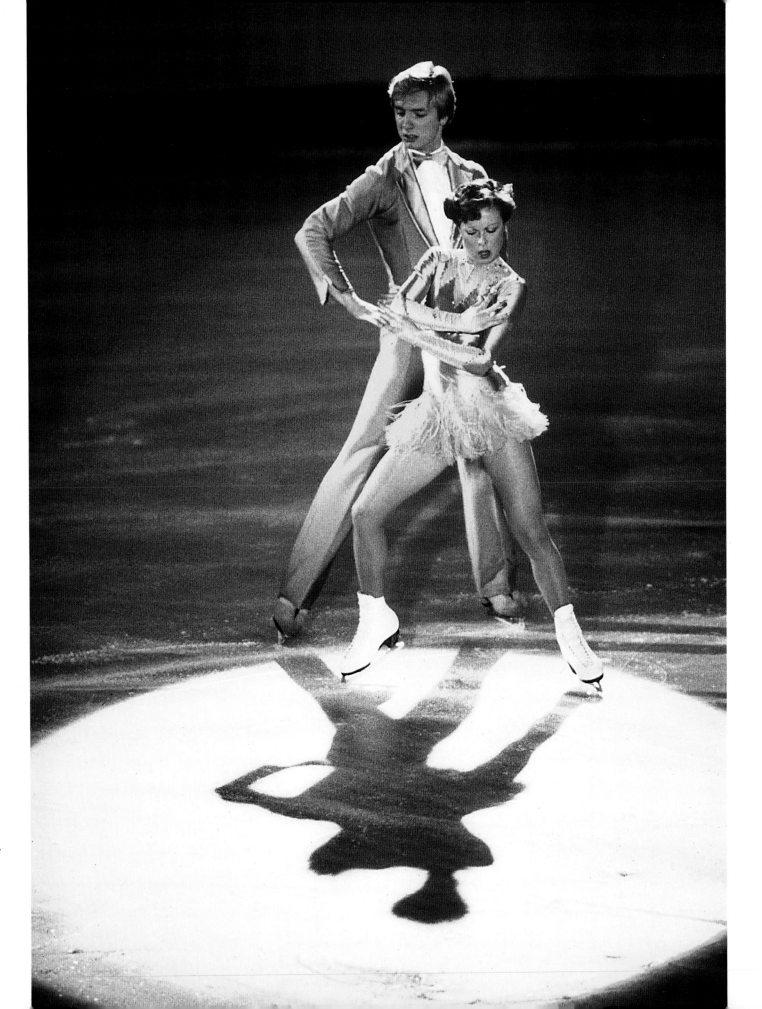

TORVILL
AND DEAN

I did lots of pictures of Torvill and Dean during their heyday in the 1980s. This one, taken at an exhibition event, was shot for their official book and is one of my favourites.

ANTONIO
BARRERA

This guy was infamous for being the most gored bullfighter in Spain, so I went to photograph him in training at his local bullring. When we arrived he had one of his trainers running about with a pram, with the horns of a dead bull tied to the front, chasing him round the ring so he could practise his moves. Apparently they all do this, so I used the shadow of the trolley to look like that of a bull. I should point out that, as with many portraits these days, the picture has been considerably enhanced in process. After the shoot we were treated to an amazing meal at his ranch. The steak was amazing and when I told him it was the best I had ever eaten, he said: "It should be, it's meat from a bull and I only fought it yesterday."

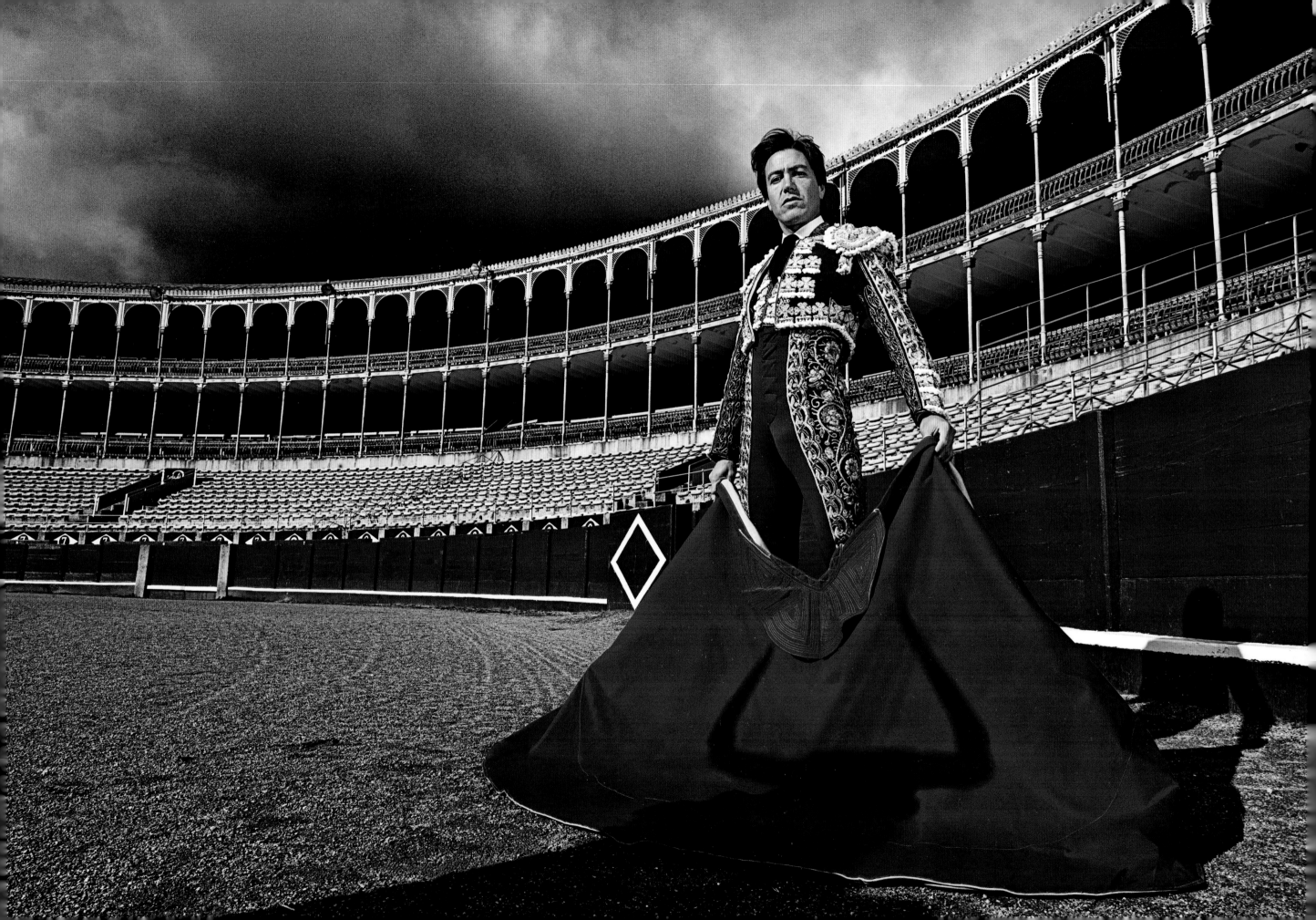

BY SIMON BRUTY

Oversized, that's Bob Martin. Not just big, but bloody big. His success has everything to do with his large personality; he always gets his way. Tournament officials, for instance, often refuse special access requests but somehow Bob finds a way. Charming and persistent, he once secured a helicopter that got him above the Brandenburg Gate during the first Berlin Marathon that traversed from East to West. At other times he has managed to get remote cameras into the most off-the-limits places.

Bob's ability to maintain a high standard within his photography also has everything to do with his refusal to cut corners. He is always prepared to re-walk a site, or visit a stadium the night before, or have the patience to wait until the light is right. Even when the heat is scorching, or the cold is burning his skin, he still perseveres. Golf often leaves even the most fit photographers with exhaustion but Bob will walk and walk to get that quintessential image.

Technical difficulties are puzzles Bob loves to solve. Since he took over management for photography at Wimbledon he has installed four robotic cameras to enhance the coverage. During the Olympic Games he was one of the first to test the new transmission capabilities and when digital cameras appeared, he mastered those too.

Many of us have grand ideas of photographs we would like to shoot but Bob has an amazing ability to make them a reality. During the Olympic Games in Beijing, he had an idea for the triathlon event. To get it he walked the length of the course several times

months in advance and then put himself into his chosen position six hours before the event started in order to make the photograph. We all see it as a blink of an eye but Bob spent months getting that image.

I think this set of pictures that Bob took at the Tough Guy Challenge UK is a really good example of something else that sets him apart from the rest. I mean who else would have bothered just turning up at something like this – a load of mad people running, jumping and crawling through mud in a field near Birmingham – because he'd read about it in the *Wolverhampton Express* while waiting for a match at Aston Villa and thought he might get a couple of good shots.

Of course, not every pursuit works out for Bob, especially because he reaches for the stars. During the Opening Ceremonies of the Olympics in Athens Bob had kept his chosen position under wraps. The rest of the *Sports Illustrated* photographers knew that Bob had figured out some signature image to trump us all. After the ceremony was over, the photographers spotted Bob trying to avoid the bar area of the hotel, which is pretty much like the Pope trying to avoid Sundays. He skulked over to us and confessed that the Greeks had turned off the lights at the Acropolis, rendering his much-researched picture impossible.

One other skill that Bob possesses but might not mention is his drinking skill. Most of his colleagues have suffered the consequences of his "just one more" statements, only to run into him during the

Right: Pictorially, this is one of the best events I have ever photographed. At one point the competitors had to swim under an obstacle made of logs, and as soon as they came up they would shake their heads to get rid of the mud and water from their faces. I got hundreds of great shots but this one is the best.

next day's event to see a beaming and bright-eyed Bob Martin loudly proclaiming his love for the game.

There's one last thing that makes him one of the best in sports photography: his generosity. Never forgetting his own pursuit, he still finds time to help the poor soul who has lost his way to the stadium or tell someone how to turn the camera on. His heart is as oversized as his talent.

Simon Bruty is a *Sports Illustrated* photographer

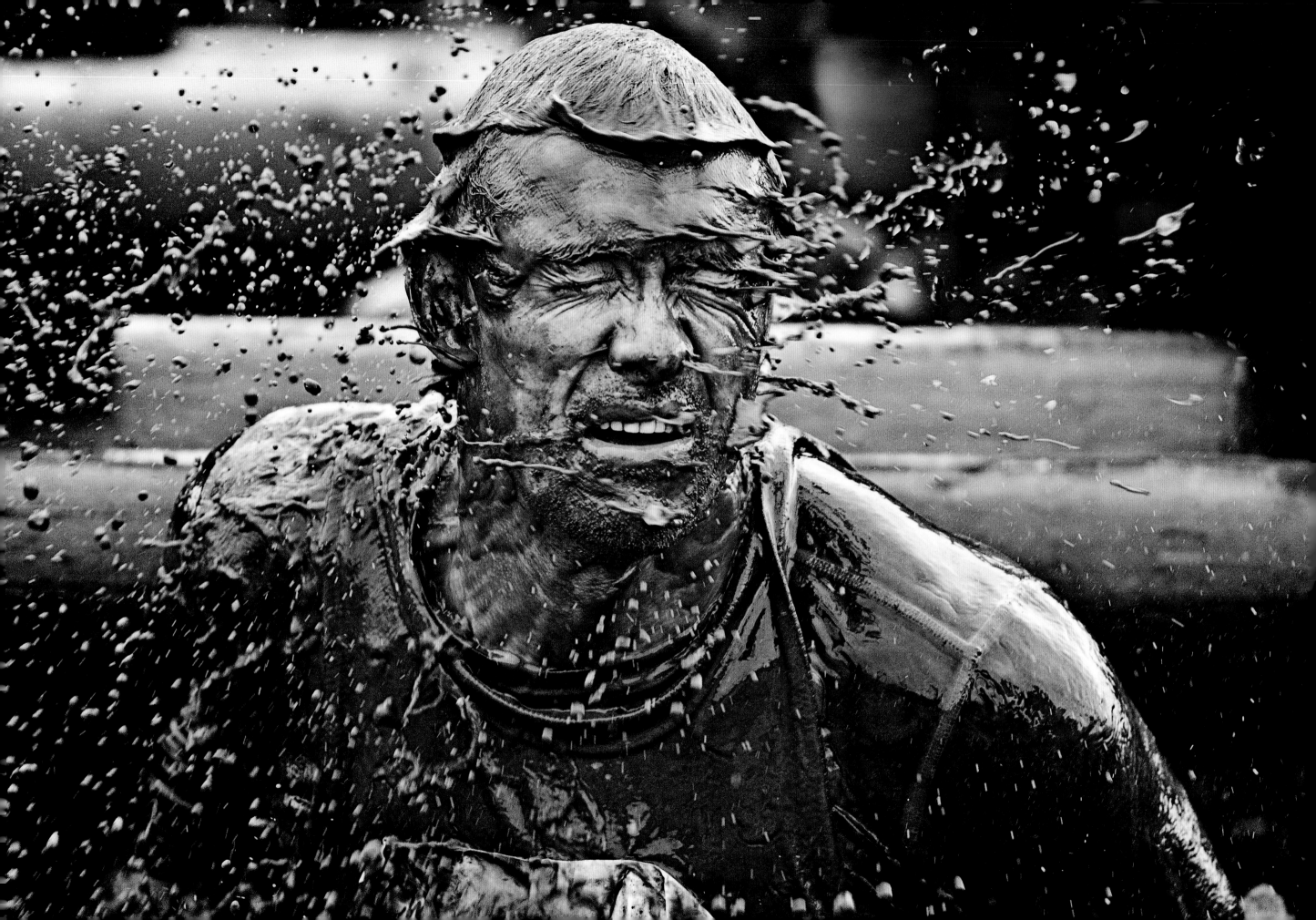

Right: At the end of one of the obstacle sections I was looking for some close-ups and got this great detail of the shoe seen through a layer of mud – especially the distinctive 'N' motif of the manufacturer.

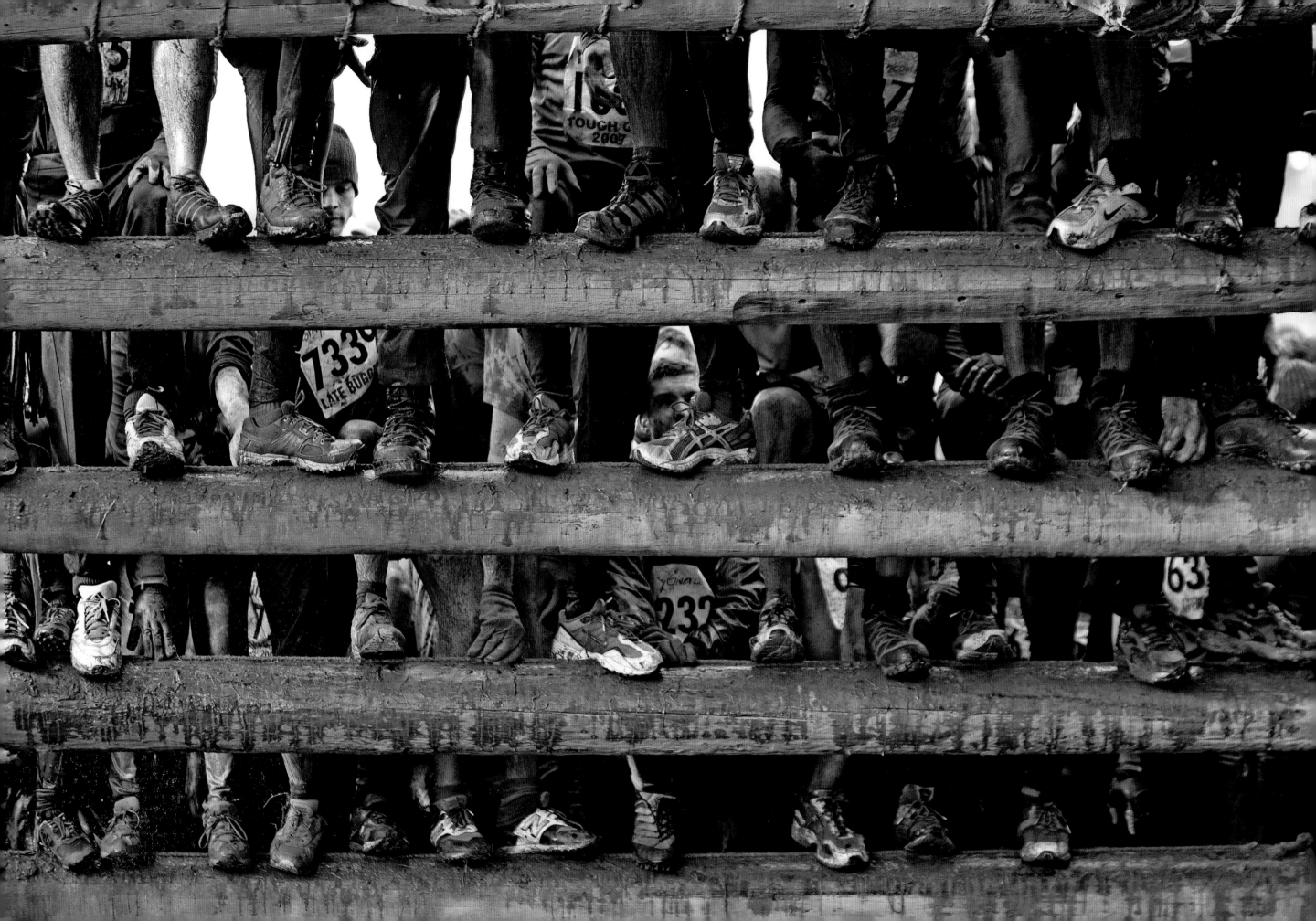

Right: The eyes looking up between the lines of barbed wire are what makes this shot.

Below right: I particularly love this picture of four very wet and cold looking women waist deep in the mud looking thoroughly miserable. They don't exactly look like extreme athletes. Mind you, the hapless bloke in the background looks even more out of place!

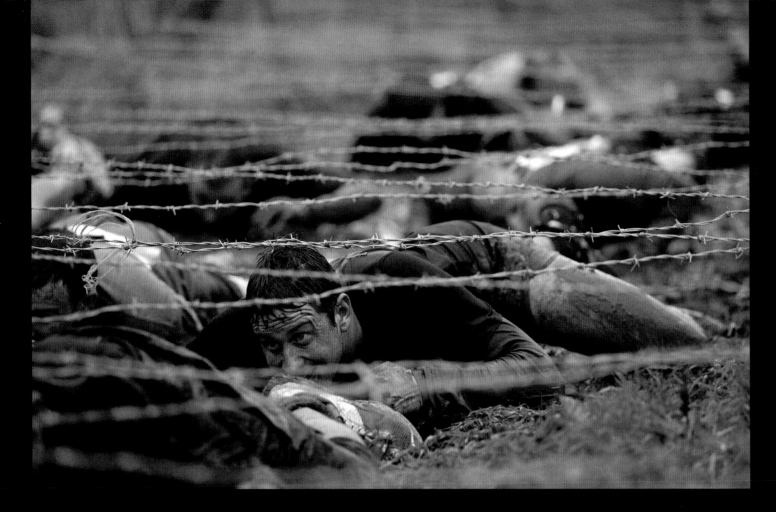

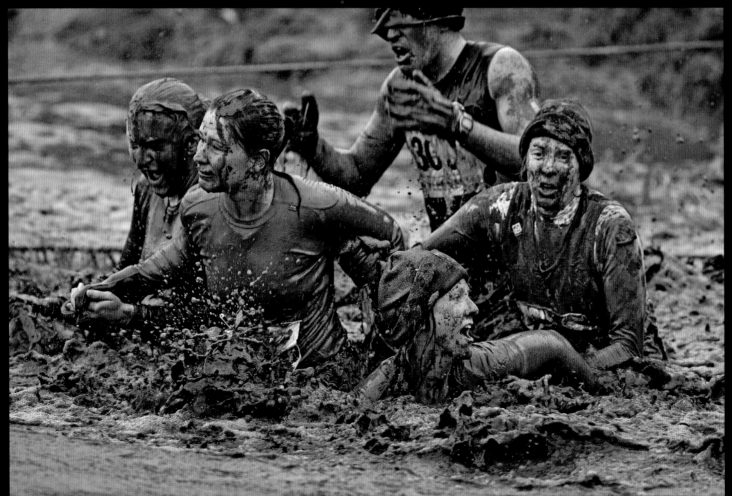

Right: I shot this with a very wide-angle lens, so I was really close to the fire and smoke. It is the only picture that has actually given me an asthma attack – I normally get them whilst trying to get to the positions for the best shot!

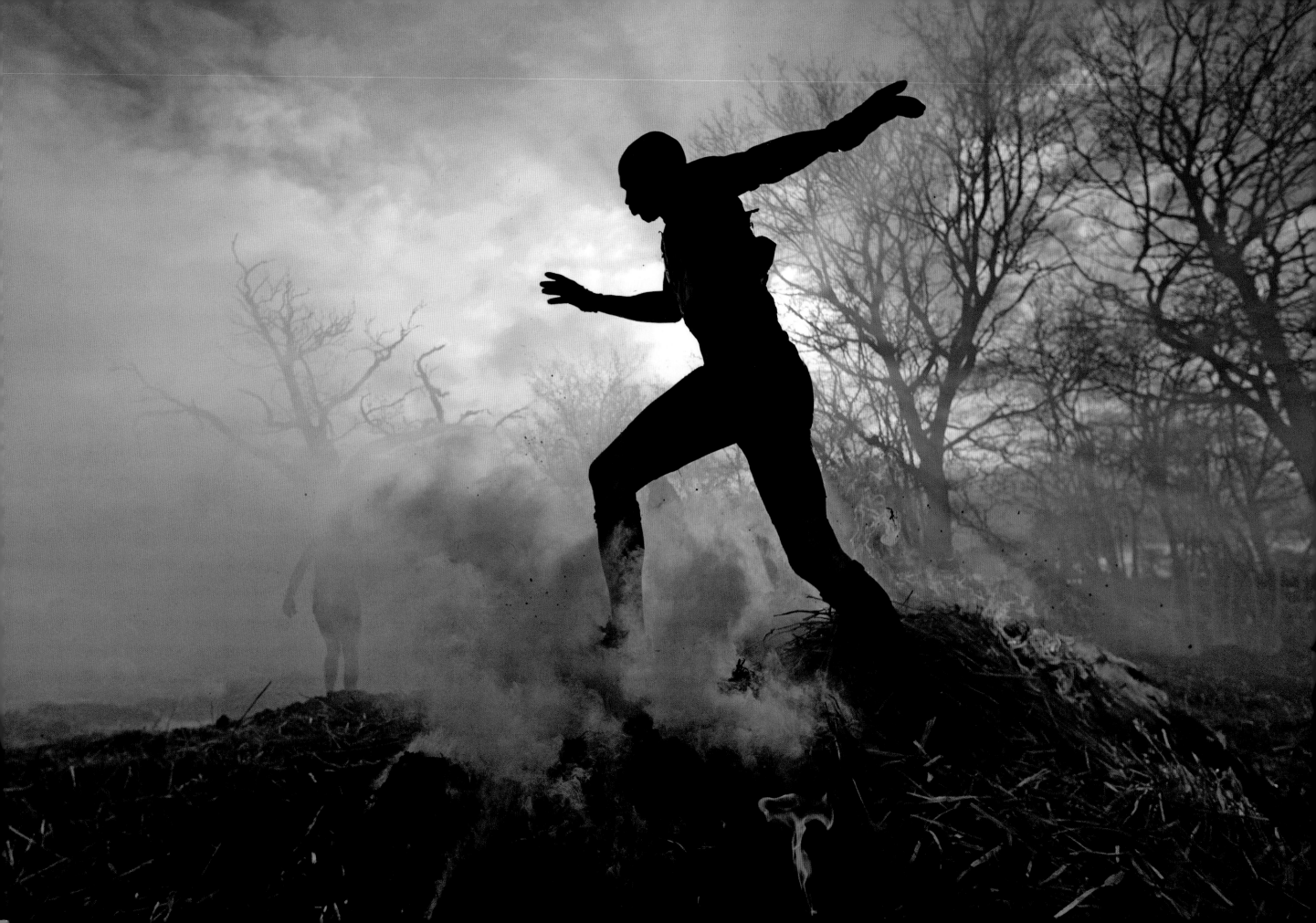

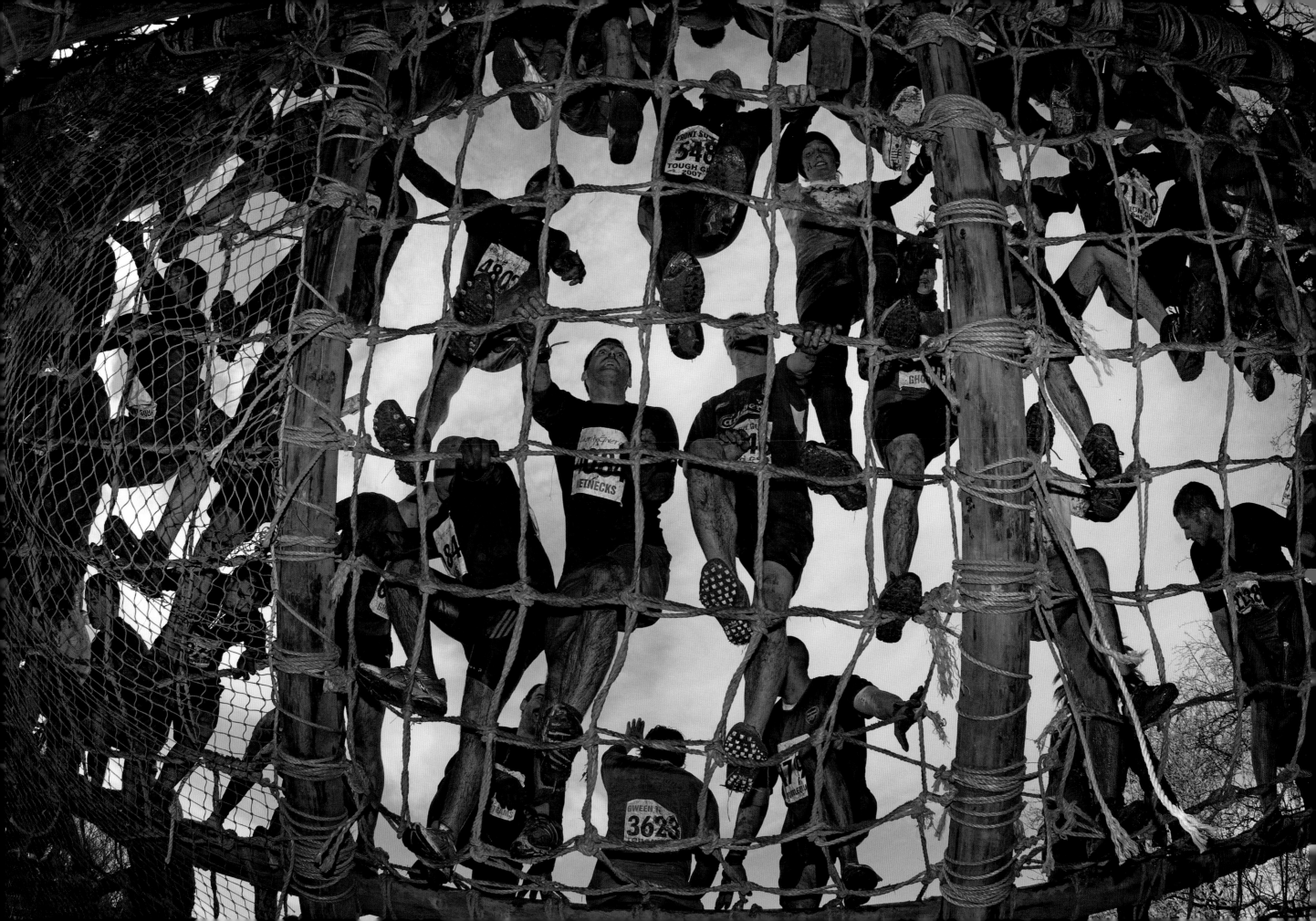

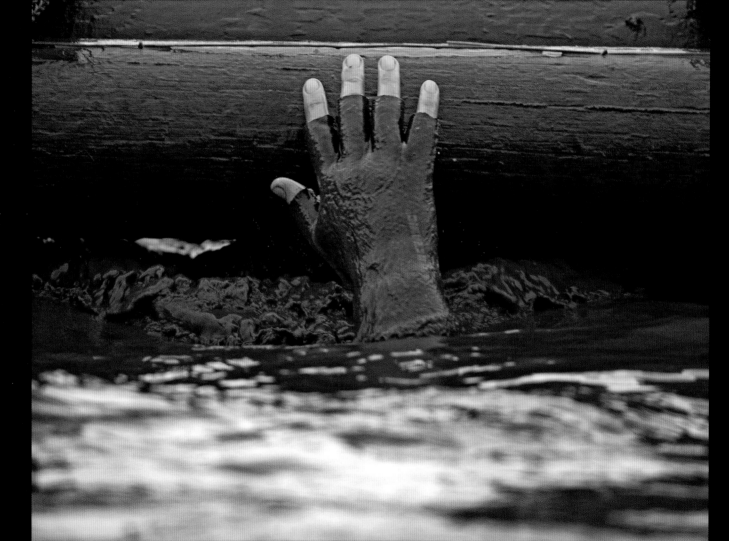

Left: This shot of a hand coming out of the water looks like the last desperate lunge of a doomed competitor...

I first shot this frame

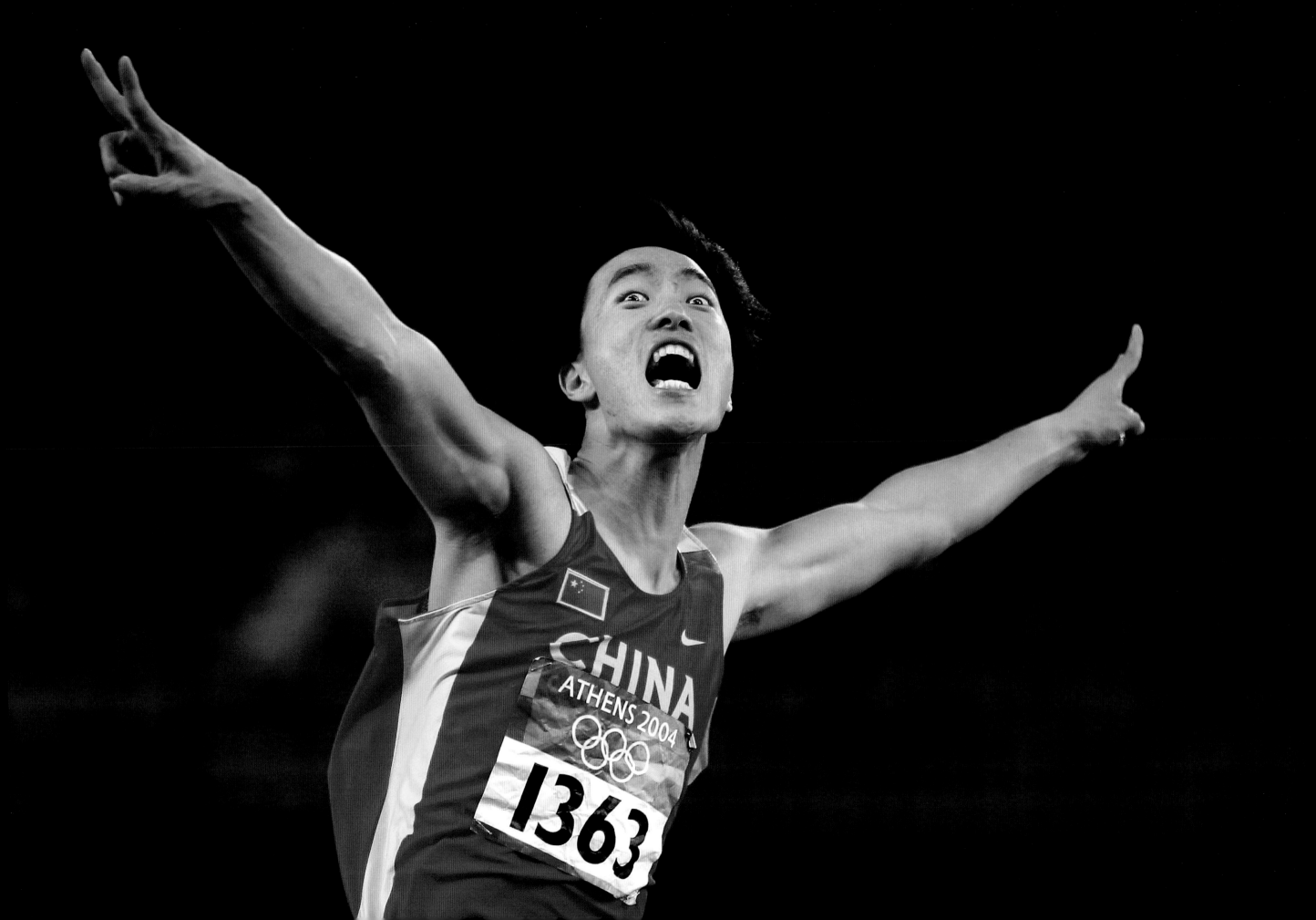

06

AGONY & ECSTASY

LIU XIANG

I positioned myself just around the bend after the finish, right underneath the Chinese coaches, and I was hoping that he would turn to them as he won. As he crossed the line he didn't do anything so I almost thought I'd wasted my time, but then just at the last minute he looked up and screamed to his coaches.

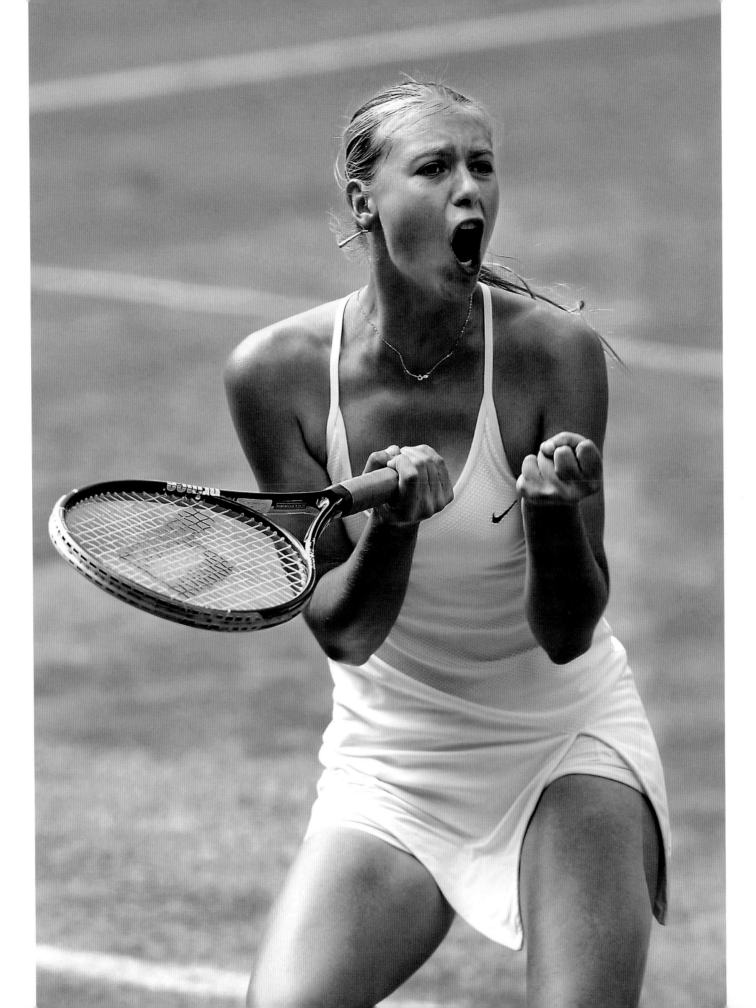

The fallen cyclist's despair
is illustrated by composing
him on the edge of the
velodrome's banked
curve. If this was shot
as a tight frame it would
have far less impact.

MARIA
SHARAPOVA

At the moment when she
clinched her first – and
so far only – Wimbledon
victory, when she was only
17, at first Sharapova had
her back to my position but
I was confident that she
would turn to her father
in the players' box. It's a
powerful sports pic but at
the same time she looks
very beautiful and feminine.

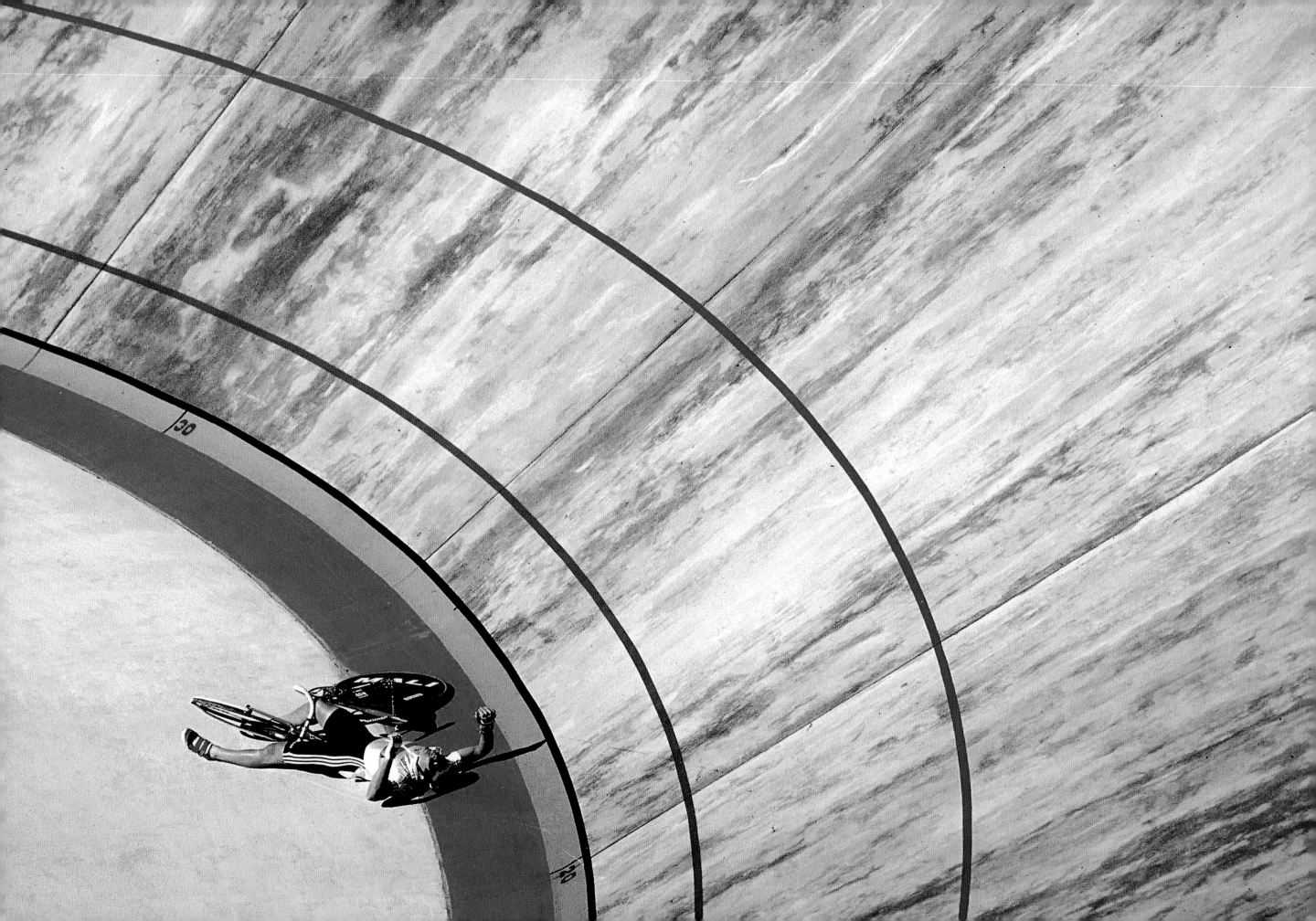

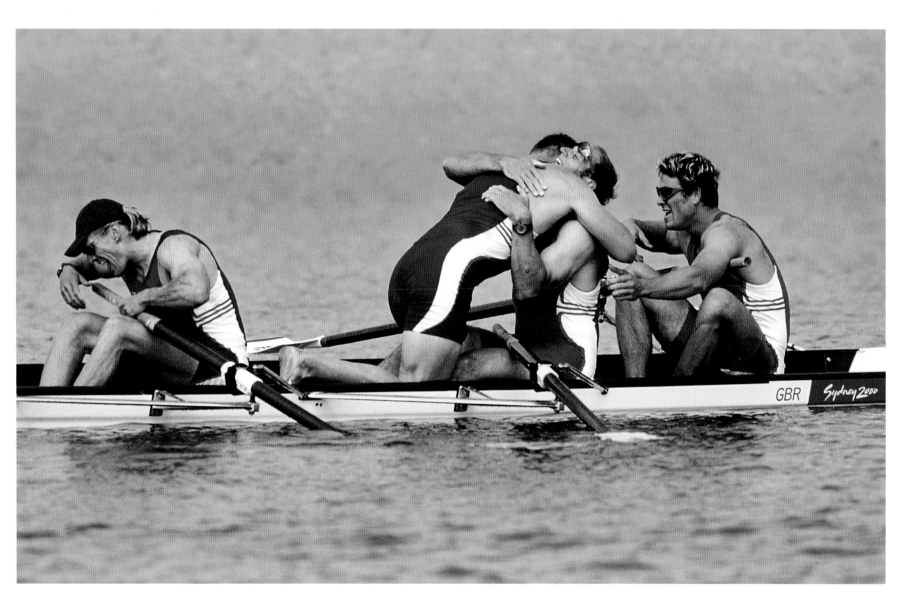

STEVE REDGRAVE

One of the greatest Olympic moments ever and a highlight of my career, and yet I nearly missed Steve Redgrave's historic fifth gold medal moment at the Sydney Games. Stuck in traffic on the way to the venue I really thought we weren't going to make it until suddenly police motorbikes appeared from nowhere and gave us an escort. We had two small Union Jacks on the front of the car and an Olympic pass in the windscreen, so I can only assume they thought we were British Olympic officials or from the embassy or something. Little did they know that we were mere photographers.

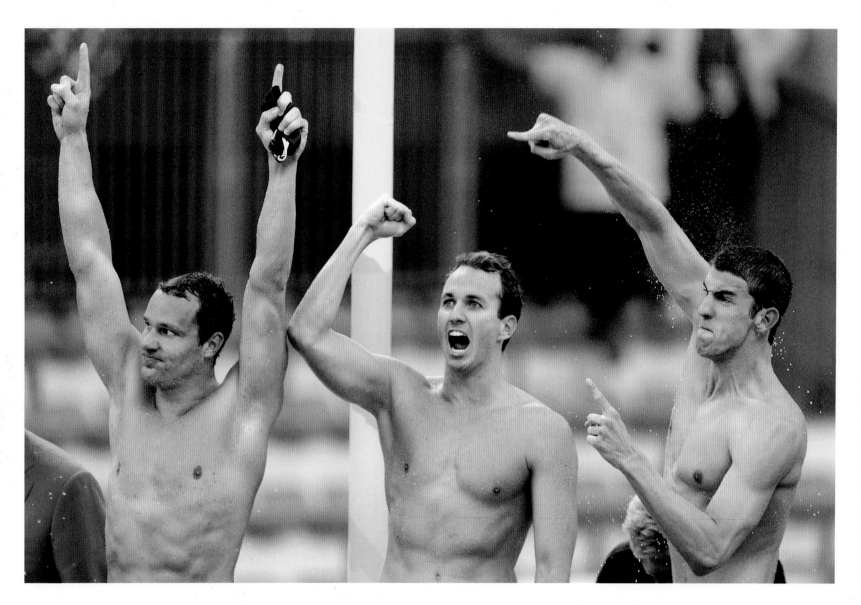

US SWIMMING TEAM

The US swimming team celebrate victory in the 4x100 metres medley relay at the Beijing Olympics, Michael Phelps's record-breaking eighth gold of the Games. If you want to get a celebration shot from a relay it's always best to position yourself so you can shoot the swimmers who are already out of the pool as the fourth member of the team finishes.

NIGERIAN
4X100 METRES
RELAY TEAM

For me, this picture sums up
the spirit of the Olympics.
These Nigerian sprinters are
watching a replay of the finish
on the big screen and this
is the moment they discover
that they have won the bronze
medal. They looked happier
than the Americans who won.

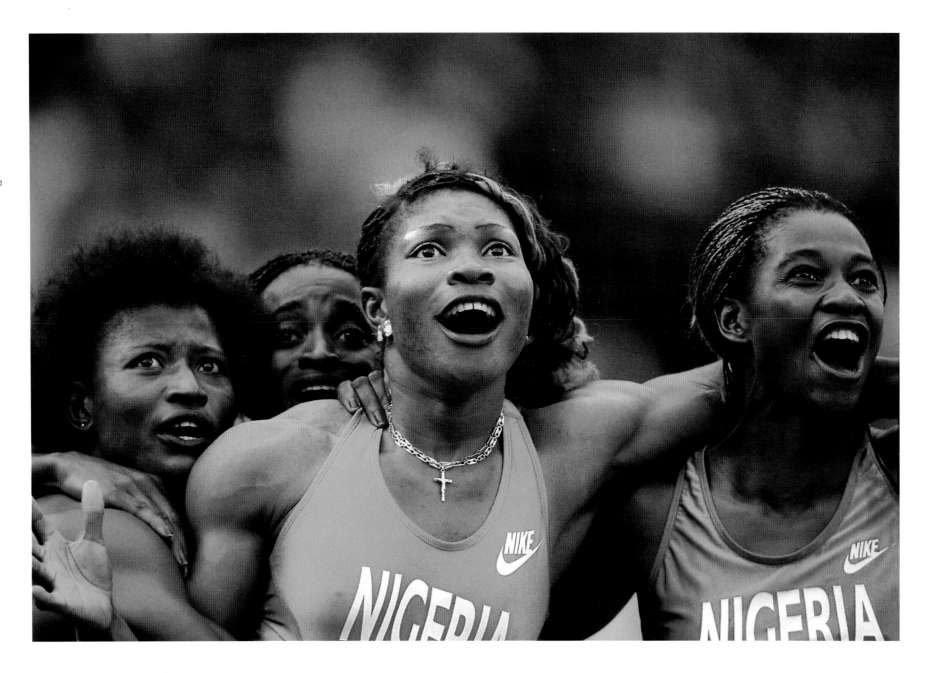

ANDRE AGASSI

The moment when Andre
Agassi retired from tennis
at the US Open at Flushing
Meadows. As usual I had
positioned myself below
the players' box, knowing
that he'd look towards Steffi
Graf and his other family
members and coaches at
the end of the match.

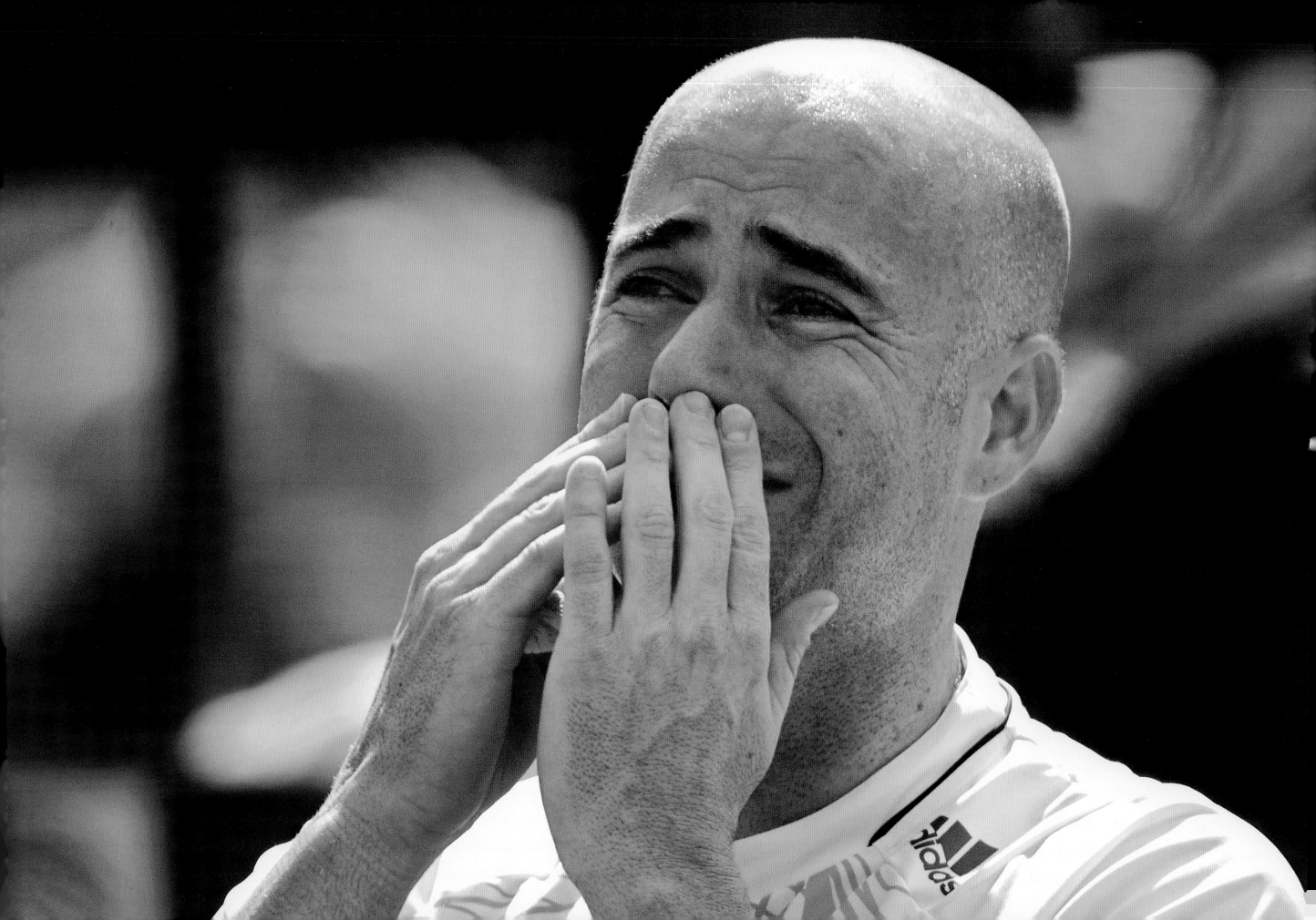

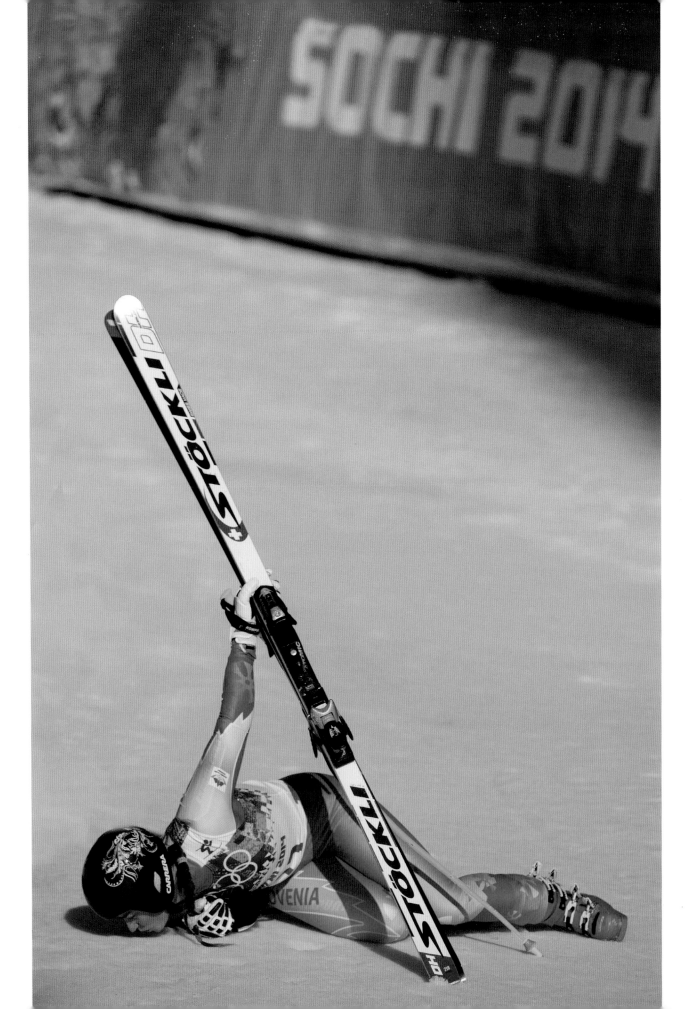

TINA MAZE

This was the historic moment when Slovenian downhiller Maze kissed the Sochi snow in celebration after she and Dominique Gisin of Switzerland recorded exactly the same time – 1 minute 41.57 seconds – in the women's downhill, which meant they shared the gold medal. The only time this has ever happened.

IAN THORPE

Ian Thorpe winning a race at the Athens Olympics. Again, I made sure I was shooting from where the rest of his team were, knowing that's where he would turn— at his moment of triumph.

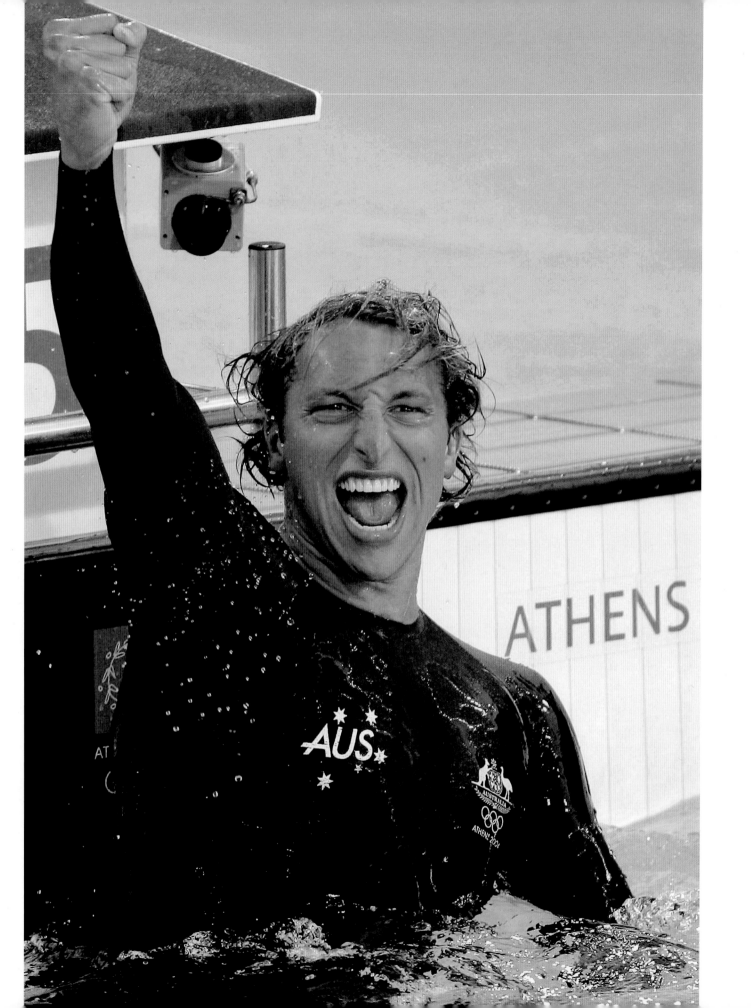

VALERIE BRISCO-HOOKS

After her lap of honour at the Stockholm Grand Prix event, the great US runner lay down on the track and, alongside her shoes and the flowers she had just been handed, it made a great shot. It was a nice moment and I tried not to be too intrusive as I leaned over her and shoved my camera in her face!

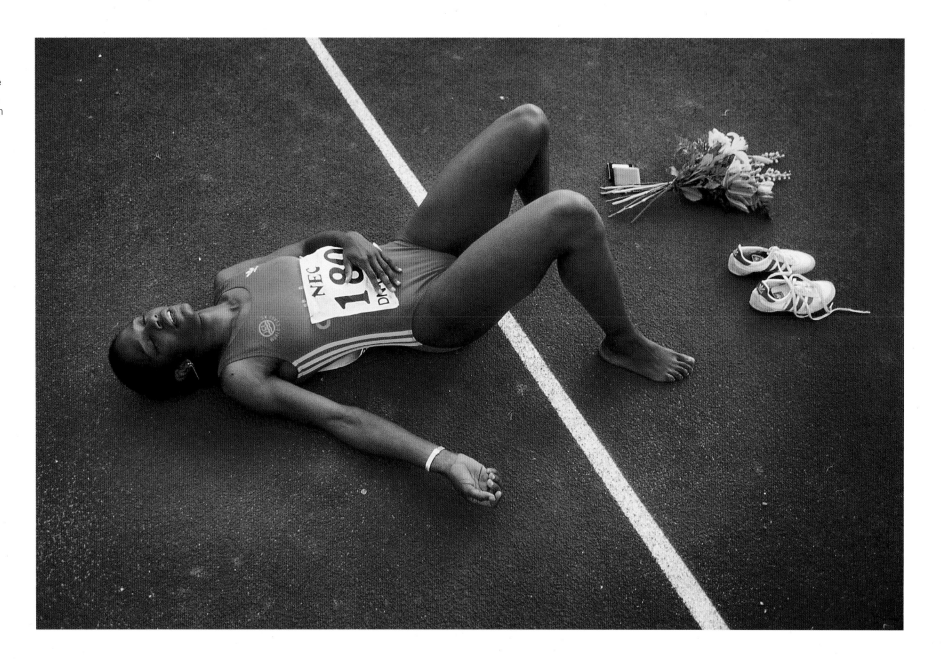

WORLD ATHLETICS CHAMPIONSHIPS, HELSINKI

I would not normally photograph a women's 5,000 metres heat, but I was really wet, cold and, quite frankly, bored stupid so to keep myself occupied I was using the race to practise my focusing. Suddenly this poor girl fell and I got the shot, much to the dismay of the other photographers sitting with me who missed it while they were having a chat!

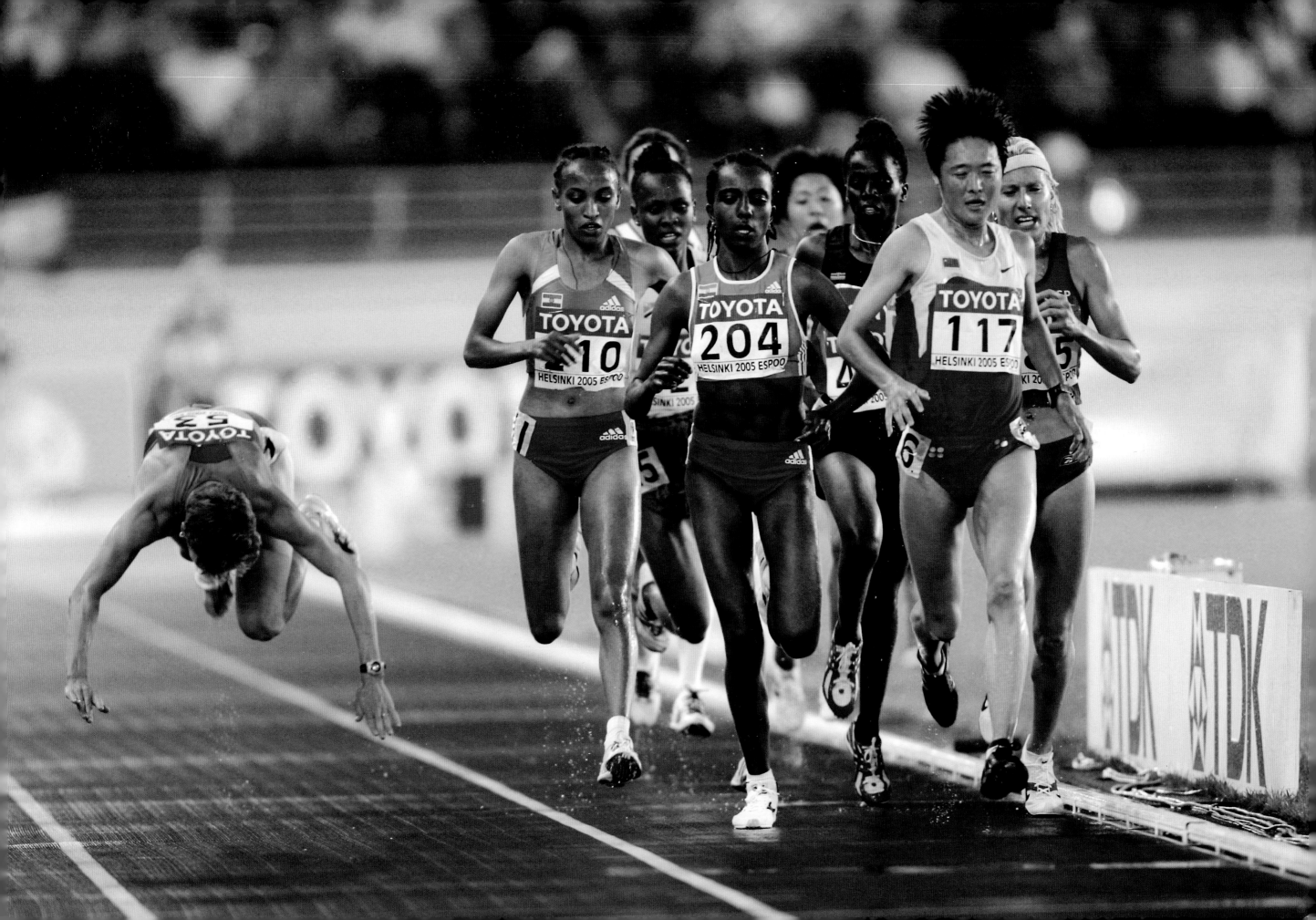

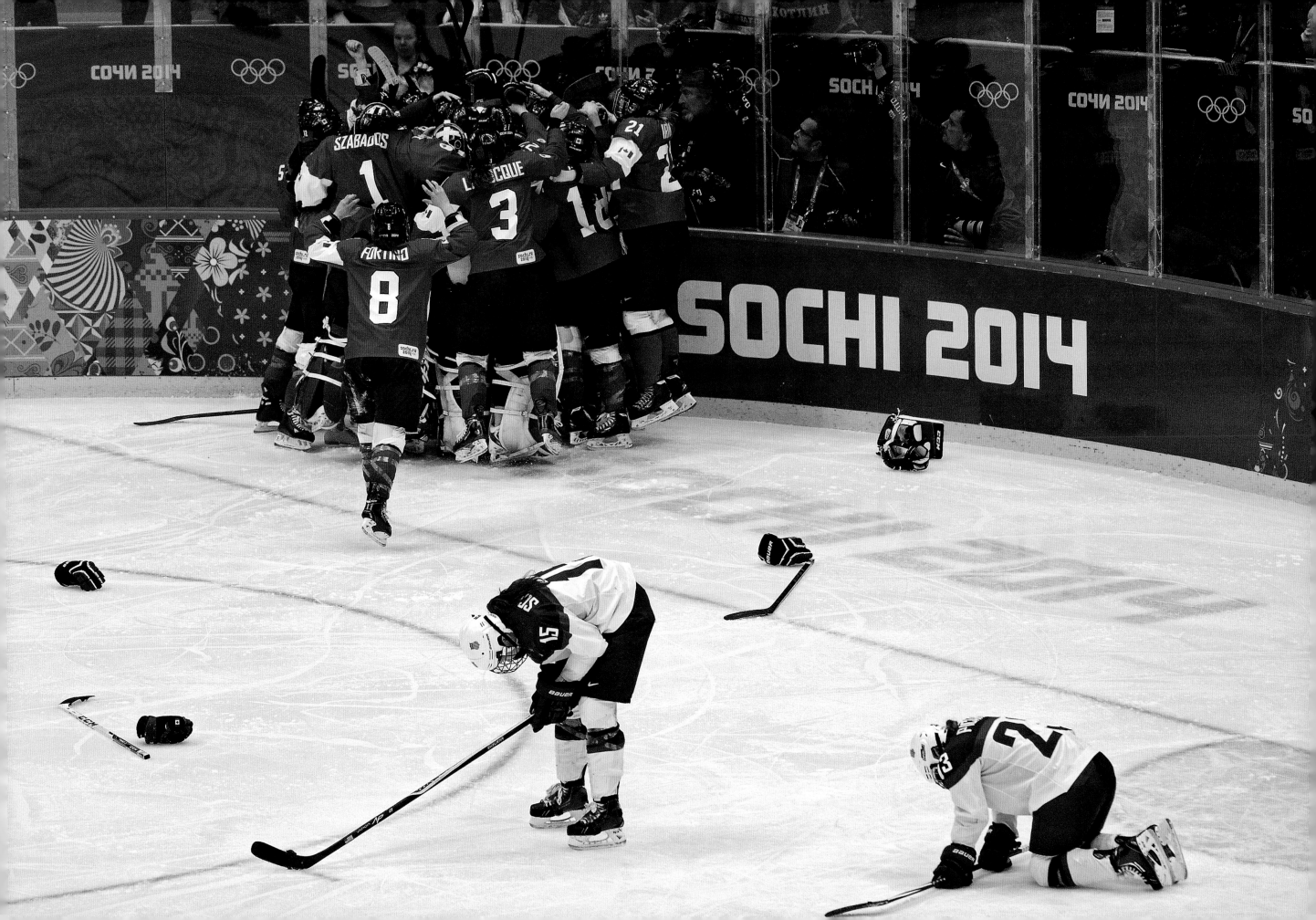

ICE HOCKEY
FINAL

This picture from the Sochi
Winter Olympics is all about
the contrast in emotions – the
joy of the Canadian women
who have just beaten their
arch-rivals, the USA, in
the gold medal game. The
helmets and sticks littered on
the ice add to the atmosphere.

SOCHI BAR

During the Sochi Olympics
I wanted to find a proper
ice hockey bar in the
working class area of the
city to photograph Russians
watching their team play
the USA. Having gained
the trust of the locals by
buying them plenty of beer, I
captured the moment when
their team took the lead.
However, the atmosphere
went quickly downhill when
the USA came back to win.

RYDER CUP, 1995

When the Ryder Cup is
presented there is always a
big scrum to get a position,
and I realised that the best
picture would really be all the
hands reaching in towards
the trophy. I like this shot
because you can tell it's
Seve Ballesteros's hand
by the copper bracelet.

WORLD CUP, FRANCE '98

This picture is all about the
moment – France lifting the
World Cup in amongst their
own fans in Paris – team
and supporters united. I
was in the crowd about
halfway up the stand and
my match pictures were
boring, but this frame
captured the story. I love
the guy in the crowd with
the red and blue bow tie.

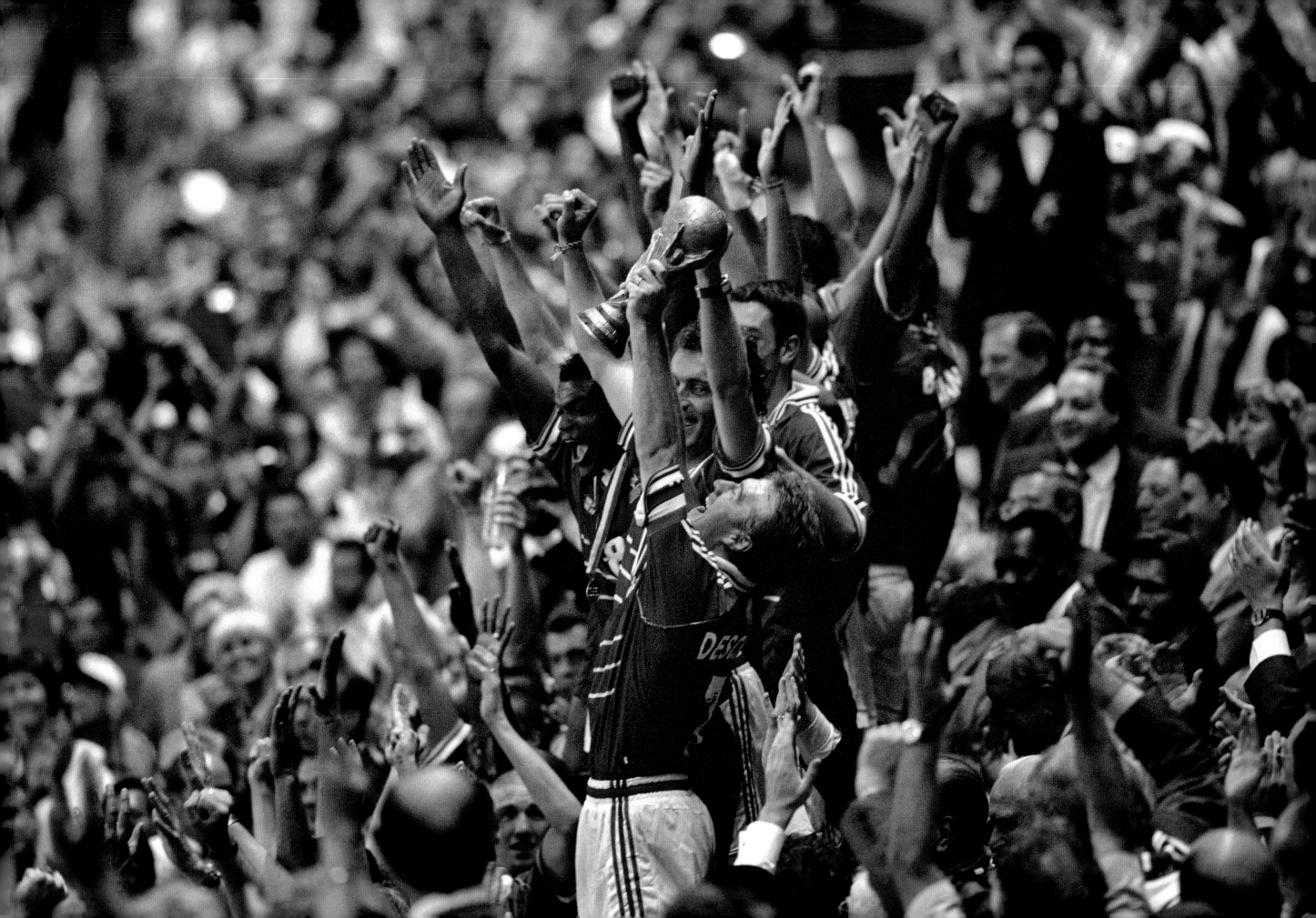

GORAN IVANISEVIC

A great moment when Ivanisevic won Wimbledon, becoming the only wild card entry ever to do so, and climbed into the crowd to celebrate with his family. The picture captures the atmosphere of the 'People's Monday' when the final was played a day later than scheduled because of bad weather during the Fortnight.

MAGDALENA NEUNER

At the Vancouver Winter Olympics it was very difficult to get good, colourful crowd backgrounds, but I had checked out the course a couple of weeks before and found this position with the trees behind. It was a very foggy day and the women's biathlon – won by Neuner – was the only event that wasn't called off.

JELENA JANKOVIC

This shot was taken from a robotic camera on the roof of Centre Court at Wimbledon in 2015, just after Jankovic had beaten the reigning champion, Petra Kvitova. I could not have got this frame from any of the photographic positions on the court and was actually operating the camera from an office underneath Court 14.

KEVIN YOUNG

From my favoured position just round the bend after the finish, where the background is clean and you are more likely to capture the key moment of jubilation, I got this shot of the US star as he looked up at the scoreboard just after his triumph in the 400 metres at the Barcelona Olympics.

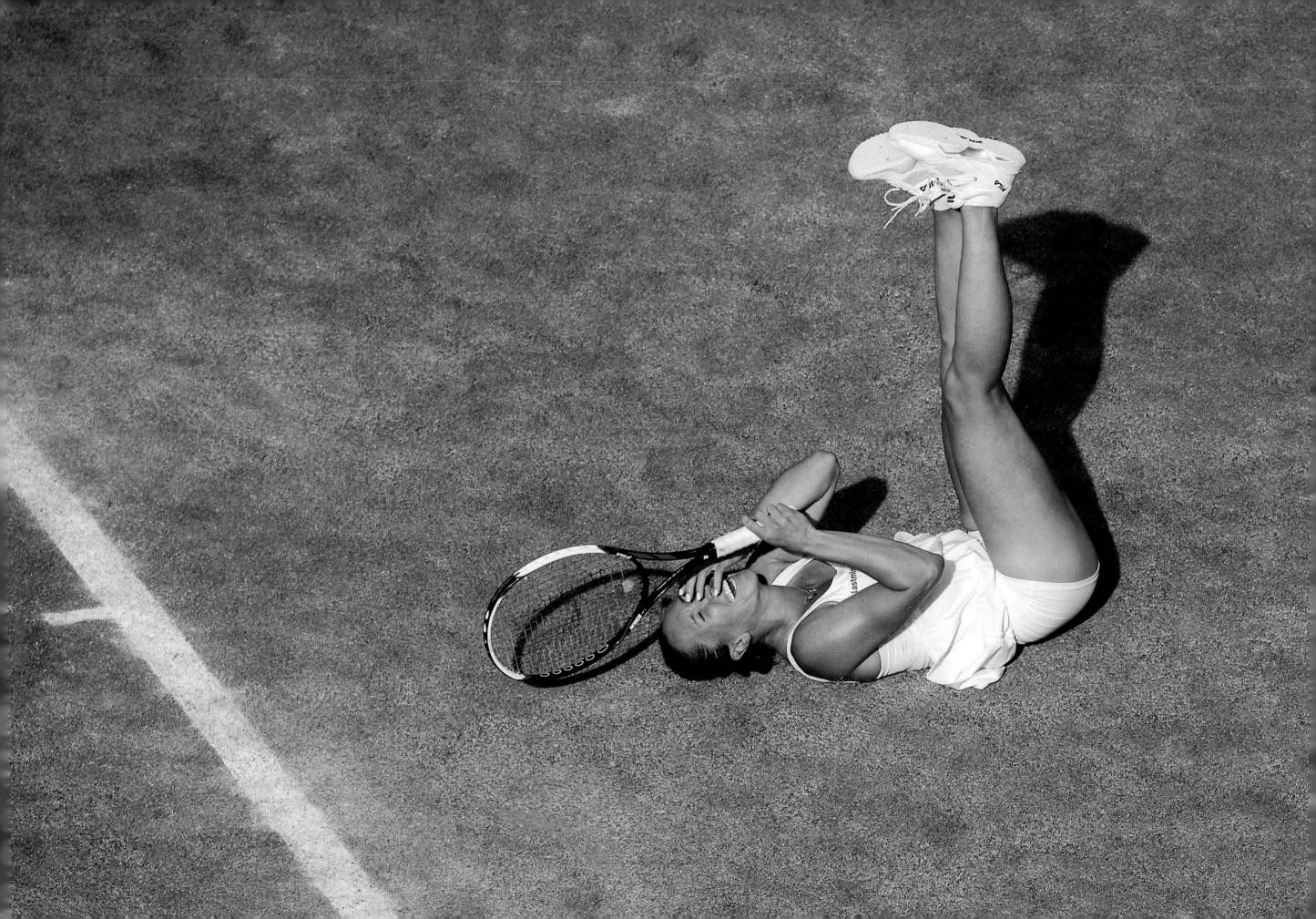

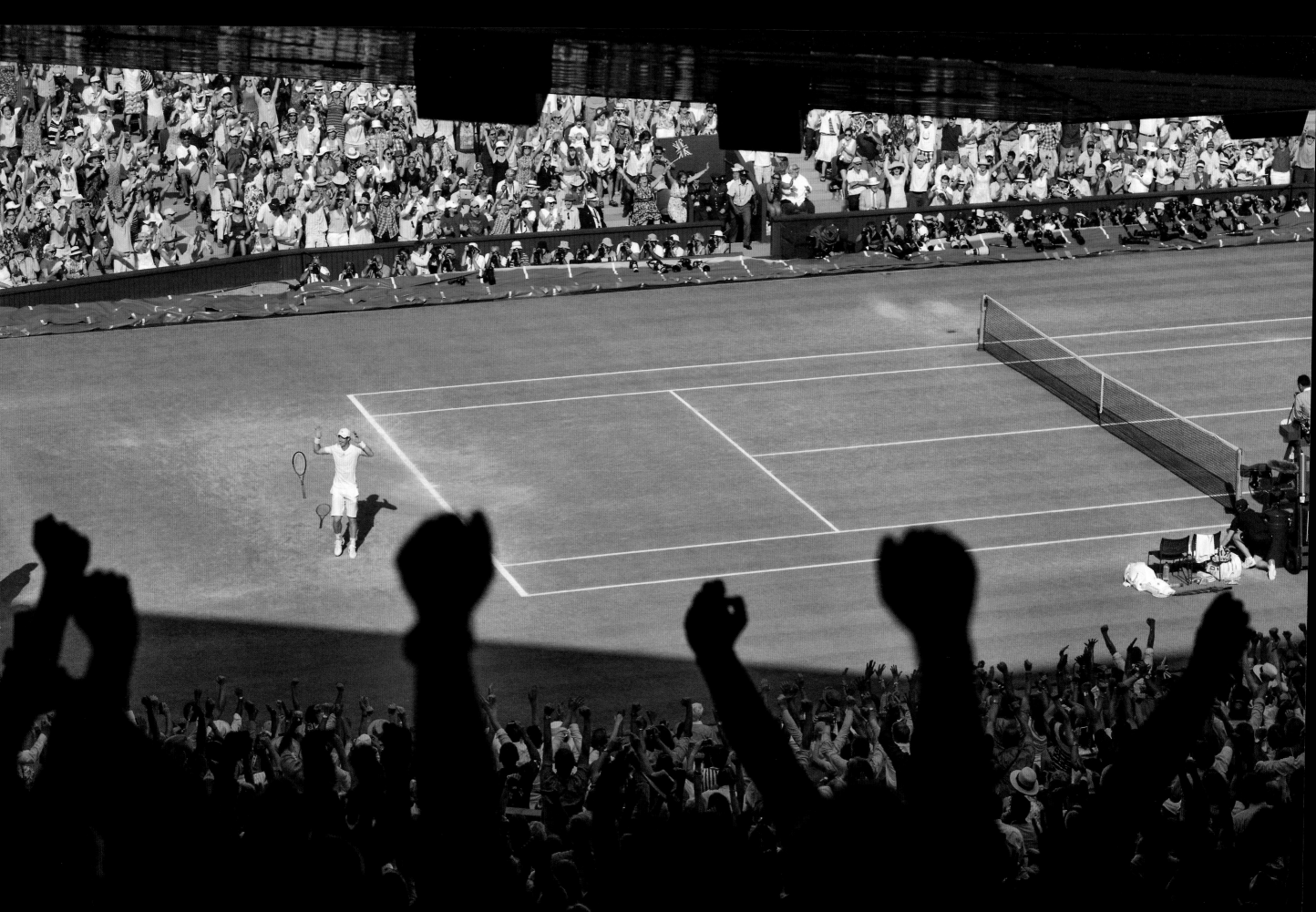

IAN BOTHAM

I was at The Oval specifically to capture the moment when Ian Botham became the highest wicket-taker in Test cricket. I was hoping he wouldn't have his back to me and I thought he would probably turn to the umpire to appeal or to the pavilion, and I also wanted to show the other players around him to give the moment context.

ANDY MURRAY

This is one of the few photographs that shows Andy Murray's face at the moment of triumph when he won Wimbledon in 2013. It is taken from a prototype robotic camera, developed by Nikon and installed that year for the first time on the roof of Centre Court. The camera, along with three others, was controlled by me from a commentary box. It is a ground-breaking picture and what I love about it most is that you can see the other photographers in the pit on the other side of the court, all taking pictures of the back of Murray's head!

ANDRE AGASSI
AND
PETE SAMPRAS

The two great American
tennis stars were playing
cards at the team hotel in
Sicily before a Davis Cup
match against Italy. The
Vegas-born Agassi was
winning every hand, so when
Sampras finally got him he
celebrated harder than he did
when he won a Grand Slam
– I guess this was actually
a much rarer occurrence.

RUSSELL WINTER

Winter was a British surfer
who made it on to the world
pro circuit. I went to shoot
him at his hometown of
Newquay in Cornwall, but
although he was a bit of a
surfer dude he didn't really
look like one so I had to tell
some of my terrible jokes to
give the picture a bit more life.

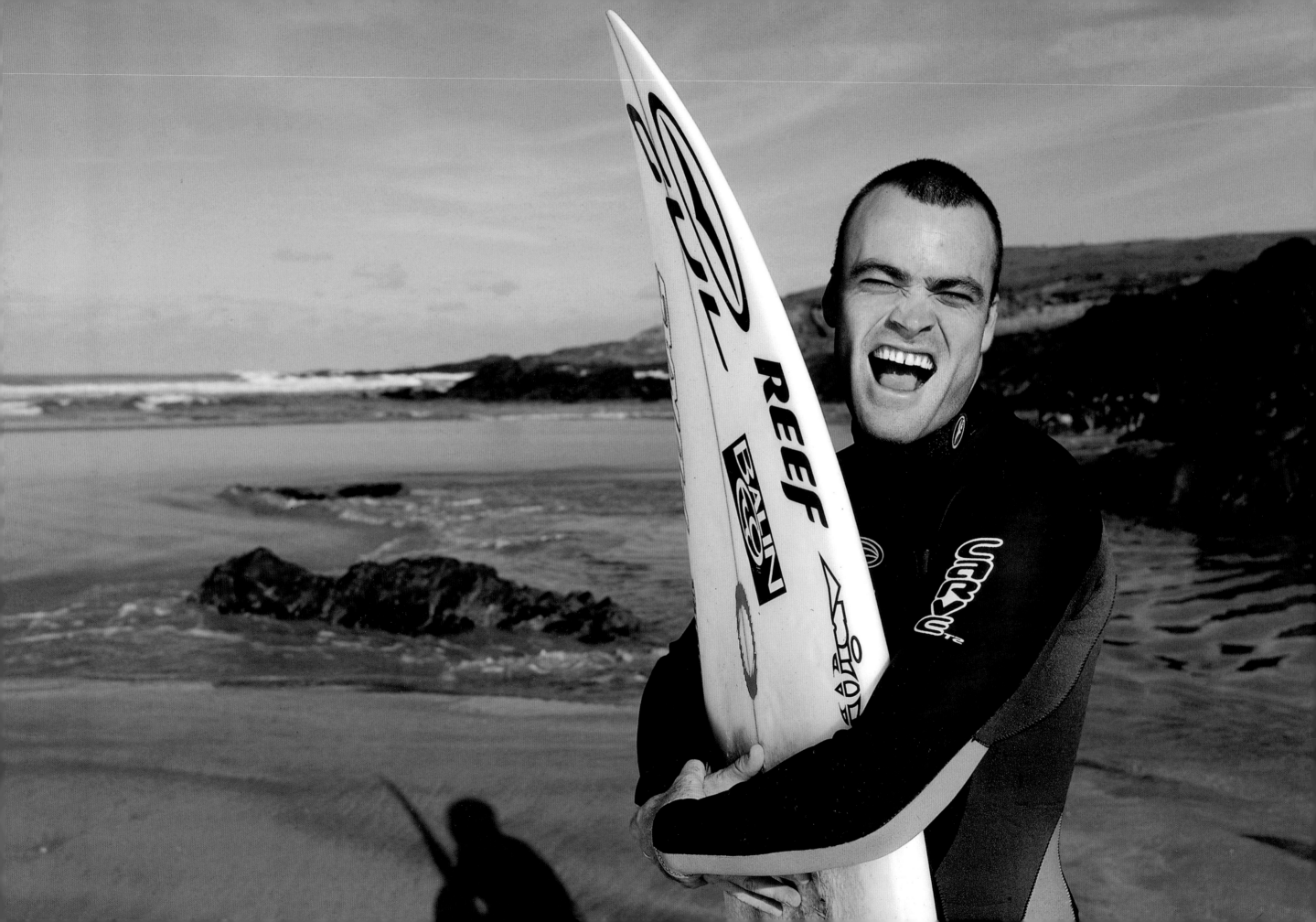

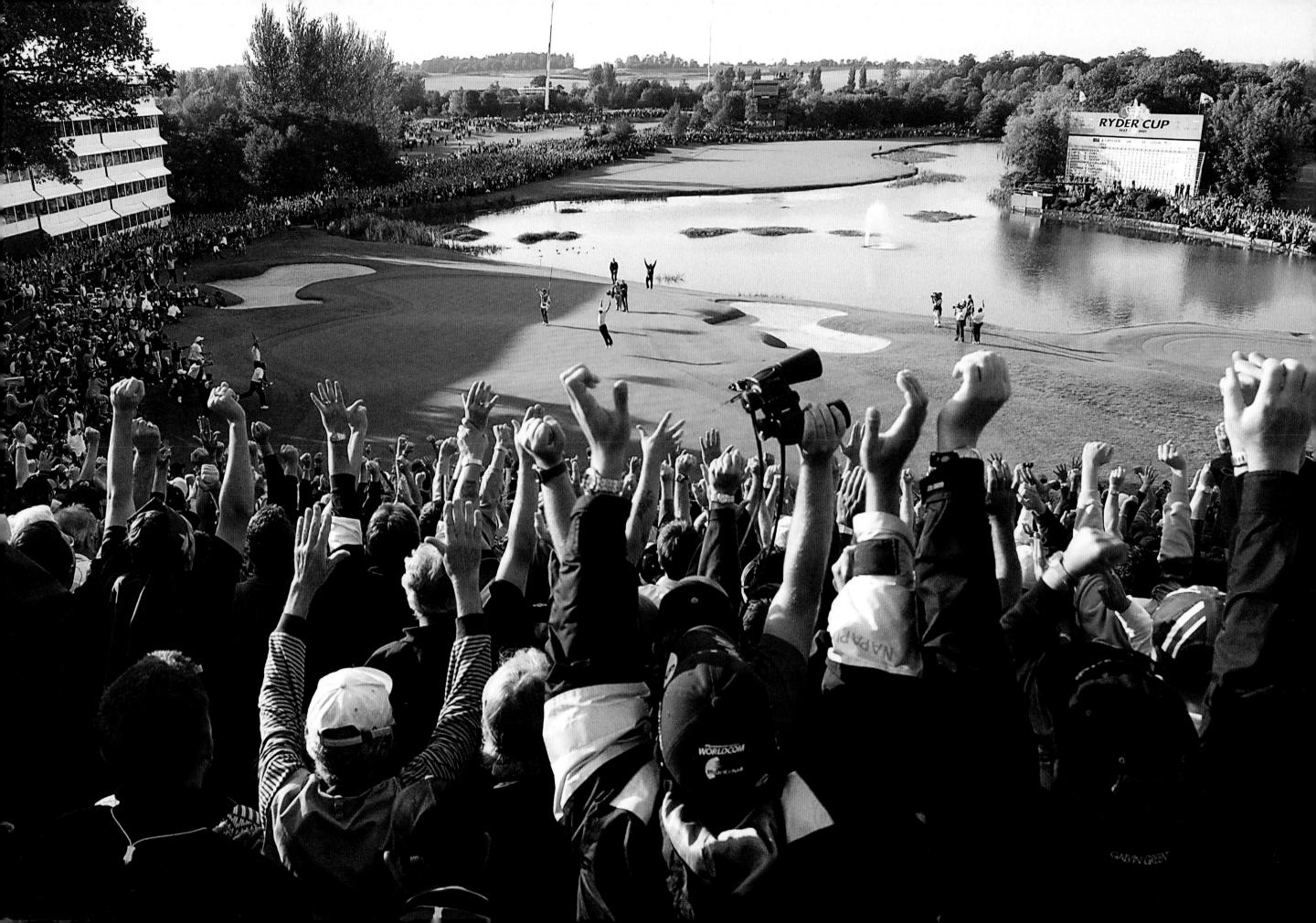

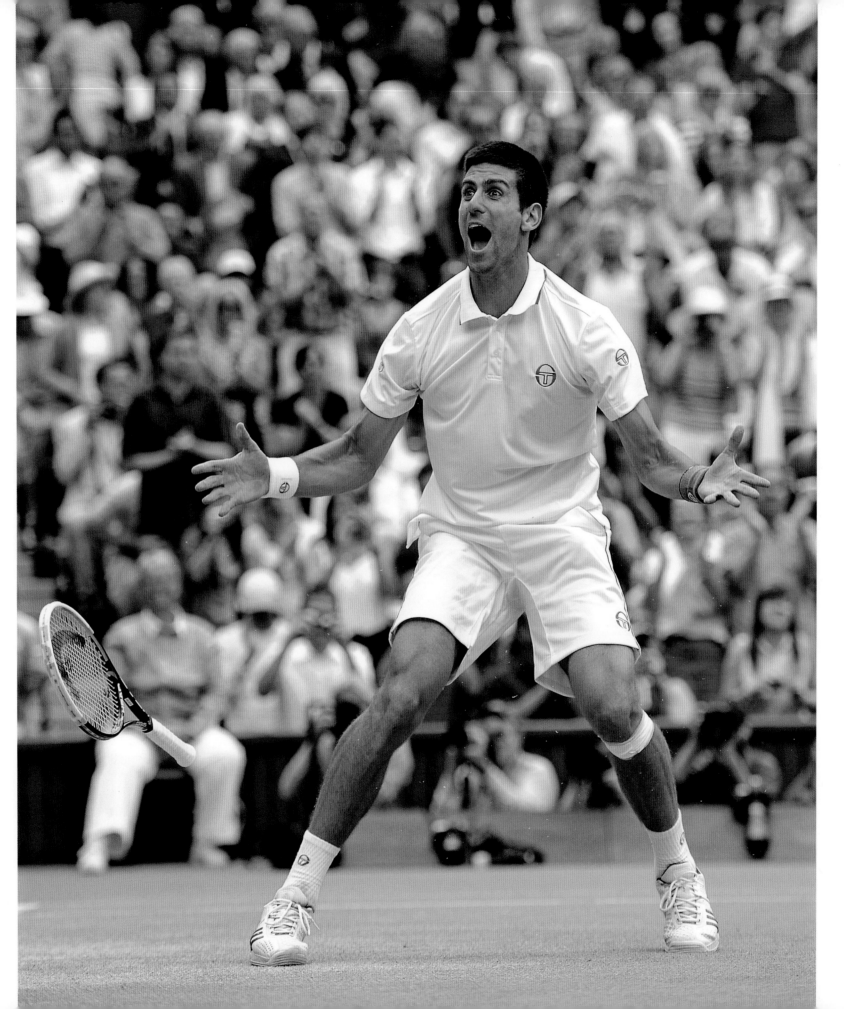

RYDER CUP, 2002

The funny thing about this picture is that I am almost certainly in it, somewhere. Paul McGinley has just holed his putt at the 18th to give Europe victory in the 2002 Ryder Cup at the Belfry, but as the crowd went wild I was on the 17th green with Phillip Price in the final match. But, thanks to my contacts the BBC radio people had allowed me to fix a remote control camera to the railing in front of their commentary box. So as soon as I heard the cheers of the crowd I fired the remote control, and then started running up the fairway to try and catch up with the action.

NOVAK DJOKOVIC

I think this is the best celebration shot I have seen of Djokovic, although it is actually from the end of the 2011 Wimbledon semi-final, not the final. It is taken from my favourite spot right under the players' box, where the players often turn at the moment of victory.

TECHNICAL INFORMATION

A MESSAGE FROM NIKON BY JOHN WALSHE, MANAGING DIRECTOR, NIKON UK

Nikon has been privileged to be Bob Martin's camera of choice for the most significant part of his photographic career and we are delighted to be associated with such a great collection of iconic sports photos.

Bob's first professional camera was a Nikon FM and like every master-craftsman, he perfected his skills from the ground up. Initially starting as a darkroom technician with Allsport, Bob soon moved on to the Nikon F2 photomic with motor drive and a highly prized 300mm f2.8 lens. He claims that it was this combination of equipment that first enabled him to start shooting sport events himself and launched his career in professional sports photography.

From my perspective, Bob has a unique talent for creating captivating images that are both visually vibrant and yet also bring a new perspective to the audience. Early in his career he was appointed as the only non-US photographer with *Sports Illustrated*, photographing the world's biggest sporting names and events. His technical ability and eye for capturing powerful images has won him countless awards including the coveted Sports Photographer of the Year, an accolade which he has received three times.

Whilst his natural eye and creativity have been the key ingredients of his success, Bob has always kept himself at the forefront of imaging technology. In 2007, Bob secured himself one of the first Nikon D3s and started exploring and pushing the boundaries of digital imaging. The 35mm frame sensor with high ISO capability allowed him to take images at fast shutter speeds, in challenging light conditions and deliver even more unique perspectives from established sport events. To this day, Bob continues to be the master of this technology and his understanding of the camera, along with his technical ability, keep him at the cutting edge of photography.

I think that each of these pictures demonstrate Bob's unrivalled ability to find a unique, striking viewpoint. The action-packed shot of horses jumping the final hurdle at The Cheltenham festival in 2012 (Nikon D4 and 14-24mm lens) is a powerful and compelling image that captures the atmosphere of drama in that very moment (see page 57). This picture unsurprisingly won first place in the USA NPPA awards for sports-action photography, an achievement which no other British photographer has replicated.

Bob again made history in 2013 by remotely shooting images at the All England Lawn Tennis Club's Championships in Wimbledon using a robotic head together with the Nikon D4. Placing the cameras in unique and inaccessible locations on the Centre Court's roof, the resulting imagery was striking and innovative and used worldwide. *Wimbledon: Visions of The Championships* won first place in the Best Illustrated Book category at the British Sports Book Awards in 2013, which was the second time Bob's work has contributed to winning this competition.

This latest book is a tour de force in sports photography. Each picture is a visual delight which tells a powerful and compelling story.

Nikon are proud to work with Bob as an ambassador. His talents continue to delight us and to inspire the next generation of sports photographers around the world.

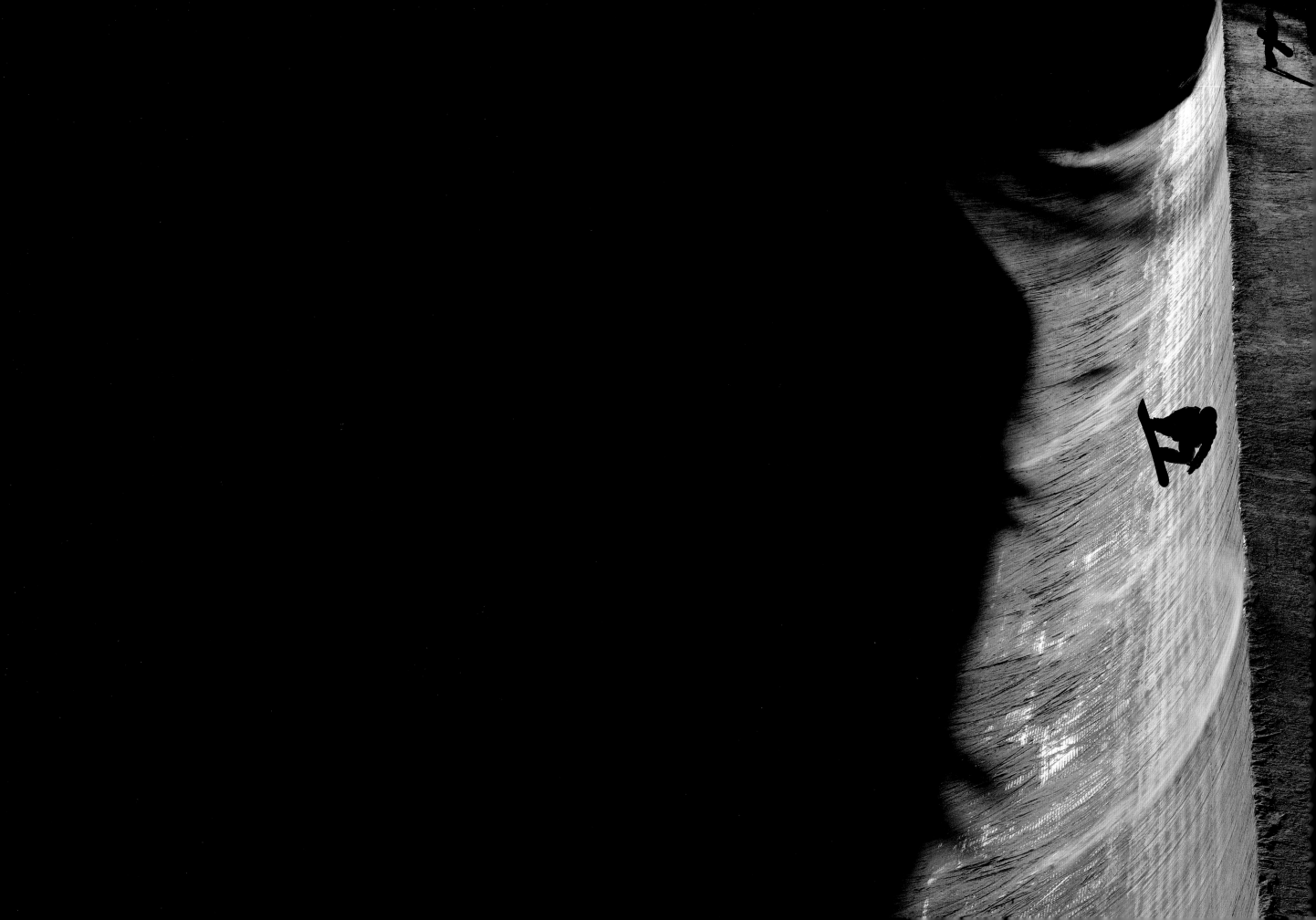

FRONT COVER

*Lens: Nikkor 70-200mm f2.8
G AF-S VR ED at 180mm*
Shutter speed: 1/15th
Aperture: f5.6
200 iso digital

I used a low shutter speed to
blur the crowd and foreground.

002

*Lens: Nikkor 70-200mm f2.8
G AF-S VR ED at 200mm*
Shutter speed: 1/1000th
Aperture: f2.8
200 iso digital

Tiger Woods at the US
Masters. Shot wide open to
give a limited depth of field.

005

*Lens: Nikkor 200mm
f2 G ED VRII*
Shutter speed: 1/640th
Aperture: f2
1000 iso digital

Shooting at f2 I managed to
freeze the chalk in lowlight.

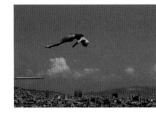

007

Lens: 150mm f5.6 6X8 format
Shutter speed: 1/500th
Aperture: f11
100 asa film

Shot with three large
studio flashes filling in
backlight sunlight.

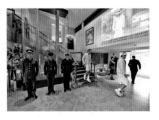

008

*Lens: Nikkor 14-24mm
f2.8G ED at 14mm*
Shutter speed: 1/320th
Aperture: f2.8
3200 iso digital

Amazing lowlight quality
from the Nikon D4.

011

Lens: 70-200mm f2.8 at 150mm
Shutter speed: 1/800th
Aperture: f2.8
1600 iso digital

Shot from the catwalk looking
down right above the start.

012

Lens: Nikkor 85mm f1.4 G
Shutter speed: 1/250th
Aperture: f11
200 iso digital

Shot with studio lighting on
the side of a road in Austria.

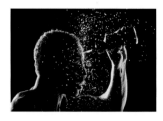

014

*Lens: Nikkor ED 180mm
f2.8 ED AIS*
Shutter speed: 1/250th
Aperture: f5.6
100 asa film

Backlit studio lighting froze
the water droplets.

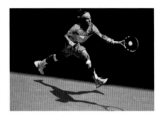

016

*Lens: Nikkor 500mm
f4.0 G ED AF-S VR*
Shutter speed: 1/1250th
Aperture: f5.6
200 iso digital

It is possible to shoot hand
held with this 500mm.

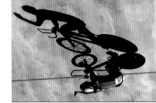

017

Lens: 70-200mm f2.8 at 180mm
Shutter speed: 1/1250th
Aperture: f4
200 iso digital

Slightly underexposed to
help define the shadow.

018

Lens: Nikkor 300mm f2.8
Shutter speed: 1/1000th
Aperture: f2.8
800 iso digital

Underexposed to silhouette the
diver against the dirty window.

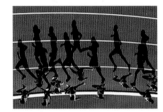

019

*Lens: Nikkor 70-200mm f2.8
G AF-S VR ED at 200mm*
Shutter speed: 1/1600th
Aperture: f8
200 iso digital

Slightly underexposed
to accentuate the long
shadows. The lane markings
help the composition.

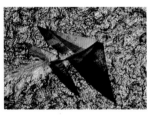

020

*Lens: Nikkor ED
180mm f2.8 AIS*
Shutter speed: 1/1000th
Aperture: f5.6
100 asa film

The texture of the water
picked out by the sun at
dusk makes this shot.

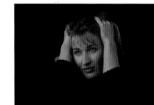

021

Lens: Nikkor 135mm f2
Shutter speed: 1/250th
Aperture: f8
100 asa film

A large softbox and a couple
of reflectors were all that was
needed for this picture.

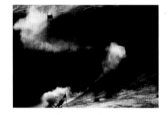

022

*Lens: Nikkor 600mm
f4.0 G ED AF-S VR*
Shutter speed: 1/1600th
Aperture: f4
200 iso digital

Heavily underexposed to
accentuate the shadows
and crosslight.

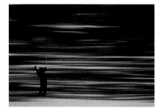

023

*Lens: Nikkor 400mm
f2.8 G ED AF-S VR*
Shutter speed: 1/1250th
Aperture: f3.5
100 iso digital

Early clear mornings
nearly always produce
great, clean light.

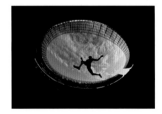

024

*Lens: Nikkor 16mm
f2.8 AF-D Fisheye*
Shutter speed: 1/2000th
Aperture: f3.5
200 iso digital

I used the distortion of a fisheye
lens to accentuate the curves
of the Berlin Olympic Stadium.

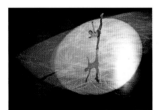

025

*Lens: Nikkor 300mm
f2.8 G AF-S VR*
Shutter speed: 1/1250th
Aperture: f2.8
1600 iso digital

I used the circle of the spotlight
to frame the subject on the ice.

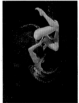

026

*Lens: Nikkor 300mm
f2.8 G AF-S VR*
Shutter speed: 1/2000th
Aperture: f2.8
3200 iso digital

With the latest D4 I was able
to shoot this indoors at 3200
asa. Impossible with film.

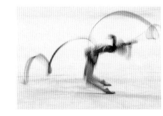

027-028

*Lens: Nikkor 400mm
f2.8 G ED AF-S VR*
Shutter speed: 1/15th
Aperture: f5.6
200 iso digital

On a monopod at
1/15th second.

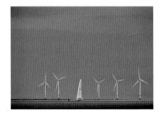

029

*Lens: Nikkor 500mm f4.0 G
ED AF-S VR + TC14 E2*
Shutter speed: 1/1250th
Aperture: f8
320 iso digital

A 1.4 converter made this
picture possible. It gave me a
700mm to compress the subject.

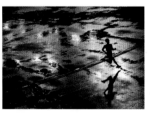

030

*Lens: Nikkor 400mm
f2.8 G ED AF-S VR*
Shutter speed: 1/640th
Aperture: f4
640 iso digital

Exposing for the reflections
of the floodlights created
a moody image.

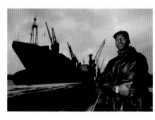

031

Lens: Nikkor 85mm f2
Shutter speed: 1/250th
Aperture: f5.6
200 asa film

A small softbox with a
speedlight inside made this
impromptu portrait possible.

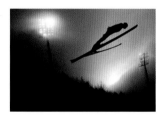

032

*Lens: Nikkor 24-70mm
f2.8G ED at 70mm*
Shutter speed: 1/800th
Aperture: f2.8
400 iso digital

As the sun went down behind
the floodlights a miserable,
wet day came good.

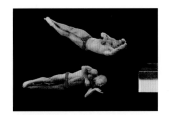

033

Lens: Nikkor 400mm f2.8
Shutter speed: 1/1600th
Aperture: f2.8
1600 iso digital

I need 1/1600th second to really stop the action in most cases.

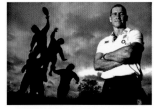

034

Lens: Nikkor 85mm f1.8G AF-S
Shutter speed: 1/250th
Aperture: f5.6
200 iso digital

Fifteen quick frames in the doorway of the RFU in Twickenham during a rainstorm – and Photoshop!

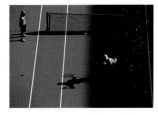

035

Lens: Nikkor 70-200mm f2.8 G AF-S VR ED at 200mm
Shutter speed: 1/1250th
Aperture: f8
100 iso digital

Keeping the ball boy in the picture helps the composition.

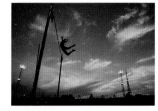

036

Lens: Nikkor 14-24mm f2.8G ED at 16mm
Shutter speed: 1/1600th
Aperture: f2.8
200 iso digital

Very wide angle and no distortion. This lens is a game changer!

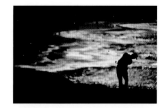

037

Lens: 350mm f5.6 Mirror
Shutter speed: 1/1250th
Aperture: f5.6
200 iso digital

A mirror lens made this picture, with the highlight 'doughnuts'. It's one of my favourite toys.

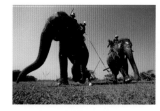

038

Lens: 24mm f2.8
Shutter speed: 1/1000th
Aperture: f5.6
200 asa film

Using a wide-angle lens and shooting really low helped to emphasise the size of the elephants.

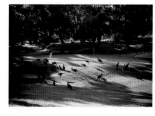

039

Lens: Nikkor 70-200mm f2.8 G AF-S VR ED at 180mm
Shutter speed: 1/1250th
Aperture: f5.6
200 iso digital

Late evening light helps to make this picture.

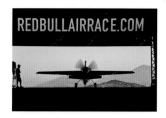

040

Lens: Nikkor 70-200mm f2.8 G AF-S VR II ED at 135mm
Shutter speed: 1/1250th
Aperture: f5.6
200 iso digital

I used the Red Bull Air Race signage in the composition.

041

Lens: 16-35mm at 16mm
Shutter speed: 1/2000th
Aperture: f4
200 asa film

On wide angles you need a really high shutter speed to stop the action.

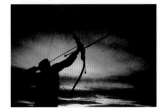

042

Lens: Nikkor 24mm f2 AI-S
Shutter speed: 1/500th
Aperture: f11
64 asa film

Shot on Kodachrome. In these days we waited three days to see the pictures!

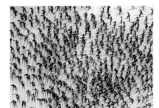

043

Lens: 70-200mm f2.8 at 180mm
Shutter speed: 1/1250th
Aperture: f4
200 asa film

Shooting from a helicopter you need at least 1/800th second to overcome the vibration.

044-045

Lens: Nikkor 14-24mm f2.8G ED at 14mm
Shutter speed: 1/125th
Aperture: f2.8
640 iso digital

Low light is where the D4S digital files really blow film away.

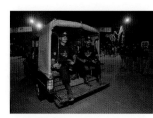

046-047

Lens: Nikkor 24-70mm f2.8G ED at 28mm
Shutter speed: 1/60th
Aperture: f2.8
640 iso digital

Modern short zooms like the 24-70mm are perfect for working unobtrusively.

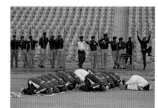

047

Lens: Nikkor 70-200mm f2.8 G AF-S VR ED at 150mm
Shutter speed: 1/1000th
Aperture: f2.8
200 iso digital

The security watching the prayers of the Pakistan team told the story.

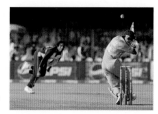

047

Lens: Nikkor 600mm f4.0
Shutter speed: 1/1000th
Aperture: f4
200 iso digital

A long telephoto lens compresses the content and blurs the background.

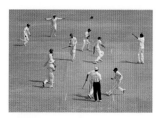

048

Lens: Nikkor 70-200mm f2.8 at 180mm
Shutter speed: 1/1250th
Aperture: f4
100 iso digital

Shot remotely with a pocketwizard – the moment India beat Pakistan in Pakistan.

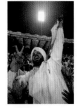

049

Lens: Nikkor 24-70mm
Shutter speed: 1/250th
Aperture: f2.8
320 iso digital

A tiny bit of flash used manually fills in the shadows.

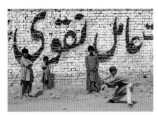

050

Lens: Nikkor 70-200mm f2.8 at 150mm
Shutter speed: 1/1250th
Aperture: f4
320 iso digital

I used the signage behind to help the composition.

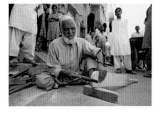

051

Lens: Nikkor 16-35mm at 20mm
Shutter speed: 1/640th
Aperture: f2.8
320 iso digital

A wide angle, if shot bold, can isolate the subject in a busy scene.

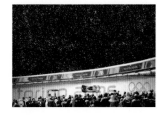

052

Lens: Nikkor 70-200mm f2.8 G AF-S VR ED at 180mm
Shutter speed: 1/1000th
Aperture: f2.8
2000 iso digital

So much snow fell we almost lost the camera bag!

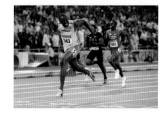

054

Lens: Nikkor 24-70mm f2.8G ED at 70mm
Shutter speed: 1/1600th
Aperture: f4
2400 iso digital

The clean backdrop at the finish line is the only spot for me.

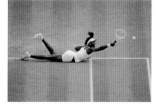

055

Lens: Nikkor 500mm f4.0 G ED AF-S VR
Shutter speed: 1/1250th
Aperture: f4
200 iso digital

The background of grass makes the subject stand out.

056

Lens: 600mm f4.0
Shutter speed: 1/1000th
Aperture: f4
800 asa film

A little detail can make a great picture amongst the action.

057

Lens: Nikkor 14-24mm f2.8G ED at 14mm
Shutter speed: 1/2000th
Aperture: f2.8
200 iso digital

14-24mm, the ultimate remote lens, helped make this picture possible.

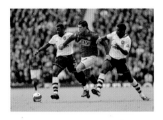

058

*Lens: Nikkor 400mm
f2.8 ED AF-S
Shutter speed: 1/1000th
Aperture: f2.8
800 iso digital*

The 400mm is the standard lens
for a football photographer.

059

*Lens: 600mm f4.0
Shutter speed: 1/1250th
Aperture: f8
200 iso digital*

When photographing skiing or
snowboarding, underexpose to
keep some detail in the snow.

060

*Lens: Nikkor 85mm f2
Shutter speed: 1/1000th
Aperture: f4
64 asa film*

One of my first remote
pictures – fired by cable
from 40 metres away.

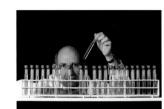

061

*Lens: 180mm f5.6 6X8 format
Shutter speed: 1/500th
Aperture: f11
50 asa film*

Studio lit with softbox strips
to keep the highlights in the
test tubes looking good.

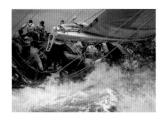

062

*Lens: Nikkor ED
180mm f2.8 AIS
Shutter speed: 1/640th
Aperture: f3.5
200 asa film*

Shooting from a boat that is
low in the water enables a
low and dramatic angle.

063

*Lens: 600mm f4.0 + 1.4 conv
Shutter speed: 1/1250th
Aperture: f5.6
200 asa film*

Use a shutter speed no
lower than the focal length
to avoid movement.

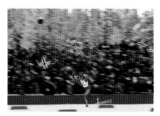

064

*Lens: 300mm f2.8 IF-ED
Shutter speed: 1/30th
Aperture: f8
64 asa film*

A slow shutter speed was
used to blur the background.

065

*Lens: 600mm f4.0 + 1.4 conv
Shutter speed: 1/1250th
Aperture: f5.6
200 iso digital*

Underexposed with so much
wash and spray about to
keep detail in the water.

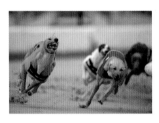

066

*Lens: Nikkor 600mm f4.0ED Ai-S
Shutter speed: 1/1000th
Aperture: f4
200 asa film*

The limited depth of field means
only the leading dog is sharp.

067

*Lens: Nikkor 400mm f2.8ED
Ai-S + TC14 conv
Shutter speed: 1/1000th
Aperture: f4.5
100 asa film*

A 1.4 converter was needed with
a 400mm to give you a 540mm.

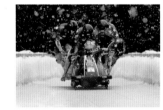

068

*Lens: Nikkor 200-400mm
f4.0G AF-S VR
Shutter speed: 1/1250th
Aperture: f8
1600 iso digital*

I only took a 200-400mm as it
was foggy so a 1.7 converter
saved the day when I found
this angle, giving a 680mm.

069

*Lens: 16-35mm at 16mm
Shutter speed: 1/1600th
Aperture: f8
200 asa film*

Only a few frames were
sharp – you should really
use 1/2000th with action so
close to a wide-angle lens.

070

*Lens: Nikkor 600mm f4.0ED Ai-S
Shutter speed: 1/1000th
Aperture: f4
200 asa film*

The long lens kills the
background with its
limited depth of field.

071

*Lens: Nikkor 500mm
f4.0 G ED AF-S VR
Shutter speed: 1/1250th
Aperture: f5.6
200 iso digital*

Backlit trees turn into a
great black background at
Wengen in Switzerland.

072

*Lens: Nikkor 200-400mm
f4.0G AF-S VRII at 340mm
Shutter speed: 1/1250th
Aperture: f5.6
200 iso digital*

The 200-400mm is a great lens
when you have to walk a long
way – very versatile and light.

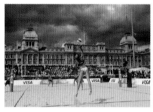

073

*Lens: Nikkor 24-70mm
f2.8G ED at 28mm
Shutter speed: 1/1600th
Aperture: f4.5
200 iso digital*

The backdrop and sky
make this picture.

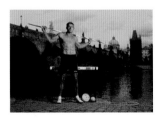

074

*Lens: Nikkor 35mm f2 AI-S
Shutter speed: 1/250th
Aperture: f5.6
100 asa film*

Gentle fill flash from a large
octa lightbox saved this
portrait on a foggy evening.

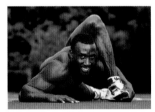

075

*Lens: Nikkor 85mm f2 AI-S
Shutter speed: 1/640th
Aperture: f5.6
100 asa film*

Late evening light with
no reflectors or lights
made this portrait.

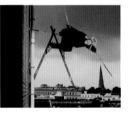

076

*Lens: 150mm f5.6 6X8 format
Shutter speed: 1/500th
Aperture: f11
100 asa film*

Two beauty dishes lit
Eddie on the top of a car
park in Cheltenham.

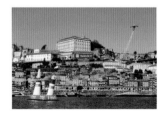

077

*Lens: Nikkor 24-70mm
f2.8G ED at 35mm
Shutter speed: 1/1600th
Aperture: f5.6
100 iso digital*

The standard lens today is a
24-70mm for so many pictures.

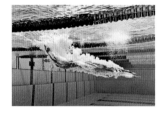

078

*Lens: Nikkor 24-70mm
f2.8G ED at 50mm
Shutter speed: 1/1250th
Aperture: f2.8
1600 iso digital*

The colour balance from
an underwater window is
very blue. I shot raw and
corrected in Photoshop.

079

*Lens: Nikkor 14-24mm
f2.8G ED at 14mm
Shutter speed: 1/125th
Aperture: f8
200 iso digital*

For this remote picture I
used a slow shutter speed
to show movement.

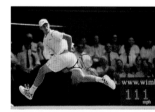

080

*Lens: Nikkor 70-200mm f2.8
G AF-S VR ED at 180mm
Shutter speed: 1/1250th
Aperture: f4
200 iso digital*

Just a good action
shot. I guess I wish the
background was better!

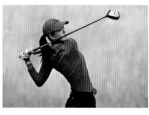

081

*Lens: Nikkor 600mm
f4.0 G ED AF-S VR
Shutter speed: 1/1250th
Aperture: f4.5
200 iso digital*

The 600mm really does isolate
the subject and produce the
softest, greatest backgrounds.

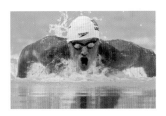

082

*Lens: Nikkor 800mm
f5.6E FL ED VR
Shutter speed: 50th
Aperture: f5.6
3200 iso digital*

800mm with indoor lighting.
This is only possible with
today's technology.

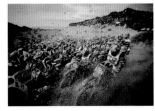

083

*Lens: Nikkor 24mm f2 AI-S
Shutter speed: 1/1250th
Aperture: f4
200 asa film*

Be very careful with autofocus
when shooting busy pictures
full of detail. It easily ends up at
infinity if you are not careful.

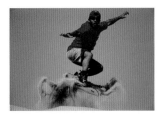

084

*Lens: Nikkor 400mm
f2.8 ED AF-S
Shutter speed: 1/1000th
Aperture: f5.6
100 asa film*

The best backdrop in
the world – blue sky!

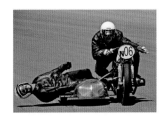

085

*Lens: Nikkor 400mm f2.8 ED
AF-S +1.4 TC14 conc
Shutter speed: 1/1000th
Aperture: f4.5
200 asa film*

560mm with the converter. I got
a clean backdrop of the track
by standing on a slight hill.

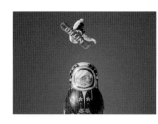

086

*Lens: Nikkor 600mm
f4.0 G ED AF-S VR
Shutter speed: 1/1600th
Aperture: f5.6
200 iso digital*

You sometimes have to shoot
early, in this case as soon as I
saw the tip of the snowboard –
11 frames a second with a D4S.

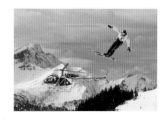

087

*Lens: Nikkor ED
180mm f2.8 AIS
Shutter speed: 1/1000th
Aperture: f5.6
200 asa film*

The telephoto lens compresses
the perspective to make
this shot look far more
dangerous than it really was!

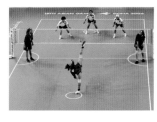

088

*Lens: 70-200mm f2.8 at 150mm
Shutter speed: 1/1250th
Aperture: f2.8
800 iso digital*

A position in the crowd got
me the backdrop I wanted.

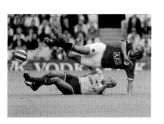

089

*Lens: 400mm f2.8
Shutter speed: 1/1000th
Aperture: f2.8
800 iso digital*

Great action – shame
the background is not as
good as it could be.

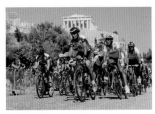

090

*Lens: 70-200mm f2.8 at 180mm
Shutter speed: 1/1250th
Aperture: f4.5
200 iso digital*

The position was chosen
to include the Parthenon,
then a telephoto lens
compresses the perspective.

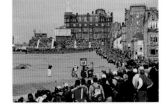

091

*Lens: Nikkor 70-200mm f2.8
G AF-S VR II ED at 120mm
Shutter speed: 1/1250th
Aperture: f4.5
200 iso digital*

Using a remote camera on a
six metre pole gave this unique
view. We call it 'polecam'.

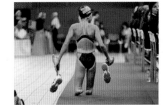

093

*Lens: 300mm f2.8
Shutter speed: 1/1000th
Aperture: f2.8
1600 iso digital*

The judge's head turning to
look makes this picture.

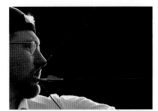

094

*Lens: 400mm f2.8
Shutter speed: 1/500th
Aperture: f4.5
200 iso digital*

A long lens throws the
background way out of focus
to isolate the subject.

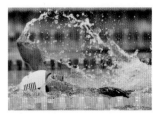

095

*Lens: 600mm f4.0
Shutter speed: 1/640th
Aperture: f4
1600 iso digital*

For swimming the standard
lens is the 600mm.

096

*Lens: 16-35mm at 20mm
Shutter speed: 1/500th
Aperture: f2.8
1600 iso digital*

A very wide-angle lens helped
to emphasise the offset
wheels of the wheelchair.

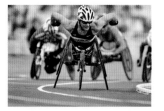

096

*Lens: 600mm f4.0
Shutter speed: 1/1000th
Aperture: f4
400 iso digital*

A good basic rule is to
get as low as possible for
more dramatic pictures.

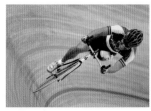

097

*Lens: 400mm f2.8
Shutter speed: 1/800th
Aperture: f2.8
1600 iso digital*

Turning the camera and
shooting at an angle helps to
add drama to this picture.

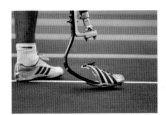

098

*Lens: 600mm F4.0
Shutter speed: 1/640th
Aperture: f4
800 iso digital*

The tiny amount of depth
of field pulls the eye to the
detail of the prosthetic leg.

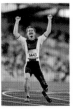

099

*Lens: 600mm f4.0
Shutter speed: 1/800th
Aperture: f4
800 iso digital*

A long lens throws the
background out of focus to
isolate the subject and a position
just around the corner from the
finish gives the cleanest shot.

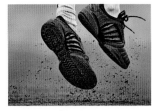

100

*Lens: Nikkor 600mm
f4.0 ED Ai-S
Shutter speed: 1/1000th
Aperture: f4
200 asa film*

I shot quite a few frames to
get this one! Don't be afraid
to use the motordrive to get
the moment you need.

102

*Lens: Nikkor 600mm
f4.0 ED Ai-S
Shutter speed: 1/1000th
Aperture: f4
200 asa film*

This was before autofocus.
However, it might have messed
this one up as the focus may
have jumped to the grass!

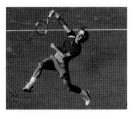

103

*Lens: Nikkor 500mm
f4.0 G ED AF-S VR
Shutter speed: 1/1250th
Aperture: f5.6
200 iso digital*

The clay court backdrop at
Roland Garros is probably
the best background in
sports photography.

104

*Lens: Nikkor 500mm
f4.0 G ED AF-S VR
Shutter speed: 1/1250th
Aperture: f4
100 iso digital*

The limited depth of field
helps to make the beads
of sweat stand out.

105

*Lens: Nikkor 500mm
f4.0 G ED AF-S VR
Shutter speed: 1/1000th
Aperture: f4.5
200 iso digital*

A portrait grabbed in the rest
period between games. Always
be on the look out for detail and
moments between the action.

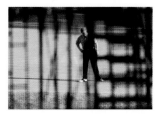

106

*Lens: Nikkor 400mm
f2.8 ED Ai-S
Shutter speed: 1/1000th
Aperture: f3.5
200 asa film*

Even today, use manual
focus for this sort of picture
– always be ready to turn
off the toys occasionally.

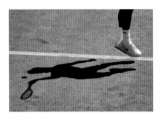

107

Lens: Nikkor 600mm f4.0 G ED AF-S VR + TC-14EII
Shutter speed: 1/1000th
Aperture: f8
200 iso digital

A long way up at the back of the public stands for this one.

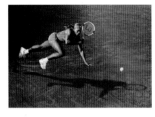

108

Lens: 400mm f2.8
Shutter speed: 1/1000th
Aperture: f5.6
200 iso digital

The ball on the racket is not always the picture you need – shoot early as the ball coming to the player is frequently better.

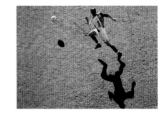

109

Lens: 300mm f2.8 + TC14
Shutter speed: 1/1000th
Aperture: f5.6
200 asa film

If you need a long lens but need to hand hold the camera use a converter, in this case a 420mm hand holdable lens.

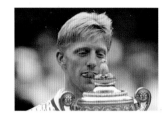

110

Lens: Nikkor 300mm f2.8 IF ED
Shutter speed: 1/500th
Aperture: f2.8
200 asa film

Sometimes during a presentation you can go from a boring picture to an engaging one by honing in on the moment.

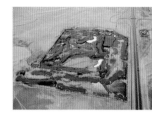

111

Lens: Nikkor 135mm f2
Shutter speed: 1/1000th
Aperture: f4.5
200 asa film

When shooting from a helicopter be careful as the rotors are spinning so fast you won't see them through the viewfinder but they will show in the pictures.

112

Lens: 70-200mm f2.8 at 180mm
Shutter speed: 1/640th
Aperture: f2.8
100 asa film

Lying down in the long grass made the subject stand out as his head was now against the sky. Use a dynamic angle for your pictures.

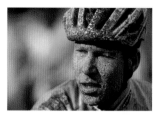

113

Lens: Nikkor ED 180mm f2.8 AIS
Shutter speed: 1/1000th
Aperture: f4
100 asa film

A grabbed portrait – the crosslight makes the image.

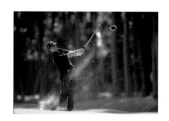

114

Lens: 300mm f2.8
Shutter speed: 1/1000th
Aperture: f5.6
200 asa film

The sand stands out in the backlight, shot late in the afternoon.

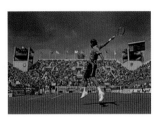

115

Lens: Nikkor 14-24mm f2.8G ED at 16mm
Shutter speed: 1/1600th
Aperture: f3.5
200 iso digital

This lens delivers yet again. It is the absolute best option when you are sitting waiting for action to fill the frame on a wide angle.

116

Lens: 70-200mm f2.8 at 150mm
Shutter speed: 1/1000th
Aperture: f4
200 asa film

The elevation made this picture. At ground level it would not have had the drama.

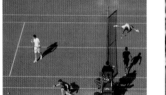

117

Lens: Nikkor 80-400mm f4-5.6G AF-S ED at 110mm
Shutter speed: 1/1250th
Aperture: f6.3
200 iso digital

A 80-400mm zoom on my robotic. This is the best lens for robotics high in the roof or also shooting from the back of a motorbike!

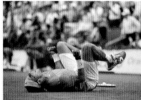

118

Lens: 70-200mm f2.8 at 150mm
Shutter speed: 1/1000th
Aperture: f2.8
320 iso digital

For match points a zoom – either 70-200 or 200-400 – is the best as you can't predict what your subject will do.

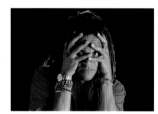

119

Lens: Nikkor 85mm f2
Shutter speed: 1/250th
Aperture: f8
100 asa film

A softbox and a back hairlight was enough for this simple portrait.

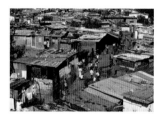

120-121

Lens: Nikkor ED 180mm f2.8 AIS
Shutter speed: 1/1000th
Aperture: f4
200 asa film

Composing to show the road running diagonally across the frame helps to draw the eye through this scene.

122

Lens: Nikkor 24mm f2 AI-S
Shutter speed: 1/1000th
Aperture: f4.5
100 asa film

This was difficult to expose as the coal on the floor was sucking all the light up.

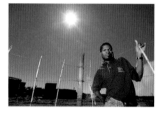

123

Lens: Nikkor 24mm f2 AI-S
Shutter speed: 1/250th
Aperture: f11
100 asa film

A speedlight off camera lit this dramatic frame.

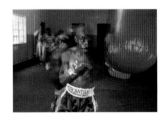

123

Lens: Nikkor 50mm f1.4 AI-S
Shutter speed: 1/30th
Aperture: f5.6
100 asa film

A little bit of flash and a slow shutter speed puts some drama into a very boring gym.

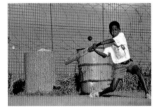

124

Lens: Nikkor 300mm f2.8 IF ED
Shutter speed: 1/1000th
Aperture: f4
100 asa film

The barbed wire background made this shot stand out.

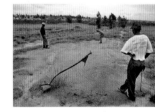

124

Lens: Nikkor 24mm f2 AI-S
Shutter speed: 1/1000th
Aperture: f2.8
200 asa film

Filling the frame on a wide angle with your subject makes it stand out whilst you can still see the background.

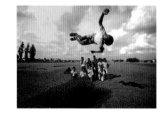

125

Lens: Nikkor 24mm f2 AI-S
Shutter speed: 1/2000th
Aperture: f4.5
200 asa film

1/2000th was the highest shutter speed on a film camera at the time (Nikon F3).

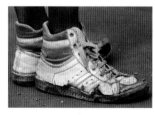

126

Lens: Nikkor 300mm f2.8 IF ED
Shutter speed: 1/1000th
Aperture: f4
100 asa film

Obviously the state of the child's shoes is what makes this picture memorable.

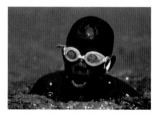

127

Lens: Nikkor 600mm f4.0 ED Ai-S
Shutter speed: 1/1000th
Aperture: f4.5
100 asa film

The 600mm isolates and emphasises the subject with such small depth of field.

128

Lens: 210mm f5.6 6X8 format
Shutter speed: 1/500th
Aperture: f11
100 asa film

A softbox and two key lights lit this shot in a corner of a Hamburg boxing gym.

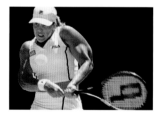

130

Lens: 400mm f2.8
Shutter speed: 1/1250th
Aperture: f3.5
100 iso digital

The Australian Open has the best backgrounds for photography in tennis during the day. At night the worst, illuminated adverts…

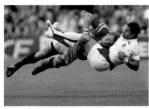 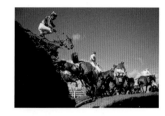 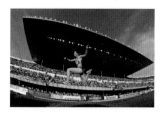 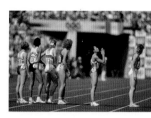 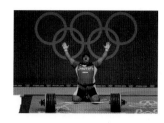 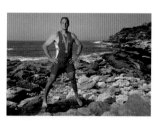

131

*Lens: Nikkor 500mm
f4.0 G ED AF-S VR
Shutter speed: 1/1250th
Aperture: f4
400 iso digital*

The 500mm is the best lens for working while sitting at the end of a rugby pitch. It's light enough to put down quickly as the action approaches.

132

*Lens: 210mm f5.6 6X8 format
Shutter speed: 1/500th
Aperture: f11
200 asa film*

Big gold umbrellas gave contrast to the lighting that really worked for the Williams sisters.

133

*Lens: Nikkor 85mm f2
Shutter speed: 1/250th
Aperture: f11
100 asa film*

A tiny set-up in the corner of a gym – small softbox and a reflector.

134

*Lens: Nikkor 24mm f2 AI-S
Shutter speed: 1/1000th
Aperture: f4.5
100 asa film*

Remotes early on were wired together with many metres of lighting cable and a big plunger. On this day I had four different remotes on Becher's Brook.

135

*Lens: Nikkor 16mm
f2.8 AF-D Fisheye
Shutter speed: 1/1250th
Aperture: f4
100 iso digital*

As long as you keep the centre of the frame level you don't notice the distortion of the fisheye lens.

136

*Lens: Nikkor 300mm f2.8 IF ED
Shutter speed: 1/1000th
Aperture: f4
64 asa film*

Framing Flo Jo in the darkness of the entrance helps to draw your eye.

137

*Lens: 70-200mm f2.8 at 180mm
Shutter speed: 1/800th
Aperture: f2.8
1600 iso digital*

Compositionally perfect as the weightlifter's hands are framed by the rings.

138

*Lens: 150mm f5.6 6X8 format
Shutter speed: 1/500th
Aperture: f11
100 asa film*

Just reflectors – along with two assistants to hold them still in the wind – lit Steve Redgrave on Bondi Beach.

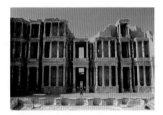 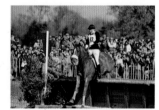 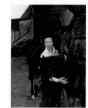 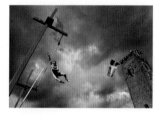 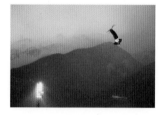 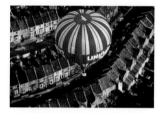

139

*Lens: Nikkor 35mm f2 Ai-S
Shutter speed: 1/500th
Aperture: f8
100 asa film*

This portrait works as the subject is so small and alone in the ruins of a Roman theatre.

140

*Lens: Nikkor 85mm f1.4 G
Shutter speed: 1/250th
Aperture: f8
100 iso digital*

A simple portrait is sometimes all that is needed. Soft light and a gradated backdrop.

141

*Lens: Nikkor 24-70mm
f2.8G ED at 24mm
Shutter speed: 1/125th
Aperture: f5.6
100 iso digital*

Fifteen frames and two minutes were all we needed of Federer's time. Always set up in advance!

142

*Lens: Nikkor 300mm f2.8 IF ED
Shutter speed: 1/500th
Aperture: f5.6
64 asa film*

An early sequence for me – 3.5 frames a second on a Nikon F2. Nowadays you get 11 frames a second on a Nikon D4S.

143

*Lens: Nikkor 50mm f1.4 AI-S
Shutter speed: 1/250th
Aperture: f8
100 iso digital*

A softbox produces a very soft light to fill in the shadows on a dull day.

144

*Lens: 24mm f2.8
Shutter speed: 1/1250th
Aperture: f4
200 iso digital*

No additional lighting – just evening sun and a great sky.

145

*Lens: 70-200mm f2.8 at 150mm
Shutter speed: 1/1000th
Aperture: f2.8
800 iso digital*

A dull, foggy day at dusk still looks dynamic as the hills behind turn blue and the stadium lights take over.

146

*Lens: Nikkor 105mm f1.8 AI-S
Shutter speed: 1/1000th
Aperture: f5.6
100 asa film*

The road below – running from one corner of the frame to the other – makes the composition.

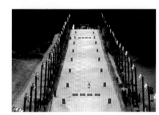 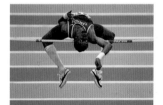 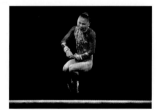 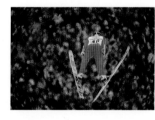 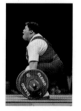 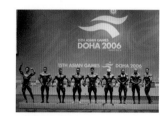 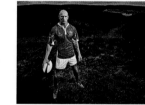

147

*Lens: 70-200mm f2.8 at 150mm
Shutter speed: 1/800th
Aperture: f2.8
1600 iso digital*

Using a telephoto lens compresses the light gantries together to help the composition.

148

*Lens: 400mm f2.8
Shutter speed: 1/1000th
Aperture: f2.8
1600 iso digital*

The blue lanes of the background make this picture, and a long lens pleasantly blurs the backdrop.

149

*Lens: Nikkor 300mm
f2.8 G AF-S VR
Shutter speed: 1/1250th
Aperture: f2.8
2400 iso digital*

A clean backdrop and a high action moment – that is all it takes sometimes.

150

*Lens: 350mm f5.6 Mirror
Shutter speed: 1/1000th
Aperture: f5.6
400 asa film*

A mirror lens makes the crowd in the background into circles like doughnuts. These are no longer availble from the mainstream brands.

151

*Lens: Nikkor 300mmf2.8
G AF-S VR
Shutter speed: 1/1000th
Aperture: f2.8
1600 iso digital*

The only clean backdrop in the arena was almost exactly side on.

152-153

*Lens: Nikkor 70-200mm F2.8
G AF-S VR ED at 70mm
Shutter speed: 1/500th
Aperture: f2.8
1000 iso digital*

I shot this from many diiferent angles. I like this one because you can read '15th Asian Games' above the athletes.

154

*Lens: Nikkor 50mm f1.4G AF-S
Shutter speed: 1/250th
Aperture: f4
200 iso digital*

Shot with battery powered studio lights out in the Welsh Valleys.

155

*Lens: 24-70mm
Shutter speed: 1/250th
Aperture: f5.6
200 asa film*

Shot with a speedlight in a small softbox.

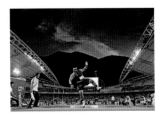

156

*Lens: Nikkor 16-35mm
f4G ED VR at 16mm*
Shutter speed: 1/800th
Aperture: f4
1600 iso digital

Waiting for the right moment as
the sun went down, the sky was
only perfect for one competitor.

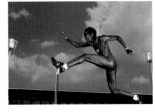

157

Lens: Nikkor 35mm f2 AI-S
Shutter speed: 1/250th
Aperture: f8
200 asa film

Balancing the studio lights to
the stadium lights and choosing
the right moment to start
shooting to get the best sky.

158

Lens: 210mm f5.6 6X8 format
Shutter speed: 1/500th
Aperture: f11
100 asa film

Exactly the same background,
lighting and film was used
as a picture of Sir Edmund
Hillary taken in New Zealand
so the shots would match.

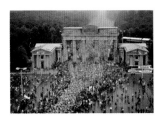

159

Lens: Nikkor 85mm f2
Shutter speed: 1/500th
Aperture: f2
200 asa film

Didn't want to go much
beyond 200 asa in the film
days as negative was the only
way and transparency film
above 200 asa was awful.

160

*Lens: Nikkor 600mm
f4.0 ED Ai-S*
Shutter speed: 1/500th
Aperture: f2.8
800 asa film

Struggling to shoot indoor sports
is a thing of the past. The new
digital cameras like the Nikon
D4S are so good at high iso it
can look better than in the sun.

161

*Lens: Nikkor 24-70mm
f2.8G ED at 24mm*
Shutter speed: 1/1000th
Aperture: f4
200 iso digital

Lovely light, great background,
up to my knees in the water.
What more do you need to do?!

162

Lens: Nikkor 85mm f1.4 G
Shutter speed: 1/250th
Aperture: f4
200 iso digital

A dull, dreary day and white
skies. Turn up the studio
lights and darken the sky by
underexposing the background.

163

*Lens: Nikkor 24-70mm
f2.8 G ED at 50mm*
Shutter speed: 1/250th
Aperture: f8
100 iso digital

Battery powered studio lights
were needed in Ethiopia – no
power plugs to be found!

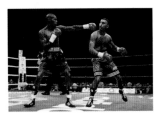

164

Lens: Nikkor 50mm f1.4 AI-S
Shutter speed: 1/1000th
Aperture: f2
800 asa film

I like a 50mm for ringside
boxing. I don't change the
lens too often as you can miss
the key moment so easily!

165

Lens: Nikkor 50mm f1.4 AI-S
Shutter speed: 1/60th
Aperture: f2.8
100 asa film

A slow shutter speed to add
a bit of blur to the subject
and background, with a small
studio light set a stop above
the ambient light level.

166

Lens: 135mm f5.6 6X8 format
Shutter speed: 1/500th
Aperture: f8.5
100 asa film

Lit with reflectors and the
sun in a great location.

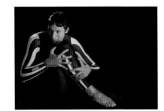

167

Lens: 210mm f5.6 6X8 format
Shutter speed: 1/500th
Aperture: f11
100 asa film

A large softbox and a
highlight on the hair, all
in his father's garage.

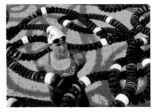

168

Lens: 210mm f5.6 6X8 format
Shutter speed: 1/500th
Aperture: f11
100 asa film

Just reflectors lit this shot.
The lane dividers waiting to
be fitted add to the picture.

169

Lens: 50mm f5.6 6X8 format
Shutter speed: 1/500th
Aperture: f11
100 asa film

An empty beach and a great flag
gave this picture a 1920s look.

170

Lens: Nikkor 600mm f4.0
Shutter speed: 1/1000th
Aperture: f5.6
100 asa film

Shot during training. Susan
O'Neill's amazing 'wingspan'
makes the picture.

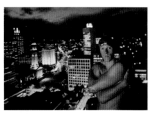

170

Lens: 90mm f5.6 6X8 format
Shutter speed: 1/15th
Aperture: f5.6
200 asa film

Shot on a tripod, exposing
for the city with a small
softbox to light Kieren. He
had to stand very still!

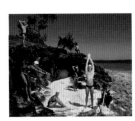

171

Lens: 110mm f5.6 6X8 format
Shutter speed: 1/500th
Aperture: f11
100 asa film

A disaster for lighting as the
generator broke down. We
resorted to speedlights on radios
hidden behind rocks with pocket
wizards to fire them. Very crude!

172

*Lens: Nikkor 14-24mm
f2.8G ED at 14mm*
Shutter speed: 1/640th
Aperture: f5.6
100 iso digital

Exposed for the sun coming
through the balloon, leaving the
guy in the balloon silhouetted.

174

*Lens: Nikkor 800mm f5.6E
FL ED VR + TC800-1.25E*
Shutter speed: 1/1000th
Aperture: f7.1
3200 iso digital

The matched converter
gave me a 1000mm lens!
Indoors at 3200 iso is almost
as good as daylight.

175

Lens: Nikkor 300mm f2.8 IF ED
Shutter speed: 1/1000th
Aperture: f4.5
64 asa film

The backlit trees gave me
a good black backdrop.

176

Lens: Nikkor 24mm f2 AI-S
Shutter speed: 1/1000th
Aperture: f5.6
100 asa film

Half in the sea to get this classic
angle on the triathlon in Nice.

177

*Lens: Nikkor ED
180mm f2.8 AIS*
Shutter speed: 1/30th
Aperture: f11
100 asa film

Panned at 1/30th second. I find
panned shots on film are much
better than panning on digital,
but I don't understand why!

178

Lens: 350mm f5.6 Mirror
Shutter speed: 1/500th
Aperture: f5.6
100 iso digital

The mirror lens at its best
gives another look to a normal
tee shot from The Masters.

179

*Lens: Nikkor ED
180mm f2.8 AIS*
Shutter speed: 1/1000th
Aperture: f5.6
100 asa film

Using the flowers as a
foreground was a bit
of a no-brainer.

180

*Lens: Nikkor 600mm
f4.0 ED Ai-S
Shutter speed: 1/1000th
Aperture: f5.6
100 asa film*

Difficult to expose all the snow in the air, you must keep detail in the whites. Not one for auto!

181

*Lens: 24-70mm at 35mm
Shutter speed: 1/1000th
Aperture: f5.6
200 iso digital*

For this I set the focus manually as the snowboarder was only in place for one frame. Autofocus would never keep up.

182-183

*Lens: Nikkor 400mm
f2.8 G ED AF-S VR
Shutter speed: 1/1000th
Aperture: f5.6
200 iso digital*

The lane markers in the foreground and background make this image – a very graphic composition.

184

*Lens: Nikkor 70-200mm f2.8
G AF-S VR ED at 180mm
Shutter speed: 1/1000th
Aperture: f5.6
100 iso digital*

One of the classic shots from Beijing. The officials kept the TV and stills guys well back which made it better for everyone.

185

*Lens: Nikkor 16mm
f2.8 AF-D Fisheye
Shutter speed: 1/1000th
Aperture: f8
200 iso digital*

Shooting from the top window of Tower Bridge, the flags make the picture.

186

*Lens: Nikkor 24-70mm
f2.8G ED at 28mm
Shutter speed: 1/500th
Aperture: f11
200 iso digital*

Stopping down to f11 resulted in sharpness through the whole image.

187

*Lens: Nikkor 300mm f2.8 IF ED
Shutter speed: 1/500th
Aperture: f4.5
100 asa film*

Underexposing the crowd also emphasises the breath freezing. Not many pictures look cold!

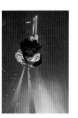

188

*Lens: Nikkor 18mm f3.5 AI-S
Shutter speed: 1/1000th
Aperture: f5.6
100 asa film*

A pocketwizard fired the camera as Jan Bucher backflipped over the camera looking up from the piste.

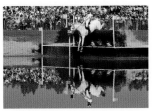

189

*Lens: Nikkor 70-200mm f2.8
G AF-S VR ED at 100mm
Shutter speed: 1/1250th
Aperture: f5.6
200 iso digital*

I composed this to include the reflection and shot about 40 different riders to get one just right. (A grey horse stood out so much more!)

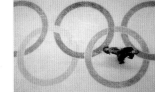

190

*Lens: Nikkor 85mm f2
Shutter speed: 1/500th
Aperture: f2.8
500 asa film*

Before digital a 250 exposure bulk film back was the only option, lent to me by Heinz Kluetmeier, the master of remotes.

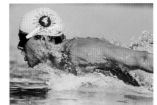

191

*Lens: Nikkor 400mm
f2.8 ED AF-S
Shutter speed: 1/1000th
Aperture: f5.6
200 asa film*

I didn't realise quite how high out of the water Andrew Jameson came until I got the film back from the lab.

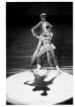

192

*Lens: Nikkor ED
180mm f2.8 AIS
Shutter speed: 1/500th
Aperture: f2.8
640 asa film*

Daylight film in tungsten balanced light added to the effect as it appears more golden/yellow, like their costumes.

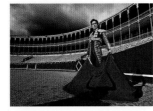

193

*Lens: Nikkor 14-24mm
f2.8G ED at 24mm
Shutter speed: 1/500th
Aperture: f5.6
200 asa film*

The reflectors had to be carefully angled only to light the matador's face, so the shadow of the bull on the cape had to be strong.

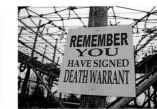

194

*Lens: Nikkor 300mm
f2.8 G AF-S VR
Shutter speed: 1/1000th
Aperture: f2.8
200 iso digital*

I often shoot details on a telephoto lens to help isolate the subject.

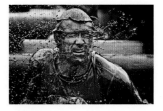

195

*Lens: Nikkor 400mm
f2.8 G ED AF-S VR
Shutter speed: 1/1000th
Aperture: f2.8
400 iso digital*

Even 1/1000th won't quite freeze the water being shaken from this guy's face. I think the slight movement helps…

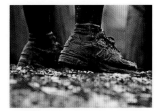

196

*Lens: ikkor 400mm f2.8 ED
AF-S +1.4 TC14 conc
Shutter speed: 1/1000th
Aperture: f2.8
400 iso digital*

A close-up with a converter gives even less depth of field which isolates the subject.

197

*Lens: Nikkor 24-70mm
f2.8G ED at 50mm
Shutter speed: 1/500th
Aperture: f2.8
400 iso digital*

I was under the obstacle to shoot this image. It almost looks like a shoe shop!

198

*Lens: Nikkor 400mm
f2.8 G ED AF-S VR
Shutter speed: 1/500th
Aperture: f2.8
400 iso digital*

Shooting between the barbed wire was the aim. His eyes make the frame.

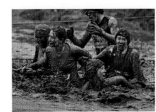

198

*Lens: Nikkor 400mm
f2.8 G ED AF-S VR
Shutter speed: 1/1000th
Aperture: f2.8
400 iso digital*

Four wet women! Almost a perfect subject isolated on a long lens.

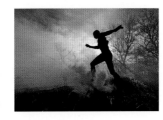

198-199

*Lens: Nikkor 24-70mm
f2.8 G ED at 24mm
Shutter speed: 1/1000th
Aperture: f3.5
400 iso digital*

I almost had an asthma attack getting this picture!

200

*Lens: Nikkor 14-24mm
f2.8G ED at 14mm
Shutter speed: 1/250th
Aperture: f4.5
200 iso digital*

'A little bit of flash' from a speedlight helped this very dark shot under an obstacle.

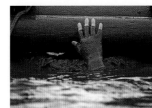

201

*Lens: Nikkor 400mm f2.8ED
Ai-S + TC14 conv
Shutter speed: 1/1000th
Aperture: f4
400 iso digital*

I noticed the competitors felt their way along the water-filled tunnels – the hands reaching up made a good detail picture.

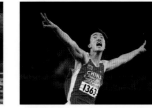

202

*Lens: 400mm f2.8
Shutter speed: 1/1000th
Aperture: f2.8
800 iso digital*

I followed Liu Xiang as he finished the 110 metres hurdles in Athens. When across the line he looked to his coach right above me!

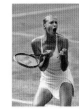

204

*Lens: Nikkor 300mm f2.8 IF ED
Shutter speed: 1/1000th
Aperture: f3.5
100 asa film*

Sharapova turned to the players' box on the service line and screamed in victory. Platform B at Wimbledon is the spot to be.

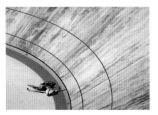

205

Lens: 70-200mm f2.8 at 70mm
Shutter speed: 1/1000th
Aperture: f4
100 asa film

Showing the bank of the velodrome helps to illustrate the fall, and, importantly, is good composition.

206

Lens: 600mm f4.0 + 1.4 conv
Shutter speed: 1/1000th
Aperture: f5.6
200 iso digital

A long lens is needed at the finish of rowing events. In fact rowing nearly always needs a long lens!

207

Lens: Nikkor 400mm f2.8 G
Shutter speed: 1/1000th
Aperture: f2.8
2000 iso digital

A long lens throws the background out of focus to isolate the subject and make the best of a bad background.

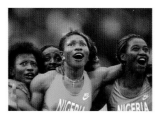

208

Lens: Nikkor 300mm f2.8 IF ED
Shutter speed: 1/500th
Aperture: f2.8
400 asa film

Looking up from my position in the finish moat, this is of the athletes' expressions as they see the result of the photo finish for third place.

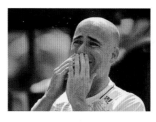

209

Lens: 600mm f4.0
Shutter speed: 1/1000th
Aperture: f4
100 iso digital

I chose my longest lens as I knew Agassi would cry as he retired at the US Open.

210

Lens: Nikkor 500mm f4.0 G ED AF-S VR
Shutter speed: 1/1250th
Aperture: f4
100 iso digital

Keeping the Sochi logo in the frame was difficult as this happened so quickly!

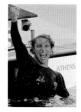

211

Lens: 400mm f2.8 + 1.4 conv
Shutter speed: 1/1000th
Aperture: f4
800 iso digital

I was positioned as always by his team mates. I shot tight to crop out all the clutter at the finish line of a swimming race.

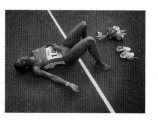

212

Lens: Nikkor 24mm f2 AI-S
Shutter speed: 1/500th
Aperture: f2
200 asa film

A tiny little bit of flash filled in the shadows and shows this intimate moment.

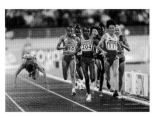

213

Lens: 400mm f2.8
Shutter speed: 1/500th
Aperture: f2.8
800 iso digital

Just practising my focusing during a heat when this girl tripped up in just the right place!

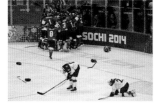

214

Lens: Nikkor 200-400mm f4.0G AF-S VRII at 200mm
Shutter speed: 1/1000th
Aperture: f4
2400 iso digital

The Nikkor 200-400mm is a great lens for the end of a match as it enables you to crop on the fly without stopping to change the lens.

215

Lens: Nikkor 14-24mm f2.8G ED at 14mm
Shutter speed: 1/125th
Aperture: f2.8
4000 iso digital

A tiny little bit of flash filled in the shadows and helps this scene without over-flashing. Manually set.

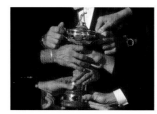

216

Lens: Nikkor 300mm f2.8 IF ED + 1.4 conv
Shutter speed: 1/500th
Aperture: f5.6
200 asa film

Closing in on the details can give you great different pics during boring presentations.

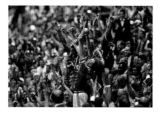

217

Lens: 300mm f2.8
Shutter speed: 1/320th
Aperture: f2.8
800 asa film

A grabbed moment in low light on negative film would be no problem today on digital!

218

Lens: Nikkor 70-200mm f2.8 G AF-S VR II ED at 135mm
Shutter speed: 1/1250th
Aperture: f3.5
400 iso digital

I used the look of the crowd to make a good scenic picture.

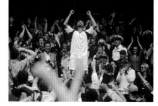

219

Lens: Nikkor 300mm f2.8 IF ED
Shutter speed: 1/500th
Aperture: f2.8
200 asa film

Standing on our seats to see Goran in the crowd. Cursing at the time, but the hands in the foreground help the picture.

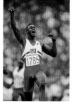

220

Lens: Nikkor 400mm F2.8ED Ai-S
Shutter speed: 1/500th
Aperture: f2.8
200 asa film

By shooting just round the corner from the finish line, I got a much better background for this celebration than on the finish line.

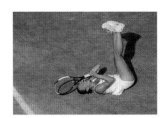

221

Lens: Nikkor 80-400mm f4-5.6G AF-S ED at 400mm
Shutter speed: 1/1600th
Aperture: f5.6
200 iso digital

The Nikon robotic head on Centre Court gives this unique angle!

222

Lens: Nikkor 80-400mm f4-5.6G AF-S ED at 100mm
Shutter speed: 1/1250th
Aperture: f8
200 iso digital

Andy Murray's finest moment! Luckily he is between the hands of the fans which make this frame shot on a Nikon robotic.

223

Lens: Nikkor 300mm f2.8 IF ED
Shutter speed: 1/1000th
Aperture: f2.8
100 asa film

Set up on a tripod high in the stands for this historic moment.

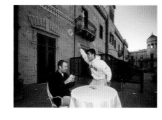

224

Lens: Nikkor 24mm f2 AI-S
Shutter speed: 1/250th
Aperture: f4.5
100 asa film

A tiny little bit of flash fills in the shadows and shows this intimate moment. This also allowed me to keep the sky blue.

225

Lens: 150mm f5.6 6X8 format
Shutter speed: 1/500th
Aperture: f8
100 asa film

I cracked a terrible joke to get the subject to laugh. One reflector, on the beach in Cornwall.

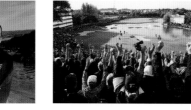

226

Lens: Nikkor 24mm f2 AI-S
Shutter speed: 1/1000th
Aperture: f3.5
200 iso digital

One of my first ever digital pictures on a Nikon D2X, fired with a pocketwizard from halfway down the fairway, so I'm somewhere in the picture.

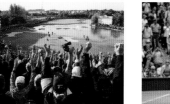

227

Lens: Nikkor 70-200mm f2.8 G AF-S VR II ED at 135mm
Shutter speed: 1/1600th
Aperture: f2.8
200 iso digital

A spot right under the players' box produced this moment. I used a zoom so if he jumped or fell to the ground I would be fine.

228

Lens: Nikkor 70-200mm f2.8 G AF-S VR ED at 100mm
Shutter speed: 1/2000th
Aperture: f5.6
100 iso digital

Exposing for the highlights! The boarder looking back at the top of the half-pipe makes the shot.

ACKNOWLEDGEMENTS

This book is dedicated to my love Sally, who is always by my side through thick and thin to help, encourage, support, nag and moan. My three sons Matthew, Russell and Nicky, and of course my little granddaughter Poppy.

My heartfelt thanks go to Nikon UK for supporting this project, Ken Mainardis of Getty Images and Karen Carpenter of *Sports Illustrated* for help in finding and allowing me to use the pictures I took whilst working for them. Jim Drewett, Toby Trotman and Paul Baillie-Lane of Vision Sports Publishing for publishing the book and Doug Cheeseman for the design, and the close friends that wrote some wonderful stories to make my pictures look half-way decent – Scott Price, Robert Philip, Steve Fine, John French, Anthony Edgar, John Walshe and Simon Bruty.

Finally, thank you to the sports stars that feature in this book and especially the ones that gave their time to pose for the portraits!

All of the pictures in this book are taken by Bob Martin and the copyright is owned by either Getty Images, *Sports Illustrated* or Bob Martin. All of the images on these pages can be licensed through either www.siphotos.com or www.gettyimages.com.

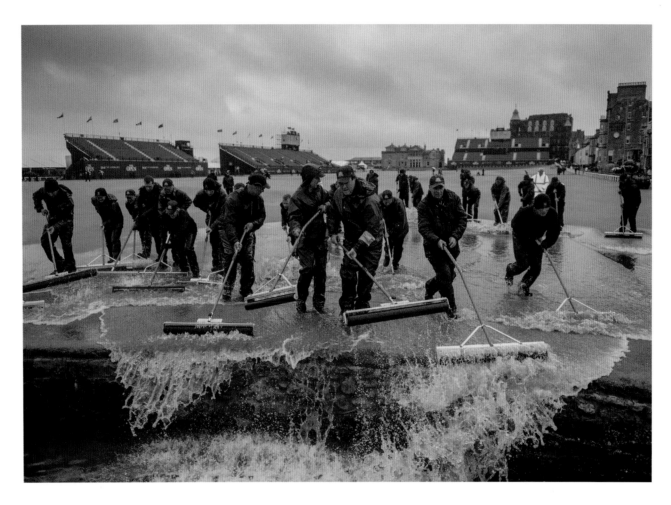

The final picture in the book is the last really good one I took before the book was published, at the 2015 British Open at St Andrews – one of the most miserable events I have ever photographed! Pouring rain, howling wind and the midges were biting. Welcome to Scotland... and, indeed, my life!

www.bobmartin.com